MODERN ART
PRACTICES AND DEBATES

Modernity and Modernism

MODERN ART
PRACTICES AND DEBATES

Modernity and Modernism
French Painting in the Nineteenth Century

Francis Frascina Nigel Blake Briony Fer
Tamar Garb Charles Harrison

YALE UNIVERSITY PRESS, NEW HAVEN & LONDON
IN ASSOCIATION WITH THE OPEN UNIVERSITY

Copyright © 1993 The Open University

First published 1993 by Yale University Press in association with The Open University
Reprinted with corrections 1994

6 8 10 9 7

Library of Congress Cataloging-in-Publication Data
Modernity and Modernism: French painting in the nineteenth century /
Francis Frascina ... [et al.].
p. cm. – (Modern art – practices and debates)
Includes index.
ISBN 978-0-300-05513-9 (cloth)
978-0-300-05514-6 (paper)

1. Painting, French. 2. Impressionism (Art) – France.
3. Modernism (Art) – France. 4. Painting, Modern – 19th century – France.
I. Frascina, Francis. II. Series.
ND547.5.I4M64 1993 759.4′09′034–dc20 92-35017

Edited, designed and typeset by The Open University.
Printed in Italy

CONTENTS

PREFACE

This is the first in a series of four books about art and its interpretation from the mid-nineteenth century to the end of the twentieth. Each book is self-sufficient and accessible to the general reader. As a series, they form the main texts of an Open University course *Modern Art: Practices and Debates*. They represent a range of approaches and methods characteristic of contemporary art-historical debate.

In the 'Introduction' Briony Fer raises issues central to recent developments in the study of 'modern art', pointing out some of the necessarily contested uses of the terms 'modern' and 'art'. She considers how and why notions of the 'modern' in art have played such an important role in culture, and introduces the issues pursued in the course of this series. The chapters consider aspects of art and visual culture in France, from *c.*1848 to the turn of the century. Conventionally, the 'modern' art of this period is considered chronologically in the categories 'Realism', 'Impressionism' and 'Post-Impressionism'. Here, however, each chapter introduces and examines a different approach to the study of the period, raising questions about historical enquiry and methodology, as well as about the status of 'art'.

In the first chapter, Nigel Blake and Francis Frascina consider the methods and arguments used by social historians of art to explain works of art as representations which are the products of social practices. For them, art practices, modernity and modernization are closely related and are inseparable from the socio-economic transformations taking place in France under a developing capitalism.

Charles Harrison argues that the relationship between modern life and modern painting is not to be established solely through examination of the social, historical and economic circumstances in which art was produced. However important contemporary events and ideas may have been for Impressionist painters, and however important it may be for us to be aware of them, the identification of their works as 'modern' is inseparable from the question of their aesthetic merit – a question which cannot be addressed without some formal analysis of painterly effects.

Tamar Garb considers aspects of Impressionist painting from a feminist perspective. Conventional representations of women in paintings present particular difficulties for the modern viewer. Furthermore, women artists lived and worked in conditions quite different from those of their male counterparts. So is it defensible to consider modern art without attempting to expose the gendered basis upon which it was developed and criticized? An analysis of the work of Manet, Renoir and Morisot shows how a feminist approach can serve to explain their works and change perceptions.

Open University texts undergo several stages of drafting and review. The authors would like to thank all those who commented on the drafts, notably Lynn Baldwin and Professor Thomas Crow. Tim Benton was the academic co-ordinator. The editors were Abigail Croydon and Clive Baldwin. Picture research was carried out by Tony Coulson and the text was keyed in by Alison Clarke. Richard Hoyle was the graphic designer. Roberta Glave was the course administrator.

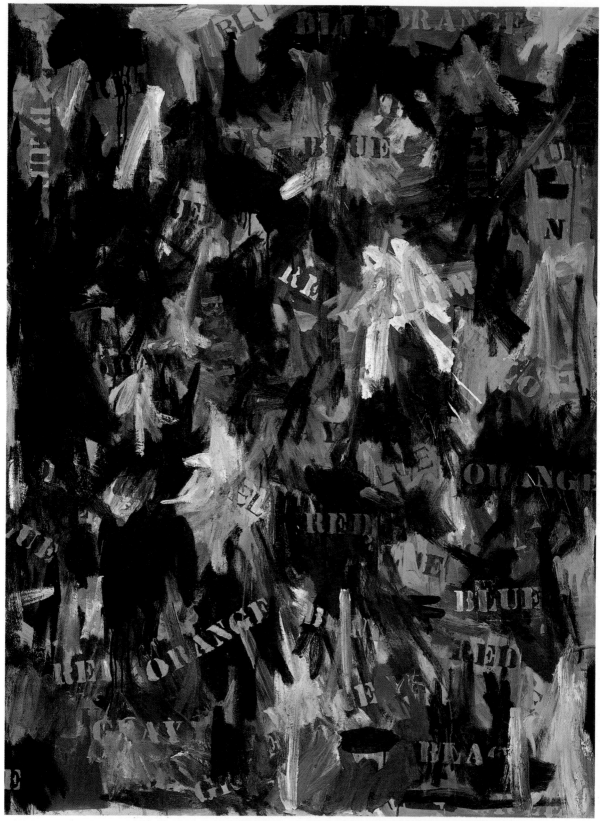

Plate 1 Jasper Johns, *Jubilee*, 1959, oil and collage on canvas, 152 x 112 cm. Private collection. Photograph courtesy of Blum Helman Gallery, New York. © Jasper Johns/DACS, London/VAGA, New York, 1991.

INTRODUCTION

by Briony Fer

When we consider the vast array of objects that are called 'modern art', how can we begin to make sense of the sheer range with which we are confronted? It's a range that can appear more disparate than unified and it includes works of art with seemingly so little in common that we may be entitled to ask whether they can sensibly be discussed in relation to one another, let alone thought to share something significant called the 'modern'. These are the problems that this introduction seeks to address, by asking what the 'modern' in art means.

I want to start by considering how we might begin to characterize one particular work of art – one that doesn't lend itself to easy interpretation. *Jubilee* (Plate 1) is a painting of 1959 by the North American artist Jasper Johns. The paint has been roughly applied and there is no recognizable imagery – only patches of black, grey and white paint and stencilled words, some of which are almost entirely obliterated. The words stencilled onto the canvas are labels which stand for colours, but for colours which are not present *as* colours in the painting. Less evident in the reproduction you see here, are the bits of paper which Johns has pasted onto the canvas. What has been painted out and painted over seems to be as much a part of Johns' work as the patches of paint that we see. How do we begin with a painting like this? Without a context for Johns' work, we might see it as a painting which has simply gone wrong. The roughness, the painting out and painting over, may seem merely to show the artist's mistakes and his unsuccessful attempts to correct them, until, exasperated, he abandons the work with nothing to show – a false start. I exaggerate here to make a point – that without an appropriate context and a sense that the work was deliberately made to look like this, it may simply fail to register, or it may register only as a series of wrong moves. So is it possible, with the help of an appropriate context, to see those wrong moves as right moves, or at least as meaningful in some way? If we compare *Jubilee* with another painting by Johns of the same year, called, as it happens, *False Start* (Plate 3), we may be prompted to notice something different going on in *Jubilee*. *False Start* is similar to *Jubilee* in many respects, but Johns has used bright colours – predominantly red, orange, yellow, blue and white. As a consequence, the effect of the work is quite different, although the same format and elements are used in both. The words labelling the colours stand in a different relationship to the colours actually used – sometimes they correspond with the colours on the canvas, sometimes they do not.

Looking at the two works together makes the 'wrongness' or arbitrariness appear at least more deliberate, as if there is a *point* to the mismatch between the painted words and the roughly painted areas, coloured or otherwise. And seeing them as companion pieces suggests that *Jubilee* is not the result of some kind of failure to put colour *into* a painting, as we might initially have supposed. For Johns, it was a question of how to take colour *out* of a painting, or at least to see what would happen if you left *in* a painting only labels for colours which you don't actually see. We may not have the visual sensation of the colours, and it may be hard to define exactly what is compelling in an encounter with a work like this, but figuring out what is going on in the picture seems to be an important part of its character. In other words, a puzzled response to a painting may be quite valid, rather than something that the study of art can or should rise above, by having, or claiming to have,

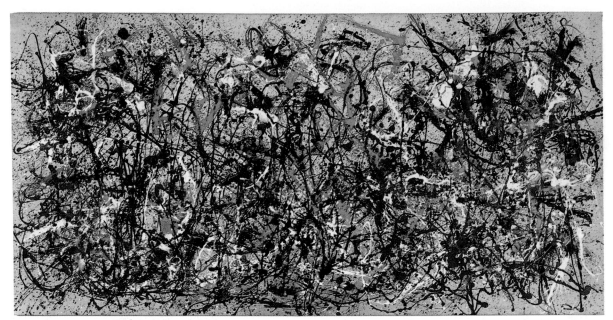

Plate 2 Jackson Pollock, *Autumn Rhythm*, 1950, oil on canvas, 271 x 538 cm. Metropolitan Museum of Art, George A. Hearn Fund 1957. © 1992 The Pollock-Krasner Foundation/ARS, New York.

all the answers. Much can be said about the effects and resources of Johns' work and the meanings it generates. All I want to signal here is that works of art may legitimately invite speculation.

If we modify the context for viewing Johns' work again, we can compare it with a slightly earlier painting by another North American painter, Jackson Pollock. *Autumn Rhythm* of 1950 (Plate 2) was not painted with a brush as Johns' work was. Instead, paint was dripped and splattered over a large canvas spread out on the studio floor; the canvas was only later stretched on a frame. (The usual way of working is on a ready-stretched canvas, in an upright position: on an easel, for example.) If we see Pollock's work as some sort of prior context for Johns, as an available point of reference, then we might notice the way that Johns both continues Pollock's interests and departs from them. He adopts the practice of making marks which do not depict objects in the world but which extend equally over the whole surface of the canvas. The marks may be different in kind, but both kinds make evident the way the work has been made: drips and brushwork are part of the process of making the work and are what we see on the canvas. To see the painting as openly revealing the working process is clearly a different way of interpreting *Jubilee* from our earlier suggestion of making and covering up mistakes. In parts of *Jubilee* the paint has been left to drip down the canvas, and in this context the drips look less like sloppy work than the cultivation of certain unforeseen effects. Johns could be seen to be courting the arbitrary effect and seeking out mismatches in quite deliberate moves. The dripped paint in Johns' work may even begin to look like a reference to Pollock's work and technique. And the stencilled letters of the words look, in this context, more like an addition, however much they are worked into the picture (sometimes underlying and sometimes over-laying the areas of brushwork). They may even seem intrusive in some way, creating a barrier of sorts between us, as viewers, and the gestural marks which make up the rest of the painting. We can see Johns both extending some aspects of Pollock's practice and also, perhaps, distancing himself from them, even questioning what they stood for.

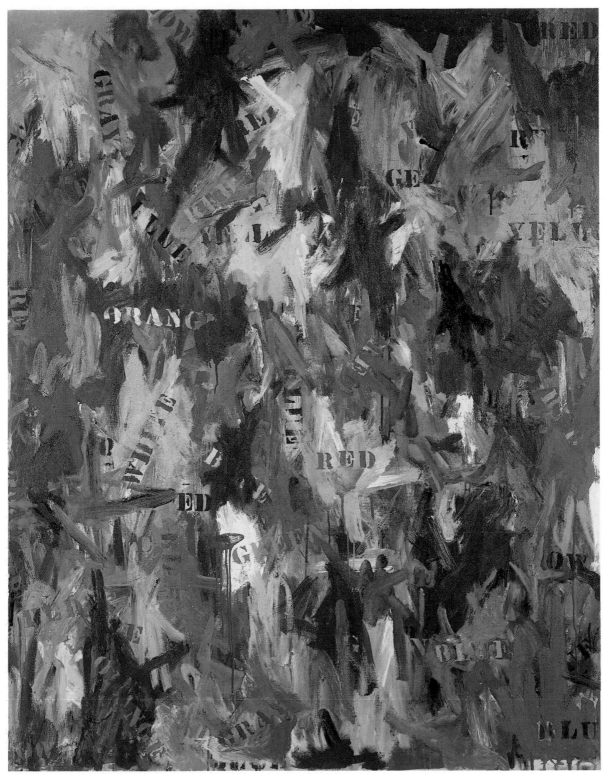

Plate 3 Jasper Johns, *False Start*, 1959, oil on canvas, 709 x 371 cm. Private collection . Photograph by courtesy of Leo Castelli Photo Archives, New York. © Jasper Johns/DACS, London/VAGA, New York 1991.

I do not want to suggest that this is a sufficient context for viewing Johns' work, or that paintings make sense only by comparison with other paintings. My point is simply this: the way we order and group works of art, and the context we place them in, will affect the way we see them. When we characterize something, we characterize it in relation to something else, even though we are not necessarily conscious of the comparisons we are making. So learning about modern art is, at least partly, learning how to establish what the relevant points of reference might be. It also involves deciding what constitutes an appropriate context, because the kinds of judgements we make about works of art tend to hinge on the kinds of context we think they inhabit. But there are no fixed answers: the way works of art are characterized, categorized and contextualized is open to question and subject to changing views. For this reason, the four volumes of essays which make up this series offer an account of the practice of art since the mid-nineteenth century but also engage with the debates surrounding modern art. Rather than providing a survey of great artists or great paintings, each of the essays will address a particular set of ideas in relation to works of art produced at a specific historical period, and different authors will adopt different views and standpoints. This series of books can itself be situated in a context, as part of a contemporary debate about what it is to engage in the study of art.

What is modern?

The purpose of this introduction is to point to a field of speculation. Firstly, I want to address some preliminary comments to the term 'modern', because disagreements over its boundaries, its validity and its meanings are at the core of the history of art of this period.

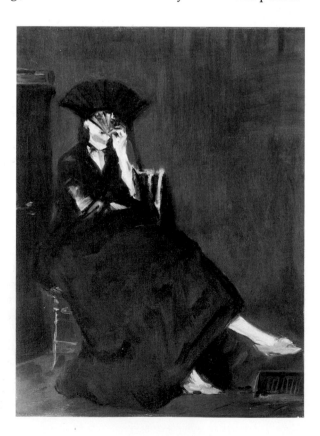

Plate 4 Édouard Manet, *Berthe Morisot with a Fan*, 1872, oil on canvas, 60 x 45 cm. Musée d'Orsay, gift of Étienne Moreau-Nélaton. Photo: Réunion des Musées Nationaux Documentation

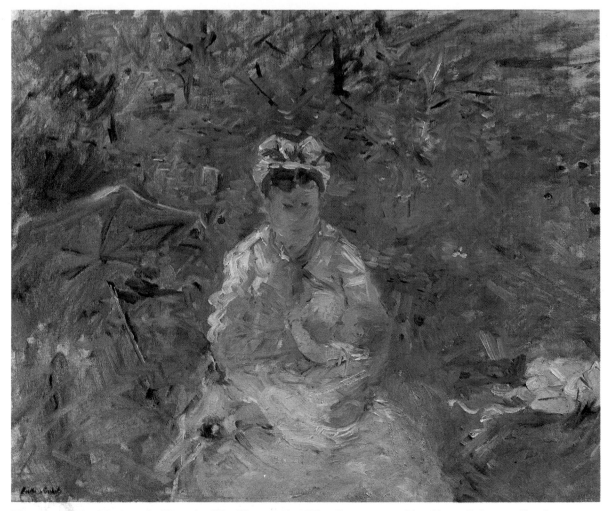

Plate 5 Berthe Morisot, *La Nourrice* (*The Wet-nurse*), 1879, oil on canvas, 50 x 61 cm. Private collection, Washington. Photograph by courtesy of Holyoke College Art Museum, South Hadley, Massachusetts.

We might commonly use the term 'modern' quite loosely, to mean 'of the present' or up-to-date. In this informal sense it refers to the contemporary and is defined by its difference from the past. But even when we use it in what appears to be a neutral, descriptive way, it is worth bearing in mind that we do so selectively, to refer to some aspects of the present as opposed to others which we see as old fashioned or traditional and in some way left over from the past: that is, we use it to mark out differences *within* the present as well as *from* the past. When it is applied to art, the term 'modern' can designate a period of history (though when that period begins is variously interpreted), and it can be used to discriminate between different types of art produced within that period. In the language of art criticism, then, it is also used selectively. 'Modern art' does not necessarily mean the same as 'art of the modern period', since not all the art that has been produced within that period is deemed to be 'modern' – only certain types of art are regarded as having a claim to be modern.

So what is it that the term 'modern' singles out, and what is supposed to give some paintings a claim to be 'modern' as opposed to others? Let me put forward a fairly conventional comparison. If we compare a group of paintings by Édouard Manet (Plate 4), Berthe Morisot (Plate 5) and Claude Monet (Plate 6) with a work by the Academic painter, William-Adolphe Bouguereau (Plate 7), all produced between 1870 and 1880, it is fairly

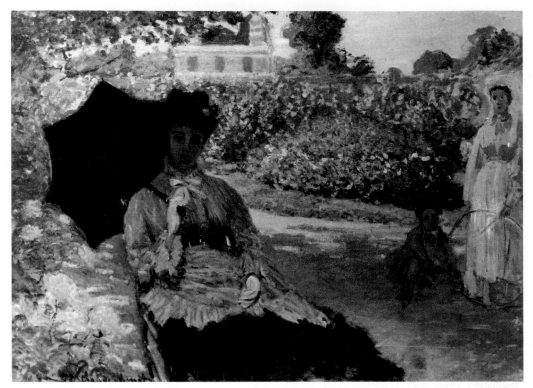

Plate 6 Claude Monet, *Camille au jardin, avec Jean et sa bonne* (*Camille in the Garden with Jean and his Maid*), 1873, oil on canvas, 59 x 79 cm. Private collection , Switzerland.

easy to see, I think, the difference between the Impressionist works on the one hand, and the painting by Bouguereau on the other. Whereas the first group treats contemporary subjects with a sketchy brushwork, the Bouguereau conforms to an established model of Academic painting. The figures are not depicted in contemporary dress (though they are undoubtedly nineteenth-century facial types) and are set in an unspecific Italianate land-scape; the scene is painted in much more detail, with little obvious evidence of brushwork; it has a much finer finish and careful attention has been given to the modelling of the figures (that is, the gradual shading of contours, used to give an illusion of three dimensions). I would not want to overstate the significance of this sort of comparison. There is no doubt that such contrasts tend to exaggerate certain features and suppress others. In fact, Academic painting was much more varied than this one example indicates; its standards were subject to change and its range wide enough to include topical and modern subjects. But here I simply want to register the point that a 'modern' art practice is constructed out of a sense of *difference*. We could even say that the modern *is* a form of difference, and that from the mid-nineteenth century, at least as far as painting is concerned, it entailed a particular relationship between the kinds of contemporary *subject* and the kinds of *treatment* that we find in the Manet, the Morisot and the Monet.

One way of describing the difference is to draw attention to the way in which the three paintings all appear, by comparison with Bouguereau's monumental composition, to break up the surface of the painting into distinct and sketchy brushstrokes. Instead of carefully modelled figures convincingly situated in a landscape, we find the figures treated with the same broken brushwork as their settings (whether they are located in an interior or a landscape). Bouguereau concentrated on the faces of his figures and idealized them, but the 'modern' paintings (Plates 4–6) all seem at least partially to obliterate the face as a possible focus of the painting. There is the almost blurred, imprecise treatment of

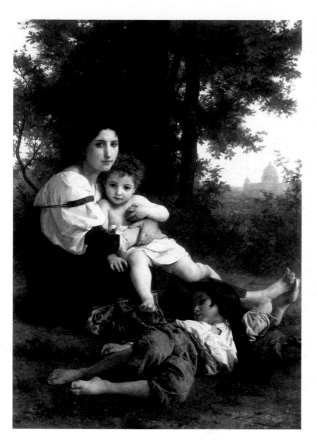

Plate 7 William-Adolphe Bouguereau, *Mother and Children* (*'The Rest'*), 1879, oil on canvas, 164 x 117 cm. The Cleveland Museum of Art, Hinman B. Hurlbut Collection 432.15.

the Morisot, the shadow cast by the parasol in Monet's work, and the intrusive fan with which Manet covers the woman's face. In all three, we could identify this erasing of the details of a woman's face as a device to redirect our attention elsewhere, *away* from what is often regarded as the psychological centre of a painting – the human face – onto other parts and characteristics of the painting. I would add that the peculiar device shared by these paintings might be coincidental if it were not linked with some more *general* movement or set of interests. The comparison with Bouguereau takes us only so far in this respect (and doesn't exhaust the interest of any of the paintings). For the poet and art critic Charles Baudelaire, this set of interests was identified with what he called 'modernity'.

In an essay called 'The painter of modern life', first published in the French newspaper *Le Figaro* in 1863, Baudelaire used the term *'modernité'* to articulate a sense of difference from the past and to describe a peculiarly modern identity. The modern, in this context, does not mean merely *of* the present but represents a particular attitude *to* the present. This attitude is related by Baudelaire to a particular *experience* of modernity, which is characteristic of the modern period as distinct from other periods. Such a self-conscious experience of modernity only developed in the middle of the nineteenth century, when, applying it to art, Baudelaire could define it in this way: 'By "modernity" I mean the ephemeral, the fugitive, the contingent, the half of art whose other half is the eternal and the immutable' (*The Painter of Modern Life and other Essays*, p.13). These two aspects – the transitory or fleeting, on the one hand, and the eternal on the other – were two sides of a duality. There was a mutual dependence and a productive tension between them. Baudelaire argued, for example, that painters should paint figures in contemporary dress, rather than in archaic costumes from the past, and that the contemporary, in all its diverse and fleeting guises, had an heroic or epic dimension. Baudelaire's idea of modernity was not merely a question of being up-to-date or subject to swiftly changing

fashions, although these were symptomatic of a modern type of experience. It claimed that the modern in art related to an experience of modernity – that is, to an experience which is always changing, which does not remain static and which is most clearly felt in the metropolitan centre of the city. As soon as we try to pin modernity down or to define it in a simple formulation, we risk losing this sense that it is, by definition, constantly subject to renewal, that it marks out shifting ground. For Baudelaire, new subjects required a new technique; just as there were appropriate forms that the modern in art could take, so too there were inappropriate forms. In these terms, paintings might not be inherently modern – by virtue, say, of the techniques used in them – but modern by virtue of the context in which they were produced, and in relation to other representations. The terms 'modern' and 'modernity' are not a matter of fixed definition but are relative and subject to historical change.

Clearly not all modern paintings depict modern or contemporary subjects, but the relationship between subject, and technique, or means of representation, was a persistent concern for artists in the late nineteenth and early twentieth centuries. We could put this slightly differently and suggest that there was an uneasy co-existence, or a tension, between the aims of modern painting and those of modernity, if we understand 'modernity'

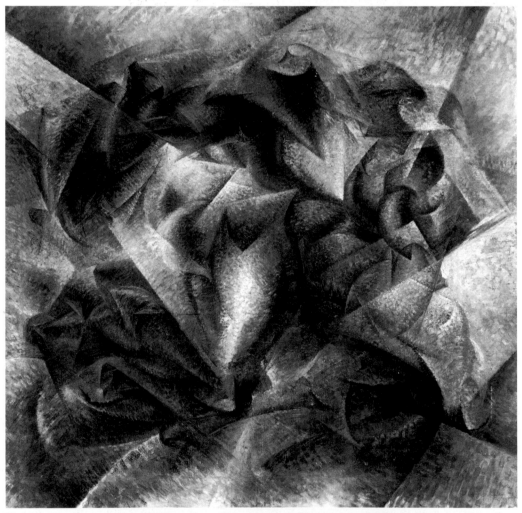

Plate 8 Umberto Boccioni, *Dinamismo di un giocatore* (*Dynamism of a Soccer Player*), 1913, oil on canvas, 193 x 201 cm. Collection, The Museum of Modern Art, New York. The Sidney and Harriet Janis Collection.

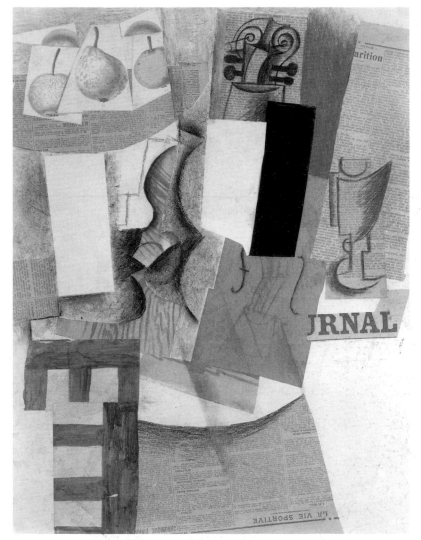

Plate 9 Pablo Picasso, *Bowl with Fruit, Violin and Wine Glass*, autumn–winter 1912, pasted papers, gouache and charcoal on cardboard, 65 x 50 cm. Philadelphia Museum of Art, A.E. Gallatin Collection. © DACS, London/SPADEM, Paris, 1991.

to refer to the changing forms of modern, metropolitan social life. I want to leave this open, but a few examples illustrate something of the changing priorities at stake, and indicate the ways in which interests diverged in different historical and geographical contexts. Umberto Boccioni's *Dynamism of a Soccer Player* (Plate 8) is a painting that demonstrates the Italian Futurist concern with modern life – the modern sporting hero, here, could even be seen as an updated Baudelairean motif. Yet Picasso's *Bowl with Fruit, Violin and Wine Glass* of 1912 (Plate 9), if we think about its motif for a moment, is a fairly conventional still-life, which departs from the conventions of still-life painting by including only fragmentary references to objects, interspersed with elements of collage (pieces of coloured paper, 'ready-made' images of fruit, and bits of newspaper) stuck onto cardboard. In both these pictures, despite the different media, the *means* of representation have been foregrounded. In the Picasso, an aspect of contemporary life may be signified by the inclusion, or intrusion, of a 'real' bit of newspaper, but the representation of modernity hinged also on the fragmentation of the whole, on making the means of representation apparent. The words *'la vie sportive'* ('the sporting life') – suggestive of a modern-life theme like Boccioni's – may be printed on the newspaper at the bottom of the picture, but the piece of newspaper, one of many inversions in the work, is turned on its head, and the meaning remains elusive.

Plate 10 Boris Kustodiev,
The Merchant's Wife, 1915,
oil on canvas, 204 x 109 cm.
State Russian Museum, St Petersburg.
Photo: Novosti Press Agency (APN).

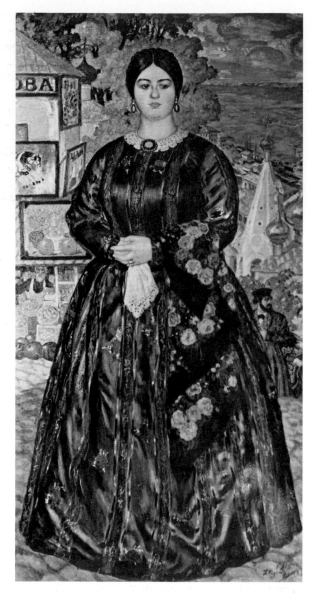

 I would like to consider a further example to draw attention to the shifting relation-
ship between modern subjects and the means of representation. Both Boris Kustodiev's
Merchant's Wife (Plate 10) and Kazimir Malevich's *Black Square* (Plate 11) were painted a
couple of years before the Bolshevik Revolution in Russia in 1917. Kustodiev paints a
merchant's wife, a contemporary type, in contemporary dress, and is seemingly within the
modern tradition in doing so. But when Malevich exhibited his recent abstract paintings,
including the *Black Square*, he asked his audience to 'spit on the old dress and put new
clothes on art', calling Kustodiev one of the 'rag merchants' and 'pedlars of the past'
('From Cubism and Futurism to Suprematism', p.27). Malevich's language is iconoclastic,
much more so than Baudelaire's, but it is worth noting that both used the metaphor of
women's fashion to evoke a sense of what modernity meant, while neither equated the
modern with the simply fashionable. We shall go on to ask more questions about
Malevich's abstract painting later, but here I simply want to register the point that
Malevich may not have been any more 'of the present' than Kustodiev. His work may
appear to be far removed from the concern with modernity and contemporary social types

that had earlier characterized, for Baudelaire, the task of the modern artist, but Malevich self-consciously addressed what it was for art to be 'modern' in a way that Kustodiev did not. By *this* date and in *this* set of historical circumstances to be 'modern' meant – in part at least – refusing to paint figuratively. For Malevich, it also meant addressing the concerns of the most recent work produced by modern artists in other European centres, such as the Italian Futurists and the French Cubists (Plates 8 and 9). My point is that modern painting was a product of a modern culture, but not the only product; it was one form of production among many other complex forms of visual representation, including Academic painting, popular illustration, photography and so on. Different forms of representation are produced in the same culture and can be shown to interact, to share conventions and assumptions about the world *and* to contest what is significant in that culture. It may be that Malevich's *Black Square* has more in common with Kustodiev's *Merchant's Wife*, in a paradoxical way, than at first glance seems plausible. These two works make competing claims for what is *significant*, for what art should be like. And although they look nothing like one another, I would suggest that the meanings of the one are generated to some extent out of the meanings of the other.

I now want to turn to the idea of a modern *tradition*, and consider how that tradition has been established and interpreted. One way of explaining the development of modern art has been to suggest that art is a self-governing or 'autonomous' field of activity, and that there is an inner logic to its development. This logic is supposed to be basically independent of other causal factors. Such a view will be examined from different standpoints in subsequent chapters of this book, but I simply want to sketch here one or two of its key suppositions, as they came to be expounded by the North American critic Clement Greenberg, who was at the height of his influence in the early 1960s. Greenberg's was only one voice among many – although a powerful and persuasive one – in what has come to be called a 'Modernist' approach to art.[1] Although the terms 'modernist' and 'modernism' are used to refer to the kind of modern *practice* I have already outlined, we shall use 'Modernism' with a capital 'M' to refer to this particular tradition in *criticism*.

As a critic, Greenberg saw his task as identifying what he took to be the best contemporary and recent art (for example, Pollock's drip paintings, see Plate 2) and accounting for it. This involved situating it within a tradition of modern art which he and others saw as having emerged in mid-nineteenth-century France, in the work of Édouard Manet. For Greenberg, the key motivating force within modern art was the pursuit of quality. 'Art', he wrote, 'is a matter strictly of experience, not of principles, and what counts first and last in art is quality' ('Abstract, representational and so forth', p.133). What Greenberg means by 'experience', here, is the practical aspect of making art (which he contrasts with the idea of art demonstrating a pre-existing set of principles or theories), and the artist's attention to the medium of painting. In his view all successful modern painting had in common an acknowledgement of the surface of a painting – that is, the flatness of its support. By contrast with the illusion of depth pursued by the 'old masters', this flatness revealed rather than concealed the medium of painting. In Greenberg's formulation, Pollock's work of the 1940s and 1950s did not leap straight from the conclusions of Manet's in the 1860s, but a logical development could be traced through a gradual process of interaction over the intervening one hundred years.

Greenberg's view depended on hindsight, so that the later work of Pollock, say, shed light on the development that had gone before and Greenberg could claim: 'Manet's paintings became the first Modernist ones by virtue of the frankness with which they declared the surfaces on which they were painted' ('Modernist painting', p.6). This refers to the way in which Manet painted his subject with sketchy brushstrokes and with very little depth – the way the nude figure of *Olympia* (Plate 14), for example, is painted as an

[1] The development of Greenberg's ideas can be traced in *Clement Greenberg: The Collected Essays and Criticism*. I pick out Greenberg here because his views have given rise to much subsequent debate, although a type of Modernism was also developed by influential figures in the institutions and museums of modern art.

Plate 11 Kazimir Malevich, *Black Square*, after 1920 (later version of 1915 painting), oil on canvas, 110 x 110 cm. State Russian Museum, St Petersburg.

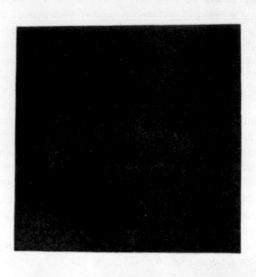

expanse of white flesh edged with abrupt grey outlines which draw attention to the flatness of the picture surface. Greenberg's judgements were thus made on *formal* grounds – which is not to say that he was blind to the subject depicted, but that he thought the quality of modern works of art depended on the acknowledgement of the medium, on the way in which a work was painted. Art moved forward by engaging critically with the most ambitious modern art to have preceded it, and it was 'self-critical' for Greenberg in this respect. In this view, priority is given to the *autonomous* properties of painting, because it is these which give painting its particular character, and which distinguish it from any other art. 'Flatness', for Greenberg, is the most important feature of painting, because it is this two-dimensional characteristic which is peculiar to it and which makes it like no other art.

The Modernist account has privileged the work of certain artists at the expense of others. The 'canon' it has established consists of exemplary works of modern art, which are seen as having an *aesthetic value* over and above other works. It tells you what is good art, and provides a framework for doing so, but the *terms* in which it does this have been contested. What is in dispute is how far aesthetic value can be seen as independent of other values and interests – social, political and cultural. But if one wishes to refute the Modernist account, as many art historians have done, especially since the early 1970s, then what is to replace it? Is all art equally worthy of attention? Is Bouguereau's or Kustodiev's work – contrary to what received wisdom tells us – of as much interest as Manet's or Malevich's? What does 'interest' mean? What other process of selection do we adopt?

Many feminist art historians have seen Modernist criticism's emphasis on a particular notion of 'aesthetic value' as a powerful mechanism of exclusion which, by the very terms it sets up, marginalizes women artists. As a consequence, the critical task has not been to tinker with this canon, but to reconsider the way art is made, who it is made by, who it is made for, and in whose interests the canon itself came to be put in place. This is to say that 'value' in art is something that is fought over, rather than something that can simply be assumed. The picture we have of the art of the past is constantly being reshaped. Judgements about what is significant in the art of the past, which will always operate whether or not they are clearly stated, vary according to different interests in pursuing the subject – and indeed what the subject is seen to be.

Perhaps the easiest way to point to the kind of diversity I mean, is to look again at the three paintings (Plates 4–6) I rather casually linked together earlier. All three depict

women: Manet uses Berthe Morisot as his model for a contemporary Parisian, Monet depicts his wife, child and nurse in a domestic setting, Morisot paints a working wet-nurse feeding Morisot's own child. At times the figures in each are painted so sketchily that they seem to be threatened with illegibility – this is something that they have in common. But we might also attend to the equally important differences between the works, not only in terms of what they look like, and the representations of gender and class they entail, but also how they came to be made. We might consider how men and women, as artists, were operating under different constraints in this respect; for example, we might ask about the significance of the artist's gender in determining how these paintings were produced and what they represent. In Manet's painting, for example, the signs of Morisot the artist are part of what is made illegible, although it is questionable how far it could properly be called a portrait, so anonymous is the figure made to appear.

In the chapters that follow, you will encounter competing claims for the character and status of the modern in art. You will find arguments, for example, for the way painting relates to the *social* experience of modernity, for the modern as a *qualitative* distinction, and for the role played by *gender* in representation. Though not necessarily mutually exclusive, different sorts of interests may lead us to characterize works of art in different ways. Now I want to consider the question of interpretation further, but from a different angle.

Invisible pictures: visual representation and language

As soon as we use concepts to think about pictures or ascribe meaning to them, we use language. The experience of looking at a picture is not directly translatable into verbal language, yet we necessarily talk and write about it *in* language. What is more, visual representation has often been talked about as a language, or as *like* language, especially in the modern period. The idea of a 'language' of art has the advantage of focusing attention on the medium of painting, the means of representation, and has therefore seemed a particularly appropriate way of drawing attention to the prime concerns of modern painting. By pausing to think about how language is used to describe paintings, I shall point to some of the clearest differences between visual representation and verbal language, in order to see more clearly how closely the one is bound up with the other.

If I offer a description of a painting, it may be useful to see how far, if at all, it is possible to construct in our minds an image of that painting.[2] The commentary I have chosen is by Max Buchon, a writer and critic. It was written in 1850 and describes a painting by Gustave Courbet, *The Stonebreakers*. The complete text contains a discussion of this and another painting by Courbet, *The Burial* (or *Funeral*) *at Ornans*. It was published in a left-wing journal, *Le Peuple*, in 1850, in anticipation of the exhibition of both works, which was to follow a couple of months later.

> The painting of *The Stonebreakers* represents two life-size figures, a child and old man, the alpha and the omega, the sunrise and the sunset of that life of drudgery. A poor young lad, between twelve and fifteen years old, his head shaven, scurvy, and stupid in the way misery too often shapes the heads of the children of the poor; a lad of fifteen years old lifts with great effort an enormous basket of stones, ready to be measured or to be interspersed in the road. A ragged shirt; pants held in place by a breech made of rope, patched on the knees, torn at the bottom, and tattered all over; lamentable, down-at-heel shoes, turned red by too much wear, like the shoes of that poor worker you know: that sums up the child.

[2] This line of questioning was initially prompted by Michael Baxandall, in the introduction to his book, *Patterns of Intention*.

To the right is the poor stonebreaker in old sabots fixed up with leather, with an old straw hat, worn by the weather, the rain, the sun, and the dirt. His shaking knees are resting on a straw mat, and he is lifting a stonebreaker's hammer with all the automatic precision that comes with long practice, but at the same time with all the weakened force that comes with old age. In spite of so much misery, his face has remained calm, sympathetic, and resigned. Does not he, the poor old man, have, in his waistcoat pocket, his old tobacco box of horn bound with copper, out of which he offers, at will, a friendship pinch to those who come and go and whose paths cross on his domain, the road? The soup pot is nearby, with the spoon, the basket, and the crust of black bread.

And that man is always there, lifting his obedient hammer, always, from New Year's Day to St. Sylvester's; always he is paving the road for mankind passing by, so as to earn enough to stay alive. Yet this man, who in no way is the product of the artist's imagination, this man of flesh and bones who is really living in Ornans, just as you see him there, this man, with his years, with his hard labour, with his misery, with his softened features of old age, this man is not yet the last word in human distress. Just think what would happen if he would take it into his head to side with the Reds: he could be resented, accused, exiled, and dismissed. Ask the prefect.

(M. Buchon, 'An introduction to *The Stonebreakers* and *The Funeral at Ornans'*, pp.60–61)

This appears to be a thorough description of the picture, so how much can we tell from it about the appearance of the work? Two principal figures, 'life-size', we are told, are described in some detail. Buchon pays particular attention to their physical attitudes and their clothing. The child is lifting a basket of stones on the left, the old man is kneeling and lifting a hammer on the right, a soup pot is somewhere nearby. Apart from these references, Buchon tells us very little about the way the figures have been formed or the way they relate to the composition as a whole. We can deduce that they are painted in great detail, because it is this detail that Buchon sees as so vividly evocative of a particular way of life. It is an *iconographical* description, in that Buchon tells us about the subject-matter of the picture but almost nothing about how the subject-matter is treated or the *form* the painting takes.

Buchon's commentary invests the painting with real-life protagonists: the old man 'really lives in Ornans'. He talks about the figures not as painted configurations but as if they were real. He reads from the painting a lived social reality and weaves a narrative around the figures, giving them a past, a present and a future: a past – a long life of drudgery; a present – working everyday on the roadside; and a future – what if the stonebreaker rose up in revolt against his oppressors? Buchon tells us a great deal about what could be inferred from the painting in 1850, when it carried powerful references to social and class division. He speaks of the painting's political content through a description of the subject depicted. It is only when Buchon turns to consider the other painting, *Burial at Ornans*, that he writes (almost in passing) that this scene, 'in spite of its fascination, is merely imperturbably sincere and faithful to reality … in front of [it] one feels so far removed from whimpering tendencies and from all melodramatic tricks'. Here Buchon is making a comparative statement about how this painting, as a representation – one that is sincere and faithful – differs from other types of representation, which he associates with sentimental and melodramatic effects. Of course, Buchon knows all along that what he is talking about is a representation, he is not actually confusing the painting with a real scene. But what is significant for our purposes is that he uses the convention of describing the figures *as if* they were real.

The Stonebreakers was destroyed in the Second World War and all we now have as a visual record of the painting is a photograph (Plate 12). The photograph is a visual analogue of the painting, reproducing its form and content, and approximately, its colour, but like all reproductions it cannot reproduce the scale, the tonal complexity or the texture of the original work. When we work with photographs of paintings, such as the reproductions in this book, we are referring to substitutes for the actual works, in this case a

substitute for a painting that no longer exists. We could not have reproduced the picture from Buchon's verbal account. His aim, of course, was not to provide a substitute for the painting but a commentary to complement the painting. Because Buchon was describing a picture his audience had not yet seen, he had to give them a verbal picture, however partial, of what they were to see. Reading his verbal account is very different from looking at the picture, or even the photographic image of the picture that we have here. One of the most obvious differences is the way Buchon, in his narrative, has to put the figures in some kind of sequence: he lists them. In the painting, on the other hand, the whole scene is available at once; we can take in the whole picture, we can concentrate on particular details, we can scan the painting from left to right or right to left. It is possible to see Buchon following a lead suggested by Courbet in the way he discusses the boy first. This is to 'enter' the picture, as it were, led by the direction of the boy's step – the movement of the leg could be seen as a fairly conventional device for leading the spectator's 'eye' into the picture. But even if this were so, we would not simply rest when we reached the figure of the boy and look at no more of the picture until we had fully taken in the details of his clothing and bearing. The ordering of a verbal account simply does not equate with the way we scan pictures.

Buchon's account 'sees' both more and less than is in the painting. 'Less' in that he concentrates on certain details at the expense of others. He omits any reference to the landscape as well as to the formal and technical aspects of the representation – the way Courbet has applied the paint on the canvas, for instance. 'More' in that he reads from the painting a narrative about the protagonists and the lives they lead. Partly because we have nothing to go on but the photograph, we strain to see the features of the old man's face, about which Buchon wrote, 'his face has remained calm, sympathetic, and resigned'. Yet despite the limitations of the photograph, we can tell that the *invisibility* of the faces of the protagonists is a notable feature of the painting – the boy's turned away, the old man's shadowed by the straw hat. Buchon's confidence in describing the features of the face, as he goes on to refer to the 'softened features of old age', seems to derive from his observations of men such as this in actuality – and he sees it as quite legitimate to weave this into his narrative about the painting. The effacement of the individual faces in the painting focuses attention on the figures' physical movement, their poverty, and the nature of their work. Buchon seems to project back from these class references the kind of facial expression he might expect to find in workers of this type. Likewise, in the painting the tobacco box pokes out of the stonebreaker's pocket – so much is visible – but Buchon actively invites his readers to connect the detail to their observation of men like this one offering 'a friendship pinch' of tobacco to passers by. Here Buchon is engaging in imaginative projection, and asking his readers to participate in that projection; this, it is implied, is an appropriate way to look at the work.

Buchon was a friend of Courbet's and because of their close association, this text has been taken to be the clearest expression we have of the artist's own intentions (see T.J. Clark, 'A bourgeois Dance of Death'). Buchon's approach is certainly similar to the way in which Courbet himself wrote about the painting in a letter of 1849 to Francis Wey:

> There is an old man of seventy, bent over his work, pick in the air, skin burnt by the sun, his head in the shade of a straw hat; his trousers of rough cloth are patched all over; he wears, inside cracked wooden clogs, stockings which were once blue, with the heels showing through. Here's a young man with his head covered in dust, his skin greyish-brown; his disgusting shirt, all in rags, exposes his arms and his flanks; leather braces hold up what is left of a pair of trousers, and his muddy leather shoes are gaping sadly in many places. The old man is on his knees, the young man is behind him, standing up, carrying a basket of stones with great energy. Alas, in this occupation you begin like the one and end like the other! Their tools are scattered here and there: a back-basket, a hand-barrow, a ditching-tool, a cooking-pot, etc. All this is set in the bright sun, in the open country, by a ditch at the side of the road; the landscape fills the whole canvas.
>
> (quoted in Clark, *Image of the People*, p.30)

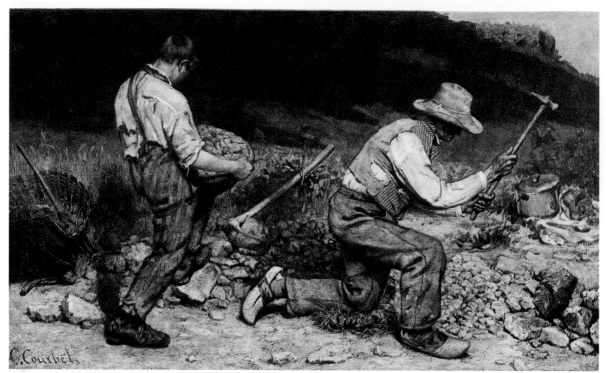

Plate 12 Gustave Courbet, *The Stonebreakers* (*Die Steinklopfer*), 1849, oil on canvas, 159 x 259 cm (destroyed 1945). Gemaldegalerie Neue Meister, Dresden. Photo: Deutsche Fototek Dresden, Sächsische Landesbibliothek, Dresden.

Read in isolation, this could be taken – until the final sentence – as a description of a real scene; read in conjunction with the picture, it picks out those iconographical elements of the work that Courbet, like Buchon, saw as its key features. It seems that Buchon read the painting 'correctly', if 'correctly' is taken to mean the way Courbet intended it to be read. In that sense, Buchon could be seen as the ideal spectator of the work, the spectator who could interpret it in the way Courbet envisaged. Buchon's text is not merely a straight-forward description, it is an account of what he saw as meaningful in *The Stonebreakers*. He picked out what was for him the significant interest in the picture, which, we can fairly reliably assume, was also its significant interest for the artist. The extent to which their interest in the painting should correspond with our own is open to question.

I want to turn now to a very different piece of criticism. It was written some seventeen years later than Buchon's, in 1867. This is the writer Émile Zola talking generally about Manet's work:

> Our task then, as judges of art, is limited to establishing the language and the characters; to study the languages and to say what new subtlety and energy they possess. The philosophers, if necessary, will take it on themselves to draw up formulas. I only want to analyse facts, and works of art are nothing but simple facts.
>
> Thus I put the past on one side – I have no rules or standards – I stand in front of Édouard Manet's pictures as if I were standing in front of something quite new which I wish to explain and comment upon.
>
> What first strikes me in these pictures, is how true is the delicate relationship of tone values. Let me explain … Some fruit is placed on a table and stands out against a grey background. Between the fruit, according to whether they are nearer or further away, there are gradations of colour producing a complete scale of tints. If you start with a 'note' which is lighter than the real note, you must paint the whole in a lighter key; and the

contrary is true if you start with a note which is lower in tone. Here is what I believe is called 'the law of values'. I know of scarcely anyone of the modern school, with the exception of Corot, Courbet and Édouard Manet, who constantly obeys this law when painting people. Their works gain thereby a singular precision, great truth and an appearance of great charm.

Manet usually paints in a higher key than is actually the case in Nature. His paintings are light in tone, luminous and pale throughout. An abundance of pure light gently illuminates his subjects. There is not the slightest forced effect here; people and landscapes are bathed in a sort of gay translucence which permeates the whole canvas.

What strikes me is due to the exact observation of the law of tone values. The artist, confronted with some subject or other, allows himself to be guided by his eyes which perceive this subject in terms of broad colours which control each other. A head posed against a wall becomes only a patch of something more, or less, grey; and the clothing, in juxtaposition to the head, becomes, for example, a patch of colour which is more, or less, white. Thus a great simplicity is achieved – hardly any details, a combination of accurate and delicate patches of colour, which, from a few paces away, give the picture an impressive sense of relief.

I stress this characteristic of Édouard Manet's works, because it is their dominating feature and makes them what they are. The whole of the artist's personality consists in the way his eye functions: he sees things in terms of light, colour and masses.

('Une nouvelle manière en peinture', pp.31–2)

Zola's view of the significant interest of a painting has little in common with Buchon's. Judging by this text, it seems that the sense of what it is to look at a painting has changed. Zola's use of the phrase 'some subject or other' gives an indication of the relative unimportance he attributes to subject-matter. It is not that he is unaware of subject-matter, he simply does not judge it to be relevant to his experience of a work of art (just as Buchon was aware that *The Stonebreakers* was a representation, but saw no need to discuss the forms and colours which Courbet used). Zola's focus is on the effect of Manet's art, but he also refers to the treatment of tonal values in the art of Courbet, placing the stress on a different aspect of Courbet's work from that which concerned Buchon. Buchon's imaginative projection related *The Stonebreakers* to a lived social reality and to class relationships; Zola regarded the significant interest of Manet's painting to be the form it took and the visual effect of the paint on canvas. The shift in priorities is clear throughout the passage. Zola writes: 'A head posed against a wall becomes only a patch of something more, or less, grey'; in other words, a 'real' head becomes something else as soon as it is painted: it becomes a patch of colour on canvas.

It is, of course, no more possible to establish an image of Manet's work from Zola's text, than it was from Buchon's description of *The Stonebreakers*. (*The Philosopher* of 1865, Plate 13, is an example of Manet's work of this period.) Zola points to a series of techniques and effects, though, which are particular to an artistic practice, and he deliberately renders inappropriate, even illegitimate, the imaginative weaving of a story around the figures, such as Buchon had engaged in. As well as commenting on Manet's work, Zola was also making a statement about the nature of the job of a modern art critic – this passage begins, for example, by setting limits on what the task entailed. The critical task was to establish what Zola calls the 'language' and the 'characters'. 'Language' referred to the medium of painting itself; 'characters' referred to both the temperament of the artist and that of the figures represented as social types in the paintings. What is important here is that he could draw a distinction between the two, and that he could consider the 'language' of painting as separate from its subject-matter. Zola used the idea of language to refer to the means of representation, and not the story-telling aspect of representation. Yet he had to describe the effect of this pictorial language in words; his criticism is a written text which attempts to describe verbally the visual effect of the medium. 'What

Plate 13 Édouard Manet,
Le Philosophe drapé (*The Philosopher*),
1865, oil on canvas, 188 x 109 cm.
Arthur Jerome Eddy Memorial
Collection, Art Institute of Chicago
1931,504.
Photograph © 1990, The Art Institute
of Chicago. All Rights Reserved.

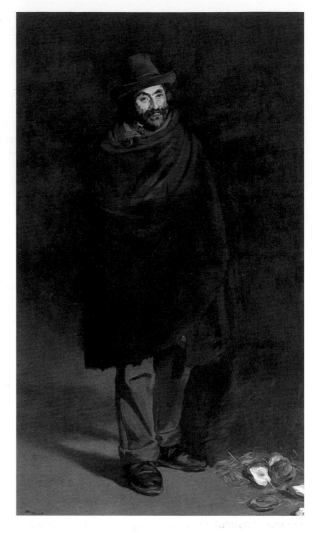

strikes me …', he says more than once, and what he remarks upon are those technical aspects of Manet's works which seemed remarkable to him as a spectator.

Zola's text, like Buchon's, only takes on a reasonably precise sense when it is read in conjunction with the works of art discussed. Both texts need to be seen in a reciprocal relationship with the works they describe. Thus Zola was not describing Manet's work as devoid of figuration – what we would now see as abstract painting – or conceiving of it in that way. This was simply not a possibility available to Zola, or something anyone could have envisioned in 1867. He placed emphasis on Manet's treatment of the formal aspects of the medium of painting at the expense of other aspects – this constitutes, for Zola, the interest of the works. His is not a straightforward description (any more than Buchon's was), but an interpretation of what is significant in Manet's work, and a conception of what it is that makes a work of art effective as a modern painting.

At the time this article was written, Zola's was a novel approach to art, contrasting with contemporary critical views, which retained an emphasis on the story-telling content of artworks. But his preoccupation with the means of representation, rather than with the subject depicted, has itself become a conventional way of talking about modern paintings. The idea that the value and interest of Manet's work resides, first and foremost, in the medium of painting is characteristic of later Modernist accounts. Clement Greenberg writes, for example, that the modern artist derives his chief inspiration from the medium

he works in. To critics of the Modernist account, what we might term the 'Buchon' type of interest (i.e. an interest in the ideological and political aspects of works of art) has been marginalized by this interpretation.

We have seen in the comparison between Buchon and Zola how certain conventions operate in talking or writing about works of art. These conventions change over time; they can serve different interests and are adapted as the conventions of picture-making change. Looking at different ways of interpreting art, as we have done in a very limited way, can show us that interpretation, though always at work, will always be problematic – not least in the face of the complexity of making art, and looking at art, as these activities take place in the world. It is in the nature of art that it raises problems of interpretation, and that these will be open to dispute.

The modern in formation

I shall now take an historical example to bring some of these problems into focus; I want to look in particular at the modern as a form of difference, cultivated in the practice of art.

In 1872 Manet painted the small, sketchy *Berthe Morisot with a Fan* (Plate 4). The usual point of focus in a picture of a figure seems deliberately to have been cancelled out in this painting. The woman's face, where we might have looked to find some clue to the sitter's identity or character, is largely concealed by the fan; the body is entirely clothed in black, and the spectator's attention is diverted to an apparently insignificant part – the woman's outstretched foot, which occupies the lower right-hand corner of the canvas. Large expanses of the picture are given over to the modulated blacks of her dress or to the brown of the wall. This painting seems almost to flaunt its own absence of detail, and to make a virtue of not allowing the viewer to piece its parts together. It also appears to invert the composition of Manet's ambitious work of almost ten years earlier, *Olympia* (Plate 14). *Berthe Morisot with a Fan* is small where *Olympia* is on a large scale; it has a vertical format where *Olympia* is horizontal. Every part of the sitter that is concealed in the later work, appears, at first sight, to be revealed in *Olympia*, who is shown in uniform light, displayed, down to the way the figure stares out of the canvas to an imaginary viewer, instead of glimpsing the viewer behind the fan. I want to keep the smaller painting in the background as I discuss *Olympia*; my aim is to show something of the problematic character of the 'modern' in art, as it was in formation from the mid-nineteenth century.

Looking at *Olympia* now, it may seem unlikely that this painting could have proved difficult or impenetrable for its contemporary public. It was, however, the considerable evidence of failure to find meaning in *Olympia*, witnessed by contemporary critical reviews, that provided the art historian T.J. Clark with the starting point for his analysis of the painting.[3] It is in recovering some of that original distaste and incomprehension that we can retrieve something of the contested character of modern painting. It is worth bearing in mind that to select this painting is immediately to privilege it above other works of art and the work of other artists. To focus on it would be seen by some art historians as falling into the trap of rehearsing argument over a painting that has been assumed to be one of the first major icons of modernism. One reason for choosing to look at this already much-discussed work is precisely because it has been argued over. For Greenberg, you will remember, Manet was the first artist to show with 'frankness' the flatness of the picture surface characteristic of modernist painting. Although the majority of contemporary critics saw *Olympia* as a failed painting, it came to be regarded as a

[3] T.J. Clark's account of this painting, on which I shall be drawing for this discussion, is to be found in his book *The Painting of Modern Life*.

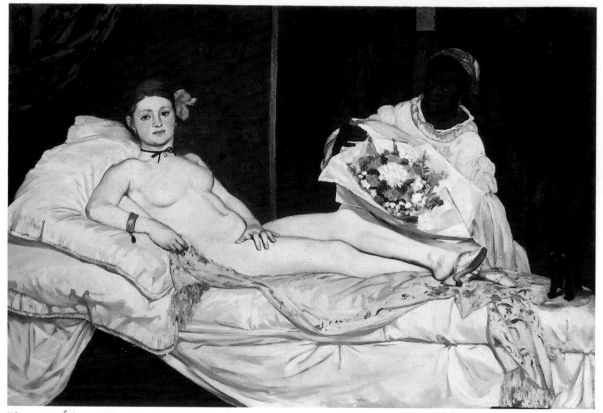

Plate 14 Édouard Manet, *L'Olympia* (*Olympia*), 1863, oil on canvas, 130 x 190 cm. Musée d'Orsay, Paris. Photo: Réunion des Musées Nationaux Documentation Photographique.

canonical work – this shows particularly vividly the way in which views about art, and about what art is, change over time. One way to show the contested nature of the modern would be to survey these differing views. I have chosen to raise that issue by starting with a more basic question – what is *Olympia* a painting of? What does it represent?

Manet's painting was first brought to public attention in 1865, when it was exhibited at the Salon, the annual exhibition organized by the state at this period. On the face of it the painting complied with the requirements of a Salon painting of this type, and it came with the usual trappings: it was a painting of a female nude with a Classicizing title and a few lines of verse accompanying it in the Salon handbook:

> When, weary of dreaming, Olympia awakes,
> Spring enters in the arms of a gentle black messenger;
> It is the slave who, like the amorous night,
> comes in and makes the day delicious to see with flowers:
> The august young woman in whom the flame [of passion] burns constantly.

The verse, by Manet's friend, the poet Zacharie Astruc, uses the fictitious name 'Olympia', where contemporary spectators might have expected to find a Venus. For it is Venus, the goddess of Love, associated with allegorical representations of Spring, who conventionally 'awakes' and ushers in the spring with flowers. Flowers were the Classical symbol of Spring; the bed of Venus, strewn with flowers, was a common device in Venetian art. In *Olympia* Manet recast the motif and its traditional associations in contemporary form, in the bouquet held by the maid-servant and in the floral pattern sketchily worked on the silk shawl at Olympia's feet. And Manet used the Classical pose of the recumbent Venus, which he drew from Titian's *Venus of Urbino* (Plate 15). The recumbent nude female figure

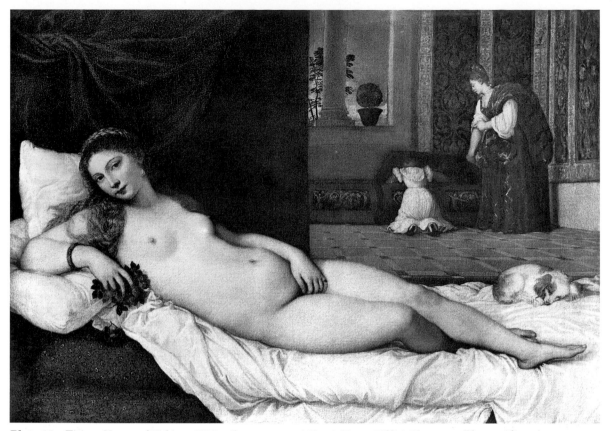

Plate 15 Titian, *Venus of Urbino*, 1538, oil on canvas, 120 x 165 cm. Uffizi, Florence. Photo: Alinari.

was a commonplace at the Salon, and among the many versions of it exhibited in 1865 was Firmin Girard's *Venus Sleeping* (see Plate 16).

What the critics saw, on the other hand, was not how far *Olympia* complied with artistic tradition, but how far it departed from conventional ways of representing the nude, and that departure proved difficult to make sense of. The critics failed to find what I have called significant interest in the painting because it did not fit, at least in some crucial ways, with what they expected of art. To call this a 'failure' on the critics' part is, perhaps, to imply that they should have known better, but they met with some real difficulties in the painting. Some of the blind-alleys they made for themselves, but others were set in train by the painting itself. It invited, but then resisted, certain patterns of interpretation, and its interest as a painting conflicted with prevailing ideas of what a Salon painting should look like in 1865. *Olympia* had the pose of Venus, the trappings of Venus (the bed, the maid, the flowers), but the picture was not *of* Venus, but of some contemporary travesty called Olympia.

A 'travesty' is a reworking of an existing model which disguises the original by clothing it in a ridiculous form. For one critic, Amédée Cantaloube, the figure of Olympia 'apes on a bed, in complete nudity, the horizontal attitude of the *Venus* of Titian'. The painting 'aped' a tradition and the nude female figure 'aped' the identity of a woman too, he continued, as a sort of 'female gorilla, a grotesque in indiarubber outlined in black' (quoted in Clark, *The Painting of Modern Life*, p.94). A discomfort with the supposed vulgarity of the woman depicted became embroiled in these reviews with the supposed inadequacy of Manet's artistic technique – his 'absolute impotence of execution' (E. Chesneau, quoted in Clark, p.290). The critic Théophile Gautier, for example, wrote: 'The

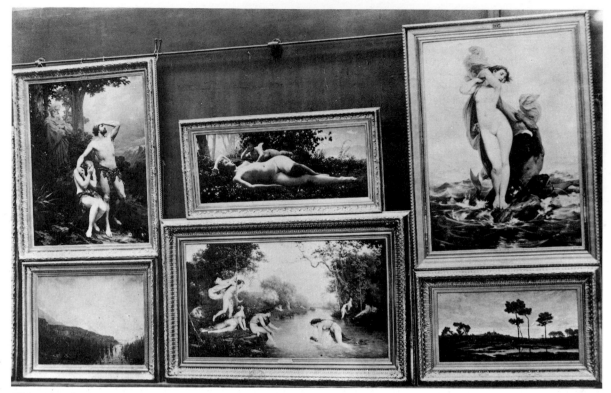

Plate 16 Contemporary photograph of State purchases from the 1865 Salon, including (top left) François Lemud's *La Chute d'Adam* (*The Fall of Adam*), (top centre) Firmin Girard's *Le Sommeil de Vénus* (*Venus Sleeping*), (top right) Félix-Henri Giacomotti's *L'Enlèvement d'Amymoné* (*The Abduction of Amymone*), and (bottom centre) Joseph-Victor Ranvier's *L'Enfance de Bacchus* (*The Childhood of Bacchus*). Photo: Bibliothèque Nationale.

colour of the flesh is dirty, the modelling non-existent. The shadows are indicated by more or less large smears of blacking', and, he went on to lament, 'The least handsome of women has bones, muscles, skin, and some kind of colour' (quoted in Clark, p.92). It is notable here that the language of dirt, of smearing, refers at one moment to the colour of the paint on the canvas, but is then associated with the supposed moral character of the woman depicted. There is a kind of slippage at work, which conflates the character of the picture with the supposed character of its subject alone.

In Manet's painting, the expanse of Olympia's body was edged, as I mentioned earlier, in a chalky grey outline, which was awkward and abrupt when compared with the softer gradation of tones in the conventional use of chiaroscuro (compare, for example, Plate 7). This lack of modelling signalled a lack of *compliance*, compliance with a tradition of painting the nude, in which the nude female body was offered for contemplation in idealized form. The seamless, smooth finish of contemporary paintings of the nude is interrupted not only by such details as the black choker, which has the effect of cutting the body at the neck, but also by the evident brushwork and the sudden shifts in the tonal range of the painting from dark to light. As one critic (Félix Deriège), spoke of the picture, it seemed to disintegrate before him: 'White, black, red, and yellow make a frightful confusion on the canvas; the woman, the Negress, the bouquet, the cat; all this hubbub of disparate colours and impossible forms seize one's attention and leave one stupefied' (quoted in Clark, pp.97–8). The painting is inarticulate for this critic because it is cut adrift from the normal conventions of picture-making: we could compare its effect to a sentence where some words are intelligible but the grammar is all wrong.

It is this apparent incoherence that I want to pursue. First, is there a 'story' to the painting and, if so, who are the protagonists? It is known that Manet painted his model, Victorine Meurend, but what fictional role was she given? The two figures depicted in the painting are the unclothed figure of Olympia and a black servant offering flowers. Where *Berthe Morisot with a Fan* (Plate 4) eschews detail, this painting is more specific in its connotations of sex, class and what were the signs, as contemporary critics observed, of a contemporary prostitute. One critic went so far as to suggest the *kind* of prostitute she was, commenting on 'the vicious strangeness of the little *faubourienne* [girl from the suburbs], a woman of the night out of Paul Niquet ...' (that is, a low-class prostitute from a bar which serviced the market area of Les Halles). The body of Olympia, seen as 'used' and 'skinny', was distinguished from the body of a *courtesan*, the accepted subject of many contemporary paintings (and Titian's *Venus* was widely accepted in the nineteenth century as a painting of a courtesan). Perhaps, even, the travesty was made more emphatic by the contradictory presence of an attendant maid-servant, who seemed more in keeping with a courtesan's boudoir. So was it this conjunction of sex and class which disturbed the critics? Was the unsettling 'frankness' not so much in the manner of execution, as Greenberg would have it, as in the frank portrayal of sex in the market-place, with the imaginary male spectator as a third protagonist – not just a spectator of art but a potential client?

The answer here may be that it is not one *or* the other – not the technique *or* the subject – but rather a combination of a problematic subject with a disconcerting way of painting. To see the difficulty of *Olympia* as residing only in its subject-matter – the fact that it is a picture of a prostitute – is to fail to account for the kind of illegibility we have been discussing, the 'impossible forms' of the painting. To understand what the painting *represents* entails more than identifying the subject depicted. To ask why Manet should have chosen to paint his model, cast as a prostitute and as an emblematic figure of modernity, and to paint the subject in the way that he did, is to ask about the painting *as* representation. My point is that the iconography of a painting, *what* is depicted, however complex, cannot be separated from the *way* in which it is represented on the canvas.

It may be true that the modernity of *Olympia* lay partly in the critics' failure to *see* that modernity, but if this was the case, it was because of the unfamiliar or disordered conjunctions Manet set up on the canvas and the jarring execution. In this context, Olympia was not properly placed at the centre of her own story: the painting was deliberately incoherent at the level of narrative. Its elements could be laid out, rearranged even, as we see in one contemporary caricature (Plate 17), but the elements only added up to a kind of

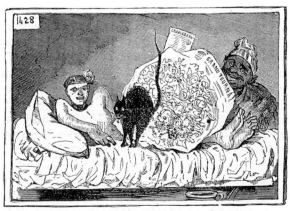

La queue du chat, ou la charbonnière des Batignolles.
Chacun admire cette belle charbonnière, dont l'eau, liquide banal, n'a jamais offensé les pudiques contours. Disons-le hardiment, la charbonnière, le bouquet dans du papier, M. Manet, et son chat, sont les lions de l'exposition de 1865. Un bravo senti pour M. Zacharie Astruc.

Plate 17 Albert Bertall, *La Queue du chat*, ou *La Charbonnière des Batignolles* (*The Cat's Tail*, or *The Coal-seller from Batignolles*), wood engraving from *L'Illustration*, 3 June 1865.

grotesque side-show, where reversals of the normal order of things are vaunted in public to comic effect. Olympia is called a 'coal-seller from Batignolles' (a working-class suburb where Manet had his studio), but the black servant takes on that guise, masculine in her appearance and grimacing over the bouquet wrapped in newspaper. In the painting, the compliance *lacking* in the body of Olympia is displaced onto the gentler curves of the servant offering flowers, but here the 'woman of the street' is likened to other street-sellers and servicers, where 'dirt' and 'hectoring for business' become the stock-in-trade of both. And at the centre of Bertall's caricature is the huge bouquet of flowers and a quivering cat, with tail erect – an exaggerated and explosive arrangement which serves as an analogue for sex – placed where the taut, contracted hand of Manet's painting should be.

For some of the critics, the hand – thought to be 'in the form of a toad' – was evidence also of the masculine, aggressive posturing of Olympia, a sign of male desire, as the phallic cat of Bertall's caricature fairly unambiguously insinuates. Because this representation did not fit with prevailing representations of compliant femininity, Olympia was seen as 'not a woman', that is, as masculine. This was certainly a bizarre conceptual leap – if she is not this, she must be that – which is hardly borne out by the picture. What it does suggest, though, is that for these commentators at least, proper, secure categories were somehow not in place in Manet's work. And Manet had painted several pictures in the early 1860s which exploited this sort of ambiguity. For example, in his *Young Woman Reclining in Spanish Costume* of 1862 (Plate 18), Manet painted a reclining female figure

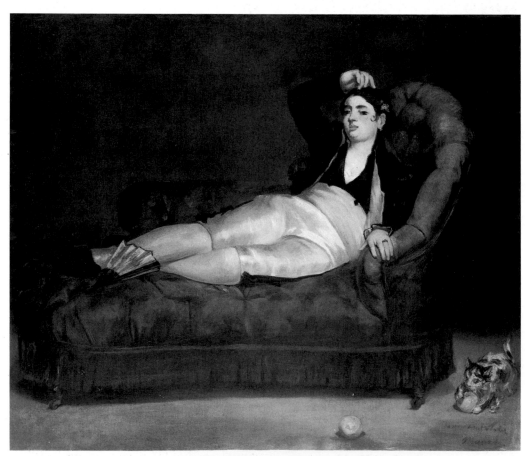

Plate 18 Édouard Manet, *Jeune femme étendue en costume espagnol* (*Young Woman Reclining in Spanish Costume*), 1862, oil on canvas, 94 x 113 cm. Yale University Art Gallery, New Haven. Bequest of Stephen Carlton Clark B.A. 1903 (61.18.33).

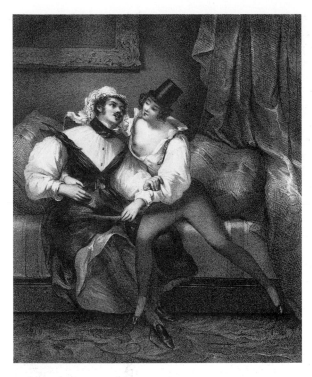

Plate 19 Octave Tassaert, 'Ne fais pas la cruelle!' ('Don't play the Heartless One!'), from *Les Amants et les Époux*, lithograph. Bibliothèque Nationale, Cabinet des Estampes 01.0a.148 fol.p.74.

dressed in a male matador's costume. Though dressed as a man, the figure lies in the alluring position of a reclining female figure. When the cross-dressing was reversed, as depicted by Tassaert in 'Don't play the heartless one!' (Plate 19) the result was comic, but masquerading as a Spanish matador, far from threatening the woman's sexuality, could be seen as adding to it. *Lola of Valencia* (Plate 20), which was painted by Manet in 1862, depicts a Spanish dancer on the stage, with the audience glimpsed through the scenery on the right. The woman's face as depicted by Manet was picked out as 'mannish' in Randon's caricature from *Le Journal amusant* (Plate 21; discussed by Richard Wollheim in *Painting as an Art*, p.176). Subtitled '*Ni homme ni femme*' ('neither a man nor a woman'), Randon's caricature drew attention to what seemed to be missing in the picture: a secure sense of the femininity of the woman. In the context of these works, *Olympia* can be seen as one of a series of paintings which used an image of a woman to represent sexuality in its *modern* aspect, if the modern is taken to involve artifice and what Baudelaire described as 'masquerade prescribed by fashion' (Baudelaire, *The Painter of Modern Life*, p.13).

Manet's use of 'impossible' forms and formal effects could only appear aberrant or incompetent within the terms of the contemporary critics' view of what a finished painting should look like. Yet, arguably, the sort of 'incoherence' to which they objected can tell us something about the way the modern was constructed in Manet's work – as a matter of technique as well as subject-matter. In addressing the question 'what is *Olympia* a painting of?', I have drawn a distinction between what is depicted – the figurative elements, the iconography; and what is represented – issues of modern sexuality. To ask what a painting *represents* is to ask about its *meaning*: what it meant, for example, to paint a female nude as a prostitute in this way in the 1860s, and how those meanings were established in relation to a configuration of forms on the canvas. We may go further than that to suggest that, although the figure of a prostitute is the subject depicted in the painting, what the painting *represents* is the obliteration of the original 'story' by Manet's manipulation of the surface of the painting, which defies a literal reading.[4] This is not to say that the subject is irrelevant, but that it is what *happens* to the subject in the picture which is at issue, and that

[4] This idea of obliteration in Manet's work is raised by the writer Georges Bataille in his book *Manet*.

Plate 20 Édouard Manet,
Lola de Valence (Lola of Valencia),
1862, oil on canvas, 123 x 95 cm.
Musée d'Orsay.
Photo: Réunion des Musées
Nationaux Documentation
Photographique.

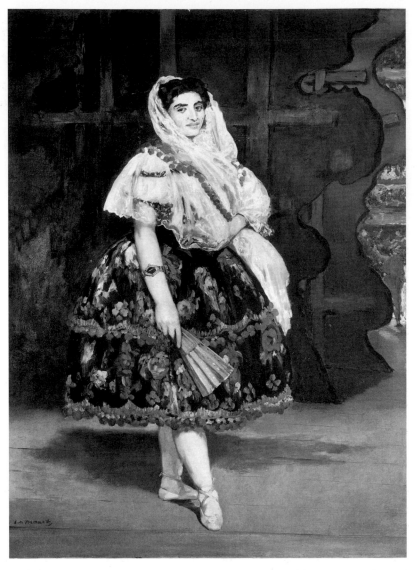

'concealing' the subject (metaphorically speaking) might be a part of *Olympia*, as it was more obviously part of the effect of *Berthe Morisot with a Fan*. I leave that open. What is certain is that while there may be agreement as to what is *depicted*, there will be disagreement as to what is *represented*.

The spectator

Given what we already know of Zola's view of painting, it will not surprise us that when he came to write about *Olympia* in 1867, he saw its interest as residing in the way it was painted. Addressing the artist, he wrote: 'You needed a nude woman and you chose Olympia, the first-comer. You needed some clear and luminous patches of colour, so you added a bouquet of flowers; you found it necessary to have some dark patches so you placed in a corner a Negress and a cat', ('Une nouvelle manière en peinture', p.36). This emphasis was a strategic counter to what was conventionally seen as most significant in painting. As for *why* Manet might have selected this subject, Zola says that where other artists 'correct nature' when they paint a Venus, Manet offers a 'truth', by choosing for

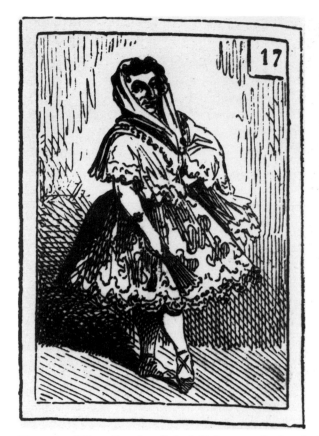

85481

LOLA DE VALENCE,

ou *l'Auvergnate espagnole.*

Ni homme, ni femme; mais qu'est-ce que ce peut être?... je me le demande.

Plate 21 Gilbert Randon, *Lola de Valence, or the Spaniard from the Auvergne. Neither man, nor woman; what can this be? ... I wonder,* wood engraving from *Le Journal amusant,* 29 June 1867. Photo: Bibliothèque Nationale Documentation Photographique.

Olympia 'a contemporary girl, the sort of girl we meet every day on the pavements, with thin shoulders wrapped in a flimsy, faded woollen shawl' (p.36). On the one hand, he establishes the 'character' of Olympia – she is depicted as a modern type – on the other, he identifies the features of Manet's 'language'. Olympia is painted 'as a large pale mass against a pale background'. He removes the interest of the painting from the *literary* aspects of the subject to the way the subject is *handled*; for Zola this was how it achieved its identity as a modern painting. The painting was pre-eminently successful and *coherent* in these terms. It followed that to read the painting as incompetent, or indecent, or obscene, was simply to fail to read it as a painting of a *modern* kind. It was a question of incompetent spectators rather than a failed painting. These spectators saw only 'subject – a subject treated in a certain manner' (p.37); they could only read the way it was painted *negatively* – as indicative of the inadequacy of Manet's technique.

 Underlying Zola's discussion of *Olympia* is the idea that modernity is qualitative and that modern paintings require modern spectators. To read a painting in an appropriate way, the viewer should attend to the way it was painted rather than try to weave a story around it. For this was the condition imposed on the viewer by the modern work of art. We could even say that Zola offered himself as a model of a modern spectator. His interpretation has subsequently been seen by some as the 'right' way to read Manet's work, and it has been used to validate the view that Manet's interests lay primarily with the *medium* of painting. But, as we have seen, in the 1860s Zola's was a minority view to say the least: a majority of spectators read paintings according to their narrative, moralizing content, and there was no pre-existing or single type of 'modern' spectator. A rather

different kind of modern spectator had been proposed, for example, by Baudelaire. This was typified by the dandy or *flâneur* (from *flâner* – to stroll) whom Baudelaire saw, though not without irony, as the modern spectator *par excellence*. The perfect *flâneur* was the 'passionate spectator', the modern man who was in his element wandering amid the ebb and flow of the urban crowd and whose most guarded possession was the anonymity made possible by life in the city. Baudelaire used this necessarily bourgeois, male type as exemplary of a particular set of attitudes to modern, metropolitan life. He compares the *flâneur* with the artist, whose job it is to extract that special quality of modernity and to express in painting the 'gait, glance and gesture' of modern life. For Baudelaire, the requirement to recognize that 'special quality' was common to both the modern artist and the modern spectator. In Manet's painting of an audience at the Tuileries Gardens (Plate 22), certain figures are picked out from the crowd but they quickly dissolve into the mass. One of these is a portrait of Baudelaire (the figure in profile behind the seated female figure to the left). A detail (Plate 23) shows the way Manet has painted the figures more or less sketchily – some stand out, some are 'caught sight of' others are not, even though they seem to stand closer to the picture plane. On the one hand, the spatial inconsistencies can be seen to draw attention to Manet's treatment of the surface of the painting, on the other hand, they can be read as suggesting the 'passing glance', the glimpsing of faces in a crowd, something Baudelaire had characterized as a peculiarly modern experience.

The distinction between Zola and Baudelaire as different kinds of modern spectator is obviously an artificial one, and certainly in the historical circumstances of the 1860s such differences would not have appeared clear-cut. Both, however, have been claimed as exemplary figures in conflicting accounts of what the modern meant. The idea of a 'modern spectator' was in formation in this historical period, and the repertoire of knowl-

Plate 22 Édouard Manet, *Concert aux Tuileries* (*Concert in the Tuileries*), 1862, oil on canvas, 76 x 118 cm. National Gallery, London. Reproduced by courtesy of the Trustees, the National Gallery, London.

Plate 23 Édouard Manet, detail of *Concert aux Tuileries*. Reproduced by courtesy of the Trustees of the National Gallery.

edge envisaged for the modern spectator was not necessarily the same repertoire of beliefs and values brought to painting by actual spectators – the men and women, say, who visited the Salon.

This suggests that we also need to be self-conscious about our own position as spectators of art. We are not 'blank tablets' either, of course, and we bring to art our own preconceptions and knowledge, and these may be different from those of historical spectators. Contexts for viewing change. We may be familiar with the idea of abstract painting, for example, even if we know very little about it, whereas the original spectators of Malevich's work in 1915 were not. In 1915, to read his *Suprematism: Painterly Realism of a Football Player* (Plate 24) as art meant recognizing the concerns of modern art and what these had come to entail – namely, that an abstract painting subtitled 'football player' need not depict a footballer, or resemble a figure, or even refer schematically to a figure in motion, in the way that Boccioni's painting had done (Plate 8).

Malevich's painting is made up of coloured geometric shapes on a white ground, and a viewer is not invited to 'fill in' the blank parts, to compensate for the absences, by imagining a different *sort* of picture, but rather to acknowledge the difference between this and other types of representation – to see the distance travelled by the artist, rather than retrace the artist's steps back to an original motif. The meaning of Malevich's work, as in his *Black Square*, is not secured by its depiction of objects in the world, or by resemblance. It is meaningless to look for figurative content in this work in the way that an eighteenth-century connoisseur looks for the content of the framed black void he puzzles over, in a satire on the eighteenth-century vogue for murky night scenes (Plate 25).[5] This caricature

5 I am indebted to an Open University student for drawing my attention to this image.

is palpably ludicrous with regard to, and quite at odds with, what is asked of the modern spectator in Malevich's *Black Square* (Plate 11). Indeed looking for figurative imagery in this way may mean not *seeing* the *Black Square* at all.

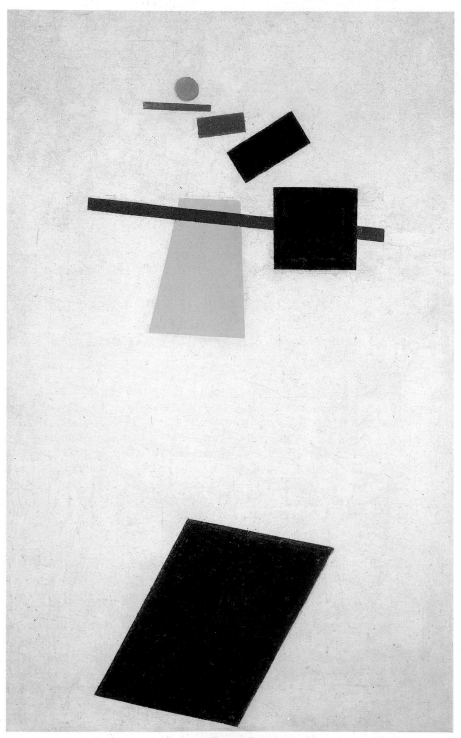

Plate 24 Kazimir Malevich, *Suprematism: Painterly Realism of a Football Player*, 1915, oil on canvas, 70 x 44 cm. Stedelijk Museum Amsterdam.

Plate 25 Anon, *A Connoisseur Admiring a Dark Night Piece*, 1771, engraving, De Witt Wallace Decorative Arts Gallery, Colonial Williamsburg Foundation.

The artist

So far I have been considering some of the problems involved in interpreting art and the role of the spectator without yet looking at the role of the artist – though, of course, artists are spectators too, of their own and other people's work. Malevich, for example, had been looking closely at Italian Futurist work, by Boccioni among others, and the shortcomings he saw in it were factors in his attempt to work differently, to find a 'new culture of art', which did not depict recognizable objects in the world. 'Objects have vanished like smoke, for the sake of the new culture of art', he said (*Essays on Art*, p.36). Looking at other art is one of the resources with which artists work, and doing so may alter how they perceive their work and their expectations of what an artist does. In an early self-portrait (Plate 26), Malevich uses bright, even lurid, contrasts of red and green. The expressive rather than naturalistic use of colour and form corresponds with the image of the artist represented. The artist's head is juxtaposed with images of the naked female body and what is at stake, as in many of the images we looked at earlier, is a fantasy of modernity, which is played out across the female nude. The artist's self-image, here, can be compared with a later abstract work, subtitled this time 'self-portrait', but made up of geometric forms on a white ground (Plate 27). The figurative elements have gone, and so too has the lurid colour and the curved delineation of forms, characteristics which suggest that the artist is a 'creator' who assumes the role of expressing emotion. In the light of what I have already said, *Suprematist Painting: Self-portrait in Two Dimensions* is not a portrait of the artist in the same sense as the earlier one. Malevich himself made it clear in the catalogue notes for the

Plate 26 Kazimir Malevich,
Self-portrait, *c*.1910, gouache on
cardboard, 27 x 27 cm. State
Tretyakov Gallery, Moscow,
1977, gift of George Costakis.

first exhibition of his abstract work that, despite his titles, the point was not to look for figurative content. But the Suprematist portrait may nevertheless reflect on the job of the artist and what it has become, just as other works, such as the *Black Square*, do. Certainly these abstract paintings generate a set of meanings about what the job of the artist is *not*: it is not, for example, to paint nature, to paint likenesses of the world, to paint the nude female figure.

It is as if all this has to be extracted from the artistic imagination and replaced by another set of forms, and another way of 'meaning'. For a work like the *Black Square* to be read as art in 1915 required spectators to be familiar with, or at least open to, changes in the role of the artist. This was an historical possibility in Russia at this period, but not in earlier contexts, as we have noted, and quite meaningless to the eighteenth-century English connoisseur (Plate 25). Furthermore, for the *Black Square* to be judged not only as art but as a *successful* work of *modern* art required a shift in evaluating the skills of the artist. If these skills were no longer to provide a naturalistic rendering of a scene, then on what grounds could a work be interpreted and evaluated? This is an open question, and one which we have already met in our discussion of *Olympia*, a painting whose status as art had not been in question (it had been accepted by the Salon jury after all) but which called into question Manet's *competence* as an artist, and the painting's *success* as art.

The practice of art involves a complex range of problems which the essays in this series will discuss. But even what appear to be fairly basic aspects of a working procedure – decisions over what medium to work in, what size of canvas to use, what colour, even, to paint a square – may be highly significant to what a work means. *Olympia* as a water-colour, and as a consequence on a smaller scale, would be a different order of picture altogether. Malevich and his contemporary Kustodiev were prompted to paint differently by competing – or at least different – ideas of the artist's role in contemporary culture.

So far, I have talked very generally about artists. But an important question remains to be asked: how neutral a term is 'artist'? Artists are people, men and women. So how far is it possible to discuss artists, without recognition of the historical circumstances in which they work, their class, gender, attitudes, beliefs, values? Should they be seen as people who occupy particular positions in society, who work under the constraints and broadly within the belief-systems of that society, rather than as individual creators for whom anything is possible? For example, the possibilities for artists who are women to work and

Plate 27 Kazimir Malevich,
*Suprematist Painting: Self-portrait
in Two Dimensions*, 1915,
oil on canvas, 80 x 62 cm.
Stedelijk Museum, Amsterdam.

exhibit their work have been severely constrained in the nineteenth and twentieth
centuries by economic and material considerations, as well as by ideological views of
women's social role and place. We might question what significance we attribute to the
fact that *Painterly Architectonics* (Plate 28), for example, is by a woman – Lyubov Popova –
who was working closely with Malevich. What difference does the gender of the artist
make, if any, to the meaning of the work? It may be that to see the artist as a producer, as
gendered, or as an individual creator will shed a different light on how we think about
what the artist does. The changes that have occurred in art over the modern period can be
seen to be closely related to the changing structures of the institutions of art, of art edu-
cation, the rise of the private dealer system and other social and economic shifts.

Does it follow, then, that to know the artist is to know the work – that to understand
an artist's intentions is to understand an artist's work? If we could know what the artist
had meant, would we have access to the meaning of a work of art? Certainly there are
many monographs on artists which suggest that this is the case – that to understand the
work of an artist, one looks to the life of an artist and the statements an artist makes.
Malevich, for example, called his *Black Square* 'the zero of form' – that is, a *tabula rasa* or
clean slate, which had extracted from art everything but form in its purest state. This may
be highly relevant to an understanding of why Malevich painted as he did, but it cannot

Plate 28 Lyubov Popova,
Painterly Architectonics
(study), 1916–17, gouache and
pasted paper on paper,
42 x 28 cm, private collection,
Moscow. Reproduced by
permission of Philippe Sers
from D. Sarabianov and
N. L. Adaskina, *Liubov Popova*.

stand in for interpretation. We might wish, for example, to consider the context in which Malevich could make such a claim, and the historical circumstances – in this case the years preceding a revolution – in which art could appear to hold such transformatory power. Even from the limited range of examples we have looked at, it is clear that the job of the artist – what an artist does – is not fixed and cannot be fixed. There are many different types of artist at any one time, and the role of the artist changes over time. Indeed it has been a characteristic of modern art to refuse to keep the boundaries of art firmly in place, and instead to revise continually what are considered the limits of art.

The modern in fragments

I discussed earlier the mid-nineteenth-century formation of the modern in art. Now I want to consider some examples of art from the 1960s and 1970s, an historical moment which can also be regarded as a watershed in the fortunes of modernism. Arguably it was by then in decline, or at least its orthodoxy was in question, both in terms of its theory and its practice. I have said that modern art has characteristically worked against the grain of certain established patterns of interpretation, but does it follow that any work of art that provokes controversy must be a successful work of modern art? I should say now that I think the answer to that question is no, but I want to mention one such controversy, in order to point to a rather different set of problems from those we identified around the original exhibition of *Olympia*.

Equivalent VIII (Plate 29) was bought by the Tate Gallery in 1972. It was one of several related works acquired at this time. Others included Richard Serra's *Shovel Plate Prop* (Plate 30, purchased 1973), Don Judd's *Untitled* (purchased 1973; Plate 31) and Sol Lewitt's *Two Open Modular Cubes/Half Off* (purchased 1974; Plate 32). 'Minimalism' is the label conventionally given to works by this group of North American artists, who shared what is often thought of as a 'reductive' approach to the art object. In 1976, the year the Press took up 'the bricks', as the work came to be known, the Tate also held a bicentennial exhibition of the work of John Constable, which prompted comparisons (Plate 33). The objection to 'the bricks', voiced by the self-declared representatives of popular opinion, who were columnists rather than art critics, was that they were not art, but simply a 'pile' of bricks. It is certainly true that if Constable's painting of *The Hay Wain* (Plate 34) is considered to meet *and* to dictate the requirements of art, then Andre's work will obviously not hold meaning as art. Similarly, if the artist is seen as an individual creator whose purpose is self-expression, then Andre will not fit easily with this characterization, as a contemporary cartoon indicates (Plate 35). The incompatibility of artist and bricklayer, gallery and building site, art and the world, was the butt of various cartoonist's jokes and also underwrote many of the columnist's objections. Briefly, these said that a pile of bricks did not become art because it was exhibited in an art gallery; the work did not show any of the skills associated with the work of an 'artist'; the material had not been worked, let alone sculpted: the components were simply laid out in the gallery. Moreover, the work had been bought with public money by a public gallery. Much of the press criticism used Andre's work as a pretext for an attack on modern art in general, because it appeared, like the emperor's new clothes, to adopt incomprehensible strategies in order wilfully to confound common sense and popular taste.

Taking the Andre example, I want to open to question the idea that we can characterize modern art as the relentless and progressive struggle against established taste, forever working against the grain of convention. It may be that to view Andre's work in the light of a model of art quite alien to it (to compare it – to overstate the case – to the model exemplified by Constable) is simply to establish an inappropriate context for it, which, arguably, closes off possible avenues of enquiry. The meaning and significance – or lack of meaning and insignificance – of *Equivalent VIII*, surely has to be established (or argued out) with regard to the historical circumstances in which it was made – in this case, in the context of recent art in the USA. And in that context, we might raise the question of how a work of art could have come to be made out of so little and not only continue to be 'art', but, arguably, a *successful* work of modern art.

Plate 29 Carl Andre, *Equivalent VIII*, 1966, firebricks, 12 x 229 x 68 cm. Tate Gallery, London.

Plate 32 Sol Lewitt,
Two Open Modular Cubes/Half Off, 1972,
baked enamel on aluminium, 160 x 303 x 233 cm.
Tate Gallery, London.

Plate 30 Richard Serra, *Shovel Plate Prop*, 1969,
metal relief, 98 x 79 x 31 cm. Tate Gallery, London.

Plate 31 Donald Judd, *Untitled*, 1973, metal relief, 37 x 194 x 75 cm. Tate Gallery, London.

Plate 33 Trog, *'And I say the Tate gallery is that way'*, *The Observer*, 22 February 1976. Tate Gallery Archive. © The Observer, London, 1976.

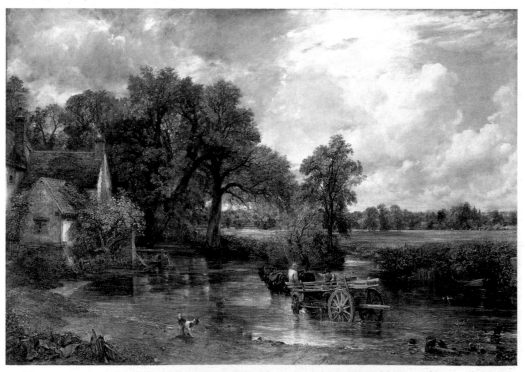

Plate 34 John Constable, *The Hay Wain*, 1821, oil on canvas, 130 x 185 cm.
National Gallery, London. Reproduced by courtesy of the Trustees of the National Gallery.

Plate 35 Giles, *'The repose and calm of this work...'* from *The Daily Express*, 19 February, 1976. Tate Gallery Archive. Reproduced by courtesy of Express Newspapers plc.

"The repose and calm of this work of art reflects the simplicity and restraint of my earlier period, the symbolism remains personal and eludes exact interpretation."

Andre had made the original version of this work in 1966, when it was one of eight brick pieces exhibited at the Tibor de Nagy Gallery that year (Plate 36 shows some of them installed in the gallery). After the show, finding no buyer, Andre sold the sandlime bricks back to the brickyard from which he had bought them. By the time the Tate showed an interest, this brickyard had closed and Andre reconstructed the work in fire-bricks. These light-coloured, yellowish bricks were treated as standard units and were arranged in two layers, making a sculpture which lay low on the gallery floor. A distinctive aspect of Andre's work, and that of other Minimalist artists, is the use of industrial materials – materials not normally used in art – left in their original state. Apart from arranging the bricks, Andre has not changed their physical or material identity: they remain bricks. The introduction of 'non-art' materials into art had many precedents – for instance, in Picasso's introduction of cut-out pieces of newspaper into his collages (Plate 9). There had also been an iconoclastic tradition in modern art. Since the early twentieth century non-art objects had been introduced into the gallery, in such anti-art gestures as Marcel Duchamp's ready-mades (Plate 37), which transformed the meaning of everyday objects – in this case a bottle rack – by changing their context. Andre's use of non-art material was certainly not without precedent, and had an established currency in art. *Equivalent VIII* was not the iconoclastic gesture the Press interpreted it as – throwing a brick, as it were, through the window of common sense. Rather, Andre's aim was to make a piece of sculpture out of the materials he used, whether bricks, as here, or magnesium tiles, as in *Magnesium Square*

Plate 36 Tibor de Nagy Gallery, photograph of exhibited works, *The Observer*, 22 February 1976. Photograph by courtesy of Paula Cooper Gallery, New York.

Plate 37 Marcel Duchamp,
Ready-Made (Bottle rack),
1914, 64 x 37 cm. Photograph by
Man Ray, 1940–1, Philadelphia
Museum of Art, The Louise and
Walter Arensberg Collection.
© DACS, London / ADAGP, Paris, 1991.

(Plate 38). Basic geometric forms or 'modules' are combined, repeated and ordered, to produce material and spatial effects in the gallery where they are installed. Although the use of 'non-art' materials may call into question the 'normal' material out of which art is made, it was produced *as* art, to be viewed *as* art, in the context of a gallery.

Andre had renounced his earlier, more conventional method of making sculpture out of wood subjected to different treatments, in favour of untreated, ready-made materials. By making works which rise only a few inches above the floor, he also turned away from the conventional, upright format of sculpture. In the *Equivalents* series, all the works occupied the same amount of floor space, but in each the bricks were arranged in different combinations. Andre liked the idea of spectators 'coming across' his works in the gallery, finding a sculpture at their feet, where they least expect to find it. This, of course, presupposes something about spectators. To 'happen upon' a work by Andre, and nevertheless to recognize it as a piece of sculpture and one which holds interest in the way it organizes and exposes material within a particular place or context, is to be familiar with, or open to, modern art's concern with the material of its making. Because of the three dimensional form sculpture takes, the viewer's relationship with it is often supposed to be more 'direct' than it is with other art forms, and Andre's desire that people just 'happen upon' his work seems to reinforce this idea. But his work, on the contrary, highlights the way in which the experience of a work of art, or an encounter with it, may be mediated. The meanings and connotations of familiar objects are transformed as a consequence of being arranged in a certain way and placed in a new context. A familiar material is made into a kind of surface (which renders it a kind of representation), but it does not invite the spectator to differentiate subtle optical effects or to distinguish relationships between its different parts; in

Plate 38 Carl Andre, *Magnesium Square*, 1969, magnesium, 1 x 366 x 366cm. Tate Gallery, London. © Carl Andre, DACS, London/VAGA, New York, 1991.

other words it denies the kinds of responses invited by other abstract works of this period. One of the effects of Andre's use of materials is to resist the possibility of interpreting the art-work as the self-expression of the artist, or of reading it in terms of the kind of express-iveness that can be identified in the work of Jackson Pollock (Plate 2).

If Andre's work merits attention, it is because, however much it has renounced (which is a great deal), and however little it appears, materially, to be made of, it still manages to hold interest as a piece of sculpture. But whether such an interest can be regarded as a *continuation* of the Modernist project and its emphasis on formal values, or as a *redefinition* of the terms whereby 'interest' is established, is a difficult question. Certainly Greenberg was extremely negative in his view of Minimalism: he thought it failed to secure aesthetic interest, remaining an idea 'and not enough anything else' (Greenberg, 'The recentness of sculpture', p.183). In the context of the work of artists he admired, Greenberg saw Minimalism as a renunciation of the values which sustained quality in art. There may be some agreement that Minimalist work involves some kind of renunciation, but what it is a renunciation *of* is open to question. For Greenberg, there was a cost in working, as Andre did, on the borders of art and non-art, not because the work's identity as art was threatened, but because it incurred a loss of aesthetic interest. For others, the interest of Andre's work is to be found in just this ambivalent position, not quite in the Modernist framework and not quite out of it. Here Minimalism's departure from Greenberg's view of art is seen as a positive rather than a negative factor, suggesting that Minimalism engaged critically with Modernism by both extending its formal and material interests *and* reaching beyond its normal boundaries. Minimalism was seen to have produced work which ex-emplified some kind of crisis in the condition of the art object and of the modernist aes-thetic itself. For modernist art to have come to this was a sign of its own disintegration. But this raises a further question: if Andre's work can be linked to a disintegration of the modernist aesthetic, then how come it was assimilated with relative ease by the insti-tutions of modern art, by galleries and museums? Is there any residue of 'crisis' once Andre's work comes to be bought and exhibited (if somewhat belatedly) by the Tate Gal-lery, for instance, or is it somehow neutralized by its assimilation into that same market? In this context, the objections raised by columnists in the popular Press are quite irrel-evant, because the critical and curatorial success of the work as modern art was achieved quite independently of such reservations (whereas originally, as in the case of *Olympia*, we saw how a sense of the modern was constructed, to a certain extent, out of the commen-taries of the critics).

Andre's work, and Minimalism in general, may originally have worked against the grain of Greenberg's view of the Modernist project, but it subsequently came to be regarded as a dominant tendency, partly because of its assimilation by the institutions of art. Irrespective of the fact that influential critics such as Greenberg had found it lacking, it came, for many artists at least, to represent a kind of orthodoxy. By the time Minimalist work was bought by the Tate in the early 1970s, it had already been opened to question by artists looking for a way forward, or a way out of the existing framework. The shifts which occurred may have been made possible in part by the legacy of Minimalism and its sabotage of conventional meanings for the art 'object', but they nevertheless changed the agenda of what art could and should address. I shall only mention here one example of an artist with a different agenda for art.

During 1976, when the popular Press had attacked the purchase of 'the bricks', a work by the feminist artist Mary Kelly called *Post Partum Document* (Plate 39) was exhibited at the Institute of Contemporary Art in London. Comparisons were drawn with 'the bricks' by commentators in the Press ('After the Tate Gallery's famous bricks, the new art is – dirty nappies', R. Morris, *Daily Mail*), but this is one of many possible examples of work produced partly out of a political commitment to feminism, but also out of a sense of antagonism with what orthodox modernism was taken to stand for. *Post Partum Document* took maternity as its subject; in so doing it contested the prevailing view of what was significant and appropriate in art in our culture, and challenged the systematic suppression of the 'feminine', the private, the domestic.

Plate 39 Mary Kelly, *Post Partum Document, Documentation VI*, 1978–9, detail '(age 3.6) O is for Orange…', slate and resin, 18 units 36 x 28 cm. Arts Council Collection.

The white dress is part of a plot to escape. From what I'm not quite sure, but all through the cold, dark and indifferent winter I have been planning it. Learned academic by day, and by night, secret reader of holiday brochures and eater of maple sugar candy, planning how the three of us would meet in Miami, happy family reunited - father, mother, child, against a backdrop of blue sky and pounding surf of course. I have told no-one. Finally, the day arrives! I pack the suitcase with devotion, the way a bride would do her trousseau: no jeans, no boots, no leather jacket or coat of any kind and nothing black, only brightly colored blouses, loosely fitting trousers, shorts, halters, high-heeled shoes and all the jewelry I ever wanted to wear and didn't have a chance to. And the dress. I refuse to wear a coat even to the airport in anticipation of the happy metamorphosis that will inevitably take place when I emerge eight hours later. And it does. The air is hot and thick. I feel it soldering the bits and pieces of my body into something tangible, entire. I can be seen, imagine men are looking at me, even look at them sometimes. Soon, they arrive, seem much shorter, fatter, whiter than I had remembered, but it doesn't matter we are together, I am glad. What's more, today is Easter Sunday. Naturally, I'm wearing the white dress - simple, silk, embroidered bodice, gathered at the waist, full skirt falling just below my knee, and thinking, thank god no one will see me (I mean everyone is in New York) and wonder who am I wearing this for anyway. Not him, he doesn't notice and the prospect of negotiating Disneyland has already given him a headache. Then my angelic son tells everyone, "look at my Mommy." The riddle solved. I am transported in a halo of fluorescent light to the land of "good-enough-mothers." The motel manager waves his magic wand and says, "Please come with me into the dining room where you will feast on champagne, strawberries and cream, the Seven Dwarfs will play the Brandenburg Concertos and I'm quite sure you will live happily ever after." And we do.

Extase

Plate 40 Mary Kelly, *Interim: Part 1: Corpus*, detail 'Extase' (two panels), 1985, laminated photo positive, screenprint on plexiglass, 122 x 91 cm. Reproduced by permission of Mary Kelly.

In *Corpus* (Plate 40), another work by Kelly from the early 1980s, photographic panels were interspersed with panels of text. The title plays on both senses of the word 'corpus', the human body and a body of work, and the two senses are mutually inflected. The panel illustrated here is only a part of the work. It is a photograph of a woman's blouse subtitled '*extase*' (ecstasy) one of five categories of female hysteria identified by the nineteenth-century psychiatrist Charcot (whose work – from a very different point of view – had also interested the Surrealists). On first encounter, it may appear odd for a feminist artist to couch her images in the stereotypical terms of hysterical symptoms, but for Kelly, whose work is informed by psychoanalysis, the point is to redefine and rework received ideas and images from a feminist perspective. Rather than turning away from the representation of the female body, Kelly tries to reformulate it. *Corpus* represents the body not by depicting it, but by incorporating photographic images of bits of clothing or accessories, as if to present the female body directly will necessarily succumb to the patterns of display associated with the female nude, of the kind we saw, for example, in Manet's *Olympia*. Instead she uses isolated fragments and juxtaposes these with panels of text reminiscent of popular women's fiction. A sort of 'story' is offered in these texts, one which appears distinctly personal and private but the 'story' is not pictured in the adjacent images. The way Kelly has assembled the images draws on many devices developed within modernism, such as isolating and fragmenting the image, but in so doing her aim appears to be to turn upside-down some of the conventional meanings of the female body. Barbara Kruger, in the work *Untitled* (Plate 41) uses images and texts to exploit their mismatches, in this case superimposing on a woman's face the slogan: 'Your body is a battleground', which seems to be taken from an advertisement in its form but not in its content. Both these works bring us back to the part played by the representation of the female body in the construction of the modern. But they have also been seen as examples of a practice which is distanced from the concerns of modernism, and it is to this question – of how far modernism is a thing of the past – that I want to address some brief remarks in my final section.

Plate 41 Barbara Kruger, *Untitled*
('Your body is a battleground'),
1989, photographic
silkscreen/vinyl. Courtesy of Mary
Boone Gallery, New York.

After modernity?

Increasingly, the view has gained ground that the 'modern period' is over and we are now
in the grips of the postmodern, and have been since the 1960s and 1970s. The 'postmodern'
has proved to be far from resilient or entirely convincing as a label for a 'movement', but
the words 'post' or 'after' continue to imply that the modern, far from being 'of the
present' has already been passed through. Does it mean that the period of modernity,
neatly categorized with a beginning, a middle and an end, can now be seen clearly, with
distance and clarity, for what it really was? Now it is behind us, do we no longer share its
mistaken assumptions, or its mistaken faith in the modern in art? Whatever the signifi-
cance of the postmodern, it is certain that history does not take on such neat forms, nor
does the art that has been produced in the modern period.

As the present is contested, so the past will be. In order to indicate how the art of the
past is continually being reshaped in terms of the interests of the present, I want to point
here to a few of the assumptions about modernism that have recently gained ground.
Some of the features which have been associated with a postmodern culture, for example,
are 'decentredness', 'multiplicity' and 'heterogeneity'. These terms make more sense if we
can see them as deliberately cutting against the grain of another set of terms, for all of
these features are set up as antitheses or opposites of the values associated with mod-
ernism, which, accordingly, are characterized as 'centredness', 'unity', and 'homogeneity'.
And most importantly, the postmodern contests the authority of the value system associ-
ated with modernism. There is not the space here to discuss these differences in detail, but
I simply want to point out the extent to which this characterization of the concerns of
contemporary culture presupposes something about the nature of modernism.

One aspect of this contemporary condition is said to be a permanent recycling of the images that endlessly proliferate in our culture, through advertising, television and other media. Barbara Kruger, for example, draws on the circulation of photographic images as the basis of her work, taking images like those which have been used in advertising to exploit women. She uses these to subvert fixed meaning and the conventional labels ascribed to women in our culture. The feminist questioning of authority has been thought by some to be compatible with the postmodern refusal of the authority of past value systems. Whether or not this is *qualitatively* different from the modernist fragmentation of images and use of popular imagery is an open question.

Finding continuity with modernist precedents may lead us to be sceptical of some of the claims for the difference in postmodernism. We might think of postmodernism plundering a past tradition of art as it might plunder any other field of culture. The Cubists, for example, had drawn on the material of popular culture and incorporated it into palpably artificial constructions (Plate 9). Cubist work also set up a chain of hints and clues which disallowed a fixed reading. In later works, Picasso even mixed different modes of painting together – figurative and fragmented Cubist elements were laid side by side – as so many different kinds of representation, none laying claim to a greater reality than another (Plate 42). This kind of heterogeneous mixing and the refusal of the idea of a fixed reality is an aspect of modernism that postmodernism draws upon.

Plate 42 Pablo Picasso, *Études* (*Studies*), 1920, oil on canvas, 100 x 81 cm. Musée Picasso, Paris. Photo: Réunion des Musées Nationaux Documentation Photographique. © DACS, London/SPADEM, Paris, 1991.

Plate 43 Robert Rauschenberg,
Persimmon, 1964, oil and
silkscreen ink on canvas,
66 x 50 cm. Private collection .
Photograph courtesy of Leo
Castelli Photo Archives.

Persimmon (Plate 43), a work by Robert Rauschenberg, has, with hindsight, been regarded as marking a turning point between modernism and postmodernism, because an eclectic use of imagery is combined with a fragmented, collage-type treatment (see Douglas Crimp, 'On the museum's ruins'). But its *effects* have been seen as changing direction away from modernism. In *Persimmon* Rauschenberg silkscreened an image of Rubens' *Venus* onto canvas, and juxtaposed it with other fragments. Although Manet had derived the *pose* of *Olympia* from a precedent – Titian's *Venus* – it has been suggested that reproduction is all there is in *Persimmon*. Images of the past are recycled, peddled with no more sanctity than any other kind of popular image.

Part of the difficulty of dealing with claims for the postmodern is that they presuppose and depend on different views of the modern. Some are premised on a very general sense of modernism in culture, for instance, rather than the more specific sense of modernism in art that we have discussed, or the kind of Modernist theory propounded by Greenberg. These distinctions need to be sorted out if we are to get a grip on the possibility of a break with modernism, and decide whether or not modernism simply continues to renew itself by taking on new forms. Given these conflicting views, it will be important to identify what is meant by modernism, and what it entailed as it developed in

the second half of the nineteenth century. We shall concentrate in this book on its development in France, for most of the debate about modernism in art in the nineteenth century has focused on France, and on Paris, which has been taken as the typical modern city in which this culture could develop. It is an open question whether the period of modernity is over or our contemporary culture is but a further symptom of it, or indeed whether 'modernity' is something that can be periodized at all. It may be that we are not in a position to construct an heroic, monolithic version of modernism out of the fragments which remain to us. Instead, speculation has become conditional upon recognizing the problems of modern art and its possible interpretations.

References

BAUDELAIRE, C., *The Painter of Modern Life and other Essays*, edited and translated by J. Mayne, London, Phaidon Press, 1964.

BATAILLE, G., *Manet*, Paris, Skira, 1955.

BAXANDALL, M., *Patterns of Intention: On the Historical Explanation of Pictures*, London and New Haven, Yale University Press, 1985.

BUCHON, M., 'An introduction to *The Stonebreakers* and *The Funeral at Ornans*', in *Courbet in Perspective*, P. ten-Doesschate (ed.), New Jersey, Prentice Hall Inc., 1977 (first published in *Le Peuple*, 7 June 1850).

CLARK, T.J., 'A bourgeois Dance of Death: Max Buchon on Courbet', *The Burlington Magazine*, vol.CXI, no.793 (Part 1) and no.794 (Part 2), 1969.

CLARK, T.J. *Image of the People: Gustave Courbet and the 1848 Revolution*, London, Thames and Hudson, 1973.

CLARK, T.J., *The Painting of Modern Life: Paris in the Art of Manet and his Followers*, London, Thames and Hudson, 1985; an extract is reprinted in F. Frascina and J. Harris (eds), *Art in Modern Culture: An Anthology of Critical Texts*, London, Phaidon, 1992, pp.38–48.

CRIMP, D., 'On the museum's ruins', in *The Anti-aesthetic: Essays on a Postmodern Culture*, H. Foster (ed.), San Francisco, Bay Press, 1983.

GREENBERG, C., 'Abstract, representational and so forth', in *Art and Culture: Critical Essays*, Beacon Press, Boston, 1961, pp.133–8.

GREENBERG, C., 'Modernist painting', *Art and Literature*, no. 4, spring 1965, pp.193–201; reprinted in *Modern Art and Modernism*, F. Frascina and C. Harrison (eds), London, Harper and Row, 1982, pp.5–10 (an edited version is reprinted in *Art in Theory, 1900–1990*, C. Harrison and P. Wood (eds), Oxford, Blackwell, 1992, section VI.b.4.)

GREENBERG, C., 'The recentness of sculpture', in *Minimal Art: A Critical Anthology*, edited by G. Battcock, Studio Vista, London, 1969.

GREENBERG, C., *The Collected Essays and Criticism*, 2 vols, edited by J. O'Brian, Chicago University Press, Chicago 1986, 1988.

MALEVICH, K., 'From Cubism and Futurism to Suprematism', in *Essays on Art*, translated by X. Glowacki-Prus and edited by Troels Andersen, London, Rapp and Whiting, 1969, vol.1, pp.19–41.

MORRIS, R., 'After the Tate Gallery's famous bricks, the new art is – dirty nappies', *Daily Mail* 15 October 1976.

WOLLHEIM, R., *Painting as an Art*, Thames and Hudson, London, 1987.

ZOLA, É., 'Une nouvelle manière en peinture: Édouard Manet', 1867, reprinted in translation as 'Édouard Manet' in *Modern Art and Modernism*, F. Frascina and C. Harrison (eds), London, Harper and Row, 1982, pp.29–38.

CHAPTER 1
MODERN PRACTICES OF ART AND MODERNITY

by Nigel Blake and Francis Frascina

Introduction: art as a social practice

The terms 'modernity' and 'postmodernity' are used not only in the history and criticism of art, but also in social history and theory. It is often claimed that where there used to be a widespread consensus as to what was valid and valuable in modern art and modern society, there is now radical disagreement, that there reigns a 'pluralism' of cultures and value systems, ideologies, religions, beliefs about gender, race and class. Yet there is strong disagreement as to what this plurality might mean or imply. Was there ever a real consensus anyway? If there was, has it broken down irretrievably, and perhaps a good thing too? Or is it the case that modern art and society require a more complex consideration of other possibilities, but a 'modern' notion of what is valid and valuable still stands?

Can we make progress with these questions by treating separately the two sets of issues – those about art and those concerning social developments? Some critics and historians believe this is possible and desirable. Like the Modernist critic Clement Greenberg in his influential essay 'Avant-garde and kitsch' (first published in 1939), some believe that the earliest development of modern art *was* bound up with social developments, with the activities and theories of revolutionary politics in mid-nineteenth-century France in particular, but that later in the century this ceased to be the case. To examine this argument more closely, we need to consider how that relationship worked.

Bohemia and the avant-garde

Both revolutionary politics and 'avant-garde' art evolved, so the argument goes, in the social context of 'Bohemianism'. Originally, Bohemianism referred to vagabondage or to the life of wandering gypsies, as represented, for example, in Zo's *Family of Voyaging Bohemians* (Plate 44). 'Bohemia', formerly a kingdom, now a province of western Czechoslovakia, was considered the home of the gypsies. The term was taken up in the nineteenth century by many artists and intellectuals who saw themselves as *metaphorically* 'homeless' within the culture of capitalist society. For them, 'Bohemianism' became an outlook; it indicated a protest against, an independence from, or an indifference to established social conventions. This is not to say that the concept had a fixed meaning: it took complex, ambiguous and often incompatible forms – including fanaticism, asceticism and disillusion with established education and decorum. Rather, it was an attitude cultivated by those impoverished artists and intellectuals who existed on the margins of society, often complicit with, but not part of, the *classes dangereuses*, the 'dangerous classes', regarded as the seed-bed of revolution, crime and disorder. 'Bohemians' were opposed to established authority, but without systematic political creed or organization. Many of

Plate 44 Achille Zo, *Famille bohémienne en voyage* (*Family of Travelling Bohemians*), 1861, oil on canvas, 127 x 160 cm. Photo © Musée Bonnat, Bayonne.

them joined the insurrection in the 1848 Revolution, fighting on the side of those artisans who reacted violently to modernization and the implementation of capitalist economic priorities. The revolution's failure was followed by a new authoritarian political order in the 1850s and 1860s, which brought an acceleration of economic and social change.

Bohemians were uniform only in their alienation from bourgeois society and the organizational principles of capitalism. To see *early* 'avant-garde' art within this context, therefore, as something produced by those steeped in 'Bohemianism', is to see it as in some sense 'oppositional' to both of these. We need, though, to distinguish 'avant-garde' from 'Bohemian'. The concept of the 'avant-garde' is profoundly ideological and shifting (as indeed was that of 'Bohemia'). On the one hand, for many privileged 'radicals' in the nineteenth century, 'avant-garde' was an expedient and fashionable label used for social climbing, a temporary token to be ditched when returning to a comfortable status in existing society. Many such voguish radicals sided, by contrast with the 'Bohemians', with the forces of order in 1848. On the other hand, those 'avant-gardists' who saw themselves as having a deeper social and political commitment attempted to engage with strategies and forms of representation, including painting and literature, that were perceived as critiques of existing conventions and of the power structures which underpinned them. In this chapter, we are concerned with the second kind of avant-gardist.

Two of the practitioners discussed here – the painter Gustave Courbet and the poet and art critic Charles Baudelaire – were inhabitants of this 'Bohemia' and early 'avant-gardists'. The painter Édouard Manet was a bourgeois 'intellectual' who cultivated close contacts with 'Bohemia', including Courbet and Baudelaire themselves.

But, to pursue the argument we introduced, Greenberg claims that 'avant-garde' art soon 'succeeded in "detaching" ... itself from society', and that from this detachment a 'pure' modern art emerged:

> it proceeded to turn around and repudiate revolutionary politics as well as bourgeois. The revolution was left inside society, a part of that welter of ideological struggle which art and poetry find so unpropitious as soon as it begins to involve those 'precious' axiomatic beliefs upon which culture thus far has had to rest ... Retiring from public [*sic*] altogether, the avant-garde poet or artist sought to maintain the high level of his art by both narrowing and raising it to the level of an absolute ... 'Art for art's sake' and 'pure poetry' appear, and subject matter or content becomes something to be avoided like the plague.
>
> ('Avant-garde and kitsch', p.36)

From such a highly influential Modernist perspective, the history of the development of 'modern' art in the nineteenth century is the history of an heroic avant-garde which moves away from literary and historical subject-matter towards an art of 'pure sensation' or 'art for art's sake'. 'Avant-garde' art is seen as 'detaching' itself from the concerns of social and political life, in the same way as the poetry of Mallarmé, for example, which stresses formal word play, is regarded as a crucial move toward 'pure poetry' – poetry without an object. We find here a claim that once 'modern' or 'avant-garde' art got going, it ceased to be much influenced by, or committed to, wider social developments – or that where such an influence exists, it's not what matters most in accounting for what is valid and valuable in such art. This claim is often referred to as the thesis of the *social autonomy of art*. Modernists see such autonomy as a positive counterpart to the 'corrupted' products, the 'kitsch' – popular fiction and music, Hollywood movies, working-class or proletarian culture – of ordinary life and mass consumption. Greenberg's 'Avant-garde and kitsch' is a classic text for those who subscribe to the primacy of 'art for art sake' and believe in the emancipatory potential of a disinterested aesthetic experience. (By 'disinterested', they mean without issues of morality, utility or what they would see as 'special pleading', impinging upon the 'imaginative life' of Art, with a capital 'A'.) The quality of the aesthetic and aesthetic experience which they seek are to be measured at least in part by the degree to which a work of art is explicitly *independent* of, or 'transcends', socio-cultural issues, and becomes concerned with itself, with 'art for art's sake'.

The thesis of the social autonomy of art and this notion of 'aesthetic experience' is used to select a canon of artists and works of art. Within this canon Monet's practice is exemplary in its move from paintings such as those of bourgeois leisure at La Grenouillère (Plates 155–157), to works that concentrate exclusively on formal and technical equivalents for subjective sensations, such as those of his purposely constructed water-lily pond (Plate 200) painted from the late 1890s onward.

There is evidence, as Greenberg suggests, that the connotations of the term 'avant-garde' changed, especially after 1870. Losing its earlier (though sometimes tenuous) association with left-wing opposition, it came to signify for many, mainly cultural and artistic interests. However, there are grounds for doubting whether this view of the development of 'modern' art and of the 'avant-garde' is tenable. Some have argued that Modernist art history has evacuated the historical – and especially the political – territory defined by the term 'avant-garde', using the term as a catch-all label to celebrate a particular line of development, an exclusive canon. We wish to argue that some early modern artists were not merely passively affected by major social changes, but responded to them by modifying the relationship between the art they produced and the social world. We would also like to question the degree to which early 'avant-garde' modern art was intended to be 'art for art's sake', to avoid subject-matter or content 'like the plague', or even to downgrade its importance. These two ideas are linked of course. One way – but not the only way – that certain artists shifted the relationship between art and society was precisely by

dealing with new subjects like the modern city, or by dealing with old-established subjects such as landscape, in a 'modern' way – perhaps even an 'oppositional' way, in the original, political sense of 'avant-garde'.

One of our main aims here is to examine a socio-historical account of such shifts of emphasis or 'meaning' as they are represented by Courbet's *Burial at Ornans*, 1849–50, and Manet's *The Old Musician*, 1862, on the one hand, and on the other Manet's *Boaters at Argenteuil*, Monet's *Effect of Autumn at Argenteuil* and Pissarro's factory landscapes at Pontoise, all produced in the 1870s (Plates 55, 67, 100, 104 and 123, 125, 126, 127). These case studies have been selected so as to consider issues of method relevant to the social history of art, including examples of major approaches in this tradition.

The heroism of modern life

There is much evidence in the early writings on 'modernity' – particularly those of Baudelaire – to suggest that artists and critics saw modern social experiences as inseparable from a self-conscious attitude to the means by which those experiences could be represented. In his essay 'The Salon of 1846: on the heroism of modern life', Baudelaire extolled the 'heroic' aspects of the underworld of the newly modernized and ever-transforming metropolitan city. For him, the life of contemporary Paris was 'rich in poetic and marvellous subjects': the uniform drabness of people's dress, the modern phenomenon of the 'dandy' who reacts against this drabness, the 'private subjects' of prostitution and criminalization, the new *flâneur* who strolls around the city 'botanizing on the asphalt', and seeking the anonymity of the crowd, an asylum for all those on the 'margins' of society – economically, socially, intellectually.[1]

In his often quoted definition of 'modernity' as an 'attitude' or 'consciousness', Baudelaire identified two main elements: 'the transitory, the fugitive, the contingent, the half of art whose other half is the eternal and immutable' ('The painter of modern life', 1863, p.553). *Modern man* (sic), he argues, is compelled to the risk of becoming a self-conscious being or agent, without the 'safety' of the given roles and conventions of the past. His resource is an ironic heroicization of the *present* ('the transitory, the fugitive, the contingent'), a transfiguring play of freedom with contemporary reality, an ascetic elaboration of the self as bohemian. But this needs to be achieved by engaging with those ideas, conventions, ordering principles and expressive means of art practice (for example, symbol systems, perspective, anatomy, use of light and shade) which make up the 'eternal and immutable'. For Baudelaire, modern life is so contradictory that such 'modernity' can only be produced in '*art*', in *representation*s. This is to suggest that forms of social consciousness, by which individuals construct their identity, can only be adequately expressed in modern life by means of metaphors, by representations. In the social production of their existence, people enter into definite forces and relations which are indispensable and independent of their will, relations of production which correspond to a particular stage of development of their material productive forces, here modernization, industrialization and the structures of modern capitalism.[2] The 'painter of modern life' who takes on this novel task is

> solitary, gifted with an active imagination, always travelling across *the great human desert*, [he] has an aim loftier than that of a mere flâneur, an aim more general, something other than the fugitive pleasure of circumstance. He is looking for that quality which you must allow me to call *modernity* ...
>
> ('The painter of modern life', p.553)

[1] See Michel Foucault, 'What is Enlightenment?'.
[2] See Karl Marx, *A Contribution to the Critique of Political Economy*.

Plate 45 Constantin Guys,
Trois femmes près d'un comptoir
(*Three Women by a Bar*), 1860,
pen and wash and watercolour,
25 x 18 cm. Petit Palais, Paris.
Photo: Musées de la Ville de
Paris/ Pierrain. © SPADEM, Paris
and DACS, London.

Immediately, we can see closures here on grounds of gender – modern *man* – and on class
– the *flâneur*, perhaps also an intellectual, with time for observing contemporary life. Does
Baudelaire mean the modern *bourgeois man* when talking of the compelling force of
'modernity'?[3] Specifically, in this text he singles out Constantin Guys, an artist who
represented contemporary experience and subjects (Plate 45).

We can observe an important, complementary view of the contemporary experience
of Baudelaire's 'modern man', who is looking for that quality called 'modernity', in the
social and political writings of Marx and Engels. Baudelaire lived in a period that experi-
enced what Marx and Engels described as the 'constant revolutionizing of production,
uninterrupted disturbance of all social conditions, everlasting uncertainty and agitation,
[which] distinguish the bourgeois epoch from all earlier ones'. They argued that, his-
torically, the bourgeoisie had played 'a most revolutionary part' in establishing modern
industry, the world market and free trade (the characteristics of *modernization*).[4] Drawing a

3 See Janet Wolff, 'The invisible *flâneuse*'.
4 By the bourgeoisie, they meant the 'class of modern capitalists, owners of the means of production and
employers of wage labour'.

particular relationship between this class and their modernizing interests, Marx and Engels saw 'modernity' as an ever-*transforming* experience, where all that once seemed 'solid' and certain 'melts into air' (quotations from 'The Manifesto of the Communist Party', pp.37–8). For them, the bourgeois epoch was characterized by the transformation from 'ancient and venerable traditions, opinions and customs' to the modern capitalist system. Baudelaire wrote on one product of this modern capitalist system, the crowd of urban manual workers, in a preface to the collected poems of his friend Pierre Dupont, a worker-poet of the 1848 Revolution (*Chants et Chansons*, 1851). With reference to 'Le Chant des ouvriers', Dupont's 'strong and true poem', he wrote:

> Whatever party one may belong to, on whose prejudices one has been nourished, it is impossible not to be gripped by the spectacle of this sickly crowd which breathes in the dust of workshops, swallows particles of cotton, becomes saturated with white-lead, mercury and all the poisons necessary for the creation of masterpieces.
>
> (*Oeuvres complètes*, p.293)

There's obvious irony here in the word 'masterpieces'. What 'masterpieces'? In Baudelaire's view, it took an heroic constitution to live through the transforming and contradictory conditions of modernity. One of the 'spectacles' of modernity was the populace on the margins of society, a populace which constituted one modern *subject*. While this subject was needed for the production of modern 'masterpieces' so, too, were 'all the poisons', such as white lead pigment, which the urban proletariat produced under new and oppressive workshop and factory conditions. In this preface, Baudelaire also condemned the 'puerile utopia of the school of *l'art pour l'art* (art for art's sake), [which] in excluding morality, and often even passion, necessarily made itself sterile'. He concluded, 'henceforth art was inseparable from morality and utility' ('The painter of modern life', p.291–2). For Baudelaire 'art' was ultimately connected to social experiences, to the contingencies of actual life. Specifically, in the mid-nineteenth century, this meant the negative transformations wrought by modernization and the economic interests of the 'epoch', the same characteristics of the age that were the subject of Marx and Engels' interest.

Baudelaire despised the official physical and social reconstruction which characterized the 'bourgeois epoch'; for him 'heroic' subjects were to be found in the 'underworld of city life' rather than the spectacle of revamped fashionable spaces. Truly modern representations needed to engage with social experiences, and with what he regarded as the contradictory signs and immediate sensations of contemporary life, where all that once seemed solid 'melts into air'. Baudelaire warned of the dangers of neglecting this 'half of art':

> you do not have the right to despise or dispense with this transitory, fugitive element, whose metamorphoses are so rapid. By neglecting it, you inevitably tumble into the void of an abstract and indefinable beauty … If for the necessary costume of the epoch you substitute another, you will be guilty of a mistranslation …
>
> ('The painter of modern life', p.554)

Was Baudelaire warning, in 1863, that a detachment of 'art' from society could lead to the 'void of an abstract and indefinable beauty'? In 1855 Courbet had written of 'the trivial goal of *art for art's sake*', and in 1861, prefiguring Baudelaire's warning about the 'void', he wrote in an open letter to his students that:

> painting is an essentially *concrete* art and can only consist of the representation of *real and existing* things. It is a completely physical language, the words of which consist of all visible objects; an object which is *abstract*, not visible, non-existent, is not within the realm of painting…
>
> (*Le Courrier du dimanche*, extract in Nochlin, *Realism and Tradition in Art*, p.35)

Two years later, Jules-Antoine Castagnary, the art critic and champion of Courbet's Realism, echoed both the latter's view and Baudelaire's idea of 'modernity':

> The object of painting is to express, according to the nature of the means at its disposal, the society which produced it ... Society is actually a moral being which does not know itself directly and which, in order to be conscious of reality, needs to externalize itself, as the philosophers say, to put its potentialities in action and to see itself in the general view of their products. Each era knows itself only through the deeds it has accomplished: political deeds, literary deeds, scientific deeds, industrial deeds, artistic deeds ... As a result, painting is not at all an abstract conception, elevated above history, a stranger to human vicissitudes, to the revolutions of ideas and customs; it is part of the social consciousness, a fragment of the mirror in which the generations each look at themselves in turn, and as such it must follow society step by step, in order to take a note of its incessant transformations.
>
> ('Le Salon de 1863', *Le Nord*, extract in Nochlin, *Realism and Tradition in Art*, p.64)

Thus it was an established point of view in mid-nineteenth-century France that modern art could not be understood in isolation from modern society. The same point of view has led many historians to agree that the very idea of 'art for art's sake' had important social origins at a specific moment of transformation in France, after the abortive Revolution of 1848. Those within the Marxist tradition, such as the cultural theorist Walter Benjamin, argue that the original strategy of *l'art pour l'art* was itself 'oppositional', but that its critical potential was frustrated and transformed by the political and social interests of the bourgeoisie during the Second Empire of Napoleon III:

> the theory of *l'art pour l'art* assumed decisive importance around 1852, at a time when the bourgeoisie sought to take its 'cause' from the hands of the writers and the poets. In *The Eighteenth Brumaire*, Marx recollects this moment when the bourgeoisie ... called upon Napoleon 'to destroy their speaking and writing segment, their politicians and literati, so that they might confidently pursue their private affairs under the protection of a strong and untrammelled government'. At the end of this development may be found Mallarmé and the theory of *poésie pure*. There the cause of his own class has become so far removed from the poet that the problem of literature without an object becomes the centre of discussion. This discussion takes place not least in Mallarmé's poems, which revolve around *blanc, absence, silence, vide* [blank, absence, silence, void].
>
> (W. Benjamin, *Charles Baudelaire*, p.106)

Benjamin is concerned with the theories of 'art for art's sake' and 'pure poetry', as Greenberg was in the passage quoted earlier, but for different reasons. He argues that in cultural forms, here poetry, many practitioners during this period no longer undertook to support explicitly any of the causes pursued by the class to which they belonged. With Mallarmé this 'basic renunciation of all manifest experiences of [his class], causes specific and considerable difficulties. These difficulties turn his poetry into an *esoteric poetry*' (*Charles Baudelaire*, p.106; our emphasis). This is to say that many artists and intellectuals such as Mallarmé, took an *aesthetic* route out of the contradictions of society by developing the complexities of their art, as *Art*. In this 'escape' they found a form of 'emancipation' from the contradictions of life. In contrast to this tendency, Benjamin argued that Baudelaire's works are 'not esoteric' because 'social experiences' are inscribed in them in 'extensive round-about ways'.

Baudelaire's concept of 'modernity', and Castagnary's view of art as a part of the 'social consciousness', contribute to a critical tradition different from the one associated with Greenberg. This tradition informed the work of the art historian Meyer Schapiro. Writing at the same period as Greenberg in 'Avant-garde and kitsch', he argued that:

the scientific elements of representation in older art – perspective, anatomy, light and shade – are ordering principles and expressive means as well as devices of rendering. All renderings of objects, no matter how exact they seem, even photographs, proceed from values, methods and viewpoints which somehow shape the image and often determine its contents. On the other hand, there is no 'pure art', unconditioned by experience; all fantasy and formal construction, even the random scribbling of the hand, are shaped by experience and by non-esthetic concerns.

('Nature of abstract art', pp.85–6)

Schapiro stresses the fact that works of art are products of social practices of various kinds. Understanding and 'consuming' works of art – viewing, enjoying, owning them – are also social practices. Further, the practices of consumption and production are inter-linked. How artists paint will be affected by their *own* understanding of what they're doing and perhaps by their *audience's* understanding of what they are doing. All artists' productions are governed by consumption – either by some mental or unconscious notion of who the imagined viewer might be, or by having a particular patron in mind – and in many instances by *both*. If this is so, there is no autonomous 'pure art', and by extension no disinterested, unconditioned 'aesthetic experience'. Both are socially and culturally 'shaped' even where artists, critics or viewers seek to 'transcend' social and cultural factors. That 'seeking' is itself a result of particular historical factors, as Benjamin suggests with respect to Mallarmé.

Why need we talk about producing and consuming art as *practices*? And why *social* practices? The production of a work of art is a complex activity. Placing pigment on a canvas, for instance, requires not only a thorough knowledge of the techniques of mark-making and an understanding of the mixing of colours, but also experience in the physical qualities of the brushes and paint being used. This kind of knowledge requires not only a familiarity with the markets for materials and the possibilities and constraints they constitute, but also an understanding of the needs of clients.

The choice of size and medium, with the physical constraints these entail, and the requirements of greater or lesser durability, interact with choices of subject and style. And these involve complicated historical and social judgements. In part they will have to do with a knowledge of what contemporary artists are doing and why; but a deep understanding of the history and traditions of art is also required. The choice of a subject will sometimes entail artists making judgements about the *conventional* understandings of the subject and its tradition, and at other times prompt artists to change or adapt conventions. Such changes may in turn involve consideration of the work of others, such as historians, philosophers, and writers. Each kind of knowledge and judgement is exercised in the context of an expanding network of activities. None of them is fully independent of the other. For each of the many 'sub-tasks' involved in making a picture, there are typically a number of possible methods. Artists don't begin new work by going right back to basics, but reconsider the technical, stylistic or interpretative alternatives currently available. Most artists imitate, or work within, one of a few available models, or *paradigms*. Sometimes this leads to predictable and conformist art, at other times the 'paradigms' are transformed with significant innovations. When we talk of an artist's *practice* we are referring to the network of activities which go into the production of a picture. We do not imply, however, that these different ways of working have all been systematically and consciously considered. Few artists have a single uniform practice; most operate in different ways under different circumstances. An important task in describing such a practice is to give an account of the paradigms within which it operates – the particular works or examples of working which could be treated as model instances of what that artist produces and how he or she operates.

All of an artist's activities have *social* preconditions. Buying materials and selling work both involve markets with their own economic systems and technological innovations. Typically, artists are trained within educational institutions with their staff, curricula and sources of funding and control. Choice and interpretation of subjects will probably have reference to what is popular or fashionable, topical, acceptable or familiar, or may relate to current intellectual ideas. All these characteristics presuppose a public which has its own education, interests, media and so on. Reference to art history and artistic traditions presupposes that artists and their audience record and pass on knowledge about art – and this too is a social activity. It is hard to conceive of any artistic activity that does not have a social aspect.

The 'consumption' and understanding of art usually presupposes some teaching, if only informal, which involves identifying critics or knowledgeable viewers as 'teachers'. The 'consumption' of art usually involves visiting exhibitions, galleries or studios, all of which have their own specific decorum. Knowledge of art might be gained through books, magazines and newspaper articles. Buying, reading, and even corresponding with these are very specific social activities. Not least, the viewer often brings to works of art moral, religious and political standards which socially condition what is regarded as 'aesthetic'; the criteria used in judgements of 'quality' in fifteenth-century Florence, for example, were different from those used in post-industrial societies. Adopting, comparing, changing and applying such standards are themselves social activities, and they occur in social contexts. A viewer's reaction to a painting such as Manet's *Olympia* (Plate 14), may have much to do with issues of gender and attitudes to sexuality, and thus to love, family life, prostitution, social decorum, conventionality and religious attitudes, and thus their adherence to political liberalism or authoritarianism, and so on.[5]

The social practices of art production and consumption cannot be isolated from other social practices. To the extent that all social practices are subject to change and to the influence of broader social transformations, so too will these be. Thus, discussion of the social practices of art can show how the task of understanding particular works of art may usefully be informed by broad concepts of social organization and change, such as the concept of modernity. On the one hand, specific works of art issue from practices of production and are the subject of practices of consumption; on the other hand, these practices are themselves constrained and determined by broader social formations and transformations, such as modernity. In turn, they may have reciprocal influence on them. We are saying that there may be aspects of 'aesthetic experience' that are elusive but a large part of such experience can be accounted for in terms of social and cultural factors.

Art practice and politics in the nineteenth-century art world

The idea that modern art begins in nineteenth-century France is a commonplace of art history, with which we shall not quarrel here. But those Modernists who argue that modern art attained a social autonomy are partly saying that the nature of art as a social practice changed radically during that century. Many of them privilege the importance of technical, formal and aesthetic changes, explaining them in terms of a 'self-critical' progression to an 'absolute', a 'pure art', an 'art for art's sake' (this is apparently achieved by an ever-refined specialization, which eradicates references external to the discipline itself). We would describe such changes differently, by considering the possibility of social concerns being among the primary causal factors.

5 On this, see T.J. Clark, 'Preliminaries to a possible treatment of *Olympia* in 1865'; and Griselda Pollock 'Modernity and the spaces of femininity'.

Plate 46 (above) Benoît Louis Prévost, *Une École de Dessein*, engraving after a drawing by Charles N. Cohin *fils*. On the left pupils copy a drawing; behind them a group is drawing 'in the round' from a plaster model. To the right are those drawing 'from nature', with the model lit from in front and above. Far right a student draws from the antique.

Fig. 2 (left) shows section of benches surrounding the revolving model's table.

Fig. 1 (below left) shows ground plan, a: position for advanced student to work on the unlit side of the model; i: shuttered window to control light; k: source of cross light. From Denis Diderot et Jean Le Rond D'Alembert, Encyclopédie, Vol III, Recueil de Planches, 1763, Paris. British Library 65.G.8. Reproduced by permission of the British Library Board.

The structure of the art industry in the early nineteenth century was hierarchical, much as the general society of the time. At the head stood three socially prestigious institutions, enjoying major political and economic support from the State. These were the Académie des Beaux-Arts, the École des Beaux-Arts and the annual exhibition known as the 'Salon'.[6]

The Academy and the Salon

First founded in 1648, the Academy was abolished during the Revolution of 1789, mainly because of its aristocratic associations. In 1795, the maintenance of French cultural life was

6 See A. Boime, *The Academy and French Painting* and *Thomas Couture and the Eclectic Vision*.

Plate 47 Léon Cochereau, *L'Atelier de David au Collège des Quatre Nations* (*Interior of David's Studio*), 1814, oil on canvas, 90 x 105 cm. Musée du Louvre, Paris. Photo: Réunion des Museés Nationaux Documentation Photographique.

entrusted to a new body, the Institut Français, which retained strong consultative powers with regard to the École des Beaux Arts (the State school). In 1816, a section of the Institute was renamed the *Académie*. It reinstated history painting in the grand manner – the *style historique* – representing scenes of Classical, biblical and contemporary history. The purpose was public edification, and the Academy ensured the suitability of the École curriculum to this end.

Academic artists were restricted in their choice of themes and subjects by the legacy of aristocratic notions of what was worthy of representation and how. This 'decorum' was encoded in a hierarchy of genres. History painting was thought more 'elevated' than portraiture, which in turn was more worthy than 'genre painting' (depicting the daily lives of ordinary people). Landscape was even lower, with still life bottom of the hierarchy. This scale of importance of subject ran parallel with a scale of required skill and expertise. The more serious the category of painting, the greater the expectation of expertise in drawing, and of complete and highly polished finish. Works in lesser genres could be tolerably sketchy in parts. These distinctions were also marked by differences of scale and format; an important painting would typically be a large one. Finally, certain subjects or themes – violence, the mob, popular crime, the less respectable vices and so on, would not be shown at all – or shown, as overt violence and sexual activity were, only in safely conventionalized (and typically mythological) contexts.

Until 1863, the curriculum of the École remained the narrow one of the eighteenth century, providing classes only in drawing, anatomy and perspective (see Plate 46), with the significant addition of classes in ancient history. The École itself did not teach *painting*, although many private *ateliers* run by established artists did (Plate 47). The premier annual art exhibition up to the 1880s was the Salon. This was organized by the Academy, but on behalf of the State (a major buyer), on State premises and at State expense. The Salon was the main public arena where artists were able to establish reputations.

Since the time of Louis XIV, culture had been a central arena for politics in French life. Painters producing work for aristocratic patrons wanted to secure prestige and status.

Academicians conceived of themselves as intellectuals, a status which aligned them with their prestigious patrons. This explains the Academy's emphasis on Classical and biblical learning and history painting, and is also the basis for its particular interest in drawing. Paradoxically, drawing was seen as a less manual task than painting. It was thought to give a more accurate representation of an artist's intellectual abilities, but another important factor was the emphasis on the concept of *dessin*. What was thought to characterize artists as intellectuals was their ability to *design* or *compose* a picture, to arrange or order the elements of a work in ways which clarified their relative importance, and highlighted the meanings of a work. 'Design' would be undertaken in sketches or *esquisses*, preparatory works, usually on a smaller scale and invariably much rougher in execution than a finished work. In the *esquisses*, the artist would first try out an idea, often attempting several different conceptions. The typical medium for the work of 'design' would be drawing (Plate 48), though colour sketches were sometimes made.

It's clear how the Academy fostered work such as Flandrin's *Theseus recognized by his Father* (Plate 49), which won the prestigious Prix de Rome in 1832. Emphasizing its claims as an intellectual institution, the Académie cultivated an art which was *erudite*. It implied Classical learning and the assimilation of a body of theoretical writing on art, concerned with such issues as the mechanics of story-telling, the Classical aesthetic questions concerning order, clarity, harmony, the edifying, and 'the beautiful', concepts that were perceived as central to the Greek and Roman tradition. In this way, the Academy sustained a complete ideology of art: a set of assumptions, beliefs and attitudes about what art should be, what made a painter an *artist*, where art fitted into society and what kind of society it fitted into. The Académie was a conservative body, both in art and politics.

Although temporarily abolished, the Académie survived the Revolution and became increasingly institutionalized, not least because the bourgeoisie wanted to perpetuate the illusion of aristocratic and superior French taste that was a necessary weapon in the growing mercantile competition with England and Germany. But just as the aristocracy of the nineteenth century was under challenge from bourgeois and intellectual adversaries, so too was the Academy subject to critiques. An important challenge came from the Romantics and from the painter Eugène Delacroix (Plate 54). Many Academics identified Delacroix with left-wing politics on the grounds of technique. His use of rich colour and 'painterly' and expressive visible brushwork contrasted with Academic taste, which disdained colouristic and painterly effect, because it was traditionally associated with 'emotion' and 'sensibility', both of which were regarded as 'feminine' and bereft of theoretical interest. This view had its roots in Academic debate, originating in the seventeenth

Plate 48 Hippolyte Flandrin, *Thésée reconnu par son père* (*Theseus Recognized by his Father*), 1832, pen and ink on paper, 20 x 27 cm. École National Supérieur des Beaux-Arts, Paris.

Plate 49 Hippolyte Flandrin, *Thésée reconnu par son père* (*Theseus Recognized by his Father*), 1832, oil on canvas, 115 x 146 cm. École national supérieur des Beaux-Arts, Paris

century, about the relative value of *dessin* (which was often regarded as signifying 'masculine' control) and of colour. For an Academic, colour traditionally served to do little more than 'fill in' a drawing and had scant value in its own right. The Academy was also committed to the value of a high finish, *'le fini'*, a quality of painting which betrays little mark of the brush, while often revealing minute pictorial detail. This technique hid any trace of manual labour, redolent of proletarian craft originals. If many Academics (though not all) painted primarily for those who aspired to aristocratic values, those outside its purview, independents, catered to a large and varied audience including on the one hand bourgeois intellectuals and on the other a more sentimentalizing section of the middle class, the inheritors of an eighteenth-century cult of *sensibilité* ('sensibility' – the cultivation of feeling, compassion, pity, the 'emotions').

After the 'Revolution' of 1830, the social context of these art practices began a radical shift. The 'July Monarchy' of Louis-Philippe focused new social forces in both political and economic life and fostered that major social transformation we call *modernization*. (In *The Protestant Ethic and the Spirit of Capitalism*, the sociologist Max Weber described social modernization as the conjoint growth of the modern state and modern capitalism). The emergent State under Louis-Philippe was an explicitly bourgeois regime, fostering capitalist industrialization, technological innovation, trade and commerce on a new scale, thus sustaining an increasingly wealthy middle class. With wealth and state encouragement and patronage, this class gained influence and even power, both political and cultural. The new bourgeoisie of the 1820s and 1830s provided a large section of the heterogeneous audience for a third kind of art, the art of the *juste milieu* – the 'middle way', the 'ideal

Plate 50 Eugène Devéria, *La Naissance de Henri IV au Château de Pau, le 13 Décembre 1553* (*The Birth of Henry IV*), 1827, oil on canvas, 484 x 392 cm. Musée du Louvre. Photo: Réunion des Museés Nationaux Documentation Photographique.

compromise'. This is an art which satisfies expectations of competent drawing and modelling of forms, vivid expression in figures and faces, clear composition and lively story-telling. However, it forgoes any commitment to the Classical or the erudite for an interest in themes and emotions closer to those of the Romantics. Devéria's *Birth of Henry IV* (Plate 50) is an early example of *juste milieu* painting.

Eclecticism and *juste milieu* painting

Juste milieu art – a tendency, not a style – was the 'official art' of the July Monarchy. *Juste milieu* works do not look particularly similar to each other (Plates 50, 51, 52 and 116). Their characteristics were negative – not consistently Classical and not unreservedly Romantic. But it might be asked why the official art did not develop a new tendency, instead of feeding off the Classic and Romantic. A peculiarity of the July Monarchy was its institutional commitment to the philosophy of eclecticism. The leading eclectic philosopher, Victor Cousin, rose to a high position in the administration, finally establishing almost autocratic dominance over the entire French educational system, including the École des Beaux Arts. Eclectics believed that progress could be advanced by a process of even-handed consideration of the validity of existing knowledge and systems of thought, by compounding the 'best' contributions of all past thinking into a single new synthesis. According to eclecticism, any art which took the 'best' from Classicism and Romanticism

Plate 51 Émile-Jean-Horace Vernet, *Prise de Smalah* (*The Capture of Smalah*), 1845, Musée Historique, Versailles. Photo: Réunion des Museés Nationaux Documentation Photographique.

seemed bound to be superior to either. An example is Couture's *Romans of the Decadence* (Plate 53), which enjoyed major critical success at the 1847 Salon, because it could be read from different, 'eclectic' points of view. Eclecticism became the official philosophy. If this philosophy linked *juste milieu* painting politically to the government, socially it was connected with the bourgeoisie. Only the middle classes, it was argued, had both the education and the benign interests necessary to characterize and decide on the merits of past ideas and to make a synthesis of all that was best.

However, as Baudelaire suggested in the 'Salon of 1846' (the passage is quoted on p.81), the danger of official subjects, approved by the State, of eclecticism in every field, was shallow compromise; *juste milieu* painters such as Vernet and Delaroche fell into that danger (Plates 51, 52). For Baudelaire, Romanticism, and Delacroix in particular (Plate 54), was symbolic of a modern critical engagement with official values. In contrast to the *juste milieu* compromise, he looked for:

> natural and living drama, terrible and melancholic drama, expressed often by colour, but always by gesture. ... In the matter of sublime gestures, Delacroix's only rivals are outside of his art ... It is because of this entirely modern and novel quality that Delacroix is the latest expression of progress in art.
>
> (*Oeuvres complètes*, p.238)

Necessarily, our threefold division of the art world into Academic, *juste milieu*/official and independent is much oversimplified. Many painters and their works crossed borderlines. But our schema allows us to consider the co-existing place of these broadly differing kinds of art practice within the wider process of social modernization. Academic painting can be considered an art which is no longer explicitly responsive to contemporary culture but which still survives because it is rooted in past power structures. It is tempting to suggest that *juste milieu* painting appeals to and is supported by new dominant classes, that it is modern in the sense that it is recognisably 'contemporary'; Romantic art, the leading

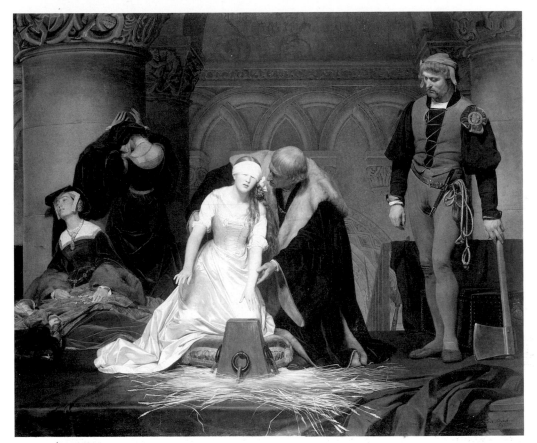

Plate 52 Paul Delaroche, *L'Exécution de Lady Jane Grey* (*The Execution of Lady Jane Grey*), 1833, oil on canvas, 246 x 297 cm. The National Gallery, London. Reproduced by permission of the Trustees.

independent tendency, was perceived by critics such as Baudelaire as 'oppositional', and may be linked to classes and sub-groups not yet empowered.

While these suggestions conceal important complexities they enable us to recognize two important points. The first is that the interests of the Académie, the École and the Salon were not synonymous, and that these institutions were sites for the articulation of political difference in French society, in so far as culture was a central arena for such differentiation. Secondly, it is necessary to distinguish between Academic art, with its legacy of 'noble' and intellectually 'elevating' subjects from religious, Classical and mythological sources, and 'official art', with its emphasis on contemporary interests, even when using historical themes. The *juste-milieu* was a form of 'modern art' which responded to modern conditions, to a society newly characterized by eclectic individualism. We'd argue that eclectic individualism is inseparable from the interests and development of capitalism, where the pursuit of 'modernization' and the market economy relies on the ideology of individual choice and the production of 'diverse' commodities, the demand for which is fuelled by this ideology.

In the following case studies we wish to examine this thesis. The nineteenth-century capitalist controlled impressive new powers of production – new material technologies, new technologies of management and consequently new kinds of knowledge and abilities, all oriented to extracting value more exhaustively from an ever wider range of sources. Both more wealth and more people come under the domination of capitalism, and the

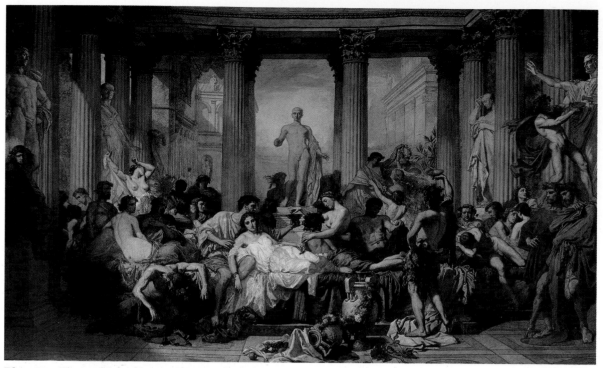

Plate 53 Thomas Couture, *Les Romains de la décadence* (*Romans of the Decadence*), 1847, oil on canvas, 466 x 775 cm. Musée d'Orsay, Paris. Photo: Réunion des Museés Nationaux Documentation Photographique.

capitalist (the industrialist, financial speculator, the entrepreneur, dealer etc.), especially after 1848 and the Second Empire of Napoleon III, eventually assumed the dominant role in politics and human relations:

> the economic development of the country was a major preoccupation under Napoleon III … The economic side of the despotism was complete economic control over public works and their financing, and government approval for the appointment of the directors of all large companies and the formation of new businesses open to public subscription. In this way, there was central economic planning and control. Financiers and industrialists acquired a new prestige … Napoleon III did not worry about great capitalists becoming too powerful …
>
> (T. Zeldin, *France 1848–1945: Politics and Anger*, pp.188–9)

In the human sphere, capitalism engendered an ever more diverse network of interlocking talents and abilities, attitudes and expectations, social sub-cultures and forms of life, of which Bohemianism is an example. In such a society, *differences*, such as of taste, fashion and style, have to be cultivated, but it helps the *system* greatly if they can be managed and integrated in the interests of finance capital and the production and consumption of commodities – such as the products of the art world. For example in the boom conditions of the 1850s, the activities of the Hôtel Drouot, an auction house,

> marked a shift in modes of consumption, with an increased emphasis on speculation and investment. Physical proximity to the stock exchange [the Bourse] encouraged analogies with the fortunes of finance capital. By the 1860s, light-hearted accounts by Henri Rochefort and Champfleury were evoking a stock exchange of art objects and drawing comparisons to a gambling house with collectors as 'roulette players'.
>
> (N. Green, 'Circuits of Production, Circuits of Consumption', p.32)

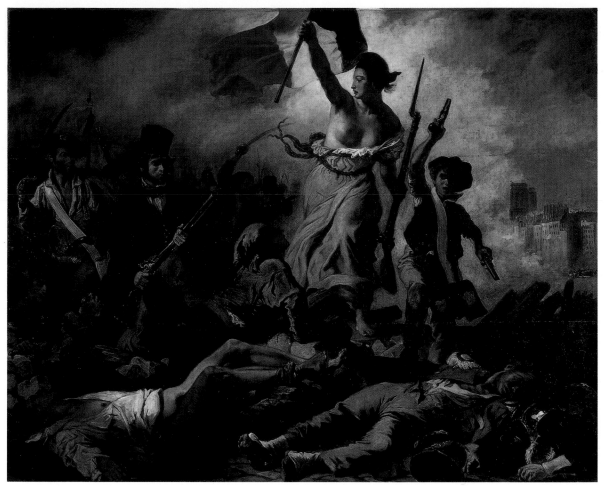

Plate 54 Eugène Delacroix, *Liberté guidant le peuple* (*Liberty Guiding the People*), 1831, oil on canvas, 260 x 325 cm. Louvre, Paris. Photo: Réunion des Museés Nationaux Documentation Photographique.

Industrial capitalism promotes what has been called *normalization*. It generates individuality, but only insofar as individuals contribute usefully to the whole. Recalcitrants and would-be rebels are 'normalized', their 'oppositional' characteristics discouraged, if not repressed, while their useful ones are developed, trained and harnessed to the needs of capitalist society. As Baudelaire noted, the Romantics had tried to resist this by taking a critical attitude to accepted artistic conventions and to official subjects, sometimes by producing history paintings on modern life subjects. One example is Géricault's *Raft of the Medusa*, 1819, which represents a scandalous incident which the government attempted to cover up; another is Delacroix's *Liberty Guiding the People* (Plate 54).[7]

However, in critically engaging with their own themes and subjects, which, unlike commissioned works, were openly for sale, the Romantics also contributed to the birth of the modern market in art dealing. Such a market requires an individualistic form of society in which to flourish. A typical characteristic of the kind of modern art that is critical of established norms and power relations is its uneasy but indissoluble relationship with the luxury market. Thus Romanticism, as a form of individual 'opposition', is impossible

[7] Géricault's work was based on an incident when a Navy flagship was wrecked off Senegal; 150 people were opportunistically cast adrift on a flimsy raft by a royalist captain and only fifteen survived appalling conditions including cannibalism.

except in a modern society where novelty is encouraged but robbed of its critical function by the process of normalization in which art becomes a marketable commodity. *Juste milieu* is perhaps a more typical product of such a modern society and feeds off normalization. It robs both Romanticism and the 'elevated' Classicism of Academic art of their critical potency. Both are reduced to sets of styles and typical subjects, which can be reshuffled without regard to their original ideological functions. The final product is no longer a source of values and knowledge which might be opposed to those of capitalist society, but a synthesis of attitudes enabling spectators from diverse political persuasions to read whatever they wished.

'Modern art', whatever that may be, has frequently been discussed as if it were somehow the natural artistic manifestation of modern society. Such accounts have often taken a form known as *reflectionist*, because they treat art as a passive mirror of society. But reflectionism overlooks the important possibility that art can be related to modernity in *more than one way*. We have seen two ways so far: Romanticism is impossible except in a modern society, but *juste milieu* is perhaps its more typical product.

Courbet: Representing the country to the town

Out of social tensions centred around the 1848 Revolution came the possibility of art occupying new territory in relation to the world of official art institutions and the viewing public, and by extension, in relation to society at large. Courbet is an example of an artist who found that since art had an established political weight in mid-nineteenth-century France, he could be politically active in society, to some small degree, by operating within the art world. This is the kind of relationship we mean by 'avant-gardism'.

This new relationship was never self-consciously designed, either by Courbet or anyone else. We can consider some of the social conditions that fostered the possibilities for establishing an avant-garde tradition by looking at specific examples of Courbet's work.

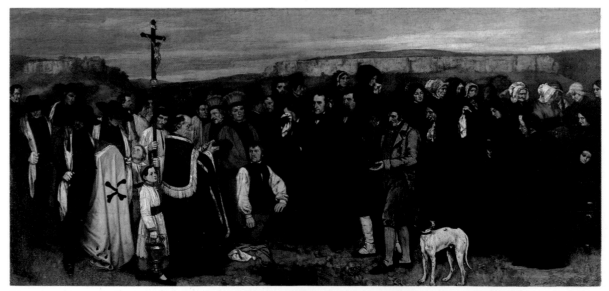

Plate 55 Gustave Courbet, *Un Enterrement à Ornans (Burial at Ornans)*, 1849–50, oil on canvas, 314 x 663 cm. Musée d'Orsay, Paris. Gift of Miss Juliette Courbet 1881.
Photo: Réunion des Museés Nationaux Documentation Photographique.

Plate 56 Gustave Courbet, *Les Paysans de Flagey revenant de la foire* (*Peasants of Flagey Returning from the Fair*), 1850–55, oil on canvas, 206 x 275 cm. Besançon, Musée des Beaux-Arts. Photo: Lauros-Giraudon.

He had achieved official recognition with Salon acceptance of his work in 1844, though during the 1840s he sold almost nothing and produced work which struggled for direction. The Revolution of 1848 marked a change.

Between the autumn of 1849 and summer of 1850, Courbet painted three ambitious works destined for the Salon – *Burial at Ornans*, *The Stonebreakers* and *Peasants of Flagey Returning from the Fair* (Plate 55, 12 and 56). In these paintings, Courbet depicts representatives of his native province of the Franche-Comté, particularly his home town of Ornans; most specifically, in two of them, he portrays members of his own family. Critics had already aligned Courbet with Realism; these works were recognized as reconstituting its methods and sharpening its aims. Before 1850, Courbet had neither an established artistic practice nor a coherent or committed political attitude. We will argue that establishing his artistic practice and adopting a political position were *twin processes* which continuously intertwined with and informed each other and that what linked these processes was his commitment to his home country – Ornans, the Doubs and Franche-Comté in general.

The Courbets were a peasant family rising into the ranks of the bourgeoisie. 'Peasant', in nineteenth-century France, meant only 'one who lives off the land', something which could be done either in wealth and comfort or in conditions of near destitution. The Courbets had acquired two homes, one in the country village of Flagey (the man in the stove-pipe hat in *Peasants of Flagey Returning from the Fair* is modelled on Courbet's father)

and another, a comfortable town house, at Ornans. Courbet's father paid sufficient tax to vote and occasionally took office in local government. Courbet himself was originally destined for a bourgeois career in law. Nonetheless, this was a family still attached to its roots. They understood, from the inside, the social and economic problems of the peasantry of their area. In Paris in the years up to 1850 Courbet could thus be seen as 'Bohemian' in his disaffection with bourgeois society, yet a fairly typical 'dependent son'. He mixed with a variety of left-wing intellectuals: Baudelaire, the anarcho-syndicalist philosopher Proudhon, the Republican writer Francis Wey, the Realist *littérateur* Champfleury, the materialist-cum-mystic Marc Trapadoux. Courbet's politics were not doctrinaire, nor even important to him, until after the Revolution of 1848. Nor did his social status suggest any obvious position for him to assume in the art world. He had enjoyed considerable success at the Salon of 1849 – the Government purchased *After Dinner at Ornans* (Plate 57), placing it in the Lille museum – and he was awarded a medal, which exempted him from submitting future works to the selection committee.

The success of *After Dinner at Ornans* appears to have confirmed Courbet in a specific artistic project – to represent the life of his family and home country for a *metropolitan* audience. What model – what paradigm – was available to Courbet for this project? Since the Courbets were a partly bourgeois family, it was particularly appropriate to concentrate on the respectable comfort of their domestic life, and therefore to produce a genre painting. That is not to say that genre typically represented bourgeois domesticity as

Plate 57 Gustave Courbet, *Après dîner à Ornans* (*After Dinner at Ornans*), 1848–49, oil on canvas, 195 x 217 cm. Musée des Beaux-Arts, Lille. Photo: Lauros-Giraudon.

Plate 58 Jan Steen, *Gebed voor de Maaltijd* (*Prayer Before the Meal*), 1660, oil on panel, Walter Morrison Collection. Reproduced by kind permission of Sudeley Castle, Winchcombe Cheltenham, Gloucestershire.

neutral reportage. For instance, Jan Steen's *Prayer before the Meal*, 1660 (Plate 58) represents a moralizing genre tradition which was not unambiguously relevant to Courbet's interests. However, as it was not Courbet's purpose either to celebrate or berate his family, but to show them 'as they were', perhaps the most appropriate French precedents were the relatively large-scale paintings of peasant families by the Le Nain brothers (Plates 59, 60). *After Dinner at Ornans* is a large painting, with figures almost life size, which was unconventional for genre painting. There are none of the kinds of detail, such as the biblical text on the placard nailed to the back wall, or the words 'Thy will be done' on the little 'chandelier', by which Steen indicates moral preoccupations, and the poses of the figures are almost unconnected – it is as much a group portrait as the representation of an event or incident. (The figure depicted on the far side of the table is Courbet). Yet the characters are not posed as if for some honorific portrait, but rather slouched in positions of comfort. And while it was not uncommon for pictures of meals to depict characters seen from the back, there is an unconventionality in placing a character so posed at the centre of the picture. This device seems to deny to the viewer the privileged viewpoint from which everything of importance is ideally visible. And that seems to preclude the attitude of social or moral superiority which genre painting so often offers its viewers – an attitude which would have been incompatible with Courbet's non-moralizing aims.

Plate 59 Louis Le Nain,
La Halte du Cavalier
(*The Horseman's Resting Place*),
*c.*1640, oil on canvas, 55 x 67 cm.
Victoria and Albert Museum,
London.

Plate 60 Louis Le Nain, *Le Repas des paysans* (*The Peasants' Meal*), 1640, oil on canvas,
93 x 122 cm. Musée du Louvre, Paris. Photo: Réunion des Museés Nationaux Documentation
Photographique.

Reactions to the painting were mixed, and Courbet had his fair share of favourable reviews. But the strong negative reactions are particularly revealing as to what he achieved. A critic named Lagenevais complained that Courbet 'should show [his characters] to us, in the Flemish manner, through the wrong end of a telescope, so that they become poetic as they recede into the distance' (quoted in Clark, *Image of the People*, p.70). Implicitly, at least, he understood that Courbet had 'bent' the conventions of the genre in which he was working and that this had altered the status of what was depicted. Since they had ceased to be 'poetic' these people had become more 'real' – and Lagenevais's 'stock responses', to sanitized 'poetic' rustics, for instance, were of no use to him. But for some, certain kinds of stock response were effectively what art was *for* – it was to underwrite and consolidate the attitudes and perceptions of respectable society, though technical or stylistic innovation *might* prove welcome. Thus, the respected conservative critic Louis Peisse could complain of Courbet and this picture that 'no one could drag art in the gutter with greater technical virtuosity' (quoted in Clark, *Image of the People*, p.69). For Courbet the 'gutter' was a necessary place for art to achieve some sort of 'realism'; for Peisse, it signalled a great danger, a danger confirmed for him two years later: 'The nation is in danger … [Courbet's] painting is an engine of revolution'. We see here what were to become standard conservative complaints against avant-garde art: that in bending or parodying artistic conventions, it both undermined the status of art itself and affronted 'society' in ways that were not 'aesthetic'.

With *After Dinner at Ornans*, Courbet *found* a paradigm for a new practice which, in its subject matter and method of depiction, answered his commitments to his provincial background, addressed a Parisian audience used to anodyne representations of an ideal or pastoral 'countryside' with critical purpose, and signalled his radical 'realist' credentials in a 'language' that his Bohemian circle could approve of. All of this became clearer *after* the picture had been seen and commented on. It was a product of working with conventionally incompatible interests, the transformation and resolution of which formed this revised practice. Pursuing his transformed practice, Courbet returned to the Franche-Comté to paint in 1849. The situation he found there had changed, and was newly disturbing to conservative opinion in far more serious ways than those represented by *After Dinner at Ornans*.

This disturbance had to do with the gap between conventional representations of the 'countryside' and its changing reality. There was a complex relationship between the 'real' conditions of rural labour and 'real' power relations and those idealized in representations of the 'pastoral' and untroubled 'genre' scenes. Such representations were rooted in traditions going back to Claude (Plate 61), in which 'nature' was seen as a source of constant 'well-being', and the conflict between dominant paradigms of representation and the realities of a modernized countryside continued to be central to later artists such as Pissarro (this will be discussed in the last section of this chapter). To a metropolitan audience, the countryside was still the place of the 'eternal verities', of a person's direct relationship with 'nature', which was sometimes troubled, sometimes a solace. It was, they assumed, the place where order was rooted, sustained by Catholic piety and a strong Church. But this had always been sentimental, and 'modernization' had already caught up with the country. The late forties had been a time of sustained economic crisis, particularly in agriculture. Sizeable farms near the cities underwent economic rationalization and grew larger. But in southern and eastern France, population levels were at a record level; the result was land hunger. Here, farms were dividing rather than growing, so for the indebted small farmers of the region, modernization was both necessary and financially impossible.

Taking advantage of the crisis situation, the wealthy bourgeoisie assumed their modern role as disciplinarians of popular finance, exacting high rates of interest from

Plate 61 Claude Lorraine, *Paysage: Mariage d'Isaac et Rébékah* (*Landscape: The Marriage of Isaac and Rebekah*), known as *The Mill*, *c.*1648, oil on canvas, 149 x 197 cm.
The National Gallery, London. Reproduced by permission of the Trustees.

farmers at a moment when taxes were also high, and making many expropriations, often using them to their own advantage by buying up the relinquished land. This role was intensely resented and resisted by their peasant debtors. After 1848, this resistance grew organized and politicized: in the election of 1849, a large number in the countryside withdrew their traditional support for the Right – the party of order – by voting for the *démocrate-socialiste* coalition (35%) or by abstaining (40%) – though Ornans and the Doubs remained, as T.J. Clark puts it, a 'white island in a red sea'. The countryside, which had been a bulwark against urban radicalism, threatened to become a new source of rebellion. The 'red menace', as one observer put it, seemed to be centred in the countryside, particularly the east corner of France.

The salient features of the society Courbet wished to represent now included exacerbated economic differences between rich and poor and a heightened and sharpened sense of class distinction, a new role for the bourgeoisie in the texture of rural life, as financial disciplinarians, a questioning of and resistance to established order and to its agent, the Church, and a new urgency to the issue of social ambiguity affecting families such as the Courbets. These changes, of their nature, permeated the forms and altered the significance of everyday existence. Old allegiances and animosities required reconsideration – what class of person was a peasant? Who was a friend? What activities could be shared with such a person? Ancient customs began to look nostalgic – what was the relevance of Carnival, for instance, in modern everyday life? Structures of families and patterns of inheritance were disturbed – which sons would stay at home, and which move off to the city? What should be theirs if the latter returned? The whole point about the everyday life of the country was that it was becoming increasingly difficult to disentangle

from broader processes of social change. If modernization was riding in on the back of a temporary economic crisis, nonetheless the change was itself epochal, and there to stay. In ignoring it, in an attempt to represent the country, an artist would not have been simply disregarding political ephemera but misrepresenting new and profound realities.

Courbet could have opted for just such misrepresentation and given the Salon what it expected. But in so doing, he would have involved himself in a profound hypocrisy, abandoning his own politics for those of the Salon audiences. Bourgeois or even aristocratic ideas, values and beliefs, wrapped up, as they often were, in the readily available *juste milieu* or academic forms for representing the countryside, would have been incompatible with the politics of the Courbets of Ornans. What Courbet clearly understood was that an opposition to bourgeois politics could entail, in certain circumstances, an opposition to bourgeois art – the art of the *juste milieu*.

The province of Franche-Comté had a considerable share of disorder and even political violence during this period, much of it organized around clandestine political clubs. However, Courbet's home department of the Doubs remained a conservative area where the church maintained strong authority, ensuring social calm in a period of crisis. In a sense, this made it – paradoxically – ideal as a subject for Courbet. Had he represented scenes of rural and provincial disorder, he would have distracted attention from the underlying causes of the disorder, the serious stresses and strains in rural areas. He would have fallen into the trap of producing just another deplorable scene of 'revolutionary mayhem'. One of the most powerful contemporary representations of this kind was the work of the highly conservative artist Meissonier, whose *Barricade* of 1849 (Plate 62) points a grim moral.

In focusing upon a religious occasion, *Burial at Ornans* evokes the social authority of the church but the picture also depicts internal tensions and ambiguities in this society. T.J. Clark's introductory characterization of the picture picks out the ambiguities:

> He has given us, in an almost schematic form, the constituents of a particular ritual, but not their unison. He had painted worship without worshippers; the occasion of religious experience, but instead of its signs, vivid or secretive, a peculiar, frozen fixity of expression. (This applies to individual faces and to the image as a whole.) It is not exactly an image of disbelief, more of collective distraction; not exactly indifference, more inattention; not exactly, except in a few of the women's faces, the marks of grief or the abstraction of mourning, more the careful, ambiguous blankness of a public face. And mixed with it, the grotesque: the bulbous red faces of the beadles and the creaking gestures of the two old men at the graveside.
>
> (Clark, *Image of the People*, p.81)

The painting is 'of religion' yet not religious; concerned with solemnity, but also satirical. And it points to vagueness, a lack of specific meanings or emotions in blank faces. These ambiguities and vaguenesses are not just 'there in the motif' or subject-matter. Rather, they are characteristic of the way Courbet *represents* the subject, the devices he uses to depict it, and what he chooses to depict the subject *as* (neither as tragedy nor as comedy, two standard modes of representation for this kind of subject-matter).

Courbet did not attract censure for devoting such a huge canvas, usually reserved for history paintings, to so banal a theme. Nevertheless, in doing so he clearly conferred historic status on a subject which, for a Parisian audience, should have stood outside or beyond history – the confrontation of the universal destiny of death in the unchanging, 'apolitical' countryside; 'history painting' devoted to an 'ahistorical' theme – that is the first ambiguity.

A second and provocative ambiguity is introduced by the relationship of the title to the image. Ornans was a small place unknown to most Parisians. 'Burial at Ornans', there-

Plate 62 Jean-Louis-Ernest Meissonier, *La Barricade, rue de la Mortellerie, Juin 1848 (Souvenir de la guerre civile) (The Barricade, rue de la Mortellerie, June 1848 (Souvenir of Civil War))*, 1849, oil on canvas, 29 x 22 cm. Louvre, Paris. Photo: Réunion des Museés Nationaux Documentation Photographique.

fore, invokes at least two expectations – that we are dealing with death and also with rural peace. Both expectations, however, are thwarted. Very few of the forty-five characters depicted pay any attention to the coffin, to the grave or to the officiating priest. Even the clerical group seem to have their minds elsewhere (pondering trout for supper, as one critic suggested – the red noses suggest venal interests). There are few signs of emotion, except from the weeping Courbet sisters (on the right), and since only one could be said to look towards the coffin, this seems rather conventional grief. The major religious symbol, the Crucifix, is visually detached from the crowd scene – associated with the empty sky, not the crowded here-below.

It is social affiliation that links these people, not religious devotion. As Clark suggests, the painting depicts a public and social occasion, devoid of deeper meaning, in which everyone has and knows their place. Thus a picture whose title promises peaceful meditation of death actually delivers a social survey of a rural community. But what kind of people are they? Many of them are portraits of Courbet's friends and relatives and of political radicals. But once again, in official responses we come up against vagueness, ambiguity and equivocation. Repeatedly, commentators singled out the kneeling grave-digger as a peasant. Only he kneels on the earth; only he resorts to shirt-sleeves. The rest

of the male characters wear the typical black coats of the middle classes. But the women are more ambiguous. The beguine caps of some suggest residual peasant connections. The pall bearers too are ambiguous. For the critic Vignon they wear 'hats *à la* Caussidière' (Caussidière was a contemporary politician of the Left who, as the revolution's chief of police in 1848, dressed his men in sashes and wide-brimmed hats).

The ensemble of clues should have identified this group as *rural* rather than urban bourgeoisie. The cynicism of the relationship between this class and its worldly religious leaders would have been foreign to the more suave hypocrisy of the urban middle classes. The intimations of the involvement of some bourgeois with the Left would also have been highly anomalous (the Left recruited from among educated professionals), and so too the reminders of peasant origins. Although this was the bourgeoisie, it was one which existed on very different terms from the bourgeoisie of Paris. The very landscape should have underlined their identity: the long bands of inland cliffs are characteristic of the Jura mountains in Franche-Comté, a notoriously strife-ridden area at that time.

However, none of the bourgeois or aristocratic critics actually identified this society exactly, and they disagreed even in their tentative guesses. Some thought they could identify local authority figures such as judges or constables – neither actually present – others seemed to suspect that these were really peasants in their Sunday best. The reasons for this difficulty intertwine artistic and political considerations. From a political point of view, the subject matter was too sensitive for Parisians to recognize fully; conservative Parisians knew that the countryside was not presently conforming to the popular myth of 'social idyll', and it would have been a major embarrassment to concede the rural bourgeoisie's own role in its dangerous disruption. The power of myth is that it enables the economic and social interests of powerful groups to go undetected in visual and verbal representations ranging from paintings and prints to novels and official documents. Furthermore, to recognize the existence of more than one bourgeoisie would be to call in question the role of the urban bourgeoisie itself and the grounds of its social pre-eminence.

As we have seen Courbet's problem was that there were no conventions for representing specifically the rural bourgeoisie. There were, in fact, few conventions for representing any aspect or element of *modern* life. Is it a characteristic of modernity that conventions and symbols lose their specificity and clarity? Does modern life become less legible; does 'all that is solid' melt 'into air'? There is a case in point with the black coats of the male figures in the *Burial* – this was one of the few conventional indicators of social class available for Courbet's use. Yet the suspicion remained that in fact we might be looking at peasants in their Sunday best. It is plausible to suggest that Courbet played on this uncertainty. For why might peasants have mimicked the bourgeoisie? One answer is that as the countryside was modernized, the status of peasants was put in question. Were they not, like the new, large-scale farmers close to Paris, to become rather a new kind of capitalist industrialist who happens to work on the land? The Courbet family were classic subjects of this ambiguity. The breakdown and fluidity of conventions, and the lack of legibility this engenders, were no mere accident. Rather, it was part of the wholesale questioning and refashioning of social identities – and therefore conventions – which modernization involves.

Many artists in his position would have opted for a less ambitious task, as Pils and Tassaert had, in their works exhibited in the 1850 Salon (Plates 63 and 64). These subjects, too, were drawn from 'actual life', but their indebtedness to the model of moralizing and sentimental eighteenth-century genre painting escaped critical disapproval. Patrick Le Noeune contrasted the 'Christian spirituality' and 'moral beauty' of the Pils to the *Burial*'s 'cold image of nothingness' (quoted in S. Faunce, 'Courbet reconsidered', p.4), these two different conceptions of the relationship between the 'aesthetic' and the 'moral'. Courbet

Plate 63 Isidore Pils, *Mort d'une soeur de charité* (*The Death of a Sister of Charity*), 1850, oil on canvas, 241 x 305 cm. Musée d'Orsay, Paris. Photo: Réunion des Museés Nationaux Documentation Photographique.

achieved a more potent effect by compounding the confusions, mixing death and satire, bourgeois and peasant, a scene of order with signs of dissent. Courbet's Parisian audience found themselves in a tricky situation. On the one hand, they were challenged to try to identify an embarrassing reality. On the other, they were deprived of the conventional artistic codes that might have helped them in this task.

Realism and social criticism

It is by forcing the viewer back on to some understanding of reality in an attempt to interpret the picture that Courbet achieves a kind of realism. His realism is not a matter of the painting having a 'realistic' appearance, nor is it a matter of taking 'humble' subject matter. These were the conventional means of other realists, as displayed in paintings such as Millet's *Sower* (Plate 65) or his *Going to Work* (Plate 179). These works deal with the depths of human brutalization, but are consonant with the 'myth of the countryside' in its more grimly stoical interpretation. In Courbet's realism, viewers are forced to interpret the image by reference to their knowledge of reality, simply because there are few conventional codes and clues to meaning; where there are any they are neutralized by incorporating others which are incompatible. Knowing the existing conventions of art would help viewers only to see how unhelpful these were in interpreting this work.

Plate 64 Octave Tassaert, *Famille malheureux*
(*An Unhappy Family*), 1849, oil on canvas,
115 x 76 cm. Musée d'Orsay. Photo: Réunion des
Museés Nationaux Documentation Photographique.

Plate 65 Jean-François Millet, *Le Semeur* (*The Sower*),
c.1849–50, oil on canvas, 101 x 81 cm. Courtesy of the
Museum of Fine Arts, Boston, Gift of Quincy Adams
Shaw 17.1485.

We can see why these paintings so disturbed the bourgeois Parisian public of 1850, and how Courbet came to be seen as a Socialist painter. They called into question the value of the bourgeois audience's privileged understanding of art and its traditions, and by implication undercut the prestige of those whose self-image was flattered by their *educated* competence in consuming art – something which set them apart from the 'lower' social orders. This questioning was perceived as shocking. By rendering artistic education irrelevant, Courbet seemed to be turning art into popular imagery. Art was being returned, after hundreds of years' attempts at elevation, to the status of artisanal craft.

A further consequence was even more disturbing. The proletariat could understand Courbet not just *as well* as the bourgeois, but better. For the newly expanding working class of Paris was constituted almost entirely of peasants from the provinces, those who had failed at farming or those who had made enough cash to chance their arm in the big city. For these people, Courbet depicted a hated state of society which many of them had only recently left. Thus, Courbet's works created a situation in which they were the ones who understood best, and what they understood – that the myth of the countryside was indeed a *myth* – was embarrassing and politically threatening to the Parisian bourgeoisie. Elisa de Mirbel, writing in *La Révolution littéraire* (the magazine's 'revolution' was strictly literary) represented this feeling:

The strange praises awarded to M. Courbet had as their first spokesman a certain in-ebriated man of the people who invaded the benches in the Salon Carré [central hall of the Salon]. What was there to look at, if not the worst daubs on show? – Then some art students took up the cry, and little by little, everyone was talking about M. Courbet.

To me, M. Courbet must have spent a long time painting signs, especially those of stove-setters and coal-merchants. Probably he aimed no higher than this when he travelled the fairs – so the rumour goes and they tell us it is true – showing his incredible canvases in a booth with a sign: GREAT PICTURES OF COURBET, WORKER-PAINTER.
(quoted in Clark, *Image of the People*, p.146)

Mirbel makes a connection with the 'worker-poets', such as Dupont, whose work Baudelaire admired, and raises the fantasy image of Courbet's *audience*: the horde of wine-besotted 'scum' that was seen by many bourgeois and aristocratic commentators as the seed bed of revolutionary disruption. There probably was no such 'man of the people' – references to such characters were a standard convention of Salon criticism – yet, in this particular context, Mme de Mirbel's invocation of such a figure has a specific connection with her view of the paintings as plebeian, and thus indicates why Courbet became identified with Socialism. His work appeared to give the proletariat a privileged position where it wasn't supposed to be welcome. Courbet, then, could be politically active in his society by subverting the role and status of art from within.

Courbet's practice stands in a different relation to modernity from either *juste milieu* art or Romanticism. His work raised serious issues which the bourgeois art of the Salon had almost abandoned. In Courbet's works, art loses its 'aestheticism', its privileged status as 'art for art's sake', in order to become something that matters socially and politically. This is one way – some theorists would say, the only way – that artists can escape, even temporarily, modern 'normalization'; it is one of the few ways they can avoid having their work stripped of social meaning and reduced to a commodity in the ever-extending network of capitalist relations.

Weber argued in 1915 that modernization involved the rationalization of society – the substitution of rational order for traditional authority, of the methodical for the customary, of clear social distinctions for social fluidity, of orthodoxy for eccentricity. In such a society, he suggested, art took on the function of 'an inner-worldly *deliverance* from everyday life and above all from the increasing pressure of theoretical and practical rationalism' (quoted in J. Habermas, *The Theory of Communicative Action*, p.161). The art of the *juste milieu*, with its meanings steeped in nostalgic traditionalism, offers good examples of this. However, Courbet's work, by calling on its viewers' knowledge of the everyday world more than their knowledge of art, regained a political potency, an ability to provoke and enlighten – an active 'oppositionality'. *Burial at Ornans* effectively questioned the status of art within the society in which it was produced and within the modern order of things. This is a defining characteristic of the avant-garde tradition.

Modernity, realism and the history of art: Manet's Old Musician

We have broached, in connection with Courbet's practice, the issue of modernity, the kind of social experience which modernization brings. But while we have considered this in a rural context, it is more typically the experience of urban life in the new modernized metropolis – Paris, London, Berlin or New York. Paris in particular underwent a massive rebuilding programme, involving new urban institutions and technologies such as the department store, the public hotel, the hired cab, street lighting and drainage, and major

Plate 66 Hippolyte Lecomte, *Combat de la porte St-Denis, le 28 juillet 1830* (*The Battle at the Porte St-Denis, 28 July 1830*), 1830, oil on canvas, 43 x 60 cm. Musée Carnavalet, Paris. Photo: Lauros–Giraudon.

new public spaces such as the boulevard and the public park. They became distinctively new kinds of place offering new modes of experience.[8]

The experience of modernity

As we have discussed, Courbet's 'Bohemian' friend Baudelaire was one of the first writers to take the experience of modernity as an important theme. For him, the life of contemporary Paris was 'rich in poetic and marvellous subjects', ironically so, because the 'rich' texture of contemporary life was the result of modern oppression or selfish greed. In his 'Salon of 1846', he wrote:

> the majority of artists who have tackled modern subjects have contented themselves with public and official subjects, with our victories and our political heroism [see Plates 51 and 66]. They do this reluctantly and because they have been ordered by the government which pays them. Yet there are subjects from private life which are heroic in quite another way.
>
> The spectacle of elegant life and of the thousands of floating existences which drift about in the underworld of a big city – criminals and kept women – *La Gazette des Tribunaux* and *Le Moniteur*[9] all prove to us that we have only to open our eyes to know our heroism.
>
> (Baudelaire, *Oeuvres complètes*, p.260)

8 Generally, see Pinkney, *Napoleon III and the Rebuilding of Paris*, and Simmel, 'Metropolis and Mental Life'.
9 Government newspapers; their contents were subject to the approval of the Minister of State.

For Baudelaire the one contemporary character who was alive to the ironic heroism of modernity was the new *flâneur*. The *flâneur* attempted to decipher the nature and biographies of the kinds of characters who became common in the new city – absinthe drinkers, fashionable women on display, ragpickers, the women of the huge new laundry industry. Baudelaire proposed that the ideal 'painter of modern life' he was seeking would constitute an advance on the *flâneur* by addressing the two inseparable halves of 'modernity': maintaining strong contacts with artistic tradition – the 'eternal and immutable' – while fully sensitive to specific contemporary experiences – the 'transitory, the fugitive, the contingent'. For Baudelaire a major aspect of contemporary change was the rapid transformation of Paris. An enormous modernization scheme was entrusted by Napoleon III (who became Emperor in 1852) to Baron Haussmann, who was Prefect of the Department of the Seine from 1853 to 1870. Such modernization is referred to as *'modernité'* or 'the experience of modernity'. Baudelaire's bourgeois friend Manet has often been seen as the first painter to respond seriously to Baudelaire's ideas. A dandy in his own right, Manet knew the life of a *flâneur* through personal experience.

The Old Musician

In 1862, Manet, like Courbet, painted a genre picture, *The Old Musician* (Plate 67) on an unusually large scale. He didn't submit it to the Salon, exhibiting it instead in the private Louis Martinet gallery, early in 1863, together with *Concert in the Tuileries* (Plate 22) among others. Manet's elevation of a traditional genre-type subject to the scale of a 'history painting' signified an investment in the subject, and a conscious reference to Courbet's example. When exhibited, *The Old Musician* was largely overlooked by critics, who found the smaller *Tuileries* painting more objectionable.

Manet's paintings of the 1860s included a range of themes directly related to Baudelaire's view of modernity: new modern themes, characters whose existences were being transformed by Haussmann's rebuilding of Paris, 'heroic' subjects, derived from 'common types', the 'refuse of the city'. *The Old Musician* represents several such 'Baudelairean' characters. The painting can be described as a composite of social 'types' from contemporary society: beggar children, bohemians, gypsies, perhaps a child player (in the lighter clothes) from the popular Théâtre des Funambules[10], a wandering violinist, a ragpicker[11] or destitute bourgeois (the Absinthe Drinker character), and to the far right the Wandering Jew (the subject of many popular prints, books, songs and a particular theme of Courbet's). These characters would have been readily identifiable from their clothes and bearing which conformed generally to real life and particularly to their stereotypical representations in a range of visual sources.[12]

The characters in the painting may appear to be 'common types', the 'refuse of the city'. However, unlike many conventional 'genre' scenes of such characters in an urban context, they are assembled in a vague and apparently rural setting – such a dislocation of expected context gives them an unexpected importance, as it does in Courbet's *After Dinner*. On the other hand, by placing them outside their expected context, Manet makes it harder for viewers to infer why these characters are portrayed together. How can we explain this image?

[10] This theatre preserved the traditions of the Commedia dell'Arte, a professional improvised comedy with traditional characters, which originated in the sixteenth and seventeenth centuries.
[11] A person who collects rags or refuse as a means of livelihood, with the attendant hazards, in this period, of pulmonary anthrax from contaminated wool or other hair.
[12] Representative discussions are: Brown, 'Manet's *Old Musician*' and *Gypsies and other Bohemians*; Fried, 'Manet's Sources' (and the reply by Reff 'Manet's Sources: A Critical Evaluation'); Hanson, *Manet and the Modern Tradition* and 'Popular imagery and the work of Édouard Manet'; De Leiris, 'Manet, Guéroult and Chrysippos' and Mauner, *Manet: Peintre-Philosophe*.

Plate 67 Édouard Manet, *Le Vieux Musicien* (*The Old Musician*), 1862, oil on canvas, 187 x 248 cm. National Gallery of Art, Washington. Chester Dale Collection.

Plate 68 Jean-Louis Hamon, *L'Escamoteur, le quart d'heure de Rabelais* (*The Conjurer*), 1861, oil on canvas, 149 x 310 cm. Musée des Beaux-Arts, Nantes, inv. 1016. Photo: Patrick Jean.

A contemporary Salon viewer, used to assessing works according to Academic criteria, might have asked questions such as: is the composition based on a conventional central point or character, as it is in Hamon's *The Conjurer* (Plate 68)? Do the characters and part of the landscape relate to one another in a conventionally organized way, as they do in Zo's *Family of Voyaging Bohemians* (Plate 44) and in Dehondencq's *Bohemians Returning from an Andalusian Festival* (Plate 69)? What is the subject of the painting? From where might the figures be derived – from other representations, or from contemporary life or from both? Why are they placed as they are? Is there a narrative structure, as there is in Hamon's *The Conjurer*? Why such a large scale for a *genre* painting?

When compared to paintings on a similar subject, the bohemian allegory or gypsy group, *The Old Musician* appears incompetent: the tree is cut-off, the figures abruptly organized, the characters self-absorbed or in blank day-dreams. It's as though a series of *études* (studies for details) have been arranged on the canvas: compared with Achille Zo's painting Manet's appears compositionally and formally disjointed.

Until the 1960s and 1970s the prevailing explanation of *The Old Musician* was a formal one. Many Modernist accounts explained the picture in relation to Manet's work *after* 1863. The painting was regarded as an immature work prior to the 'great breakthrough' of 1863, a year seen to mark the 'technical innovation' of Manet's 'modernism' in pictures such as *Le Déjeuner sur l'herbe* (Plate 70). (*Le Déjeuner sur l'herbe* was first exhibited in the Salon des Réfusés, an exhibition arranged, after much protest, by artists, and their supporters, who believed that they had been rejected from the official Salon of 1863 for ideological reasons.) *The Old Musician* was singled out as a clear example of Manet's supposed inability to compose successfully, of his poor use of academic compositional principles. The picture was described as composed of uneasy, perfunctory, juxtaposed 'quotes' – some from other works of art – and treated as an ambitious failure. It was often argued that the subject was regarded by Manet as a pretext, that the 'quotes' were juxtaposed for

Plate 69 Alfred Dehondencq, *Bohèmes revenant d'une fête andalusienne* (*Bohemians Returning from an Andalusian Festival*), 1853, oil on canvas. Musée de Chaumont

Plate 70 Édouard Manet, *Le Déjeuner sur l'herbe* (*Luncheon on the Grass*), 1863, oil on canvas, 208 x 264 cm. Musée d'Orsay. Photo: Réunion des Musées Nationaux Documentation Photographique.

form's sake or out of routine, without interest in their function or significance except for their formal and aesthetic appearance. Such characterizations follow the sort of claim we find made by the Symbolist critic Joseph Péladan, who wrote in *L'Artiste*, February 1884, 'Manet is merely a painter, and a painter of fragments – devoid of ideas, imagination, emotion, poetry or powers of draughtsmanship. He is incapable of composing a picture … Only a technician can judge it and enjoy it' ('Manet's methods', p.186).

Those Modernist critics who saw virtue in this disjunction, argued that Manet was spelling out the artifice of his practice in order to make the painting's influences, causes and references seem incoherent in conventional terms. Thus the painting was established as a Modernist icon: it was seen as marking an abrupt break with the art of the immediate past and with the kinds of expectations that the public had of painting. Rather, the nature of the painter's own practice, the construction and elaboration of a 'self-conscious painterly individuality' (a deliberate preoccupation with problems 'intrinsic to painting itself', as a modern, individual specialization) were henceforth to prove the most interesting aspects of visual art. Modern reality, as it were, had become too problematic or contradictory to be represented other than by an emphasis on a self-conscious attitude to the 'essential' qualities of the medium. To see *The Old Musician* this way is to echo the view of art as a place of aesthetic retreat, in Weber's words as 'an inner-worldly deliverance from every-day life', in which the contemplative values of art for art's sake may be cultivated, and where there is potential for the emancipation of the initiated leisured viewer from social, political or moral restraints and responsibilities.

However, there are at least two further possible explanations for *The Old Musician*. One is that the relatively unusual formal, technical and compositional characteristics of the work are evidence of Manet's interest in remaking painting as a sphere of 'autonomy', but one where the 'autonomy' represents an *otherness* critical of reality, a transformation of conventional artistic values by the painter, which does have a political function. The other – not unlike Baudelaire's view – is that Manet's work is one of several forms of representation of a wider social 'consciousness of modernity'. In the second case, Manet would be seen, like Courbet, as a 'realist', combining a critical reworking of existing artistic conventions (both contemporary and those of past art) with the contingent signs and references of contemporary life.

A 'Realist' account of the picture would emphasize different aspects and meanings of the painting. Manet wilfully and deliberately constructed a *naïveté*, a disjointedness. In terms of Academic or official norms of composition the painting is artless, guileless, incompetent, even meaningless. But that *naïveté* represents certain technical and ideological transformations, which are made in an attempt to produce images which referred to life after 1848, in ways which evoked Baudelairean ideas and the Paris of Haussmann. By the contemporary norms of the Salon, the painting is technically crude, but this is *related* to a concern to represent the contradictory experience of *modernité*. Manet was using new painting techniques and ways of composing and lighting, bearing in mind the then current revisions of self-consciously 'progressive' artists such as Delacroix, Couture and Courbet. In doing so, he was relating his work to paintings in an iconographical and technical tradition which was seen to provide an alternative to Salon painting. If Manet's project was to represent *modernité*, a distinctly 'modern' technique was appropriate. In the 1850s, the way to develop such a technique was to study in the atelier of Thomas Couture, and this is what Manet chose to do in 1850.

Couture earned a reputation for being technically 'progressive' on account of his painting *Romans of the Decadence*. He taught a range of pictorial techniques (Zo was also a pupil), creating a system of training with different emphases to those of the Academy. Couture encouraged departures from conventional painting procedures. He emphasized the importance of the early stages of pictorial representation – *croquis* (preparatory compositional sketches), *études* (studies) and *esquisses* (painted sketches, for example, Plate 71), and encouraged a wide range of subject matter for preparatory compositional sketches, from street scenes to copies of paintings in the Louvre. Using these notebook sketches for reference, and reworking them in the studio, Couture's students learnt to convey the immediacy and spontaneity of the *croquis* in all stages of practice.

In executing the final work, painters traditionally arranged in order the *croquis*, the *esquisse* and the *études*, as preparatory guides for the *ébauche*. The *ébauche* formed the underpainted basis for the final work. Less 'finished' than the sketch (*esquisse*), it was usually rendered with earth colours in a rubbing technique (often using cloths), giving a vague indication of the modelling of the final composition. The important light and dark masses would be laid in with a thin surface of paint, in which layers of glazes or thicker

Plate 71 Édouard Manet, sketch for *Le Déjeuner sur l'herbe*, 1863, oil on canvas, 89 x 116 cm. Courtauld Institute Galleries, London.

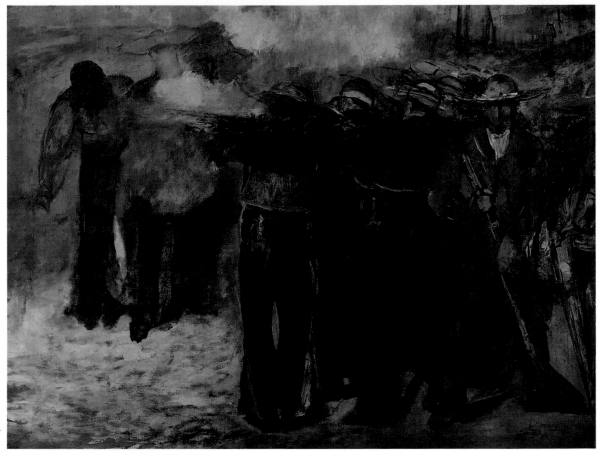

Plate 72 Édouard Manet, *L'Exécution de l'Empereur Maximilian* (*The Execution of the Emperor Maximilian*), 1867, oil on canvas, 196 x 260 cm. Gift of Mr and Mrs Frank Gair Macomber, courtesy of the Museum of Fine Arts, Boston

paint would be applied. In contrast to Academic practice, Couture emphasized the *ébauche* as a positive pictorial element in the *final* work. This can be seen in the shallow 'flatness' of his *Romans of the Decadence*.

Manet took Couture's concept of the *ébauche* and used its technical characteristics to particular effect during the 1860s (Plates 72, 73). He extended the technique by using in the *ébauche* the 'local colours' (for example, green for grass) of the objects portrayed, rather than earth colours. Manet's paintings, including those exhibited in the Salon des Réfusés (Plate 70 and 74), were regarded as unfinished because they were seen as elevating the *ébauche* to the status of the finished surface. His painting came to be seen as a series of *ébauches*, one superimposed on the other. But this innovative technique was construed by public and critics as signalling a more general attack on established notions of competence with the values they evoked. As we noted with Courbet, this kind of affront to decorum was taken as a typically 'modern' departure.

If Manet's technique was seen as modern, why did the iconography of *The Old Musician* fail to attract attention? Firstly it is important to consider what sort of knowledge of representations was involved in the production and the potential readings of the picture, to see what ideas, images, values and beliefs were used as its raw material and how the painting *works* that material.

Plate 73 Édouard Manet, *L'Exécution de l'Empereur Maximilian* (*The Execution of the Emperor Maximilian*), 1867, oil on canvas, 252 x 305 cm. Kunsthalle Mannheim.

A major area of knowledge concerns the artistic models of representation that Manet's painting uses and the possible references to sources other than high art, such as popular prints in mass reproduction, portraying themes from the myths and rituals of everyday life. The more obvious references demonstrate the network of images and modes of representation evoked by Manet's painting. Paintings by the Le Nain brothers (Plates 59, 60, 75) are quoted in terms of both the composition and the characters. The man in the top hat can be matched with 'ragpicker' or 'bohemian' paintings by Manet, Bonvin and Gavarni (Plates 76, 77, 78) and with popular prints such as those by Traviès and Bertall (Plates 79, 80). Watteau's painting of *Gilles* (Plate 81) is an obvious source for the boy in white. Manet's violinist may be derived from the seated piper in Louis Le Nain's painting of *c.* 1640 (Plate 59), from the seated figures in his *Peasant Meal* (Plate 60), or even the cloaked figure in Velasquez's *Los Borrachos* (Plate 82). Defensible comparisons can also be made with the children in the three Le Nain paintings, their clothing and the compositional arrangement, and with images in popular prints and paintings (Plates 83, 87). Manet's drawings of a *Hellenistic figure* or *Seated Philosopher* may well have been used as a preparatory study of the violinist (Plates 84, 85). And, as Marilyn Brown persuasively argues, the gypsy Jean Lagrène was almost certainly a model for the old musician (Plate 86).

Plate 74 Édouard Manet, *Mademoiselle Victorine en costume d'espada* (*Mlle. Victorine in Matador's Costume*), 1862, oil on canvas, 165 x 127 cm. Metropolitan Museum of Art, New York, The Metropolitan Museum of Art, bequest of Mrs H.O. Havemeyer, 1929. The H.O. Havemeyer Collection (29.100.53).

Plate 75 Antoine Le Nain, *Le Vieux Joueur de flageolet* (*The Village Piper*), 1642, oil on copper, 21 x 29 cm. Detroit Institute of Arts. City of Detroit purchase.

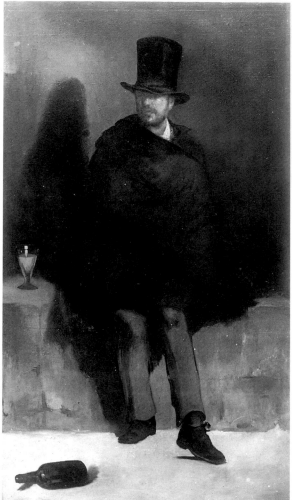

Plate 76 Édouard Manet, *Buveur d'Absinthe* (*The Absinthe Drinke*r), 1858–59, oil on canvas, 181 x 106 cm. The Ny Carlsberg Glyptotek, Copenhagen.

Plate 77 (above right) François Bonvin, *Chiffonier* (*Ragpicker*), 1854, charcoal drawing, present whereabouts unknown. Photograph by courtesy of Archives of Noortman (London) Ltd.

Plate 78 Paul Gavarni, *Ménage bohémienne* (*The Bohemian Ménage*), c.1859–60, oil on canvas. Musée de Dunkerque. Photo: Thériez.

Plate 79 Charles-Joseph Traviès, *Le Chiffonier* (*The Ragpicker*) from *Les Français peints par eux-memes*, 1841, vol. III, p.333, Bibliothèque Nationale, Paris.

Plate 80 Albert Bertall, *Le Marchand d'habits* (*Seller of Old Clothes*), engraving on wood, dimensions unknown, Musée Carnavalet, Paris. Meurs PC 17/7. Photo: Musées de la Ville de Paris/Andreani.
© SPADEM Paris and DACS London 1993.

Plate 81 Antoine Watteau, *Le Gilles* or *Pierrot*, 1721, oil on canvas, 185 x 150 cm. Musée du Louvre, Paris. Photo: Réunion des Museés Nationaux Documentation Photographique.

Plate 82 Diego Velasquez, *Los Borrachos* (*The Drinkers*), 1629, oil on canvas, 165 x 225 cm. Museo del Prado, Madrid.

Plate 83 Henri Guillaume Schlesinger, *L'Enfant volé* (*The Stolen Child*), engraving after painting, *Le Magasin Pittoresque*, XXIX, 1861, p.293. Bibliothèque Nationale, Paris.

Plate 84 Chrysippos, *Seated Philosopher*, before the head was exchanged, ancient copy of Greek marble of third century B.C., 120 cm high. Musée du Louvre, Paris. Photo: Réunion des Museés Nationaux Documentation Photographique.

Plate 85 Édouard Manet, *Philosophe assis (Seated Philosopher)*, c.1860, red chalk and pencil on grey paper, 23 x 14 cm. Musée du Louvre, Cabinet de Dessins, Paris. Photo: Réunion des Museés Nationaux Documentation Photographique.

Plate 86 Potteau, Jean Lagrène, 1865, photograph. Bibliothèque Centrale du Muséum de l'Histoire Naturelle, Paris.

Plate 87 Hippolyte-Louis-
Émile Pauquet, 'La Béarnaise',
from *Les Français peints par
eux-memes*, 1841, Vol III, p.111.
Bibliothèque Nationale, Paris

LA BÉARNAISE

Such references and evocations were not private to Manet. They would have been recognizable and recognized by some contemporaries, particularly in his own circle of acquaintances. Furthermore, Le Nain's *Joueur de Flageolet* and Watteau's *Gilles* appeared in the same volume of the *Gazette des Beaux Arts* in 1860; Schlesinger's painting was exhibited at the Salon of 1861 and appeared in the *Magasin Pittoresque*. Manet's admiration of the brothers Le Nain and of Spanish painting could have come from observing how Courbet used these sources. But he was also friendly with the novelist, writer and critic Champfleury, an early supporter of Courbet and of 'Realism' in painting, who wrote a manifesto of the Realist movement (*Le Réalisme*, 1857). Champfleury championed Spanish art and wrote important works on the Le Nain brothers, on popular illustrations (in *L'Histoire de l'imagerie populaire*, 1869) and costumes. In 1850 he published a book on popular songs from the provinces, and in 1852 one on the Romantics; from 1865 onwards his major project was a five-volume *History of Caricature*; and in 1869 he produced a book *Les Chats – histoire, moeurs, observations, anecdotes*, for which Manet made one of the 52 illustrations, which was also used as a centrepiece for a poster advertizing the book.

The Spanish references in this and other Manet paintings are consistent with his concern to adopt some technical characteristics of Spanish painting, such as bold handling of paint. These references and techniques were associated with a 'Latin temperament', which evoked 'nature' in ways consistent with Romanticism – that is, they were associated with what Baudelaire called a 'natural and living drama' and with 'emotions' and '*sensibilité*', and were seen as devoid of the control of 'reason' and rationalism. Again, in

the context of the historical debate between 'Ancients' (who gave primacy to *dessin* and intellect) and 'Moderns' (who stressed colour and *sensibilité*), to opt for such references and techniques in this period was 'critical' in that 'control' was associated with *official* French verities (philosophical rationalism and the tradition of Classicism) which were encoded in the Academy's criteria of competence.

The Old Musician and the modernization of Paris

In *The Old Musician* 'quotes' are arranged like a series of *études* in a seemingly unspecific landscape. In comparison with existing 'bohemian' or 'gypsy' paintings, this was a subversive act and consistent with Baudelairean notions of modernity. And the 'site' depicted may also evoke the contemporary experience of Haussman's modernization rather than the landscape typical of the bohemian 'myth' in conventional representations. Evidence for this are the memoirs of Antonin Proust, who wrote of the period 1860:

> I have already said what a *flâneur* Manet was. We strolled together, one day, along what was later to be the Boulevard Malesherbes [see Plates 88 and 89], through the midst of the demolitions, intersected by gaping holes where the ground had already been levelled. The Monceau district had not yet been planned ... Farther on, house-breakers stood out white against a wall less white, which was collapsing under their blows, covering them in a cloud of dust. For a long time Manet remained absorbed in admiration of this scene ... A woman came out of a low tavern holding up her dress and clutching a guitar; Manet went straight up to her and asked her to pose for him. She began to laugh.
>
> (in P. Courthion and P. Callier, *Portrait of Manet*, p.42)

In the period described, Manet lived and worked in the Batignolles area of Paris. Now roughly between Gare St. Lazare and the Montmartre cemetery, this area was subject to Haussmann's development in the early 1860s. The area that Proust refers to was known as

Plate 88 A.P. Martial (Adolphe Théodore Jules Martial Potémont), *La Petite Pologne*, demolition and excavation for the construction of the Boulevard Malesherbes, *c*.1860, engraving. Bibliothèque Nationale, Cabinet des Dessins, Paris 81.c. 108 657

Plate 89 Félix Thorigny, after Roevens, *Décoration du boulevard Malesherbes, le 13 août 1861, jour de l'inauguration* (*The Decoration of the Boulevard Malesherbes on Inauguration Day, 13 August, 1861*). Engraving. Photo: Roger Viollet.

La Petite Pologne; in *La Cousine Bette*, Balzac wrote of 'its sinister populations, those dens into which the police never venture unless they are obliged to do so' (quoted in Reff, *Manet and Modern Paris*, p.172–3). The novelist Eugène Sue described it as a place where 'there were not streets but alleys, no houses but hovels, no pavements but a twin carpet of mud and manure' (quoted in Reff, p.173). The refuge of the homeless and poor gypsy families, organ grinders, monkey trainers and so on, its centre was transformed by the construction of the Boulevard Malesherbes. In Martial's engraving (Plate 88), we can see, at the top of the image, the ramshackle homes that were being undermined by excavations for the boulevard. A later engraving (Plate 89) shows it after Haussmann's redevelopment. *The Old Musician* was produced while Manet lived and worked in this environment, in 'the midst of the demolitions, intersected by gaping holes where the ground had already been levelled', as Proust had written. Many of the traditional inhabitants of this location were displaced by the rebuilding. Simultaneously with this displacement, and linked to the development of the railways, there had been a large growth in the population from 3,000 in 1837 to 65,000 in 1860, when Haussmann incorporated La Petite Pologne into the new greater Paris (see Plate 91). Sucked in by industrialization and redevelopment many of the people who came to the area were refugees from the inner city, driven out by taxes, high rents, unemployment or bad living conditions.

Significantly, the figure of the old gypsy musician is, as we said earlier, a portrait of a well-known member of this displaced class: the model was Lagrène (Plate 86), the famous patriarch of a band of gypsies in the Batignolles.[13] He supported his family by finding employment in Haussmann's building campaigns until injured by an accident; he then

[13] He was the subject of fourteen photographs by Potteau (a photographer associated with the Musée de l'histoire naturelle) and several press notices in the late 1860s.

worked as an organ-grinder and artist's model. In 1867, the leading French gypsiologist Paul Bataillard wrote that Lagrène 'represents the Bohemian type better than any other', and that 'all the artists are familiar with this little man and his superb face' (quoted in M. Brown 'Manet's *Old Musician*', p.79). By 1867 Lagrène had appeared in the paintings of so many artists (as Lear, Isaac, Belisarius, etc.) that he found it difficult to get modelling jobs (this may be a case of the exhaustion of a modern *myth* – the bohemian gypsy – dressed up as a pre-modern artistic character). In reality, the Second Empire's modernization programme included strict laws against vagabondage, mendicancy, ambulant entertainment and what it termed *étrangers dangereux* (dangerous outsiders or foreigners). During the 1850s and 1860s, following the abolition of gypsy slavery in Eastern Europe, there was a strong reaction to the waves of gypsies who migrated to France. Lagrène's situation has been described by Marilyn Brown:

> ... [He] mourned the fact that Paris was increasingly uninhabitable for gypsies. He complained that the police prevented him performing his street act, except in the *banlieue* [suburbs] where earnings were scarce. He lived in a poor gypsy wagon that he had parked for years in the marginal, shantytown area of the Batignolles and Clichy; but he complained that the railroad [a *new* development] that owned his favourite spot continually raised his parking fee.
>
> ('Manet's *Old Musician*', p.79)

Fellow artists, in the Baudelairean circle at least, would have recognized 'the Gypsy' as one *dispossessed* or displaced victim of modernization, as the bearer of an ironic experience of modernity. But in Manet's painting we have a double displacement: Lagrène is the representative of a social class *and* the (recognizable) 'face' of the myth of bohemia, as it appeared in idealized representations. What social implications would such displacement have had? To answer this, we need to look more closely at the transformations of Paris and the rationale behind them.

For a substantial part of the period 1850–70, life in Paris was overshadowed by Baron Haussmann's planning and supervision of the systematic demolition of narrow, rabbit-warren-like streets, and their replacement by eighty-five miles of straight, wide, tree-lined avenues and boulevards, which private enterprise was to line with shops and cafés beneath new apartments let at high rents. Between 1853 and 1870, one fifth of the streets in central Paris were Haussmann's creation; 100,000 trees were planted, four bridges built across the Seine and ten widened or restored, 27,500 houses were demolished and 102,500 houses built or rebuilt. There were thirteen new churches, two synagogues, five town halls and six new army barracks, as well as new markets, schools and police stations in virtually every arrondissement. At one point in the 1860s, one in five Parisian workers were employed in the building trade. The audience for Manet's picture experienced an environment conditioned by the continual displacement of neighbourhood communities, by the often unpleasant realities and activities of city life in transformation, and by the reconstruction of a city to serve the interests of capitalism. Haussmann's own estimate of people displaced by the new boulevards and open spaces was 350,000 – of these 12,000 were uprooted by the building of the rue de Rivoli and Les Halles alone. This was an enormous percentage of the total population, which in 1851, just before Haussmann's appointment, was 1,053,000, and in 1872, two years after his departure, was 1,851,000.

The scale of demolition involved was as astonishing as the ambitious planned city. New Paris did not grow up alongside or in the empty corners of the old Paris. On the contrary, new boulevards were constructed in the heart of the city (see Plates 88, 89, 90, 91, 92). As a demolition and building site, Paris impressed an idea of modernity on all who lived in it by the spectacle of the symbols of the physical past being swept away and replaced. On a lesser scale, similar reconstruction took place in Lyons, Marseilles and Le Havre; nothing like this had been seen since Roman times.

Plate 90 Félix Thorigny, *Percement du boulevard Sébastopol; aspect des démolitions de la rue de la Barillerie* (*Demolition of the Rue de Barillerie for the construction of the Boulevard Sebastopol*), after an engraving of 1859. Musée Carnavalet, Paris.
Photo: Musées de la Ville de Paris/Andreani © SPADEM, Paris and DACS, London 1993.

What was the probable effect on the population of such change? For some, the parks, cafés, places of entertainment and the rail links to the suburbs provided opportunities for leisure (the racecourse Longchamps, in the Bois de Boulogne, also dates from this time). Such leisure was accompanied by increased commercial life – several of the great Parisian department stores date from this period, including *Printemps* and *Bon Marché*. Invisible but important was a great new system of sewers, which did much to drain the streets, helping both traffic and pedestrians, and improve hygiene (Plate 115). The new appearance of the city helped to create the ideal image of a bourgeois lifestyle and order. The thoroughfares had a similar type of façade with the height and style prescribed by the authorities. But while the straight boulevards and avenues had Classical vistas, they also facilitated, for the first time, rapid transit across the city: rapid for increased commerce as well as for troops in the event of insurrection.

The spectacle of modernization

Many have argued, and did so at the time, that these transformations were moral as well as material: that behind the progressive utilitarian improvements of Haussmann's Paris there were not only corrupt and despotic interests but also changes to the fabric of human relations, changes which created new forms of social misery and alienation. The Second Empire was a period of boom, with a number of people making a great deal of money out of questionable financial speculation. The enormous sums required for the rebuilding (about 2,500 million francs, which was forty-four times the city's normal annual budget at the beginning of the Second Empire) were raised mostly by mortgaging the city to an unprecedented extent, bypassing the legislature to do so. By contrast, although workers in

skilled occupations and new industries improved their living standards, artisans were often in real distress. In Paris, over half the working population was in debt and only a quarter managed to save; over a million people were living in a state of poverty verging on starvation. In 1863, 118,000 of the urban poor were officially listed as indigent and 10,000 others were arrested as vagabonds. The language of statistics can give conflicting images of the city. On the one hand, it was used during the period, as it still is, by politicians keen to promote an image of modernized well-being. Such use of data is a modern symptom of rationalization itself. On the other hand, statistics can provide landmarks in a mapping of government policy and the development of the modern city as spectacle. 'Spectacle' suggests that despite material changes, power relations were not all that far removed from those of the ruling-class of the Ancien Régime which had cared relatively little about starvation and the poor living conditions of the populace as long as it remained submissive. What was significant in the new situation of the Second Empire was the exacerbation of existing class divisions by the implementation of modernization – with all its financial benefits for the speculator and the capitalist – in the name of *universal* progress. For many this was really a simulacrum: between 1850 and 1870 profits rose by 286%, wages by 45%, and real wages, after inflation, by only 28%. These changes were possible because of the failure of the Revolution of 1848. Those artisans who had fought against a powerful process of industrialization and the displacement and transformation of their traditional methods of production and organization – in other words, against 'modernization' with all its rhetoric of 'progress' condemning 'old-fashioned' working practices – had been on the losing side.

Plate 91 Map of Paris and its western environs in the late nineteenth century, showing some of the sites favoured by the Impressionists (Bougival, Argenteuil, Asnières), which were newly accessible by rail, and the location of areas where major social transformation took place (Batignolles, Petite Pologne).

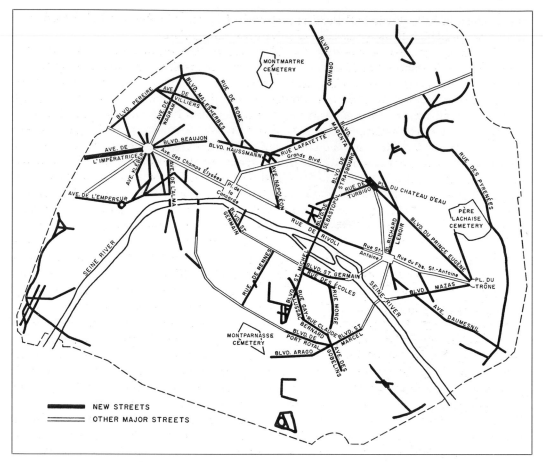

Plate 92 Map showing principal streets built between 1850 and 1870.

Even in the city centre, the physical fabric of the new Paris seemed to some commentators to embody an illusion of progress. Haussmann's planners prescribed the type of street façades, but behind them the builders had a freer hand. Slums were often created in the imposing new buildings. Running water was only supplied if the owner of a building took up the option. Furthermore, the grand system of sewers was primarily designed to carry rainwater off the Boulevards and to prevent flooding in the city itself. The collector sewers, though, had to dump their wares *somewhere*, and this was further down river at Asnières and Saint Denis, out of the sight and smell of those in the centre. The network of sewers, like the street lights, spread out to undeveloped 'limbo' areas, areas once delimiting 'city' from 'country', and now ripe for private speculation. Refuse still had to be removed by the traditional night-time army of collectors, buried in cess pits, or illegally dumped in streets or gardens. Those unable to afford the rent increases resulting from the 'progress' of Haussmann's redevelopment moved into even more overcrowded areas and squalid buildings. Many in search of cheaper living were forced out to ghettos – huge poverty-stricken encampments of shacks often around railway works and factories.

The contradictory reality of modernization creating new indigence and divisions in areas such as La Petite Pologne is described by Louis Ulbach, a journalist who visited the Batignolles gypsies in 1865 and described their tenacious resistance in the face of the urbanization around Gare Saint Lazare: 'It was like an irony of progress and of social forces to see this last shelter of the eternal insurgents of civilization, cramped in between

the western railway yards and the fortified wall of Paris. Will the one kill the other? I think not' (quoted in Brown, *Gypsies and Other Bohemians*, p.79).

The cluster of ideas evoked by *The Old Musician* (the simulacrum, image without substance, the 'substitute' or effigy, the dispossessed or displaced person) also appear in Marx's writings on the period. He writes of false heroism and the ironic contradictions of contemporary life; in these there are parallels, too, with Baudelaire's concerns. Analysing Napoleon III's *coup d'état* in *The Eighteenth Brumaire of Louis Bonaparte*, Marx considers the corrupting power of illusion, of the spectacle of 'substitutes' for the 'real' thing (Napoleon III, who came to power in the wake of the failure of the 1848 Revolution, was the nephew of Napoleon Bonaparte, who had become Emperor in the wake of the failures of the Revolution of 1789). For Marx, the 'culminating point' of illusory '*idées napoléoniennes*' (napoleonic ideas) is the 'preponderance of the *army*. The army [under Napoleon I] was the *point d'honneur* [matter of honour] of the small-holding peasants, it was they themselves transformed into heroes, defending their new possessions against the outer world'. This was, for Marx, a *false heroism* of the exploited in an absolutist state: 'the small-holding, extended and rounded-off in imagination, was their fatherland, and patriotism the ideal form of the sense of property'. Under Napoleon III, he continues, this situation was transformed. Marx considers what happened after 1848, when there was a burgeoning bureaucratic, centralized modern social structure: 'the enemies against whom the French peasantry has now to defend his property are not the Cossacks; they are the *huissiers* [bailiffs] and the tax-collectors. The small-holding lies no longer in the so-called fatherland, but in the register of mortgages' (quotations from Marx and Engels, *Selected Works*, p.175). Under Napoleon III, the army is 'no longer the flower of the peasant youth', it is now an illusion of that original *illusion*, it is 'the swamp-flower of the peasant *lumpenproletariat*. It consists in large measure of *remplaçants*, of substitutes, just as the second Bonaparte is himself only a *remplaçant*, the substitute for Napoleon'. In Marx's interpretation, Bonaparte constitutes himself 'chief of the *lumpenproletariat*', that 'refuse of all classes', comprising 'ruined and adventurous offshoots of the bourgeoisie … vagabonds, discharged soldiers, discharged jailbirds … swindlers … pickpockets gamblers … organ-grinders, ragpickers, knife grinders, tinkers, beggars' (*Selected Works*, pp.136–7), in short the 'disintegrated mass' upon whom Louis Bonaparte relied in his struggle for power.

The Old Musician, in its characters and setting, is an image of the *lumpenproletariat*. Displaced from their class and roots by crisis and social disintegration in a capitalist society, they become a 'free floating' mass, especially vulnerable to reactionary ideologies. They are, too, the product of Haussmann's substitute Paris, a city of spectacular 'elegant life', full of the 'disintegrated mass', the dispossessed, whom Baudelaire saw, ironically, as a suitable subject for the painters and poets of this 'modern life'.

The characters in *The Old Musician* evoke, then, Baudelaire's and, indeed, Marx's ideas. A particular figure, that of Manet's *Absinthe Drinker*, is a case in point. He has the bearing of a *chiffonier*, a ragpicker, one of those whom Baudelaire saw as 'philosopher heroes', who were painted as such by Manet in at least four paintings. These characters had been part of the winding old city, but Haussmann's redevelopment required a more 'efficient' system of refuse collection. This was not implemented until 1884, when M. Poubelle, Prefect of the Seine, instituted a system of household dustbins that put 4,000 *chiffoniers* out of work. However an earlier move to suppress *chiffoniers* had taken place in 1861, when Manet was painting *The Old Musician*. The '*Compagnie de nettoyage des rues de Paris*' (Paris Street Cleaning Company) was set up to clear the streets efficiently during the early hours of the morning, to take the rubbish to depots outside Paris, where *chiffoniers* were to be employed by the company to do the sorting. Objections to the plan, which were successful, were mainly a response to the number of *chiffoniers* who would have been

made redundant. At the level of representation, Manet's use of this figure with other displaced Batignolles characters shows up the ideological limits of such paradigmatic images as Gavarni's (Plate 78), which reproduce a conventional myth.

If Baudelairean *modernité* is the critical consciousness of the contradictions of modernization, we can locate Manet as a painter concerned with ways of representing such consciousness. For some Parisians of the Second Empire, *modernité* was a consciousness of artificiality and illusion, of decadence behind bright façades, of displacement and rootlessness, of cheap substitutes for reality. The problem for artists was how to represent this *modernité*? Walter Benjamin, writing of Baudelaire and other new urban poets of this period, suggested that they modelled themselves on, or actually became, comparably dispossessed people, they 'find the refuse of society on their street and derive their heroic subject from this very refuse. This means that a common type is, as it were, superimposed upon their illustrious type. This new type is permeated by the features of the ragpicker with whom Baudelaire repeatedly concerned himself'. (Benjamin, *Charles Baudelaire*, p.79). These urban poets make the dispossessed sensibility into their own, and see the ragpicker as among those most keenly aware of what modernization really means. Consider Baudelaire's description:

> Here we have a man who has to gather the day's refuse in the capital city. Everything that the big city threw away, everything it lost, everything it despised, everything it crushed under foot, he catalogues and collects. He collates the annals of intemperance, the *capharnaüm* (stockpile) of waste. He sorts things out and makes a wise choice; he collects, like a miser guarding a treasure, the refuse which will assume the shape of useful or gratifying objects between the jaws of the goddess of Industry.
>
> (quoted in Benjamin, *Charles Baudelaire*, p.79)

This could be used as a description of Manet's own technique: collecting all the characters that the new city 'throws away'; choosing the subjects despised by academic standards; sorting, choosing and collecting the 'refuse' of social and artistic sources to represent the social characters of a city being transformed. Baudelaire described the 'dregs of society' as the philosopher heroes of the big city; the two halves of Manet's modernity are these 'heroes' and the ragbag of 'art history'.

The characters in *The Old Musician* evoke a range of traditional references as a means of representing the human types of a Paris in modernization. A striking example is Manet's reference to Watteau's *Gilles*, which was on view at Louis Martinet's gallery in 1860. The character of Gilles was mentioned frequently at this time in connection with part of Haussmann's renovation of Paris. On 14 July 1862 wrecking crews began the demolition of the Théâtre des Funambules as part of the overall destruction of the Boulevard du Temple, popularly known as the 'Boulevard du Crime'. As the Funambules was the home of the popular *Commedia dell'Arte*, Gilles and his prototype Pierrot were, metaphorically, made homeless. Manet's painting represents an illusionistic 'home' for displaced, dispossessed 'characters' from both 'pre-history' and contemporary immediate life. In Castagnary's terms a 'social consciousness' is being externalized here. And we can see this again in the figure of the 'old musician'. While he can be related to the Le Nains' paintings and to Velasquez' *Los Borrachos*, Manet may also have used his drawing of *c.*1860 of the Hellenic *Seated Philosopher* (Plate 85). If so, then we find here a Classical figure of a type to interest Academicians *transformed* into a modern displaced figure. And this evokes other elements of Baudelaire's ideas: the combination of the constant elements of Classical antiquity with those characteristics which change in each epoch. The two together, one superimposed on the other, make up Baudelaire's heroic *modernité*: 'a constant, unchangeable element … and a relative, limited element co-operate to produce beauty … The latter element is supplied by the epoch, by fashion, by morality, and the passions.

Without this second element … the first would not be assimilable', he wrote, and 'Woe to him who studies other aspects of antiquity than pure art, logic, the general method. He who becomes excessively absorbed in antiquity, divests himself of the privileges opportunity offers him' (quoted in Benjamin, *Charles Baudelaire*, p.82). Manet's practice at the time of *The Old Musician* was modern without resorting to pure aestheticism or cultivating 'art for art's sake'. It shares aspects of Courbet's critical Realism, but equally, Manet's cultivation of references to the history of art seem to refer to an 'otherness' that is critical of reality; Baudelaire's 'constant, unchangeable element' necessary to the production of 'beauty' and of 'art' is also identifiable. The only way that Manet could demonstrate his bourgeois interest in 'the poor' or 'the outcast' was by means of a range of available 'types' of depictions. Manet used these 'types' from existing representations and staged them as 'quotes'. In so doing, he revealed the constraints, the ideological limits, of existing visual resources and paradigms with which to work in producing representations of the social experience of modernity.

Typically, the 'avant-garde' and the Bohemian are regarded as social groupings resisting social and political conformity. At the level of *representation* – what these groups produced – Realism and Baudelairean *modernité* were critically opposed to Academic and *juste milieu* practice and to the political authority which they represented. This is avant-gardism in practice: a self-conscious and critical engagement with representations of modernization and all its rapid and contradictory transformations in pursuit of capitalism and bourgeois ideals.

The problem of official tolerance: The Painter's Studio *and* View of the International Exhibition of 1867

Clearly *The Old Musician* is not a 'slice of life' but a symbolic or allegorical painting. It seems oblique and indirect when compared to Courbet's *Burial*. This is *partly* because the artistic and political circumstances in which Manet worked were even less amenable to political painting than those in which Courbet worked. Courbet had resorted to allegory in his enormous painting *The Painter's Studio, A Real Allegory Defining a Phase of Seven Years of My Artistic Life* (Plate 93). What were perceived as the corrupt and imperialist ambitions and activities of Napoleon III's regime had outraged liberal and left opinion, which the Emperor tried to control through censorship. Courbet addresses this problem by ensuring that his painting could be read *at least* two ways. Literally, it could be read as a representation of 'social types', from a range of classes. But what of the allegory of the title? This has provoked much controversy, but one reading suggests that the painting encodes a moral dialectic between the two sides with Courbet portrayed as its central mediator.[14] In this reading the figures on the left represent the Emperor (popularly known as 'the Poacher', he is the man in the thigh boots with the dogs), his political allies, clients and victims. On the right are portraits and representatives of the Left intelligentsia, committed variously to Realism, anarchism, socialism and modernity (Baudelaire is portrayed on the far right edge). While there may be much more to Courbet's 'allegory' itself, by 1854 it seemed that the *use* of allegory was the safest way to present dissent and to get it past the censors. In *The Old Musician*, Manet took a similar course. Yet Manet's painting is more ambiguous, even, than Courbet's cryptic attempt to avoid censorship. It's as though it offers Courbet's 'dialectic' at 'standstill'. In the evocation of a range of earlier and contemporary references and sources, Manet's painting offers not Courbet's dialectic between

14 See H. Toussaint, 'The Dossier on *The Studio* by Courbet, in *Gustave Courbet: 1819–1877*. Also see Nochlin, 'Courbet's Real Allegory: Rereading *The Painter's Studio*'.

Plate 93 Gustave Courbet, *L'Atelier du peintre: allégorie réelle déterminant une phase de sept années de ma vie artistique* (*The Painter's Studio, Real Allegory Defining a Period of Seven Years of my Artistic Life*), 1854–55, oil on canvas, 359 x 598 cm. Musée d'Orsay, Paris. Photo: Réunion des Museés Nationaux Documentation Photographique.

two halves but an ambiguously coded, single 'dream image'. In this image, modern figures conjuring up references to the past are organized, not compositionally (as in Courbet's *L'Atelier*) but as though waiting to be arranged in some active dialectic. We can relate this to Baudelaire's ideas in which the 'modern', because it is characterized by contradictory social relations and events, always conjures up its opposite, 'the constant, the unchangeable', which is rooted in the past. Manet's painting, this 'dialectic at standstill', offers an ambiguous 'no place'. What else was possible to characterize a rapidly transforming modernity?

The other side of imperial censorship was the *official* attempt to construct major public 'dream images', glamorous but misleading, of the social life of the new Empire. Sometimes, this was a matter of the way utilitarian projects were decorated. Haussmann had an image of Paris as a technological and leisure metropolis to be displayed to the world in the Exposition Universelle of 1867. Between 1864 and 1867 (that is, ready for the Exposition), a park was created on sixty-two acres of deserted land at Buttes-Chaumont (see Plates 94, 95 and 91). Once the place of public execution and, until 1849, the depository of the city's sanitary sewage, this site of abandoned quarries and rubbish dumps, almost without vegetation, was cleaned up and converted into a spectacular park serving the growing industrial districts of La Villette and Belleville on the north-east side of the city. Following the terrain, the park was designed to resemble a mountainous landscape with top soil hauled in to support trees, shrubs and lawns. Haussmann called it 'the inevitable grotto' (quoted in Pinkney, *Napoleon III and the Rebuilding of Paris*, p.101). A waterfall over 300 metres high was fed from water pumped up from the Canal de L'Ourcq. Two streams ran through the park and a lake was dug around the principal promontory. Only a twentieth of the size of the Bois de Boulogne, the park cost the city nearly twice as much.

Plate 94 Transformation of the Buttes-Chaumont, after a contemporary engraving. Reproduced from *Paris de 1800 à 1900*, vol.2, 1830–1870, 1900 Paris, Plon.

If the Parc des Buttes-Chaumont was a dazzling artificial landscape, then the Exposition Universelle itself was a spectacle on an enormous scale. Inaugurated in the May of that year on the Champ de Mars (see Plate 96), it attracted thousands of visitors from all over the world and was celebrated in a range of representations. Manet, for instance, attempted to paint a large-scale picture of the panoramic view of the Exposition from the top of the park of the Trocadero (Plate 97). But his *View of the International Exhibition*, along with pictures such as his various versions of the *Execution of Maximilian*, represents an attempt to reinvest 'history painting' with some political life (Plates 72, 73).

Plate 95 Bird's eye view of the Park of the Buttes-Chaumont, built on the site of an abandoned quarry. Reproduced from Alphonse Alphand, *Les Promenades de Paris, 1867–73*, fig. 306. Bibliothèque Nationale, Paris.

Plate 96 Charles François Pinot and Sagaire, *General view of Paris and of the Universal Exposition of 1867, taken from the heights of the Trocadéro*, 1867, Épinal print. The text provides a guide to the exhibition site and contents. Bibliothèque Nationale, Cabinet des Dessins, Paris.

During the early part of the year, Manet decided not to submit to the annual Salon and did not receive an invitation from the selection committee to show in the art section of the Exposition. In competition with the official art shows, he opened on 24 May a solo show in a temporary pavilion at the Place de l'Alma, as Courbet had done in 1855, and did again in a private retrospective at this Exposition. Manet exhibited fifty paintings, representing eight year's work, including *Le Déjeuner sur l'herbe* (Plate 70), *Olympia* (Plate 14) and *The Old Musician*. The show received a harsh critical and public response. Despite his disappointment and the seeming failure of his enterprise, Manet continued work on the production of a painting based on the Universal Exhibition itself.

It has been convincingly argued by T.J. Clark that this painting represents an ironic comment on the spectacular transformation of the area around the exhibition into a kind of stage-managed spectacle. What could be identified by contemporary Parisians and what might it mean to them? Many would have known that the view from the opposite bank of the Seine that Manet depicts, which was recommended in contemporary guide-books and used in souvenir prints, had a particular significance.

The imaginary viewer (which we become) is positioned so as to be looking from the summit of the Butte de Chaillot across to the exhibition buildings on the Champ de Mars in the middle distance. Three months before the exhibition opening, the Butte de Chaillot was considered by the organization to be 'irregular' and 'wild'. Haussmann was therefore ordered to lower the hill by about four metres to make it 'regular' and to provide *a view*. In

Plate 97 Édouard Manet, *L'Exposition universelle 1867* (*View of the International Exhibition of 1867*), 1867, oil on canvas, 108 x 196 cm. © Nasjonalgaleriet, Oslo. Photo: Jacques Lathion.

order to meet the deadline, navvies worked under arc lights through the night. The event in itself constituted a public spectacle attracting sightseers and press comment. By the time the Exposition opened, the enormous oval hall by Frédéric Le Play, surrounded by towered pavilions on the grounds of the Champ de Mars, could be viewed from the top of the newly altered hill (Plate 96), making it, in Weber's terms, *normalized*.

This painting of a public event represents one of Manet's several attempts to find a theme for a full-scale modern 'history painting' on public events which captured headlines – those fragile, ephemeral spectacles which had to be represented immediately. Here, in contrast with *The Old Musician*, the envisaged spectator does not require a knowledge of Classical history, or of past 'Old Master' art, but a knowledge of contemporary prints or photographic reproductions, of Haussmann's attempts to provide an *image* of the imperial city, of specific locations and sites and of contemporary middle-class dress. The contradictory tensions in *this* picture are not, as with *The Old Musician*, centred on the mixing of codes, of supposedly incompatible social 'types' with those quotations from previous art. Here, it may include puzzling over the discrepancies in conventional perspective, the perfunctory paint marks, the scale of figures, the social 'types' – tourists, cocottes, various classes and professions paraded in fashions of 1867 – isolated by pictorial spaces and delineated by sketchy abbreviated paint marks.

What could be identified by the contemporary Parisian – apart, that is, from the panorama of the city is the photographer Nadar's balloon to the right, over the fairground, and for those closer to Manet, his son Léon Leenhoff, walking his dog, bottom right. Otherwise Manet provides just enough information for the landmarks of the city on display to be recognized:

> The towers and pavilions still overlap the bridge, and the distant flags and foliage blend in with Antoine-Auguste Préault's *Gallic Horseman*, perched there at the picture's centre as a noble (and illegible) reminder of the republic. These things are all part of the same disembodied flat show, the same spectacle ... [that is] it points to the ways in which the

city (and social life in general) was presented as a unity in the later nineteenth century, as a separate something made to be looked at – an image, a pantomime, a panorama.

(Clark, *The Painting of Modern Life*, p.63)

Official attempts to fabricate a prestigious view of Paris for the world at large are addressed by Manet's self-declaringly artificial image, which attempts to avoid 'naturalization of meaning'. Manet abandons allegory to address the artificiality of the 'images' provided in contemporary life. It is a painting of ironies, at the expense of a Republic much concerned with image-making.

The ideology of individualism and the art market

Alongside censorship and the production of spectacles, it had been government policy since 1848 to eliminate political and class-based difference by stressing an eclectic individualism. Not only was this a political objective but also an artistic one. In 1855, after the Universal Exhibition of that year, Delacroix noted in his journal that Academicians were outraged by the award of nine Medals of Honour to *different* artists. The jury was under the official presidency of the Duc de Morny, Napoleon III's half-brother, and the awards were an extension of the Imperial Commission's decision to choose particular artists as representatives of 'major styles' and to provide each with a special retrospective exhibition. Here the qualities of 'progress' and 'development' were officially located in the 'eclectic unity' of Second Empire art, in its supposed tolerant diversity. The Empire was to be all things to all people. The artists chosen were Delacroix, Ingres, Vernet and Decamps (see Plates 98 and 99). Courbet refused their invitation to be a fifth, (and thus to be normalized?) setting up his independent retrospective around *The Painter's Studio*. Ironically, Courbet's show and the official displays *together* established the ideology of the *individual* retrospective exhibition. It was, though, the honouring of a multitude of styles that caused the greatest stir, because it implied that all styles were implicitly neutral and interchangeable, differences were reduced to questions of taste and popularity.

Plate 98 Photograph of the Ingres installation at the Exposition Universelle 1855, with *The Apotheosis of Napoleon I*, Bibliothèque Nationale, Paris.

Plate 99 Photograph of the Delacroix installation at the Exposition Universelle 1855. Bibliothèque Nationale, Paris

For many the Classical hierarchy of categories had been dealt a fatal blow by this act, and thereby, Patricia Mainardi argues, it 'established the principle that one could become as great an artist by painting monkeys as by painting gods and heroes'. This seemed to be confirmed by Prince Napoleon, President of the Exhibition, who published his critical reactions to the exhibition as a whole, and to Delacroix's *Liberty Guiding the People* (Plate 54), taken out of storage for the artist's retrospective:

> There are no longer any violent discussions, inflammatory opinions about art, and in Delacroix the colourist one no longer recognizes the flaming revolutionary whom an immature School set in opposition to Ingres. Each artist today occupies his legitimate place. The 1855 Exposition has done well to elevate Delacroix; his works, judged in so many different ways, have now been reviewed, studied, admired, like all works marked by genius.
>
> (quoted in P. Mainardi, 'The political origins of modernism', p.15)

Delacroix as 'revolutionary' became normalized within eclectic ideology as a 'colourist' and 'marked by genius'. This is something more than controversial works of art becoming 'quiet' with age. The year 1855, regarded by many contemporary critics as a 'cemetery' for art, saw an officially inspired attempt to remove the possibility of art having a political vitality or popular understanding. Delacroix's friend Pérignon, wrote in 1856 of the Exposition Universelle: 'today everything is forgotten, everything is smoothed over, there are no longer either halos or scars; the works appear isolated, deprived of the interest they had borrowed from circumstances, from judgements, from passing events. Above all, they've lost the train of violent passions that gave them their magic life' (quoted in Mainardi, 'The political origins of modernism', p.15). By 1867, the job of provoking a political or moral response was more difficult – the 'magic life' of Delacroix's *Liberty* no longer seemed a possibility, particularly for artists who wished to operate as coherent groups. Such artists needed to avoid the divisive tendency of an emphasis on individualism in critical and artistic judgements, at a time when other pressures made that avoidance almost impossible.

The new ideal observer was to be the mobile 'individual', giving full 'aesthetic' attention to the 'idiosyncratic' formal and technical qualities of a wide range of marketable works of art. In the 1860s and the 1870s a major characteristic of 'oppositional' art was the stress on novelty in pictorial forms: the sketch elevated to the status of the *'fini'*, the transformation of genres (as in Courbet's *Burial*), the flouting of narrative structures, the mixing of the codes of 'high art' and 'mass culture' (as in Manet's *The Old Musician*). On an institutional level there was considerable political advantage in the renewed and enhanced official celebration of eclectic diversity, which diminished the *effect* of innovation in art as a carrier of political and popular meanings. Ironically, too, many critical defences of new art stressed its political insignificance. From Zola's early defence of Manet's work in the 1860s, through to criticism of the 1870s and 1880s, there was a tendency to shield art from partisan attacks (from the right or left) by emphasizing the formal or technical qualities of new art as carriers of meaning. Such stresses on *l'art pour l'art* were in part defensive responses to the official distancing of art from general historical developments, in social class relations quite as much as in methods of production. The work of so-called 'radical' artists (such as Delacroix, Courbet and Manet) could be officially accommodated ideologically by eclecticism as if they were examples of 'art for art's sake'. After all wasn't that what artists and critics such as Zola and Mallarmé were arguing for?

Economically, the considerable growth in dealers' 'solo' shows, in auction houses (such as the Hôtel Drouot from about 1853) and in the international market reinforced this individualism. By 1861 there were 104 picture dealers in Paris, which indicates the large increase in the number of paintings produced outside the Salon or direct commissioning system. As mixtures of banker, stockist and promoter, dealers such as Durand-Ruel had a large influence on art practices. With the security of a financial backer, he introduced the practice of acquiring a monopoly of the production of artists with whom he dealt. Durand-Ruel dealt at first in paintings of the Barbizon group and then the Impressionists. In 1866 he bought 70 paintings by Théodore Rousseau, in 1871 he bought from Manet all the paintings he had, numbering 23, for 35,000 francs, and by the 1880s and 1890s he had a purchaser in the USA ready to pay 4–6,000 francs each for *any* painting Monet could produce. Thus there was official sanction for the ideology of the solo show on several levels. While Courbet (in 1855 and 1867) and Manet (in 1867) may have regarded their solo shows as 'oppositional' and avant-gardist attempts to circumvent the process of official rejection of their work, the appropriation of such a strategy as a money-maker by dealers happened quickly.

In the public sector, the Salon des Réfusés of 1863 further encouraged individualism. On the one hand, this Salon may have been a public demonstration of liberalism on the part of a regime concerned about its self-image. On the other, it was less a show of unified dissidents and more a further entrenchment of official eclecticism sanctioning diversity and novelty, in a manner consistent with a capitalist market economy. There were similar Salons des Réfusés in 1864 and 1873, which set ideological precedents for those exhibitions of the 1870s and 1880s that were free from the intervention of juries and 'despotic' control. Indeed the first Impressionist exhibition in 1874 was a privately organized Salon des Réfusés. Here, the word *private* signifies an aspect of entrepreneurial activity that was greatly prized by the Republican ideology of eclectic individualism. There were also more collective 'public' examples such as the Salon des Indépendents and Salon d'Automne.

The first Impressionist exhibition in 1874 is often singled out as a major innovatory landmark in the history of modern art. The painters who exhibited there are frequently celebrated as a group intent on establishing their 'independence', their freedom of pictorial expression and freedom of exhibition. There was however, a wide, perhaps eclectic, range of subjects and techniques on display (see Plates 136, 139, 143). These

paintings demonstrated different interests and commitments. While it's mythology to regard the Impressionists as unified in their artistic production, it is the case that their exhibition contributed to a shift in the status of artists who wished to distance themselves from Academic or official art. Were these works of art, which have traditionally been regarded as 'breaking with the past', doing any more than meeting an economic transformation of the 'art market' and conforming to an official ideology of individualism – of the 'self' with its narcissistic implications?

Modernization: spectacle and irony

We can begin to address this question by examining *The Boaters, Argenteuil* (Plate 100), a large, ambitious painting that Manet produced during the summer of 1874, which was his sole submission to the Salon of 1875. Why this painting? One reason is that, as with *The Old Musician*, or *Le Déjeuner sur l'herbe*, it exemplifies criteria of competence for a self-consciously modern practice – this time for the 1870s. It was produced in the same year as the first Impressionist exhibition and it demonstrates an indebtedness to some of their technical interests. Manet never exhibited with the Impressionists, always insisting that the Salon was the only true testing ground; yet he was often characterized as their mentor.

This painting has had particular significance in the historiographical terrain of the social history of art. Robert Herbert for example, points to a major characteristic of the painting in relation to Manet's work of the 1860s:

> In effect, Manet, perhaps owing to his association that summer with Monet and Renoir, has brought up to date his own *Déjeuner sur l'herbe*. In 1863, he had been thinking primarily of the history of painting and of modernizing it by the irruptive presence of his contemporary figures. By 1874, he has become much more the naturalist, drawing upon a well-known, not an imaginary setting, and one that had distinctive resonance in the contemporary mind.
>
> (*Impressionism; Art, Leisure and Parisian Society*, p.236)

It has a central importance, too, in a chapter of T.J. Clark's *Painting of Modern Life:*

> here, I believe, the main elements of the matter are assembled: the middle class and its pleasures, the countryside organized to attend to them, and the answering presence of industry. This is the picture, it seems to me, in which the most literal effort was made to put such things in order and insist they belonged together.
>
> (p. 164)

Already we can begin to speculate on the types of knowledge that the contemporary spectator was likely to need when looking at this painting. As Herbert says, it does not require a knowledge of the 'history of painting' as well as of 'contemporary figures', as Manet's paintings of the 1860s often did. Realism for Courbet and for Manet, in the 1860s, necessitated reference to historical artistic conventions and themes, such as 'the reclining nude', the 'fête champètre' or 'the public execution', *as well as* to contemporary class specific codes. It's as though the Franco-Prussian War and the suppression of the Commune in 1871 had marked a watershed for artists concerned with Realism and the modern subject.

Contemporary reaction to *The Boaters, Argenteuil* is provided by Jean Rousseau, a young Belgian artist, who wrote as art critic of *Figaro*:

> The heads and cotumes have a certain liveliness. That is all. Behind the figures, there is an indigo river, hard as iron and straight as a wall. In the background, a view, or rather a

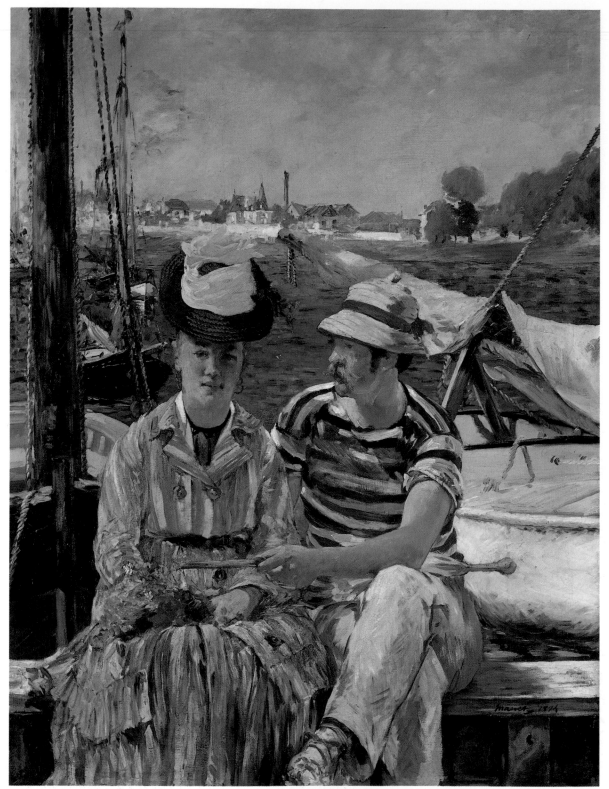

Plate 100 Édouard Manet, *Argenteuil, les canotiers* (*The Boaters, Argenteuil*), 1874, oil on canvas, 148 x 115 cm. Musée des Beaux-Arts, Tournai. Photo: Giraudon.

stew of Argenteuil; not a line, not a plane, not a shape carried out. The master has reached the stage of a twenty-year old student.

(quoted in Hamilton, *Manet and his Critics*, p.189)

There were other references to 'that blue wall' or to 'the background … executed by the son of the house, aged four, who has a taste for landscape', or to the painting being 'incomplete'. And T.J. Clark quotes Maurice Chaumelin writing in *Le Bien Public* in 1875:

> Under the pretext of representing nature and society just as they present themselves, the realists dispense with balance in their pictures of both. But let that pass. There are at least, in this nature and this society, aspects which are more agreeable than others, and types which are more attractive. Monsieur Manet is deliberately setting out to choose the flattest sites, the grossest types. He shows us a butcher's boy, with ruddy arms and a pug nose, out boating on a river of indigo, and turning with the air of an amorous marine towards a trollop seated by his side, decked out in horrible finery, and looking horribly sullen.
>
> (quoted in Clark, *The Painting of Modern Life*, p.168)

KEY

Seine = Over 200 yards wide;
flowing *towards* Ile Marante (6)
Carrières à Plâtre = Gypsum/plaster quarries
Plâtriers = Plaster works

1 Road bridge
2 Railway bridge
3 Monet's rented houses
4 Boat rental area
5 Promenade, at the end of which the town's second iron works opened in 1874

6 Ile Marante
7 Petit Bras
8 Joly iron works
9 Loading docks, warehouse, crystal factory and from 1876 the town's third iron foundry
10 Port of Argenteuil with docks (see also plate 110)

Plate 101 Map of Argenteuil, based on information kindly provided by Professor Paul Hayes Tucker. The key provides details of the combination of industrial and leisure sites characteristic of the area.

What seemed to concern many critics was, firstly a 'lack' of technical and compositional 'finish' in the painting. When compared to the modest size of many Impressionist works, this is on the scale of a modern Salon history painting. It's posed 'snap-shot' quality might have been acceptable in an *étude* or *esquisse* or even in a small-scale landscape work. Here, though, the preparatory sketch or the worked *ébauche* is elevated, alongside the landscape/genre theme, to the format expected of history paintings. Secondly, critics had no option but to identify the class of these two characters. Unlike Manet's *Déjeuner sur l'herbe* where class associations *could* be lost in dreaming about the art historical references to Titian, Marcantonio Raimondi, Raphael, Watteau etc., here no such option was available. Who, then, were these two boaters? Thirdly, the exact location of Argenteuil was important. This was not an unspecific landscape, as in *The Old Musician*, but a particular identifiable view at a place with a reputation in the popular imagination. What do we make of this specific location? Are there any significant differences between this work and other artists concerned with similar themes? If there are, what implications can we draw about the conditions for producing 'modern' works in the early 1870s?

Argenteuil was several kilometres outside Paris, half an hour's journey on the relatively recent railway line (inaugurated in 1851) out of Gare St. Lazare (Plate 91). If we look at a detailed map of the area (Plate 101), Manet's viewpoint is from the boat rental area on the south bank (see key to plate 101), slightly downstream from the highway bridge looking west across to the river bank north of the Île Marante. The buildings in the background can be seen in several of Monet's paintings from the period, such as *The Promenade along the Seine* and *Sailboats in the Boat Rental Area* (Plates 102, 103). They can also be seen in the distance in his *Effet d'automne à Argenteuil* (Plate 104), but from the other direction – that is, from the Petit Bras (17 on the key), to the south of the Île Marante, looking upstream to the north bank. We will have more to say about the latter painting shortly.

The two figures prominently depicted in the foreground of Manet's painting are seated near the pleasure boats, not with any of the steamboats used both for industrial purposes and as pleasure craft (Plate 105). This may be because they were regarded by many sailors as 'stinkpots', but more likely because it was only 'young men of fortune' who could afford to buy a steamboat (15–25,000 francs) or to rent one (75–100 francs a

Plate 102 Claude Monet, *Argenteuil, The Promenade along the Seine*, 1872, oil on canvas, 50 x 65 cm. National Gallery of Art, Washington, Ailsa Mellon Bruce collection.

Plate 103 Claude Monet, *Sailboats on the Seine, Argenteuil*, 1874, oil on canvas, 54 x 65 cm. The Fine Arts Museums of San Francisco, Gift of Bruno and Sadie Adriani 1962.23.

day): 'To buy a sailboat, on the other hand, was also beyond the means of many, but at least the rate of three to four francs a day allowed the majority of the middle to lower classes to pass a few Sunday afternoons gliding up and down the Seine' (P. Tucker, *Monet at Argenteuil*, p.105).

The identification of boating with the 'middle to lower classes' happened in the 1850s and 1860s; it was a sport which contemporaries did not see as dependent on wealth:

> these scruffy pleasure-seekers [students, workers, artists, etc.] still existed in the 1870s and many frequented the basin at Argenteuil. The town was the weekend hangout of people like Guy de Maupassant, who in the 1870s was a 'penniless clerk leading his life between the office in Paris and the river at Argenteuil'. His existence was 'carefree and athletic, a life of poverty and gaiety, of noisy rollicking fun'.
>
> (Tucker, *Monet at Argenteuil*, p.106)

The period saw a transformation of many activities in Haussmann's Paris from commercial to leisure usage. At Argenteuil, commercial sailing became pleasure-boating, with older river craft transformed into yachts for pleasure and traditional river boatmen displaced by 'gentleman amateurs'. The man in Manet's painting can be identified as an aspiring 'gentleman amateur' by his clothes, sportsman's straw hat and the presence of a female companion. This is Chaumelin's 'butcher's boy', dressed up to observe the 'right' codes for someone with mobile class aspirations. Comparing this painting with *Boating* (Plate 106), it's clear that Manet used his brother-in-law Rodolphe Leenhoff as a model in both. However, in *Boating* he is wearing the colours of the prestigious 'Cercle nautique' (white shirt, white flannel trousers and straw boater with blue border), whose headquarters were at Asnières. In the Argenteuil painting, the male figure is clothed as a pleasure-seeking 'amateur' of a different class. It was well known that Argenteuil was associated with amateur yachtsmen of indifferent morals who favoured similar female companions (Chaumelin's 'trollop'):

> Art critics of the period and Manet's male friends alike assumed that the blank-faced woman was such a one, and surely the boatsman is assiduously soliciting his companion's

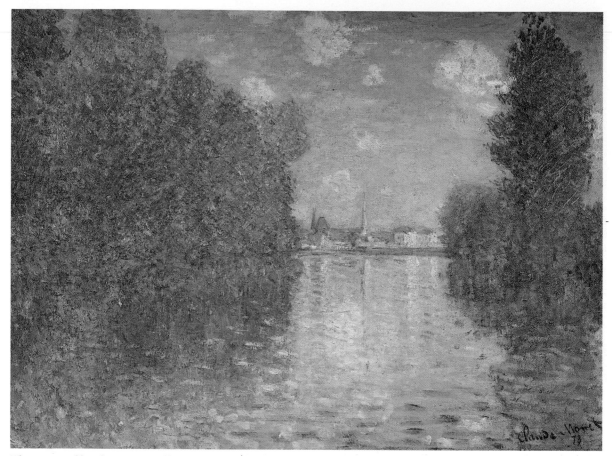

Plate 104 Claude Monet, *Effet d'Automne à Argenteuil* (*The Effect of Autumn at Argenteuil*), 1873, oil on canvas, 56 x 75 cm. Courtauld Institute Galleries, London.

Plate 105 Anonymous, *Course de canots à vapeur à Argenteuil* (*Steam-boat Race at Argenteuil*), 1874, wood engraving. Bibliothèque Nationale, Cabinet des Dessins, Paris.

Plate 106 Édouard Manet, *En bateau* (*Boating*), 1874, oil on canvas, 97 x 130 cm.
All rights reserved, Metropolitan Museum of Art, New York. Bequest of Mrs H.O. Havemeyer.
The H.O. Havemeyer collection (29.100.115)

Plate 107 Berthe Morisot, *Jour d'été* (*Summer's Day*), 1879, oil on canvas, 46 x 75 cm.
National Gallery, London. Lane bequest 1917. Reproduced by permission of the Trustees.

attention. She is, further, dressed in the showy clothing of lower middle-class women, rather than the more elegant and restrained dress of the woman in *Boating* [Plate 106] or in Morisot's later *Summer's Day* [Plate 107].

(Herbert, *Impressionism*, p.236)

And this Argenteuil, on the outward fringe of the city, what was it like? By the 1870s it could no longer be regarded as an example of 'Nature' unspoilt by the ripple effect of Haussmann's redevelopment in central Paris. One of the numerous signs in Manet's painting is the smoke belching out of a chimney to the top left of the painting. While Argenteuil was still indebted to agriculture, which had been geared since the eighteenth century to the Parisian market, in the 1870s it was modernizing fast. As Tucker (pp.15–18 and pp.35–42) and Clark (*The Painting of Moden Life*, pp.173–4) have detailed, there was extensive industrial development and suburban building during the period. In 1851, the population was 4,757, almost doubling by 1871, when there were 8,046 inhabitants; in 1882 a Paris handbook gives a figure of nearly 12,000. Some of this increase was due to a growth in commuters for whom Argenteuil meant a suburban house with a garden, a pleasurable contrast to their place of work in the city. However, there was also the effect of industrial growth in the town. In the 1860s, both the gypsum quarries and plaster works and the Joly iron foundary were large employers. The latter forged the parts for the railway bridge when it was rebuilt, in 1872, having been destroyed in the Franco-Prussian War (Plates 108 and 109), and was renowned in Paris for building the Palace of Industry for the Exposition Universelle, and the famous market hall, Les Halles. To the tannery, tallow shop and distilleries there were added a factory producing phosphate extracts, a dye factory, starch works, a machine-made lace premises, a gas-works, a large saw-mill and construction operation, a chemical plant, a works making mineral and carbonated water, a cardboard-box factory and one making fine crystal. To the south, Bezons boasted a rubber factory, which by 1869 had killed off the local fish with its dumped waste. Not surprisingly, the municipal and departmental authorities keen to encourage capital investment ignored residents objections to all these transformations and approved factory construction even in picturesque areas of the town. If we compare contemporary photographs of Argenteuil with engravings, the contrast between the *real* industrial life of the town with its *image* as a boating haven is startling (Plates 109, 110, 111, 112). By 1884, the

Plate 108 Photograph of the Argenteuil railroad bridge destroyed during the Franco-Prussian War, *c*.1870–71. Photo: Roger Viollet, Paris.

Plate 109 Anonymous, *Argenteuil – Le Pont du chemin de fer* (*Argenteuil – The Railway Bridge*), *c*.1895–1900, postcard photograph. Musée de l'Île de France, Château de Sceaux.

place had become a well-known location for a designated day out, when 'pleasure' could be conspicuously 'enjoyed', as Louis Blairet observed in 'Autour de Paris' in June 1884:

> Come Sunday, there is an invasion at the Gare St. Lazare, lady fruit-sellers from the Rue Saint Denis, cabinetmakers from the Rue de Cléry, girls who make chocolate in the Rue de Vivienne – there is not one of them who does not descend on the banks of the Seine, beneath the Moulin d'Orgemont or in the Auberge des Canotiers. And wherever there trots a Parisienne, a Parisien is sure to follow … There is singing, shouting, dancing, running about, falling down and going astray. It all begins with *entrecôtes au cresson* and ends with aching limbs. The banks of the Seine are full of mysteries that day, mysteries of the private and pastoral life … Here we serve lobster salad on the grass, messieurs!
>
> (quoted in Clark, *The Painting of Modern Life*, pp. 177–8)

Plate 110 Anonymous, *Argenteuil, Bords de la Seine* (*Argenteuil, Banks of the Seine*), *c*.1895–1900, postcard photograph. Bibliothèque Historique de la Ville de Paris.

Plate 111 Paul Renouard, *Les Régates d'automne à Argenteuil* (*Autumn Regattas at Argenteuil*), wood engraving by M. Moller, 1879, Bibliothèque Nationale, Cabinet des Dessins, Paris.

Plate 112 T. Weber, *Environs de Paris, Argenteuil* (*The Outskirts of Paris, Argenteuil*) , 1869, wood engraving, Bibliothèque Nationale, Paris.

Plate 113 Paul Hadol, *Le Salon comique*, wood engraving in *L'Eclipse*, 30 May 1875. Cartoons of Salon exhibits, including a suggestive caricature of Manet's *Boaters, Argenteuil* as a pair of hats floating between an indigo dye factory and the sewer at Saint-Denis. Bibliothèque Nationale, Paris.

There is one further piece of significant information contributing to local knowledge of Argenteuil. As we have seen, Jean Rousseau wrote of Manet's 'indigo river, hard as iron and straight as a wall'. Cartoonists, too, made the river a central part of their caricature of Manet's Salon work. As Clark shows, Hadol's cartoon in *L'Eclipse* (Plate 113) draws attention to the 'indigo factory' and is captioned 'the Seine at the sewer of Saint-Denis'. If we look at a more detailed map of the area (Plate 114), and to a plan of Haussmann's new sewer system (Plate 115), we can see what filled the river in the area. A few miles upstream from Argenteuil, at Saint-Denis there were chemical dye factories which poured their waste into the sewers. It's important to note that Haussmann's updating of the medieval system with two hundred miles of pipe relied on the construction of two large collector sewers which carried the waste away from the city to flow into the Seine at Asnières and at Saint-Denis:

> These collectors were not processing plants, however; the untreated waste was simply dumped in the Seine. Government studies in 1874 estimated that over 450,000 kilograms of waste was flushed into the river every day, five sixths of it at Asnières and one sixth at Saint-Denis. The Seine at both these points was, according to these reports 'a cauldron of bacteria, infection and disease'. The stench was frequently unbearable and the banks of the river were often littered with solid waste.
>
> (Tucker, *Monet at Argenteuil*, p.151)

In the 1860s, the government had tried to alleviate this problem by pumping waste into an irrigation system in the area of Gennevilliers in the loop of the river. By 1874, the area irrigated by this waste amounted to one hundred and fifteen acres. In July 1875, it was proposed that this be increased to twelve hundred acres (shaded area on the map, Plate 101). By the time that the waste and indigo dye had passed downstream to Argenteuil, pleasure-seekers could both see and smell the effects of modernization. In the heat of the summer, and judging from the shadows in Manet's painting, it's at the height of such a day, a foetid stench rose from the fields at Gennevilliers, and from the stinking waters of the Seine (not to mention the solid waste). All this would have been known by many Parisians who flocked to the Salon.

In Manet's painting there is a juxtaposition, or mixing, of codes about the modern. Think for instance about the specific detailing of the two models' contemporary clothes or the 'solid wall' of indigo blue signifying paint *surface*, 'flatness', and the polluted river Seine. The woman's hat signifies both an elaborately pinned item of contemporary fashion

Plate 114 Map of Gennevilliers showing projected irrigation, from 'Le Rapport de la Commission d'assainissement de la Seine', 1874, Archives Communales, Argenteuil. The dotted lines show the location of the main sewer outlets (see Plate 115); the shaded part is the proposed area to be irrigated with waste from the sewage system.

Plate 115 Collector sewers of Paris, entering into the Seine, 1870. (Based on Eugène Belgrand, *Les Travaux souterrains* (Paris 1873–77), Atlas, V, Plate 2.)

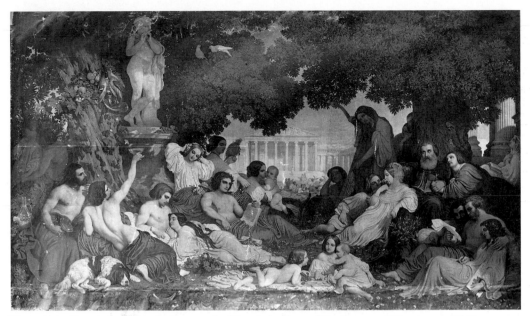

Plate 116 Dominique-Louis Papety, *Le Rêve de bonheur*, (*The Dream of Happiness*), 1843,
oil on canvas, Musée National de Palais de Compiègne et Musée du Second Empire.
Photo: Réunion des Musées Nationaux Documentation Photographique.

and a concern with acknowledging the surface of the canvas, the *means* by which the hat is
suggested. As Clark has it,

> It is a black straw oval, hardly seeming to belong to the head underneath it. It is a simple
> surface; and onto the surface is spread that wild twist of tulle, piped onto the oval like
> cream on a cake, smeared on like a great flourishing brushmark, blown up to impossible
> size. It is a great metaphor, that tulle: and it is, yes, a metaphor of paint and painting.
> (*The Painting of Modern Life*, p.164)

The blue of the river serves a similar function. Symbolic of 'nature', it is also a textured in-
sistence of paint *as paint* and a sign of capital, of the presence of the effects of modern-
ization and modern factory labour. For Manet, there was no settled way of doing the
'modern', only characteristic sites which he could attempt to represent in their burgeoning
complexity. At Argenteuil there was a spectacle of mixed codes for all those prepared to
read the ways that 'pleasure' and 'modernization' uneasily coalesced. In his painting we
have two particular individuals out for a day of conspicuous pleasure at this ambiguous
modern site. Their 'proper' fashionable decorum, however, is still in the process of
formation by members of the 'new social stratas' of Haussmann's *modernized* Paris.

But, as critics noted, the woman looks 'horribly sullen' or has 'the air of being
tolerably bored, as far as the wilful impasto on the faces allows one to judge' (quoted in
The Painting of Modern Life, p.168). For Clark, the 'deadpan', the 'uncertainty' which he sees
offered in Manet's depiction is suppressed in the critics' response which stresses
'vulgarity and grossness'. We might say that the pleasures of a *fête champêtre* (Plates 116,
117), those real and idealized pleasures consistent with the rituals of a rural landscape un-
touched by iron-works, dye factories or urban sewer outlets, are no longer
uncompromisingly available to Sunday visitors. Nor are they to the new inhabitants of
Argenteuil, one of whom was the painter Claude Monet (Plate 118). His representations of
the locale offer a very different image to that which interested Manet.

Plate 117 Auguste-Barthélémy Glaize, *Souvenir des pyrénées ou Le Goûter Champêtre* (*Souvenir of the Pyrenees or The Picnic*), 1850–51, oil on canvas, 145 x 114 cm. Musée Fabre, Montpelier, inv. 38.51. Photo: Frédéric Jaulmes.

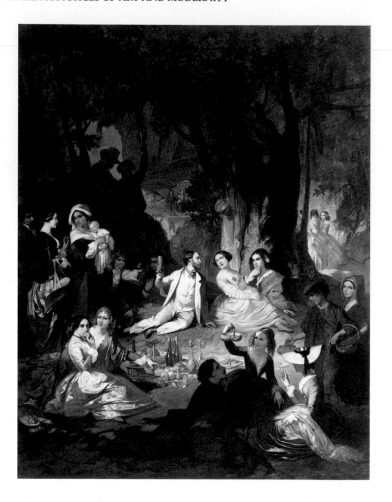

Plate 118 Édouard Manet, *Claude Monet et sa femme dans son bateau-atelier* (*Claude Monet and his Wife in his Studio-Boat*), Argenteuil, 1874, oil on canvas, 82 x 100 cm. Neue Pinakothek, Bayerische Staatsgemaldessammlungen, Munich.

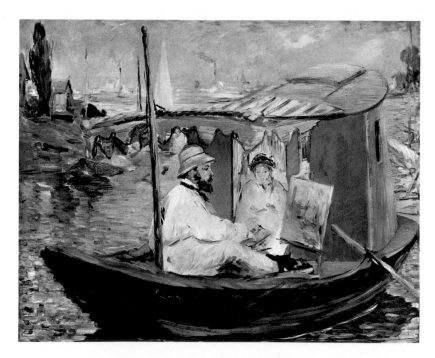

Plate 119 Claude Monet, *Petit Bras with Unmanned Boats*, 1872, oil on canvas, 54 x 72 cm. Private collection.

Monet's representation of Argenteuil

Monet had settled in Argenteuil in 1871 not long after he had been to England to escape the Franco-Prussian War, and to Holland to escape the Commune and its aftermath. Out of about 175 surviving paintings produced at Argenteuil, seventy-five are depictions of the boat basin adjacent to the highway bridge (see Plates 101 and 103) and the area near the Île Marante (Plates 102, 104, 119, 120). Other topics included the railway bridge, his own garden, the village streets, nearby fields and boats on the river (Plate 121). As both Tucker and Clark demonstrate, Monet's views are extremely discriminating: most of his paintings of Argenteuil pictorially minimize signs of industrialism. After 1875, there's little evidence in his work of the complexities and impersonality of the modernized

Plate 120 Claude Monet, *The Petit Bras of the Seine*, 1872, oil on canvas, 52 x 71 cm. The National Gallery, London. Reproduced by permission of the Trustees.

Plate 121 Claude Monet,
Le Pont de chemin de fer
(*The Railway Bridge*), 1873,
oil on canvas, 54 x 71 cm.
Musée d'Orsay, Paris. Photo:
Réunion des Museés Nationaux
Documentation
Photographique.

Argenteuil. And even before that, he was often intent on transforming observed reality into a *private* world of peace, security and natural beauty. For instance, his depictions of the railway bridge (Plate 121) do not include views where a significant working area would have been seen (Plates 108, 109, 110). The view, from the north bank of the river, meant that Monet had his back to these signs of industrialization, added to, shortly, by another iron works (see Plate 101); the Argenteuil docks to his right were blocked out by the bridge itself. While he did depict the working dock at Asnières (Plate 122) he did not paint similar work in action at Argenteuil.

Monet's *Effet d'Automne, Argenteuil*, is a significant contrast with Manet's *Boaters*. They represent two very different views of a similar background landscape; from the Petit Bras and from the boat rental area respectively. In the Manet we see, prominently placed, two Parisians about to embark on a pleasure trip and watery liaison. However, in the Monet painting, it is as though we as spectators have become the two figures now down river in the Petit Bras (see Plates 101 and 119), in a boat looking back at the landscape Manet depicts. Here, Monet adopts a conventional compositional format, a paradigm used endlessly by artists from Claude to Turner (see Plate 61). Everything from horizontal line, format, compositional organization is the antithesis of the Manet. A more private, individual, self-reflective *sensibilité* is encoded in Monet's attention to 'nature', to the effect of light and its reflection on water. His Seine is no 'solid wall of blue' but recedes pictorially as in all competent conventional landscapes. Monet's only concession to the signs evident in the Manet are the distant landscape of buildings and the strip of blue, so pronounced in the original painting, below the far river bank. Often described as a 'compositional device', it could also surely be read as a *distant* slick of indigo blue passing down the main part of the river, viewed from the narrow Petit Bras to the south of the Île Marante. Monet mostly took the option of insisting on an idyllic *petite ville*, of closing off the contradictory reality of contemporary ephemeral life in the process of modernization. Manet, on the other hand, continued to produce paintings in which contradiction, both in terms of technique and of social codes, was problematically offered to the viewer.

Plate 122 Claude Monet, *Les Déchargeurs de Charbon*, 1875, oil on canvas, 55 x 66 cm. Durand–Ruel Collection, Paris. Photo: Giraudon.

Modernity: the social and the aesthetic

We have seen in Courbet's practice the work of an avant-gardist – that is, someone who works on representations of contemporary society by means of a critical engagement with the codes, conventions and political assumptions of the ideologically dominant class. Though he was an avant-gardist, he was not yet a modernist. We have argued that Manet was someone who was both. We can ask whether in Monet we find someone who was a modernist but not an avant-gardist.

By 'modernism' we refer to those new social practices in both 'high art' and 'mass culture' which engage with the experiences of modern life, with *modernity*, by means of a self-conscious use of experiment and innovation. Their engagements are sometimes critical, sometimes celebratory, sometimes ironic. The term 'modernism' should not to be confused with Modernism which represents one particular, much contested account of modernist art practices, which stresses 'art for art's sake', artistic autonomy, aesthetic disinterestedness and the formal and technical characteristics of works of modern art. It systematically relegates the social emphases that we are concerned to discuss. In

Modernist accounts, Monet's technical innovations are a mark of his critical and moral detachment from the codes, conventions and assumptions of Academic art. But just as important, they are seen to represent a similar detachment from the experiences and commodities of 'mass culture' which are considered 'inauthentic'. Monet's modernism, therefore, is regarded in such accounts as establishing a *self-critical otherness* to modernization and to capitalism's commodification both of experience and of most representations of experience.

For Modernists, the autonomy of art and of aesthetic judgements is regarded as potentially emancipatory in an economic and social system where everything appears subject to rationalization and normalization. We might ask, though, for *whom* is there the possibility of such emancipation? Inevitably, as Modernists acknowledge, it will be for an élite (possessing, in Pierre Bourdieu's analysis, *intellectual* capital, though not necessarily economic capital) with the appropriate sensibility and developed critical faculties.[15] For them, this is less an attempt to construct a social or intellectual exclusivity than a recognition of the effects of the historical marginalization of economically and socially disadvantaged groups, and also of the highly 'specialized' skills required in identifying the aesthetic value of modern 'specialized' art. Nevertheless, élitism is one criticism of the Modernist account.

A further criticism is that it excludes central issues of gender, ethnicity and class, of the ideological and psychological position of the viewer, even though it may do so in pursuit of what it sees as a moral and ethical obligation to identify and to preserve in art qualities which establish an *aesthetic* 'self-critical' otherness, both to capitalism and to political or moral commitment.[16] Another is that while Modernism permits the description of the 'autonomy of art' as an *historical development*, it relegates the importance of accounts which stress that this 'detachment' of art from practical contexts is an *historical process* – that is, it is itself a socially conditioned process. This means that Modernist accounts are 'interested', as all histories are, whether or not this is acknowledged in practice. Peter Bürger goes further by arguing that the 'autonomy of art' thesis, essential to Modernist accounts, is ideological:

> The relative dissociation of the work of art from the praxis of life in bourgeois society thus becomes transformed into the (erroneous) idea that the work of art is totally independent of society. In the strict meaning of the term, 'autonomy' is thus an ideological category that joins an element of truth (the apartness of art from the praxis of life) and an element of untruth (the hypostatization [to reify an abstraction, as though real] of this fact, which is a result of historical development, as the 'essence' of art).
>
> (P. Bürger, *Theory of the Avant-Garde*, p.46)

These ideological interests help to explain why, for many Modernists, Monet's practice, where there is some level of emphasis on technical and formal issues, is regarded as exemplary. This *relative* emphasis is sometimes regarded as an absolute, pure and independent essence; the 'autonomy of medium' (surface, flatness, colour, shape, texture etc.) is seen as a value supposedly transcending the moral and social demands of historical circumstance. But are there important social attitudes encoded in Monet's paintings? Modernists might say 'yes' – but that they are secondary to Monet's progressive pursuit of autonomy (technical, formal, social) which is most emphatically realized in his last paintings, such as the *Nymphéas* series (Plate 198). In such an account, Monet is

[15] See Bourdieu's *Distinction: A Social Critique of the Judgement of Taste*, and *The Love Of Art*, with Alan Darbel.

[16] See Griselda Pollock, 'Modernity and the spaces of feminity'; Raymond Williams, 'When was Modernism?', and 'Culture is ordinary'; Part III of Frascina and Harris *Art in Modern Culture*, and Terry Eagleton, *The Ideology of the Aesthetic*.

Plate 123 Claude Monet, *Five Figures in a Field*, oil on canvas, 80 x 80 cm. Private Collection. Photo courtesy of the Art Institute of Chicago.

represented as little concerned with non-aesthetic 'meanings' and more concerned with qualities of 'surface', or 'flatness'. It is said that the kind of pictorial surface that Monet's paintings present acts as a 'barrier' to a 'social', 'anecdotal' or 'literary' reading. We suggest, on the contrary, that social issues are encoded in all of Monet's paintings, in the inseparable relationship between the method of depiction and that which is depicted.

Sometimes this encoding is positive, sometimes negative and at others *both*. A reading of social value and anecdotal content as positively encoded in Monet's later figure paintings is offered by Paul Tucker. In discussing works such as *Five Figures in a Field*, he argues that what 'Monet seems to be asserting in all of these paintings is his ability to outdo Seurat, Pissarro, and Renoir – to prove Impressionism's superior capacity to exploit colour, describe particular climatic conditions, use paint in novel ways, and reveal fundamental truths about art and the world' (*Monet in the 90s*, p.25). In *Five Figures in a Field* (Plate 123), the adults portrayed in the background are Monet's son Jean, and Alice Hoschedé's daughter Suzanne; in the foreground their younger siblings Michel Monet and Germaine and Jean-Pierre Hoschedé:

> The older children appropriately stand behind the younger ones and are paired with the larger, more substantial grove of trees in the background. The younger ones, unlike their older counterparts, stand in more vulnerable positions against open fields, the edge of which they do not break. Jean and Suzanne are not self-absorbed ... Instead, they appear to be watching their younger siblings ... Though youthful, they assume adult postures ... Unlike all of Seurat's figures, the younger children have recognizable personalities; they even exhibit combinations of uneasiness and naïveté befitting their age.

> Combined, these factors suggest that Monet is advancing rather traditional ideas about innocence and maturity, sentimentality and sharing, dedication and persistence, all of

which seem to be the result of the fact that these figures are not in a city or suburb but are intimate parts of a more natural environment … The values Monet asserts in this picture have little place in Seurat's more critical view of contemporary life.

(*Monet in the 90s*, p.26)

Tucker goes on to argue that what Monet seems to be doing in such paintings is to insist upon 'the superiority of a style [Impressionism] that could assert these multiple values about art and life while preserving the individuality of the artist and his personal vision … Like *laissez-faire* capitalists, the Impressionists had claimed the right to devise their own methods and to market their own results' (p.26).

But what evidence of a negative encoding? What evidence is there of social issues being readable *both* in terms of what Monet 'edited out' of his images of particular sites *and* in terms of his relative emphases on formal and technical equivalents for his personal communion with 'nature'? One possible view is that at Argenteuil Monet avoided the sort of critical realism that we see in Manet's painting, by carefully selecting viewpoints where the signs of modernization were least apparent, and that this avoidance was symptomatic of an aesthetic retreat into a *personal* absorption with 'nature'. Such issues relate to Weber's consideration of the reasons *why* many artists in the modern period, here Monet, consciously or unconsciously, developed a more elaborate emphasis on an 'inner-world' in terms of autonomy and of self-absorption. He argues that they do this largely as a compensation for, a salvation from, the effects of the lengthy process of modernization: the increasing pressure of practical and theoretical rationalism.[17] For him, the patterns we associate with modernization in post-industrialized societies (such as alienation, control, the oppressiveness of rationalized systems) have their roots in shifts in ideas, values and beliefs during the rise of Protestantism and mercantile capitalism. In *The Protestant Ethic and the Spirit of Capitalism*, Weber refers to 'worldly asceticism' – a secular ethos, characterized by the tendency to deny oneself pleasure and delay gratification, which are regarded within this 'ethic' and 'spirit' as assertive signs of a strong personality and the *worth* of the individual – both to persons themselves and to a wider public. In Protestant terms 'worldly asceticism' is a denial of the pleasure of ritual religion (the 'loss' of Catholicism); in capitalist terms it is the denial of sensual gratification in the use of money in social company (the dominance of the industrialized work ethic). 'Worldly asceticism' emphasises an 'inner-world' which paradoxically has two sides: not only a moral severity and self-control but also the context for pursuing 'personal visions' as compensations for the demands of every day life under capitalism. In both there is a desire to be recognized as a superior individual. Was Monet asserting his worth in his technically rich equivalents for, and reworkings of, *his* view of 'nature'? An 'inner-worldly' alternative to a critical engagement with the representations of industrial society driven by mass production, exploited labour and profit margins?

The emphasis on the 'inner-world', on 'personal visions' rather than social realities has much in common with Richard Sennett's description of 'narcissism', the fascination with and pleasure in one's own *sensibility*. In both 'worldly asceticism' and 'narcissism',

'What am I feeling?' becomes an obsession. In both, showing to others the checks and impulses on oneself feeling is a way of showing that one does have a worthy self. In both, there is a projection of the self onto the world, rather than an engagement in worldly experience beyond one's control.

(R. Sennett, *The Fall of Public Man*, p.334)

Such a view, it could be countered, may be too tendentious or moralistic a verdict on Monet's modernism. Perhaps, there is something in seeing Monet not so much as

17 See Weber's 'Religious rejections of the world and their directions', p.342.

consciously *avoiding* the complexities of modernization at Argenteuil, but as 'aspect blind'. The indicators of industrial transformation are *absent*, or marginalized, in his work because of the limited range of 'schemas' or pictorial paradigms that were available to him: there were few if any precedents for him to draw upon for representing the modernized landscape. We first raised this issue when considering Courbet's work: are 'schemas' or paradigms largely related to the psychology of pictorial representation, or are there social and political dimensions to what is chosen and to the way choices are worked on and transformed in practice?

To consider this question with reference to Monet, it is instructive to examine how another Impressionist tackled the 'landscape' and the 'factory', two of the main elements that made up the codes for representing the modernity of Argenteuil. Pissarro, the most politicized of those who participated in the Impressionist exhibitions, produced, in 1873, four paintings of the Chalon et Cie factory at Pontoise, where he lived (Plates 124, 125, 126, 127). This was a significant choice as few landscape painters of the time painted factories, though there were numerous representations in popular prints. How did Pissarro represent this 'factory in a landscape', and what attitudes to modernization are signified by these paintings?

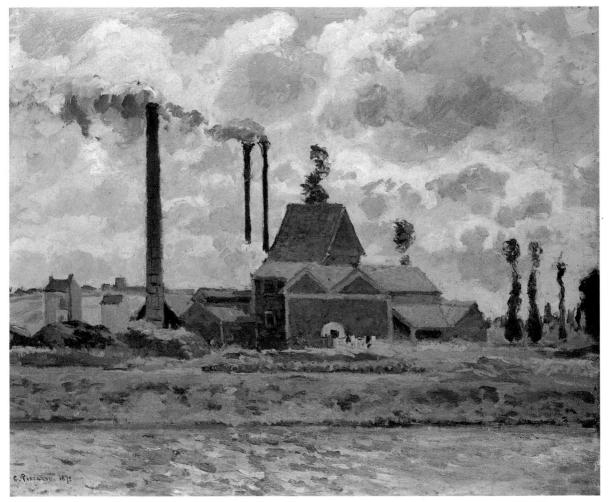

Plate 124 Camille Pissarro, *Usine près de Pontoise* (*Factory near Pontoise*), 1873, oil on canvas, 45 x 55 cm. The Museum of Fine Arts, Springfield, Massachusetts, James Philip Gray collection.

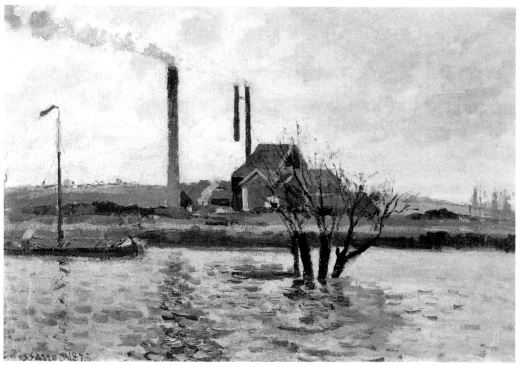

Plate 125 Camille Pissarro, *La Crue de l'Oise, Pontoise* (*The Factory on the Oise, Pontoise*), 1873, oil on canvas, 39 x 47 cm. Collection of the Earl of Jersey. Photo: Robin Briault.

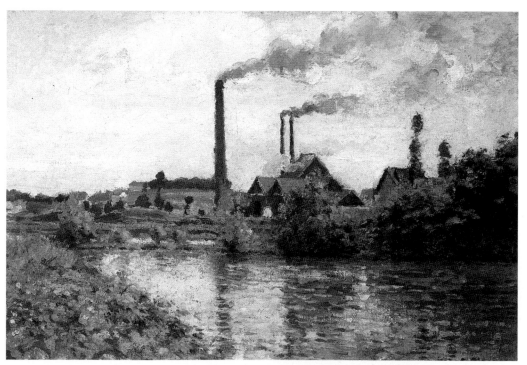

Plate 126 Camille Pissarro, *L'Usine à Pontoise* (*The Factory of Pontoise*), 1873, oil on canvas, 45 x 54 cm. Private collection. Photograph by courtesy of Franklin Silverstone.

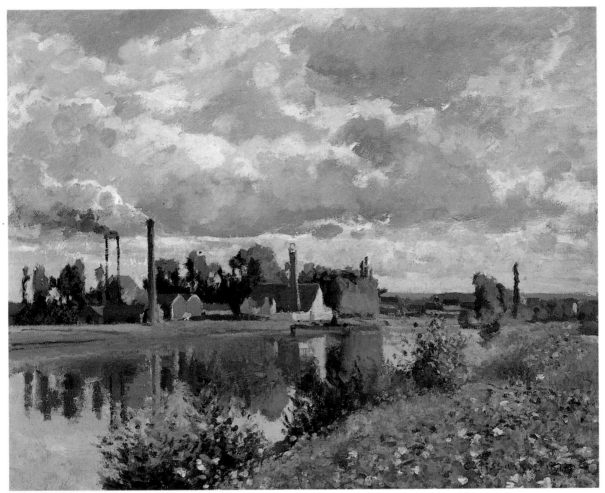

Plate 127 Camille Pissarro, *L'Oise aux environs de Pontoise* (*River Oise near Pontoise*), 1873, oil on canvas, 45 x 55 cm. Sterling and Francine Clark Art Institute, Williamstown, Massachusetts.

Richard Brettell, in *Pissarro and Pontoise*, draws our attention to several important facts. The first is that Pissarro's pictorial exploration of almost every region of Pontoise and its environs differentiates him from painters, who

> spent a considerable portion of the day looking for the absolutely right pictorial motif or, alternatively, simply returning to an habitual motif … [this variety] differentiates his Pontoise from Monet's Argenteuil or Cézanne's Aix-en-Provence [Plates 102, 103, 104, 119, 120, 121, 134 and 135] … [they] had certain areas or 'spots' … that they preferred to others and that they depicted many times.
>
> (*Pissarro and Pontoise*, pp.37–8)

Pissarro's representations were mediated by different commitments and interests:

> In the main, his response to the landscape was political and social as much as pictorial. He avoided images of either wealth or poverty. He de-emphasized leisure, while revelling in agricultural work … the enduring aspects of quotidian life. More than anything else, his landscapes are anti-Romantic.
>
> (Brettell, *Pissarro and Pontoise*, p.39)

Pissarro, like many other political observers of the industrial transformation of France and of its rapid expansion under the third Empire, was caught between two attitudes. On the one hand, there was the idea of a pre-industrial 'nature' as 'authentic' and enduring, a resource for moral well-being. This underpinned one paradigm of representation that connects compositions by Claude (Plate 61) with nineteenth-century ones, like those of Daubigny (Plate 128) and Monet (Plates 104 and 120). Many writers and landscape painters espoused such an idea and Pissarro's training was steeped in its traditions and conventions of representation. In *Bords de l'Oise, Pontoise* (Plate 129), Pissarro follows the compositional format exemplified by Daubigny, adding signs of industrialization to the 'image' of 'nature'. For some 'nature' was also recommended as an escape from the excesses of modern life – for instance from the dehumanizing effects of modern cities, such as those in Haussmann's modernization of Paris. On the other hand, there was the idea of modernization as progressively leading to the betterment of most people's lives, especially of those who had been subject to the deprivations and adverse conditions of feudalism. Were the symbols of modernization to be accepted, even celebrated; or should they be denied, revealed as alienating, corrupting and environmentally harmful?

This became a pressing question for Pissarro at Pontoise in the 1870s, till then the most intense period of industrial expansion in the area. An example is the development of the potato distillery of Chalon et Compagnie, dating from 1871, when the company built its first small factory, or *fabrique*. Significantly, the building was traditionally styled, making it consistent with the shed-like, non-mechanized workshops of the area. In 1873, the company began to construct a large and expanding factory, or *usine*, specializing in the distillation of industrial alcohol from sugar beet. The site was next to their smaller *fabrique*. Generally, the *usine* differed from the *fabrique* by its large scale industrial shop-floor and mechanized processes. This difference relates to the two attitudes which formed part of the discourse on 'nature', 'modernization' and 'industrialization' in mid-nineteenth-century France. Chalon's new building was both massive and brutal, giving the river Oise 'an industrial character for the first time in the history of Pontoise. Its large smokestack soared over every form in the environment, and its industrial image can be

Plate 128 Charles-François Daubigny, *Soir à l'Oise* (*Evening on the Oise*), 1863, oil on canvas, 100 x 200 cm. Taft Museum, Cincinnati, Ohio; Bequest of Mr and Mrs Charles Phelps Taft, The Taft Museum, Cincinnati Ohio. 1931.462.

Plate 129 Camille Pissarro, *Bords de l'Oise (Bank of the Oise near Pontoise)*, oil on canvas, 38 x 55 cm. Indianapolis Museum of Art, James E. Roberts Fund.

contrasted with its historical precursors, the *moulins* [mills] and the *fabriques*' (Brettell, *Pissarro and Pontoise*, pp.80–81). The latter were small and numerous, merging into the semi-rural landscape. In contrast, this large and solitary *usine* occupied a definite position in relation not only to the town of Pontoise but to the river Oise, which now hosted a developing traffic in barges, facilitated by the extensive canal network to which it was connected. Besides this mark of modernization, the factory was evidence of a transition from water-powered manufacture to modern industry in which the river is no longer a harnessed source of power but an exploitable means of transport, on the one hand, for portable fuel and raw materials and, on the other, for the factory's products.

Brettell demonstrates that in a number of ways Pissarro was comfortable in depicting the *fabrique* in the landscape (Plate 130), but not in attempting to represent the modern industrialized *usine*. Evidence of this is to be found in his paintings of the Chalon *usine*, in which he symbolically altered the proportions and scale of the factory, and pictorially rearranged characteristics of the buildings and surrounding trees. This is apparent in *Usine près de Pontoise* (Plate 124) where the trees and chimneys increase in size from right to left (from 'nature' to 'industry'), with the belching smoke continuing the uniform compositional incline. In comparison with the *actual* factory, the roof of the central building is exaggerated in scale and incline, increasing the impression of the factory's physical bulk. The scale of the latter is pictorially enhanced by the inclusion of two vertical dwellings, to the left of the factory, neither of which existed. For Brettell they serve to 'suggest that the scale of this new factory, unlike any previously portrayed by the painter, is beyond what we might call 'human scale', an abstract idea of great importance in the history and theory of landscape painting' (*Pissarro and Pontoise*, p.83). Existing conventions, rooted in French and Dutch precedents, encouraged the depiction of small industry, the *fabrique*, and mills, often by a river (Plate 61). These conventions were taken as encoding a view of a decent society of moral well-being, in which human industry and intelligence triumph over and are in harmony with 'nature'. This 'schema' or 'paradigm'

Plate 130 Camille Pissarro, *La Petite Fabrique* (*The Little Factory*), *c.*1863–65, oil on canvas, 26 x 40 cm. Musée National d'Art Moderne de Strasbourg.

was Pissarro's resource – and one that provided a means by which he could organize a populated and compositionally important foreground and middleground (Plate 130). In the Chalon pictures (124, 125, 126, 127), however, there is a significant absence of a 'humanized foreground'. For Pissarro the disruption that the *usine* makes to the landscape convention in which he was trained went hand in hand with the threats that industrial work makes to society.

In the version we have discussed, the factory is pictorially dominant not only because of its altered scale but also because of the painting's compositional frontality and compressed pictorial planes. There is an attempt at a critical realism in the way that Pissarro addressed available conventions of 'landscape' and the contemporary viewer's expectations. Spectators were confronted with the need to interpret Pissarro's working of familiar conventions in the light of the reality of the Chalon factory. We might say that encoded in this representation is the view of the *usine* as an equivocal symbol of modernization. However, Pissarro, the most political of the Impressionists, experienced major problems in his project, which are evident in another of the group of four, *L'Oise aux environs de Pontoise* (Plate 127). Here, Pissarro's engagement with the problematic reality and ambiguous meaning of the Chalon factory becomes secondary to his preoccupation with the existing conventions of landscape painting (as it does with *Bords de l'Oise* (Plate 129)). The *usine* with all its codes, is treated as a *fabrique* in a conventionally composed 'picturesque' landscape:

> The picture can be compared with the more comfortably traditional factory-scapes painted by Pissarro's good friend Guillaumin in the period 1869–73, most notably the *Soleil couchant à Ivry* [Plate 131], which was exhibited in the first Impressionist exhibition. Both Guillaumin and Pissarro viewed factories from a distance in the landscape. Their spectacular skies, a sunset for Guillaumin and icy blue clouds for Pissarro, dominate the landscapes. Nature holds her own against industry.
>
> (Brettel, *Pissarro and Pontoise*, pp.91–2)

Plate 131 Armand Guillaumin, *Soleil couchant à Ivry (Sunset at Ivry)*, *c*.1869, oil on canvas, 65 x 81 cm.
Musée d'Orsay, Paris, Gift of Paul Gachet, 1951.
Photo: Réunion des Museés Nationaux Documentation Photographique.

This group of paintings by Pissarro demonstrates the problems and difficulties involved
in representing the industrial transformation of a particular site, especially one which
embodied the customs, rituals, and allegiances of the artist's immediate community.
Pissarro's practice is evidence of an attempt to be an avant-gardist and a modernist, and
importantly, evidence of what it was to struggle at the level of representation. Perhaps the
worst that can be said about Monet's practice is that he did not try to address the
transformations and piecemeal industrialization of Argenteuil, his community. From what
we know of Monet's (and Cézanne's) narrow range of motifs, sites and concerns, they
were not interested in the modernity which differently characterizes Manet's and
Pissarro's avant-gardism.

Whether the lack of any systematic attempt at a critical realism in Monet's works are
regarded as 'avoidances' or 'absences', we suggest that social issues are encoded in all of
Monet's paintings, either positively or negatively. Meyer Schapiro argued in 1937 that
early Impressionist paintings, such as those by Monet at Argenteuil, have particular social
and cultural meaning:

> These urban idylls not only present the objective forms of bourgeois recreation in the
> 1860s and 1870s they also reflect in the very choice of subjects and in the new esthetic

devices the conception of art as solely a field of individual enjoyment, without reference to ideas and motives, and they presuppose the cultivation of these pleasures as the highest field of freedom for an enlightened bourgeois detached from the official beliefs of his class. In enjoying realistic pictures of his surroundings as a spectacle of traffic and changing atmospheres, the cultivated *rentier* was experiencing in its phenomenal aspect that mobility of the environment, the market and of industry to which he owed his income and his freedom. And in the new Impressionist techniques which broke things up into finely discriminated points of color, as well as in the 'accidental' momentary vision, he found, in a degree hitherto unknown in art, conditions of sensibility closely related to those of the urban promenader and the refined consumer of luxury goods.

('Nature of abstract art', p.83)

Schapiro's account is indebted to the writings of Marx and Baudelaire on 'Modern experience'. In 'The painter of modern life', Baudelaire had argued that by neglecting the 'transitory, fugitive element' of modernity, you 'inevitably tumble into the void of an abstract and indefinable beauty' (in other words, it could be said, you treat 'aesthetic value', which is historically and culturally contingent, as an absolute and transcending 'essence'). This is clearly a danger for artists. But it is equally so for those who interpret the work of the past: 'If for the necessary costume of the epoch you substitute another, you will be guilty of mistranslation', Baudelaire wrote. We argue that Modernist accounts of the period, as exemplified by the writings of Fry, Bell, Greenberg and Fried, neglect the importance of those social aspects of practice 'whose metamorphoses are so rapid'. We have attempted instead to examine specific social practices of art which represent contradictory aspects of 'modernity', the experiences of those changes brought about by the advent of modernization in an epoch in which 'all that is solid melts into air'. In doing so we have examined some of the methods, questions and problems raised by accounts indebted to the tradition of the social history of art, a tradition with its roots in the nineteenth century, which continues to contribute to current debates and controversies about the meaning of art in modern culture.

References

BAUDELAIRE, C., 'The salon of 1846', in *Oeuvres complètes*.

BAUDELAIRE, C., 'The painter of modern life', 1863, in *Oeuvres complètes*.

BAUDELAIRE, C., *Oeuvres complètes*, Paris, Éditions du Seuil, 1968.

BENJAMIN, W., *Charles Baudelaire: A Lyric Poet in the Era of High Capitalism*, London, Verso, 1983.

BOIME, A., *The Academy and French Painting in the Nineteenth Century*, Oxford, Phaidon, 1971.

BOIME, A., *Thomas Couture and the Eclectic Vision*, New Haven and London, Yale University Press, 1980.

BOURDIEU, P., *Distinction: A Social Critique of the Judgement of Taste*, translated by R. Nice, London, Routledge, 1984.

BOURDIEU, P. and DARBEL, A., *The Love of Art: European Art Museums and their Public*, translated by C. Beattie, and N. Merriman, Cambridge, Polity Press, 1991; extract in Frascina and Harris, *Art in Modern Culture*, pp.172–8.

BRETTELL, R., *Pissarro and Pontoise*, New Haven and London, Yale University Press, 1990.

BROWN, M., 'Manet's *Old Musician*: Portrait of a gypsy and naturalist allegory', in *National Gallery of Art: Studies in the History of Art*, VIII, Washington, 1978, pp.77–87.

BROWN, M., *Gypsies and other Bohemians, The Myth of the Artist in Nineteenth-Century France*, Ann Arbor, UMI Research Press, 1985.

BÜRGER, P., *Theory of the Avant-Garde*, Manchester, Manchester University Press, 1984; extract in Frascina and Harris, *Art in Modern Culture*.

CLARK, T.J., *Image of the People: Gustave Courbet and the 1848 Revolution*, London, Thames and Hudson, 1973.

CLARK, T.J., 'Preliminaries to a possible treatment of *Olympia* in 1865', Screen, vol. 21 no. 1, spring 1980, pp.18–41; edited version in Frascina and Harris, *Art in Modern Culture*, pp.103–118.

CLARK, T.J., *The Painting of Modern Life: Paris in the Art of Manet and his Followers*, London, Thames and Hudson, 1985; edited extract in Frascina and Harris, *Art in Modern Culture*, pp. 38–48.

COURTHION, P. and CAILLER, P. (eds), *Portrait of Manet by himself and his Contemporaries*, translated by M. Ross, London, Cassell, 1960.

DE LEIRES, A., 'Manet, Guéroult and Chrysippos', *Art Bulletin*, 46, 1964, pp.401–4.

EAGLETON, T., *The Ideology of the Aesthetic*, Oxford, Blackwell, 1990.

FAUNCE, S., 'Reconsidering Courbet', in S. Faunce and L. Nochlin (eds), *Courbet Reconsidered*, Brooklyn, The Brooklyn Museum, 1988.

FOUCAULT, M., 'What is Enlightenment?' in P. Rabinow (ed.), *The Foucault Reader*, Harmondsworth, Penguin, 1984.

FRASCINA, F. and HARRIS, J., *Art in Modern Culture: An Anthology of Critical Texts*, London, Phaidon, 1992.

FRIED, M., 'Manet's sources: aspects of his art 1859–1865', *Artforum*, VII, March 1969, pp.29–82.

GREEN, N., 'Circuits of production, circuits of consumption: the case of mid-nineteenth-century French art dealing', *Art Journal*, vol.48, no.1, spring 1989, pp.29–34.

GREENBERG, C., 'Avant-garde and kitsch', *Partisan Review*, vol.vi, no.5, fall 1939, pp.34–49.

HABERMAS, J. *The Theory of Communicative Action*, vol.1: *Reason and the Rationalization of Society*, translated by T. McCarthy, London, Heinemann, 1984.

HAMILTON, G.H., *Manet and his Critics*, New York, Norton, 1969 (first published 1954).

HANSON, A.C., 'Popular imagery and the work of Édouard Manet' in U. Finke (ed.), *French Nineteenth-Century Painting and Literature*, Manchester, Manchester University Press, 1972.

HANSON, A.C., *Manet and the Modern Tradition*, New Haven and London, Yale University Press, 1977.

HARRISON, C. and WOOD, P. (eds), *Art In Theory 1900–1990*, Oxford, Basil Blackwell, 1992.

HERBERT, R., *Impressionism; Art, Leisure and Parisian Society*, New Haven and London, Yale University Press, 1988.

MAINARDI, P., 'The Political Origins of Modernism', *Art Journal*, spring 1985, pp.11–17.

MARX, K., 'The Eighteenth Brumaire of Louis Bonaparte', 1852, in K. Marx and F. Engels, *Selected Works in One Volume*, London, Lawrence and Wishart, 1968.

MARX, K., '*A Contribution to the Critique of Political Economy*, Moscow, Progress Press, 1970 (first published 1859).

MARX, K. and ENGELS, F., 'The manifesto of the Communist Party', 1848, in Marx, K. and Engels, F., *Selected Works in One Volume*, London, Lawrence and Wishart, 1968.

MAUNER, G., *Manet: Peintre-Philosophe: A Study of the Painter's Themes*, University Park and London, Pennsylvania State University Press, 1975.

NOCHLIN, L., (ed.) *Realism and Tradition in Art 1848–1900 Sources and Documents*, Englewood Cliffs, Prentice-Hall, 1966.

NOCHLIN, L., 'Courbet's real allegory: rereading *The Painter's Studio*', in S. Faunce and L. Nochlin (eds) *Courbet Reconsidered*, Brooklyn, The Brooklyn Museum, 1988.

PÉLADAN, J., 'Manet's methods', in Courthion and Cailler (eds), *Portrait of Manet*.

PINKNEY, D.H., *Napoleon III and the Rebuilding of Paris*, Princeton, Princeton University Press, 1972.

POLLOCK, G., 'Modernity and the spaces of femininity', in *Vision and Difference: Femininity, Feminism and the Histories of Art*, London, Routledge, 1988; an edited version is reprinted in Frascina and Harris *Art in Modern Culture*.

REFF, T., 'Manet's sources: a critical evaluation', *Artforum*, VIII, September 1969, pp.40–8.

REFF, T., *Manet and Modern Paris: One Hundred Paintings, Drawings, Prints and Photographs by Manet and his Contemporaries*, Chicago, Washington and London, Universtity of Chicago Press and National Gallery of Art, Washington, 1982.

SCHAPIRO, M., 'Nature of abstract art', *Marxist Quarterly*, vol.1, no.1, January–March 1937, pp.77–98.

SENNET, R., *The Fall of Public Man*, Cambridge, Cambridge University Press, 1977.

SIMMEL, G., 'The metropolis and mental life', in D. Levine (ed.) *Georg Simmel on Individuality and Social Forms*, Chicago, University of Chicago, 1971; an edited version is reprinted in Harrison and Wood, *Art in Theory 1900–1990*.

TOUSSAINT, H., 'The dossier on *The Studio* by Courbet' in *Gustave Courbet 1819–1877*, London, Royal Academy of Arts Exhibition Catalogue, 1978.

TUCKER, P., *Monet at Argenteuil*, New Haven and London, Yale University Press, 1982.

TUCKER, P., *Monet in the 90s*, New Haven and London, Yale University Press, 1990.

WEBER, M., 'Religious rejections of the world and their directions', in H.H. Gerth and C. Wright Mills (eds) *From Max Weber: Essays in Sociology*, London, Routledge, 1991 (first published 1915).

WEBER, M., *The Protestant Ethic and the Spirit of Capitalism*, translated by T. Parsons, London, Allen and Unwin, 1930 (first published 1904–5); an extract is reprinted in Harrison and Wood *Art in Theory 1900–1990*.

WILLIAMS, R., 'Culture is ordinary', in *Resources of Hope*, London, Verso, 1989.

WILLIAMS, R., 'When Was Modernism?', *New Left Review*, no.175, May/June 1989, pp.48–52; reprinted in Frascina and Harris, *Art in Modern Culture*, pp.21–25.

WOLFF, J., 'The invisible *flâneuse*: women and the literature of modernity', *Theory, Culture, Society*, vol.2, no.3, 1985, pp.37–46.

ZELDIN, T., *France 1848–1945: Politics and Anger*, Oxford, Oxford University Press, 1979.

CHAPTER 2
IMPRESSIONISM, MODERNISM AND ORIGINALITY
by Charles Harrison

Introduction

This chapter will be principally concerned with the style of art known as Impressionism, and with developments in French painting which ensued during the 1880s and 1890s. The paintings of the Impressionists are generally popular and well known. This is more than can be said for many other typical works of modern art. Yet the paintings we shall be considering have played a particularly important part in the formation of various notions and theories of modernism in art. In the process of discussing them we shall be concerned

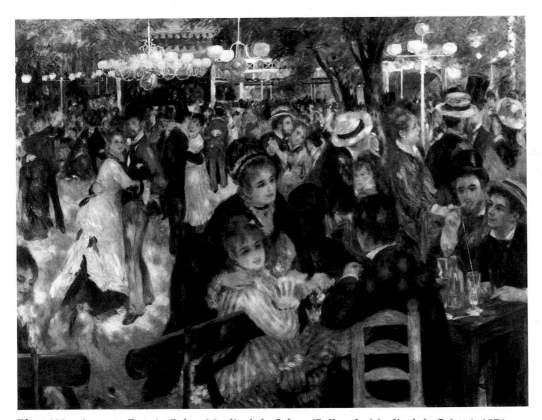

Plate 132 Auguste Renoir, *Bal au Moulin de la Galette* (*Ball at the Moulin de la Galette*), 1876, oil on canvas, 131 x 175 cm. Musée d'Orsay, Paris. Photo: Réunion des Musées Nationaux Documentation Photographique. (Exhibited in the third Impressionist exhibition, 1877.)

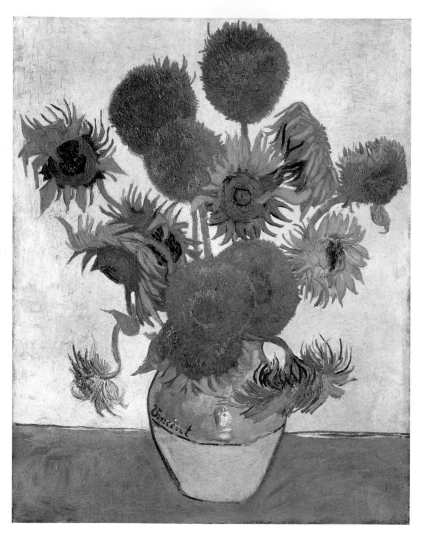

less with the history of modern art as such than with the development of a certain set of critical values, those generally referred to as 'Modernist'. It does not follow, however, that the paintings themselves will be treated as objects of secondary interest. On the contrary, to ask whether the properties and qualities ascribed to a work of art are actually discernible in it is to make that work the specific focus of an open inquiry. For what we mean by the term 'works of art' are not necessarily things that we can simply see and know 'for themselves' or 'in themselves'. Rather they are present to us in a world of ideas, theories, values and beliefs, and are inseparable from those.

In fact, I suspect that there will be very few people reading these words who have not *already* been exposed to relevant judgements and interpretations in some form. I mean that most readers of texts like this one are likely, at the very least, to have read about the high prices paid at auction for Impressionist and 'Post-Impressionist' paintings, to have absorbed reports of Van Gogh's madness or Cézanne's obsessiveness, and to have acquired views, however uninformed, on Renoir's pictures of women, and that even these are forms of exposure to judgements and interpretations; I also mean that the values placed upon these artists and their works over the course of a century have had consequences within a wider field of attitudes and beliefs. Monet's paintings of sunlight on water (Plates 155,

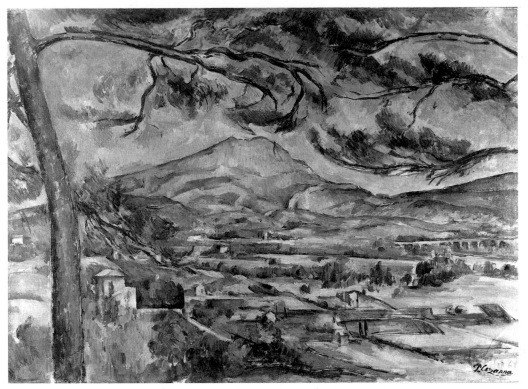

Plate 134 Paul Cézanne, *Mont Sainte-Victoire*, *c.*1886–88, oil on canvas, 66 x 90 cm. Courtauld Institute Galleries, London. Reproduced by permission of the Home House Trustees.

156) and Renoir's Parisian women (Plates 132 and 154) have each furnished powerful models of delight and picturesqueness in the modern experience of the visual world.

These are values we may tend to take for granted. Yet the values and meanings we take for granted can be the hardest to examine critically. The supposedly 'innocent' or un-theorized view is likely to be one in which certain stereotypes are reproduced as if they were the fruit of 'direct' and 'personal' experience – one that claims, for example, to find Van Gogh's 'madness' in his agitated brushwork (Plate 133) and Cézanne's obsessiveness in his repeated views of the same landscape subjects (Plates 134 and 135). French painting of the late nineteenth century has been a particularly fertile breeding-ground for the myths of modern art. The way to achieve some independence from these myths and stereotypes is not to avoid exposure to the accumulation of judgements and interpretations, since a state of complete insulation is impossible, but to acknowledge the ways in which the accumulation itself may condition the experience of the work. Once we have a conscious sense of that accumulation we can try to see through it, in both senses of seeing through: we can look at the art in the ways that established forms of judgement and interpretation suggest that we should, and we can also expose those judgements and interpretations themselves to scrutiny, the better to perceive the ways in which they may be partial or otherwise fallible. In what follows, I shall consider some of the circumstances under which the image of modern art was formed and developed in criticism and will examine some of the assumptions associated with that image. Taking the first exhibition of the Impressionists as a starting point, I shall try to trace a series of pathways into the art-criti-cal and art-historical issues of the twentieth century, using as principal material for dis-cussion the work of four of the original exhibitions.

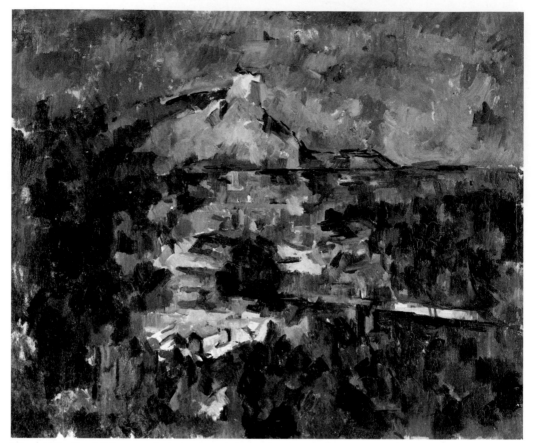

Plate 135 Paul Cézanne, *La Montagne Sainte-Victoire*, 1904–6, oil on canvas, 60 x 72 cm. Öffentliche Kunstsammlung Basel, Kunstmuseum Basel Inv. G.1955.12.

Impression and Impressionism

In the 1870s the concept of art as 'impression' was associated with a 'modern' recognition of the inescapably subjective aspects of perception and experience. It was also associated with those stylistic characteristics in painting through which a personal and spontaneous vision was supposed to be expressed. An 'impressionist' in this sense was one in whose work a certain informality of technique appeared to reveal a vision of the natural world which was both instantaneous and individual. The label became associated with a specific movement in 1874, when it was applied to a group of artists showing together as 'independents' – that's to say showing independently of the official Salon. Though the label was used by some writers to deride the artists,[1] there were those, like Jules Castagnary, who employed it to signal a sympathetic understanding of the work on show:

> What quick intelligence of the object and what amusing brushwork! True, it is summary, but how just the indications are! ... The common concept which unites them as a group and gives them a collective strength in the midst of our disaggregate epoch is the determination not to search for a smooth execution, to be satisfied with a certain general aspect. Once the impression is captured, they declare their role terminated ... If one wants

[1] Notably by Louis Leroy in a now notorious review published in *Le Charivari*, 25 April 1874.

to characterize them with a single word that explains their efforts, one would have to create the new term of *Impressionists*. They are impressionists in the sense that they render not a landscape but the sensation produced by a landscape.

(*Le Siècle*, 29 April 1874, as translated in L. Nochlin, *Impressionism and Post-Impressionism*, pp.329–30)

The exhibition in question – the first exhibition of the newly-formed 'Société anonyme des artistes, peintres, sculpteurs, graveurs, etc.,' – has come to be known as the 'First Impressionist Exhibition', although the group did not formally adopt the name for themselves until their third exhibition, in 1877. It has also been celebrated in modern art history as the moment of self-conscious establishment of an avant-garde – 'the touchstone for all such future Modernists' efforts' (P. Tucker, 'The first exhibition in context', p.93). Given that avant-gardism is traditionally associated with a hostile critical reception, it should be stressed that by the early 1870s dissent from the decorum of the official Salon was well established among writers like Castagnary, Ernest Chesneau and Émile Zola, whose interests had been aroused by the Realism of Courbet, by the naturalism of the Barbizon painters, or by the 'modernity' of Manet. By 1874, all but the most conservative critics were aware that the criteria of finish prevailing at the Salon – for instance, the 'smooth execution' mentioned by Castagnary – were tending to stultify the development of painting. Independence and originality had come to be accorded dominant positions in the hierarchy of progressive critical concepts, and interested writers looked for signs of these qualities in those techniques that suggested directness of observation and spontaneity of expression.

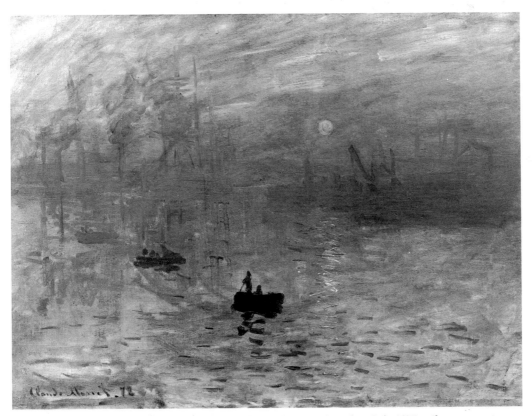

Plate 136 Claude Monet, *Impression, soleil levant* (*Impression, Sunrise*), 1872, oil on canvas, 50 x 62 cm. Musée Marmottan, Paris. Photo: Routhier/Studio Lourmel. (Exhibited in the first Impressionist exhibition, 1874.)

Plate 137 Alfred Sisley, *Scieurs de long* (*Pit Sawyers*), 1876, oil on canvas, 50 x 65 cm.
Petit Palais, Paris. Photo: Pierrain, Musées de la Ville de Paris © SPADEM, Paris 1993, DACS,
London 1993. (Exhibited in the third Impressionist exhibition, 1877.)

By the mid-1870s a network of connections had developed between the notions of
avant-gardism, technical improvization, modernity and originality. Castagnary, a cham-
pion of Realism in the 1860s, believed that painting was 'a part of the social
consciousness', but he also believed that some people 'saw' more clearly than others: the
true artist was someone in close touch with nature and more immediately responsive to
sensation than the majority of people. To be 'original' was to offer a (relatively) faithful
representation of the material origins of perception and experience in the actual world. It
was a small step from this position to the view that to be 'original' was to be able to per-
ceive, to face and to show 'truths' hidden from or disregarded by contemporary society at
large. Fidelity to the authentic and subjective impression thus came to be viewed not only
as a measure of the 'originality' of the avant-garde artists, but also as a condition of their
modernity.

The exhibition that Castagnary was discussing included all those artists who have
consistently and uncontroversially been associated with the development of an
'Impressionist' style in the late 1860s and early 1870s: Claude Monet (Plate 136), Pierre-
Auguste Renoir (Plate 132), Camille Pissarro (Plate 149), and Alfred Sisley (Plate 137). It
also included artists of established importance in the history of modern art whose work is
less securely identified with Impressionism as a specific painterly style: Edgar Degas
(Plate 138) and Berthe Morisot (Plate 139) – both of whom showed in seven of the eight
group exhibitions – and Paul Cézanne who showed in two of the first three. (Renoir and
Sisley showed in four.) By no means all the artists involved were as well-known as these
have become. In all, thirty artists were represented in the first exhibition and fifty-five con-
tributed to the group shows at one time or another, Paul Gauguin, Georges Seurat (Plates

186 and 187) and Odilon Redon (Plate 140) among them. But we now hear comparatively little of Stanislas-Henri Rouart (Plate 141), a wealthy engineer and part-time painter, who showed in as many of the group exhibitions as Degas and Morisot, or of Adolphe-Félix Cals, who showed in the first four (Plate 142), let alone of those who appeared only once, like Auguste de Molins (Plate 143).

With the benefit of hindsight we tend to accept that the standards and grounds of selection by which Salon exhibitions were regulated in the later nineteenth century were such as to make the virtues of the most technically adventurous Impressionist painting unrecognizable or inadmissible as such, but it would be a ludicrous over-simplification to suggest that only conservative and retrograde art was shown at the Salon, while all that was shown in the independent exhibitions was progressive and of abiding quality. Nor can we say that all those who dissociated themselves from the Salon were necessarily distinguished in terms of the quality of their work. While the historical emergence of the avant-garde was certainly associated both with the increasing conservatism of the Salon and with the critical distinctness of the more 'modern' work, that distinctness – or quality – cannot be defined *simply* by contrast with the run-of-the-mill offerings of the Salon. The idea of an independent exhibition was clearly also attractive to some relatively conservative artists who were accustomed to seeing their work admitted to the Salon. So the desire for independent exposure was not simply a consequence of exclusion on stylistic grounds. Apart from anything else, though many of the Impressionist exhibitions were relatively substantial (165 works in the first, 250 in the second, the rest falling between these totals) they were a fraction of the size of the Salons, in which smaller works in particular were likely to go unnoticed unless they were identified with established names. It also needs to be borne in mind that the great majority of the wider Impressionist group – and some of those most often celebrated as 'moderns' – continued to seek admission to the Salon during the 1870s and 1880s, and for the most part with some reward. This was a

Plate 138 Edgar Degas, *Blanchisseuse, silhouette (Laundress, Silhouette)*, known as *A Woman Ironing*, c.1874, oil on canvas, 54 x 39 cm. All Rights Reserved. The Metropolitan Museum of Art, New York; bequest of Mrs H.O. Havemeyer, 1929, the H.O. Havemeyer Collection (29.100.46). (Exhibited in the second Impressionist exhibition, 1876.)

Plate 139 Berthe Morisot,
Cache-cache (*Hide and Seek*),
1873, oil on canvas, 45 x 55 cm.
Collection of Mrs John Hay
Whitney, New York. (Exhibited
in the first Impressionist
exhibition, 1874.)

matter over which the Impressionists themselves were divided. Renoir in particular was assiduous in pursuit of success in the Salon, while Pissarro kept aloof. Clearly the desire for independence was not straightforwardly a matter of principle – or rather, in so far as it *was* a matter of principle, the principle was not one to which all members subscribed. Nor were the Impressionists the only artists to collaborate on exhibitions outside the Salon in the 1870s and 1880s.

Impressionism and art history

To talk about 'Impressionism', as I have suggested, is inevitably to raise questions about the grounds on which canonical status is accorded in modern art. In talking of the Impressionists as a group we tend to refer to many more contributing individuals than those whose work is normally used to define an Impressionist style. In what terms, then, have the latter been singled out? What is it that qualifies Monet, Renoir, Pissarro and Sisley as the definitive representatives of Impressionism? If the answer is that their work is joined by common features not present in the work of others, could we not object that a richer and less exclusive understanding of the style might be achieved by taking into account the work of Degas, or Morisot, or Cézanne, or of Rouart, or Cals, or de Molins? And does this objection itself have the same meaning or weight in the case of Degas (a 'major' artist whose work is on the whole technically dissimilar to that of Monet or Pissarro), as it does in the case of, say, Cals (a 'minor' artist whose exhibited work looked stylistically like some of Monet's or Pissarro's)? Questions like these invite us to consider to what ends the concept of Impressionism has been used by critics and art historians, i.e. what forms of art have been singled out and why?

For some while the prevailing tendency of art-historical work has been to restore some complexity to terms such as Impressionism and Post-Impressionism, both by re-examining the practical and historical contexts in which such terms achieved currency, and by generating awareness of those wider prejudices and mechanisms of exclusion in which art history is liable to be implicated. 'Women Impressionists' and 'Forgotten

Plate 140 Odilon Redon, *Profil de Femme* (*Profile of a Woman*), known as *Profil de Lumière*, 1886, pastel, 34 x 24 cm. Petit-Palais, Paris. Photo: Pierrain, Musées de la Ville de Paris © SPADEM, Paris 1993, DACS, London 1992. (Exhibited in the eighth Impressionist exhibition, 1886.)

Impressionists' have featured among the topics of recent art-historical study and publication. One aim of such studies has been to correct the normal tendency to concentrate upon a limited canon of supposedly 'major' figures. The concept of 'originality', on the other hand, has been powerfully associated with the formation of a modern artistic canon and it has been art-historically out of favour for a while. Clearly, when employed as an evaluative term, it can be used as a means to restrict the canon, and by implication to disparage those deemed followers or late-comers. In this chapter, I aim to encourage a self-critical awareness about the ends to which evaluative terms are used, but it is not a primary objective that the chapter should offer a revision of the established art-historical canon. Rather I mean to discuss some thoroughly canonical examples of Impressionist and of 'Post-Impressionist' painting and to inquire into the art-historical and art-critical grounds of their supposed originality, modernity and quality. We shall be concentrating upon aspects of the work of Claude Monet and Paul Cézanne, with some discussion of the work of Pierre-Auguste Renoir and Camille Pissarro. We shall also look at some paintings from the 1880s which treat of explicitly human and social themes.

Monet and Renoir figure centrally in all accounts of the Impressionist movement. Monet was closely involved in the setting-up of the independent group and he showed in the first four exhibitions and in the seventh. His *Impression, Sunrise* (Plate 136), shown in the first group exhibition, appears to have played a significant part in establishing the movement's public identity. Renoir was also important in the group's inception, and much of its early critical support followed from his friendship with the writer Georges Rivière. He showed in the first three exhibitions, and was included in the seventh, but he remained ambitious for exposure in the Salon and his commitment to the group waned as he acquired wealthy patrons.

Plate 141 Stanislas-Henri Rouart, *Melun* or *La terrasse au bord de la Seine à Melun* (*The Terrace beside the Seine at Melun*), *c.*1880, oil on canvas, 46 x 65 cm. Musée d'Orsay, Paris. Photo: Réunion des Musées Nationaux Documentation Photographique. (Exhibited in the fifth Impressionist exhibition, 1880.)

Plate 142 Adolphe-Félix Cals, *Paysage à Saint-Siméon* (*Landscape at Saint-Siméon*), known as *Landscape with figures*, 1876, oil on canvas. The John G. Johnson Collection, Philadelphia Museum of Art. (Exhibited in the third Impressionist exhibition, 1877).

Plate 143 Auguste de Molins, *The Coming Storm*, 1874, oil on canvas, 35 x 55 cm. Private collection, Lausanne. (Exhibited in the first Impressionist exhibition, 1874.)

Pissarro was the only artist to show in all eight of the group exhibitions. He also helped to establish the style which gave Impressionism its name, and was subsequently closely involved with younger artists, Cézanne and Gauguin among them, for whom Impressionism was a significant transitional phase.

Cézanne showed only in the first exhibition and in the third. A dominant critical tradition has tended to represent him as the most important of the Post-Impressionists. This designation is not one used by the artists concerned – it was coined in 1910 on the occasion of an exhibition of 'Manet and the Post-Impressionists', organized by Roger Fry in London, and has been much used since then. The implication of the term is that the true current of Modernist development flowed directly from Manet to Cézanne, Gauguin and Van Gogh, bypassing the Impressionists, and thus that Cézanne's work represents a stage of development in modern art *beyond* that with which Monet is associated, though Monet died twenty years after Cézanne, in 1926. To the American writer Sheldon Cheney, for example, Monet's Impressionism was 'typical of the last phase of realism', whereas Cézanne 'put an end to the four-centuries reign of imitativeness in painting' (*A Primer of Modern Art*, p.80). Cheney's *A Primer of Modern Art* was first published in 1924. By the time of its revision in 1939 it had already received ten printings, which suggests that it was an accepted and influential text among those interested in modern art. The point I mean to stress is that to consider the work of these artists is also to consider how the image of a modern art was formed by reference to late nineteenth-century French painting, and how this image has developed in the West over the past century. Before going any further, therefore, I would like to examine one specific moment in the formation of that image: a moment explicitly associated with the work of Cézanne, or, to be precise, with a certain *critical response* to his work.

'Significant form'

The Doctor (Plate 144) is a painting by the English artist Luke Fildes. It was exhibited in the Royal Academy in 1891. This is what one notable critic had to say about the painting. He has just finished denigrating another English painting, William Powell Frith's immensely popular *Paddington Station* (Plate 145), which he regarded as an example of a kind of anecdotal and documentary painting now 'grown superfluous' in face of the rise of photography:

> Still [such pictures] are not unpleasant, which is more than can be said for the kind of descriptive painting of which *The Doctor* is the most flagrant example. Of course, *The Doctor* is not a work of art. In it form is not used as an object of emotion, but as a means of suggesting emotions. This alone suffices to make it nugatory; it is worse than nugatory because the emotion it suggests is false. What it suggests is not pity and admiration but a sense of complacency in our own pitifulness and generosity. It is sentimental. Art is above morals, or rather all art is moral because works of art are immediate means to good. Once we have judged a thing a work of art, we have judged it ethically of the first importance and put it beyond reach of the moralist. Not being a work of art, *The Doctor* has none of the immense ethical value possessed by all objects that provoke aesthetic ecstasy; and the state of mind to which it is a means, as illustration, appears to me undesirable.
> (Bell, *Art*, pp.19–20)

The writer is Clive Bell. The passage quoted is taken from his book *Art*, published in London in 1914. I want to explore the reasons for the evident strength of Bell's feelings. Apparently, the matter turns upon the question of form – the artist's use of it and the spectator's response to it. Bell employs the concept of 'form' in a special way. In fact his theory

Plate 144 Luke Fildes, *The Doctor*, exhibited 1891, oil on canvas, 166 x 242 cm. Tate Gallery, London.

Plate 145 William Frith, *The Railway Station* (*Paddington Station*), 1862, oil on canvas, 117 x 257 cm. Reproduced by permission of Royal Holloway and Bedford New College, University of London.

of art rests on a distinction between two *kinds* of form. There is form which is descriptive and which imitates the appearance of things in the world, and there is what he elsewhere calls 'significant form' – 'lines and colours combined in a particular way, certain forms and relations of forms [which] stir our aesthetic emotions' (*Art*, p.15). Clearly, all works of art, except those we call abstract, derive their formal characteristics to some extent from the appearance of things in the world. But Bell wants to distinguish between works which use these appearances *persuasively*, to 'suggest emotion' (*Art*, p.8), and those which use them 'aesthetically' – by which he means in a disinterested fashion:

> Let no one imagine that representation is bad in itself; a realistic form may be as signifi-
> cant, in its place as part of the design, as an abstract. But if a representative [or illustrative]
> form has value, it is as form, not as representation. The representative element in a work
> of art may or may not be harmful; always it is irrelevant. For, to appreciate a work of art
> we need bring with us nothing from life, no knowledge of its ideas and affairs, no
> familiarity with its emotions. Art transports us from the world of man's activity to a world
> of aesthetic exaltation.
>
> (*Art*, p.25)

Bell overstates his case. There cannot be appreciation without *some* form of knowledge, nor can it be *entirely* irrelevant that a picture of a tree is a picture of a tree and not of a steam-engine. Furthermore we would now be far less inclined to collapse together 'representative' or representational form and realistic form (to put it crudely, form may represent without being realistic) and then to contrast both with the abstract. But one important point may be extracted from Bell's admonitions: neither the meaning nor the value of a work of art can simply or safely be identified with what it depicts or with the story it tells. All things being equal, a picture of the decline of the Roman Empire is not necessarily better or more meaningful – as a *work of art* – than a picture of a pair of boots. Beneath the surface of Bell's argument there lies a quarrel with the kinds of priorities observed in both the French Salon and the English Academy. He is attacking the idea that a fixed hierarchy of genres can plausibly be established on the basis of subject-matter, with moralizing history painting accorded the highest status. The skills that matter, he is saying, are not those involved in the production of recognizable likenesses, the elaboration of

intriguing narratives or the interpretation of moral themes. These lead all too often, he implies, to the mere prompting of such emotions and prejudices as are already present in our social and psychological make-up. In Bell's view the important achievements of art are those which present us with something *other*, something which stands outside ourselves by virtue of the self-sufficiency of its form, which is original in the sense that it is the *origin* – the primary cause – of our responsive emotion (hence his belief that we need bring no prior knowledge of 'life' to our experience of art). For Bell, it is in this sense that works of art are 'means to good': they require of us that we recognize that which is other than ourselves; or, to put it another way, they require that we do not take them as confirmation of the rightness of our beliefs and attitudes, or as evidence of the unquestionable validity of our experience, but that we respond to them *aesthetically*.

Bell's is a partisan form of criticism. He clearly saw the issues as substantial and he invited the reader to take sides. He and his friend Roger Fry were largely responsible for propagandizing the modern movement in art to an English audience (and to an American audience, via those authors like Sheldon Cheney who read their books and who absorbed their ideas). Bell's *Art* was to stay in print throughout the 1920s and 1930s. A new edition was issued in 1949 and a paperback edition was published in 1987. Its easy progress from manifesto of avant-garde opinion to acknowledged art-historical document tells us something about its place within a tradition.

Art is one of a distinct group of publications produced over a period of some twenty-five years in France, Germany, England and America, the common aim of which was to characterize and to proselytize a modern movement in art. The writings of the French painter-critic Maurice Denis were an important source for the critical protocols of early Modernism, as we can now label the tendency to which these various publications belonged and which they helped to form. Denis's essay on Cézanne, first printed in 1907, was translated into English by Roger Fry and was published in the *Burlington Magazine* in 1910. His collected essays were published as *Théories 1890–1910* in 1912. The first substantial book claiming to survey modern art as a whole was published by the German writer Julius Meier-Graefe in 1904 (first English translation as *Modern Art*, in 1908). Other relevant publications include Fry's own collected essays *Vision and Design* (published in London in 1920, it was continuously in print throughout the 1920s and 1930s; a Pelican edition was printed 1937, reprinted 1961, and a new edition was published in 1981). Cheney's *Primer* has already been cited; R. H. Wilenski's *The Modern Movement in Art* was first published in London in 1927 (revised edition 1935) and Amédée Ozenfant's *Foundations of Modern Art* appeared in Paris in 1928, in London in 1931, and in New York in 1952. Each of these publications was concerned to propagandize a break with the past, each represented the distinctive character of modern art as the sign and the qualitative measure of an epochal change, each associated that character with an abandonment of naturalistic description and anecdote, each drew attention to the virtues of the 'primitive', and each accorded Cézanne a pivotal role.

Such works both testified and contributed to the development of a relatively specific system of beliefs about modernism in art during the first three decades of the twentieth century. With the benefit of hindsight we can say that they represent a specific phase in the development of an ideology of Modernism. If the tradition of critical priorities did not emerge coincidentally with the art of Manet and the Impressionists (and various cases have been made for tracing it back further, in some instances well into the eighteenth century), the authority of that tradition during the twentieth century was certainly associated with the international success of modern French art. The success of the art appeared to be both an achievement and a validation of the critical tradition. The status of Cézanne's work in particular is central to Modernist accounts of the nature of quality in art and of virtue in artistic practice. In addition to the publications cited above, Fry published a

monograph on Cézanne in 1927. Five years earlier Bell had issued his collected essays on recent art under the title *Since Cézanne*. Here is Bell on Cézanne:

> In so far as one man can be said to inspire a whole age, Cézanne inspires the contemporary movement … Cézanne is the Christopher Columbus of a new continent of form … The period in which we find ourselves in the year 1913 begins with the maturity of Cézanne (about 1885) …
>
> (*Art*, p.207)

And here is Cheney:

> … Cézanne is really the first epochal figure since El Greco … of this much I am sure: some rewriting of history is becoming necessary as the world gradually accepts Cézanne's achievement as a turning point in art development, as it becomes apparent that for hundreds of years photography[2] has been a false god among painters and sculptors.
>
> (*A Primer of Modern Art*, p.30)

We may note that when Cézanne was featured in the first of Fry's two 'Post-Impressionist' exhibitions in 1910, three years after his death, the great majority in the English art world treated his supporters as if they had taken leave of their senses. It was to be over twenty years before any work by Cézanne was displayed in an English public collection. If we allow for the fact that *Art* was written in the grip of an enthusiasm for Cézanne's work (Plate 146), it may be easier to understand the vehemence of Bell's condemnation of *The*

2 Cheney means a 'photographic' criterion of likeness.

Doctor. The requirement that the Modernist makes of art is that instead of *illustrating* moral themes it should be pursued as a form of sceptical and self-questioning activity in itself, without the aid of narrative. Writing at a much later stage in the development of the Modernist tradition, in 1965, the American critic Michael Fried claimed that modern art has 'taken on more and more of the denseness, structure and complexity of moral experience – that is, of life itself, but life lived as few are inclined to live it: in a state of continuous intellectual and moral alertness' ('Three American Painters', pp. 9–10). This is the form of (ideal) life and these the values that the likes of Bell saw half a century earlier as exemplified in the carefully worked surfaces of Cézanne's paintings. In the view of the Modernist, the process of painting involves an exemplary struggle to maintain quality in experience. The ethical obligation on the artist is to examine what he or she has done and to do whatever is needed to improve its *formal* quality – which is to say, the quality of its effect on the spectator. The measure of success in this struggle is aesthetic: the achievement of a work of art which is both original and formally self-sufficient.

On the question of this self-sufficiency – or autonomy – one important distinction needs to be made. The tendency of Modernist criticism is to treat the experience of art as an experience of value in and for itself – an experience independent of the 'emotions of life'. That it offers the opportunity for such independent experience is seen as the sign of quality in the individual work of art. It does not follow, however, that critics of a Modernist persuasion have seen the *making* of art as an activity independent of social or historical life. To say that one finds meaning or value in the form of any artefact – considered as a *human* artefact – is to imply that its production has involved some ordering of experience.

Plate 147 Gustave Caillebotte, *Le Pont de l'Europe*, 1876, oil on canvas, 125 x 181 cm. Petit Palais, Geneva. (Exhibited in the third Impressionist exhibition, 1877.)

It is to presuppose some relatively normal background of existence from which this particular object of attention has been detached. Indeed, I suggest that in noticing form in art, it is this very ordering of experience – this detachment – that we are really responding to. It is this response that connects judgements of formal integrity in works of art – aesthetic judgements – to those kinds of judgement about human experience and action which we call ethical. Of course, to say that there must be some such connection is to leave open the question of *how* the ordering of people's experience takes form as art.

Depth, flatness and self-criticism

The concepts of 'depth', 'flatness' and 'self-criticism' are central to Modernist criticism. I'd like to use a comparison in order to connect these critical concepts to developments in the Modernist tradition associated with the writings of Clement Greenberg. Caillebotte's *Le Pont de l'Europe* and Monet's painting of the same title (Plates 147 and 148) were both

Plate 148 Claude Monet, *Le Pont de l'Europe, Gare Saint-Lazare* (sometimes known as *Le Pont de Rome*), 1877, oil on canvas, 64 x 81 cm. Musée Marmottan, Paris; bequest of Madame Donop de Monchy. Photo: Routhier/Studio Lourmel. (Exhibited in the third Impressionist exhibition, 1877.)

Plate 149 Camille Pissarro, *La Côte des boeufs à l'Hermitage, près de Pontoise* (*The Côte des boeufs at l'Hermitage near Pontoise*), 1877, oil on canvas, 115 x 87 cm. The National Gallery London. Reproduced by permission of the Trustees. (Exhibited in the Third Impressionist exhibition.)

shown in the third exhibition of the Impressionist group in 1877. This was the first exhibition in which the members of the group identified themselves as 'Impressionist painters' and, with the total number of exhibitors reduced to eighteen, it provided the most coherent display of work by the principal contributors to the movement: Gustave Caillebotte, Paul Cézanne, Edgar Degas, Claude Monet, Berthe Morisot, Camille Pissarro (Plate 149), Pierre-Auguste Renoir and Alfred Sisley.

Caillebotte showed only five works, but two of them, *Paris Street: A Rainy Day* (Plate 150), and *Le Pont de l'Europe* (Plate 147), were large paintings of urban 'modern-life' subjects set on intersections close to the Gare St-Lazare, in an area of Paris which had been partially affected by Haussmann's reorganization of the city. Thirty works by Monet were listed in the catalogue, including six scenes of the Gare St-Lazare, together with his *Pont de l'Europe*, which shows a view from the end of one of the station platforms where the bridge crosses the railway tracks. (The bridge is a complex structure built in 1868 over the tracks where three streets intersect. The small engine at the extreme right of Caillebotte's painting coincides approximately with the viewpoint of Monet's.) Caillebotte's *Pont de l'Europe* attracted considerable comment. One reviewer noted that 'his figures are firmly set down; the perspective is good; and his paintings have space, a great deal of it' (quoted in *The New Painting*, p.208). Its apparent spatial depth is indeed a remarkable feature of the painting. It is of a kind which invites the spectator to enter it, to engage in appropriate imaginative activity and perhaps to accord a fictional life to the represented figures it contains – as with Fildes' painting, though in a very different kind of context. This was an invitation to which contemporary commentators were quick to respond:

> A young dandy walks past an elegant woman, exquisite beneath her flecked veil, a common little vignette that we have all observed with a discreet and benevolent smile …
>
> (*L'Homme libre*, 12 April 1877, quoted in *The New Painting*, p.210)

The main figure is the painter himself, chatting with a very pretty woman close at hand (another portrait no doubt). Our compliments, Caillebotte ... you must have had some very happy *impressions* that day.

(*L'Événement*, 6 April 1877, quoted in *The New Painting*, p.210)

Clearly the reviewers were at home with this painting. They were able to demonstrate the relevant accomplishments by playing the game of 'reading-in' and they could be both knowing and condescending about the supposed pleasures of the *flâneur* – pleasures which they associated with the distinctive character of 'modern life' (if not with Modernism as later critics were to define it). Another writer paid the artist a doubtful compliment:

Caillebotte is an Impressionist only in name. He knows how to draw and paints more seriously than his friends. *Le pont de l'Europe* and *Une rue de Paris, par un jour de pluie* ... deserve all possible critical praises.

(*La Petite République française*, 10 April 1877, quoted in *The New Painting*, p.209)

Despite this implied slur, Monet's painting was also accorded its share of praise. In fact, by 1877 the more representative work of the Impressionist group was receiving a measure of relatively informed and sympathetic attention. The most revealing comment, however, was a pejorative one made by a reviewer writing in *Le Gaulois* under the name Léon de Lora. Monet's *Pont de l'Europe*, he wrote, 'is not without merit but utterly lacks any attraction' (quoted in *The New Painting*, p.224). What this reviewer meant, I suspect, was

Plate 150 Gustave Caillebotte, *Rue de Paris: Temps de pluie* (*Paris Street: A Rainy Day*), 1877, oil on canvas, 212 x 276 cm. The Art Institute of Chicago. Charles H. and Mary F.S. Worcester Collection 1964.336 © 1990 The Art Institute of Chicago. All Rights Reserved. (Exhibited in the third Impressionist exhibition, 1877.)

that the painting failed to attract the attention of the writer *as a writer*. In front of Monet's painting the usual game could not be played to advantage. Many of the reviewers did try. Writing of Monet's *Interior of the Gare Saint-Lazare* (Plate 151), Renoir's friend Georges Rivière, writing in *L'Impressioniste* on 6 April 1877, claimed with a proto-Futurist enthusiasm: 'We hear the shouts of the workers, the sharp whistles of the engines blasting their cry of alarm, the incessant noise of scrap-iron, and the formidable panting of the steam' (quoted in *The New Painting*, p.223). But the average reviewer's customary skills were not so easily deployed in the construction of a literary equivalent – a kind of story. In place of the expected invitation to 'read-in', what they encountered was a surface, palpably covered with swirls and touches of paint. What was required if Monet's painting was to be written about sensibly was not an arch display of familiarity with the manners of the street, as offered by the critics of Caillebotte's painting, but rather an account of what it looked like as a painting. The problem was that the construction of such an account would require different competences from those with which the typical *writer* was equipped in 1877. For instance it would require a different understanding of the relationship between painting and language – an understanding which acknowledged the *limits* of language as a means of representation of visual experience. To put the matter bluntly, an encounter of the kind Caillebotte represents in his picture would be a technical anomaly in the context of Monet's, just as Jacques's 'discreet and benevolent smile' would clearly be inappropriate as a form of response on the part of the spectator. Rivière's sympathetic imaginings were intended to persuade readers of the virtues of Monet's work, but even *his* prose stood, as it were, some distance to the side of the painting. It is in the nature of the surface of Monet's painting that it acts as a form of barrier, tending to exclude both the anecdotal subject and the practised literary response.

For Clive Bell and the other Modernist critics of the early twentieth century, this double exclusion was a symptom of the relative virtue of the art:

> … if in the artist an inclination to play upon the emotions of life is often the sign of a flickering inspiration, in the spectator a tendency to seek, behind form, the emotions of life is a sign of defective sensibility always. It means that his aesthetic emotions are weak or, at any rate, imperfect.
>
> (*Art*, pp. 28–9)

In fact Bell, like Cheney, regarded Monet's Impressionism as still too naturalistic to be aesthetically 'perfect'. He saw it as too closely tied to the actual appearance of things in the world and to the impression made by such things upon the senses, and not sufficiently independent in its pursuit of that formal integrity and richness which he found so amply exemplified in Cézanne's painting. We can see clearly enough, however, that the kinds of 'emotions of life' attributed to Caillebotte's painting are very much harder to associate with Monet's (compare Plates 152 and 153).

The relevant technical difference can be thought of in terms of a contrast defined by Clement Greenberg, writing in 1961 at a much later stage in the development of the Modernist critical tradition, by which time Impressionism had been accorded its current status as a crucial stage in the development of modern art.

> The Old Masters had sensed that it was necessary to preserve what is called the integrity of the picture plane; that is, to signify the enduring presence of flatness under the most vivid illusion of three-dimensional space. The apparent contradiction involved – the dialectical tension, to use a fashionable but apt phase – was essential to the success of their art, as it is indeed to the success of all pictorial art. The Modernists have neither avoided nor resolved this contradiction; rather they have reversed its terms. One is made aware of the flatness of their pictures before, instead of after, being made aware of what that flatness contains. Whereas one tends to see what is *in* an Old Master before seeing it as a picture, one sees a Modernist painting as a picture first. This is, of course, the best way of

Plate 151 Claude Monet, *Intérieur de la Gare Saint-Lazare* (*Interior of the Gare Saint-Lazare*), 1877, oil on canvas, 75 x 104 cm. Musée d'Orsay, Paris RF 2775. Photo: Réunion des Musées Nationaux Documentation Photographique. (Exhibited in the third Impressionist exhibition, 1877.)

seeing any kind of picture, Old Master or Modernist, but Modernism imposes it as the only and necessary way, and Modernism's success in doing so is a success of self-criticism.

('Modernist Painting', p.6)

Greenberg's concept of 'self-criticism' is crucial to his account of how and why painting changes. The concept as he employs it refers to the ability of a discipline or practice to acknowledge its own proper limits, and to proceed within them. To apply his distinction to our two paintings, we might say that we are aware of the pictured scene Caillebotte's painting presents *before* we are aware of the means by which that scene has been painted, whereas we confront Monet's surface immediately as the surface of a painting – as something *made*. Of course it is not *only* as a surface that we see it. The point is that what Greenberg calls the 'dialectical tension' – the tension between seeing a literal surface and seeing something in that surface – is the more vivid in Monet's painting precisely because the surface is not just 'seen through'. The decorative swirls and touches of paint make some kind of impression upon our senses independently of (or at least concurrently with) their role in forming an image. Applying Bell's terms we might say that the forms of the painting are 'used' to an aesthetic end and are not simply treated as cues to a suggestive scenario. Even Rivière noted 'that skill in arrangement, that organization of the canvas, that is one of the main qualities of Monet's work' (quoted in *The New Painting*, p.223).

Plate 152 Gustave Caillebotte,
detail of *Le Pont de l'Europe*
(Plate 147).

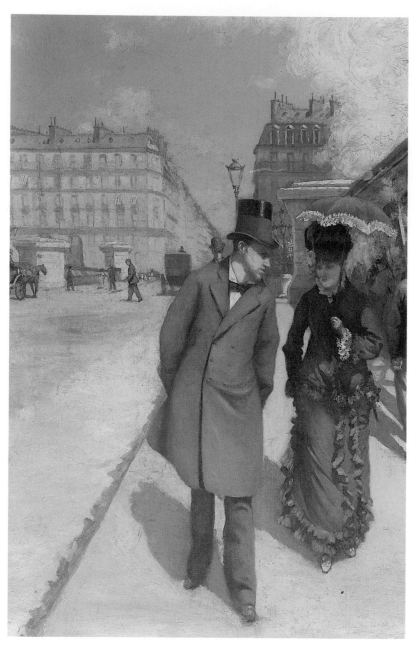

For Greenberg, Manet's paintings became the first Modernist ones 'by virtue of the
frankness with which they declared the surfaces on which they were painted', while, in
Manet's wake, the Impressionists left the eye 'under no doubt as to the fact that the
colours used were made of real paint that came from pots or tubes', in other words these
colours had a 'presence' of their own, and were not merely subservient to the construction
of an image. In 'Modernist Painting', from which these further quotations are taken,
Greenberg claims that the self-critical tendency of Modernism is its motivating force. It is
through the process of self-criticism, he believes, that painting becomes 'modern'. 'The
essence of Modernism lies in the use of the characteristic methods of a discipline to criti-
cize the discipline itself – not in order to subvert it, but to entrench it more firmly in its
area of competence.' He sees this self-critical tendency both as *historically* specific and as

Plate 153 Claude Monet, detail of *La Grenouillère* (Plate 156).

specific to the *medium* of each form of art. Those forms of high culture which were under threat during the nineteenth century 'could save themselves from levelling down [to the status of 'entertainment pure and simple'] only by demonstrating that the kind of experience they provided was valuable in its own right and not to be obtained from any other kind of activity' (such as reading a book or watching a play). The means to this demonstration was for each art to isolate 'the effects peculiar and exclusive to itself', effects which would clearly be proper to the specific nature of the medium.

> The task of self-criticism became to eliminate from the effects of each art any and every effect that might conceivably be borrowed from or by the medium of any other art. Thereby each art would be rendered 'pure', and in its 'purity' find the guarantee of its standards of quality as well as of its independence.
>
> ('Modernist Painting', pp.5–6)

In Greenberg's terms, the kinds of anecdotal effect found in Caillebotte's *Pont de l'Europe* are also discoverable in literature; they would thus count as 'impure' effects in painting. According to Greenberg, one property which painting as a medium shares with no other art form is flatness, two-dimensionality, and so: 'Modernist painting oriented itself to flatness as it did to nothing else'. On grounds such as these, the relative technical modernism of Monet's painting is taken as the sign of a more acute self-criticism, that is to say of a more advanced grasp of the character and demands of painting as a medium.

Modernism and its priorities

It is important to recognize certain characteristics of the theory which is here being represented. Firstly, it is a theory of *high* art, and of the modern grounds of high art's distinctness (for example its distinctness from 'mere entertainment'). Secondly, it assumes that the definite function of high art is to maintain 'standards of quality' (whatever these may be). Thirdly, it purports to explain changes in high art in terms of a retrospectively perceived and specialized logic of development (for example the 'orientation to flatness'). And fourthly, it argues that there is an inextricable connection, in Modernist art at least, between quality and 'self-definition' or independence (independence, for instance, from the requirements of 'mere entertainment' or of story-telling).

Clearly, there are likely to be sociological implications to a theory which conceives of high art and standards of quality in terms of logical development and independence from the ends of entertainment. It should be noted that both the early version of Modernist theory, represented by Bell, and the more developed (and more sophisticated) form advanced by Greenberg represent attempts to *rationalize preferences* – or, as the writers themselves would have put it, to justify the findings of taste. The question which both writers asked themselves was: what is it that connects those works of art which I find good? Bell's answer was that *all* successful works of art stir the emotions of the viewer, not by appealing to 'the emotions of life', but through their *independent* possession of the property of 'significant form' (whatever that might be). Greenberg's answer was that all successful works of *modern* art are linked as stages in the working out of a specialized and 'self-critical' tendency.

In all phases of its development Modernist theory rests upon three crucial assumptions; firstly, that nothing about art matters so much as its quality; secondly, that for the purposes of criticism the important historical development is the one that connects works of the highest quality; and thirdly, that where judgements of quality appear to be in conflict with considerations of relevance or with moral judgements, what should be re-examined first is not the aesthetic judgement (which is supposed to be involuntary and thus not open to revision) but the particular criteria of relevance being applied and the grounds of the moral judgement. Relevance, in Greenberg's view, must mean 'relevance to the quality of the effect' of the work of art ('Complaints of an art critic', p.8), and no moralizing judgement will be considered pertinent if it simply addresses what the work of art shows rather than the *form* in which the showing is done. In the view of the Modernist critic, this stricture on relevance applies not only to works with overt figurative subject-matter, such as *The Doctor*. It is equally applicable to abstract paintings. In the eyes of the Modernist, if we are to see the work of art for what it is, we should not allow what it happens to look *like* to distract us from the particular quality of its *effect*. (We shall return to the concept of 'effect' in a subsequent section.)

Questions to the Modernist

There are three important and interrelated questions with which these assumptions need to be confronted. The first is: how do we know that the effect which the critic claims to perceive is actually produced by the painting and is not simply a product of the critic's own psychology and self-interest? Another way to put this is to ask: is the judgement of quality backed up by anything *other* than personal preference? (Because if not, no more authority can be attached to that judgement than we are prepared to accord to the person making the judgement.)

The second question is: what kind of evidence is offered to connect the judgements of quality to the account of art's historical development? If only certain works are allowed to count as components of art history, and if all that seems to connect them is that they confirm the findings of the critic's taste, then we shall have a strong reason to suspect a lack of objectivity in the historical account. Of course, all interpretation of history is done in furtherance of some interest or other, and some of the most instructive history is written explicitly to make a case. But we need to be alert to the dangers of what the philosopher Karl Popper has called 'historicism' – the perception of rhythms and patterns in history and their use as evidence for the purposes of prediction and prescription. As defined by Popper, historicism is associated with neglect or even suppression of evidence

Plate 154 Auguste Renoir, *Étude* (*Study*), now known as *Torse de femme au soleil* (*Torso of a Woman in Sunlight*), *c*.1876, oil on canvas, 81 x 65 cm. Musée d'Orsay, Paris RF 2740. Photo: Réunion des Musées Nationaux Documentation Photographique. (Exhibited in the second Impressionist exhibition, 1876.)

inconsistent with the writer's own interests and ends. The accusation of historicism is one that has frequently been levelled at the Greenberg of 'Modernist Painting' – this is to impute that, despite the claim to an empirical response, he organizes his retrospective evidence in accordance with his theoretical forecasts.

The third question is: on what grounds are decisions made about what is and is not relevant to the business of judging works of art? If it turns out that the only information allowed to be relevant is information that supports a judgement already made – if, for example, evidence having been offered of the chauvinistic character of Renoir's sexual politics, this evidence is ruled out by an admirer on the grounds that it is rendered irrelevant by the 'beautiful effects' of his paintings (see Plates 154 and 183), and if that admirer claims that the beauty of those effects is *beyond argument* – then we will be justified in returning to our first question and in insisting on an adequate answer to one or both of its versions before we give heed to the criteria of relevance being applied. It is a form of idealism to claim that art can have meaning independently of what it is made of. One way or another, the question of the character of the producer is implicated in the question of the character of the product.

In the next section I aim to bring together and to pursue what have so far been two separate strands in our discussion; on the one hand the relationship between Modernism

Plate 155 Claude Monet, *Les Bains de la Grenouillère*, (*Bathing at la Grenouillère*), 1869, oil on canvas, 73 x 92 cm. National Gallery, London. Reproduced by permission of the Trustees of the National Gallery.

and modernity, on the other the relationship between quality and 'independence'. We shall next be considering a group of paintings which have conventionally been seen as marking the beginnings of the Impressionist project.

Monet at La Grenouillère

Look at the six paintings by Monet and Renoir which show scenes of bathing at La Grenouillère (Plates 155, 156, 157, 158, 159, 160). La Grenouillère was a boating and bathing place on the Seine, about a mile from the nearest station, to which trains ran from the Gare Saint-Lazare. It was located on the island of Croissy, close to Bougival in the spreading western suburbs of Paris and within walking-distance of the village to which Monet moved in the summer of 1869. In the words of Robert Herbert, the Impressionist painters 'participated in the suburbanization of the area, and they brought back their produce to the Paris market; images of harmonious and productive villages, and of receptive landscapes' (*Impressionism*, p.196). By the 1860s Bougival itself had grown into a popular centre for boating, bathing and fishing. Besides the facilities for bathing and for boat hire, the establishment at La Grenouillère included a floating restaurant and dance-hall and riverside tables for eating and drinking. It could be said that it presented a

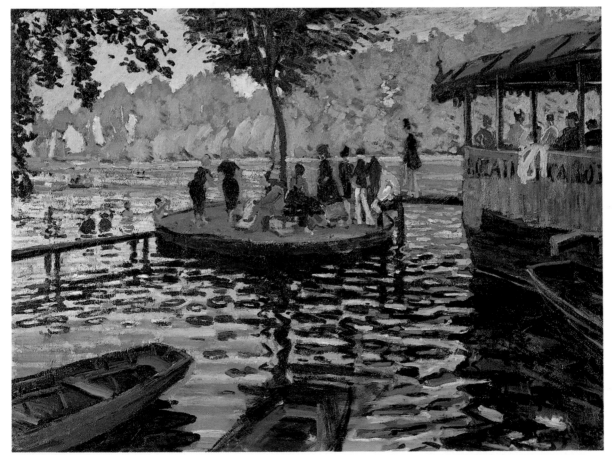

Plate 156 Claude Monet, *La Grenouillère*, 1869, oil on canvas, 74 x 100 cm. All Rights Reserved. Metropolitan Museum of Art, New York. The H.O. Havemeyer Collection, bequest of Mrs H.O. Havemeyer, 1929.

Plate 157 Claude Monet, *La Grenouillère*, 1869, oil on canvas. Formerly in the Arnhold Collection, Berlin, destroyed by bombing in 1945. Photograph as reproduced in *Monet* by Robert Gordon and Andrew Forge, 1983, Harry N. Abrams, by permission of Robert Gordon.

compendium of fashionable attractions for the city-dweller in pursuit of leisure, and thus a highly appropriate subject for an attractive modern painting.

The works that Monet and Renoir painted at La Grenouillère in the late summer of 1869 are celebrated as marking a decisive stage in the development of Impressionism and thus of modern painting as a whole. The surviving examples are now exhibited as unquestioned works of high art among other more evidently finished works. Yet their original status was very much less secure. It is their status and function in 1869 that I intend to explore, the better to understand the basis of their meaning for us now.

The six paintings illustrated were executed largely, if not wholly, out of doors, in front of the motif. If we use as reference the print of La Grenouillère, by Yon (Plate 169), we can work out that the six paintings were made from adjacent positions at the extreme right, looking towards the left, as in the diagram (Plate 161). The Renoir in Moscow (Plate 160) shows a viewpoint looking from the bank down the river, the Monet in London and the Renoir in Winterthür (Plates 155 and 158) show basically the same view from a position some way out from the bank, perhaps on a projecting boat landing, while the remaining three pictures are painted from approximately the same position, looking further to the right across the pontoon and circular island towards the opposite bank.

Working directly from the outdoor motif was by no means an unusual practice for the landscape painter by the end of the 1860s, though it generally resulted in less colourful paintings than these. The particular distinctness of the surviving works lies in the relationship between the brightness of the colour and the breadth of the tonal range they display on the one hand, and on the other the apparently rapid, 'broken' brushwork with which they are executed. These are paintings, Monet's in particular, which seem clearly dedicated to the pursuit of a certain visual effect, an impression. They constitute an

account of existence established not primarily in terms of the occupation of certain spaces by certain solid bodies, but rather in terms of specific and momentary conditions of atmosphere and of light – conditions which cannot conceivably have prevailed on any given day for more than a proportion of the time it would take to complete even so rapid an account as one of these. Accustomed as we now are to such paintings, we tend to underestimate the strangeness of the resulting enterprise – that is, painting redolent of the atmosphere of modern life, which treats that atmosphere as if it could be reduced to spontaneously captured effects of light and colour.

Recent technical examination of Monet's *Bathing at La Grenouillère* (Plate 155) confirms both that the artist exploited the full brilliance of newly available coloured pigments (at least fifteen separate pigments were used in the blending of the colours) and that the execution of the painting was relatively rapid. On the other hand, it is also clear that Monet made substantial revisions, both to the overall organization of his composition, and to the colours and colour relationships, as well as to such details as the boats in the foreground. Generally speaking, the techniques of painterly modelling – those which serve to establish the sense of distinct forms in the round – appear to have been set aside for the *effect* of an all-over animation. And note that it is by no means clear how we as viewers might distinguish between our response to the animation of the *scene* represented and our response to the animation of the representing *surface*.

A comparison of Monet's *Bathing at La Grenouillère* with Caillebotte's *Paris Street: A Rainy Day* not only makes clear how little modelling Monet has employed but also serves to reveal how this technical difference is related to differences of content or meaning. For instance, if we ask where the animation lies in Caillebotte's painting, it is clear enough, I think, that it lies in the scene rather than the surface. As witness the responses of contem-

Plate 158 Auguste Renoir, *La Grenouillère*, 1869, oil on canvas, 65 x 93 cm. Oskar Reinhart Collection, "am Römerholz", Winterthür.

porary commentators, the 'life' of the picture tends to be identified with the supposed psychological character of the figures and not with the technical character of the painting. In Monet's painting, although the figures on the pontoon are accorded some basic characterization through costume and pose, they read less as individuals than as tokens – nor do they ever quite lose their identity as groupings of brushstrokes (see Plate 153).

Of course the comparison is in many respects misleading. Monet's painting is less than a third the size of Caillebotte's. It was painted eight years earlier, and it has the appearance of a preparatory sketch. And yet these very differences are also significant in their way. Let's say we regard Monet's painting not as an end in itself but as a stage in the working out of a more conventionally ambitious composition, to be pursued, like Caillebotte's, on a larger format and in a more evidently 'finished' style. (This suggestion can be filled out by comparing Monet's painting with the smaller preparatory study for Caillebotte's *Paris Street* (Plate 162). Though it still suggests a comparatively deep pictorial space, the latter has far more in common technically with Monet's paintings of La Grenouillère than does the finished version of the same composition.) Can we conjecture what might have been involved in realizing a large-scale finished painting on the basis of Monet's *Bathing at La Grenouillère* – what gains and losses in relationship to the painting as it stands?

I suggest that Monet could not have enlarged his composition without losing many of those qualities which make *Bathing at La Grenouillère* interesting in the first place. I don't just mean that the painting would be deprived of the effect of spontaneity and informality. It is rather that it would have had to become a categorically different kind of thing. For

Plate 159 Auguste Renoir, *La Grenouillère*, 1869, oil on canvas, 66 x 81 cm. Nationalmuseum, Stockholm. Photo: Statens Konstmuseer.

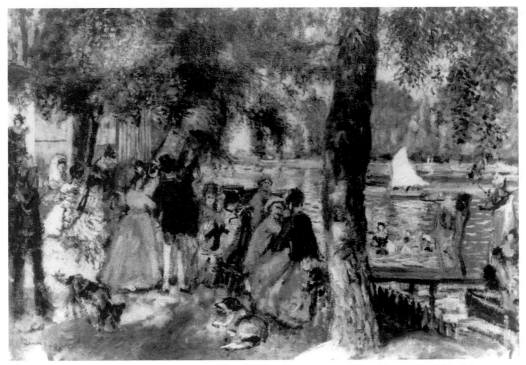

Plate 160 Auguste Renoir, *La Grenouillère*, 1869, oil on canvas, 59 x 80 cm. Pushkin Museum, Moscow.

example, either the surface of water, light and reflections at the bottom right corner would have had to be represented through some quite different technique, or the apparently 'spontaneous' brushstrokes themselves would have had to be enlarged, and would thus have lost that sense of enactment of the movement of the hand which is the very means by which spontaneity in painting is signified. In the brightest section of the painting, at the top right beyond the pontoon, the heads and shoulders of the bathers seem to be partly dissolved by the brilliance of the light reflected from the water. Here the lack of 'finish' in the brushwork serves as a kind of metaphor by which this vivid effect is in part created. It is hard to conceive how the same effect could be produced by the more carefully graduated technique we find in Caillebotte's painting. And as to the figures on the pontoon, if they were not simply to appear in a larger version as stark and over-simplified cut-outs they would have to be more carefully differentiated, characterized and modelled. This is to say that they would have to be accorded that kind of imaginary personality which serves in Caillebotte's painting both to evoke the manners of a modern social world and to distract attention from the painting's decorative aspect. Furthermore, conventional techniques of modelling tend to depend upon even gradations of light and shade, and thus upon organization in terms of *tone* rather than *hue*. Paintings which are both roundly modelled *and* brightly coloured tend to look garish or overstuffed or both.

What I am saying is that the distinctness of Monet's painting is very much a consequence of its size, scale and technique; that it stands as an end in itself and is not the means to a painting which could be 'finished' as Caillebotte's is. Its technical modernism – the modernism of its *effect* – appears to impose a form of limit on its iconographical modernity – on the modernism of its *imagery*. We can see now what the conservative critic of *La République française* meant in saying that Caillebotte was 'an Impressionist only in name'. He meant that he painted 'proper' pictures, unlike his colleagues who exhibited paintings which were too like mere sketches to be taken seriously.

Plate 161 Conjectural ground-plan of La Grenouillère, showing viewpoints of paintings by Monet and Renoir.

Plate 162 Gustave Caillebotte, sketch for *Rue de Paris; Temps de pluie*, 1877, oil on canvas, 54 x 65 cm. Académie des Beaux-Arts, Musée Marmottan, Paris; formerly collection of Claude Monet. Photo: Routhier/Studio Lourmel.

Plate 163 Claude Monet,
Le Déjeuner sur l'herbe, 1865–66,
oil on canvas, 130 x 181 cm.
Pushkin Museum, Moscow.

And yet we should not assume that Monet set out in the summer of 1869 to paint pictures which would assert the priority of surface over subject. Indeed, there is considerable circumstantial evidence to suggest that when both he and Renoir were working at La Grenouillère they had in mind something much closer to paintings such as Caillebotte's than either of them in the end produced. In Monet's case the evidence is as follows. Between 1865 and 1867 he had worked on two large paintings, *Déjeuner sur l'herbe* (*Luncheon on the Grass*) and *Women in the Garden*, which were clearly intended for the Salon – even though the overt reference to Manet's notorious *Déjeuner sur l'herbe* signalled that Monet's approach to the Salon was far from straightforward. For the former of these paintings he made several studies and a complete version in reduced size (Plate 163) before embarking on a canvas approximately four metres by six. The full-sized work was never completed to his satisfaction and only fragments have survived (Plate 164). Of course, we are looking at the remnants of an unfinished work, but even so I think it is clear from the evidence they present that the problem of how to paint large-scale open-air subjects with naturalistic lighting was not satisfactorily solved by making apparently 'spontaneous' marks with very large square-ended brushes. That's to say, the fragments tend to look like parts of an enlarged sketch. For *Women in the Garden* (Plate 165) Monet adopted a less traditional approach. His aim was to work on it entirely out of doors and only when the right lighting conditions prevailed. This posed severe technical difficulties given the size of the painting – some 260 by 206 centimetres. It was rejected from the Salon of 1867, though it was bought subsequently by the painter Frédéric Bazille. On 25 September 1869 Monet wrote to Bazille from La Grenouillère:

> Here I'm at a halt, from lack of paints …! Only I this year will have done nothing … I have indeed a dream, a picture of bathing at La Grenouillère, for which I've made some bad sketches[3], but it's a dream. Renoir, who has been spending two months here, also wants to do this picture.
>
> (quoted in Rewald, *The History of Impressionism*, p.227–8)

[3] 'Sketches' here translates the French term *'pochade'*, which Monet used in place of the more usual *'esquisse'*. An *esquisse* was a small-scale trial sketch for a finished picture, such as Caillebotte's study for *A Paris Street*. A *pochade* was both more free and more tentative, representing an even earlier stage in the process of invention and development of a composition.

Plate 164 \\Claude Monet, two fragments of *Le Déjeuner sur l'herbe*, 1865–66, oil on canvas, left section 418 x 150 cm, right section 248 x 217 cm. Musée d'Orsay, Paris.
Photo: Réunion des Musées Nationaux Documentation Photographique.

That same summer Bazille had also been at work on a large scene of bathing, destined for the Salon. His stilted and solidly modelled painting clearly proved acceptable as a form of modernization of the traditional subject. *Summer Scene, Bathers* was exhibited in the Salon of 1870 (Plate 166). Given these circumstances it seems more than likely that the 'picture of bathing at La Grenouillère' mentioned by Monet was to have been a large-scale work also suitable for submission to the Salon as a modernized form of subject painting, and that the works we have been considering are among the works that he saw in 1869 as his 'bad sketches'. If so, it was some time before he felt sufficiently confident of what he *had* done to revise his judgement. He waited for seven years before showing a painting of La Grenouillère in the second Impressionist exhibition, probably a work now lost, possibly the New York version (Plate 156). As to Renoir, there is no clear evidence that he exhibited any of his paintings of La Grenouillère during his lifetime.

Can we come any closer to the picture or pictures they dreamed of painting? I think we can – though, if I am right, the results are somewhat surprising given the subsequent

Plate 165 Claude Monet, *Femmes au jardin* (*Women in the Garden*), 1866–67, oil on canvas, 255 x 205 cm. Musée d'Orsay, Paris.
Photo: Réunion des Musées Nationaux Documentation Photographique.

image of Impressionist painting. I suggest that Monet's three paintings were produced as studies for a single panoramic view, with the London painting showing the left-hand section and the New York painting the right. (The non-alignment of the pontoon would be explained by a shift in Monet's angle of vision to the right to paint the New York picture, and by the lost third study.) Just how the different views might have joined up is clear from the Renoir in the Winterthür Collection (Plate 158). Being slightly wider in format than the London painting, this shows how the footbridge leads to the round island ('the Camembert') on its way to the floating restaurant which appears at the extreme right of the New York painting. In the version to which Monet's two surviving studies seem to lead, the total composition would have been a view looking down the left-hand bank of the river, with the floating restaurant providing a lead-in at the right and the far bank closing off the picture space beyond it.[4] Plate 167 offers a conjectural reconstruction of the panorama that might have resulted. Plate 168 offers a slightly different version based on the three surviving sketches by Renoir.

4 A small sketch of two rowing-boats by Monet, now in the Kunsthalle, Bremen, may also be linked to this project as a study for its foreground detail.

Plate 166 Jean Frédéric Bazille, *Scène d'été* (*Summer Scene*), 1869, oil on canvas, 158 x 159 cm. Fogg Art Museum, Harvard University; gift of Mr and Mrs F. Meynier de Salinelles.

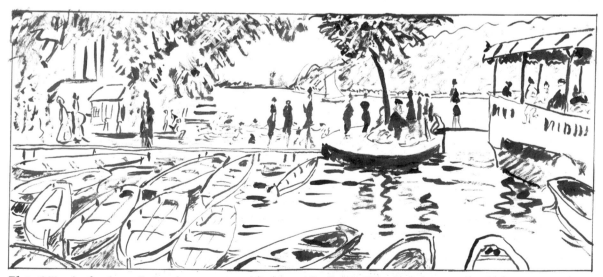

Plate 167 Author's conjectural panorama of *Bathing at La Grenouillère*, based on studies by Monet.

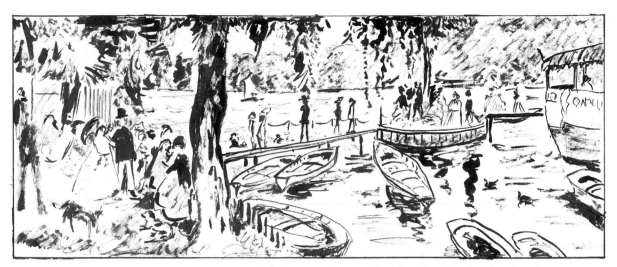

Plate 168 Author's conjectural panorama of *Bathing at La Grenouillère*, based on studies by Renoir.

If these reconstructions bear any relation to the picture of bathing at La Grenouillère of which Monet dreamed, the viewer would have been faced with a wide and deep pictorial space, conventionally framed with motifs to channel the eye into the perspective, and with the middle ground populated with a large cast of characters. The activities of these characters would surely have signified more clearly than they do in the 'bad sketches' just how La Grenouillère could be seen as representative of the habits and manners of an age. We would have been faced, in fact, with something very much closer to the spirit of Caillebotte's two street scenes, and closer also to the contemporary image of La Grenouillère as it appears in more popular forms of illustration such as those produced by Yon and Pelcoq (Plates 169 and 170). The place shown in these latter pictures is notable not so much for the brilliant effect of sunlight on water as for the opportunities it provides for the intermingling of sexes and social classes. Such a composition might also have invited comparison with other fashionable forms of picturesque panorama: those of topographical photography (Plate 171). Monet may not have had such photography explicitly in mind, but I think that the least suggestion of such a comparison would probably have seemed too close for comfort. That's to say it would have pointed only too clearly to the redundancy in painting of those displays of pictorial depth which could now be automatically, and thus cheaply, produced. In the terms of Greenberg's 'Modernist Painting', then, by completing a painting of the kind apparently prefigured by the sketches, Monet would have been risking both the 'levelling-down' of his work to the status of entertainment, and the adulteration of its value by effects which could be seen as 'borrowed' from another medium. Abandoning a projected painting under such circumstances could thus be seen as a positive act of 'self-criticism' in Greenberg's sense – that is to say, as a form of recognition, which was at one and the same time a rejection of his own ambitions *vis-à-vis* the Salon, and a form of submission to the technical limits on modern painting.

Is that the end of the story? That painting must abandon what painting must abandon? In his book *The Painting of Modern Life*, T.J. Clark considers how we might approach Monet's paintings of La Grenouillère as representations of the modern world and of some set attitudes towards that world:

Let us ask how Monet's depictions might possibly stand in relation to an image of the same place taken from the weekly magazines – like the one by Jules Pelcoq [Plate 170] (accepting straightaway that there is no question here of imitation or influence of a direct

Plate 169 Edmond-Charles-Joseph Yon, *La Grenouillère*, engraving from *L'Illustration*, 16 August 1873.

kind)? To what extent does Monet's oil painting borrow its vitality from the illustration, or is its purpose somehow to contradict such a quality, or at least its generalizing force? The painting's composure, and the cool way it savours certain (rather simple) formal rhythms, in the pattern of boats or the punctuation of figures on the straight pontoon – are these meant, so to speak, as refutations of Pelcoq, as so many signs of the painter's way with things as opposed to the illustrator's? Does painting get done in spite of illustration – is that the proposal? Get done in spite of modernity, even, or because modernity does not amount to much? But then, why go to La Grenouillère in the first place? In search of the insignificant – is that it?

(*The Painting of Modern Life*, pp.160–1)

Clark's suggestion is both speculative and, in part, ironic. Manet, rather than Monet, might have gone to La Grenouillère in knowing search of 'the insignificant': those who 'failed to signify' – the prostitutes, the bar maids – because they had no established place in the representational codes, the language, of the bourgeois social world. As Clark himself has shown, Manet if anyone would have known how to make that 'insignificance' or 'marginality' tell in paint. But not, I think, Monet, who was a painter of a different kind and a different generation. If Monet went to La Grenouillère in search of the insignificant, he did so believing he was doing something else. As I have suggested, and as his letter to Bazille appears to confirm, the attraction of the place must at least in part have been that it appeared to present the possibility of a substantial modern painting – a painting on a theme that was licensed by a tradition of artistic *baignades* and *baigneuses*, but which was also topical. We should not forget the public status associated with certain major canvases by French painters of the previous hundred years – Jacques-Louis David, Gustave Courbet, Eugène Delacroix, and of course Manet – nor should we underestimate the power of example these achievements exercised over subsequent deliberations on the potential reach of painting. Monet was certainly an ambitious painter. It would not have been strange if he went to Croissy intending (again) to attempt a self-consciously 'significant' painting – but one which would also be modern in its 'impression'.

A LA GRENOUILLÈRE, — par JULES PELCOQ.

Un Eden où bêtes et gens se meuvent dans une douce confraternité; échange cordial de puces (de la part des individus de la race canine).

LE MUSÉE DE L'ÉTABLISSEMENT
Un commencement qui promet... des dessinteurs pour le *Journal amusant.*

LES VOLONTAIRES D'UN AN DE LA GARNISON DE SAINT-GERMAIN.
Une occasion de se mettre en civil sans enfreindre les règlements.

LE PIANO DU CAFÉ.
Par 35 degrés!... Nouveau moyen de se rafraîchir : se mettre en nage. — Gribouille n'avait pas trouvé celui-là.

LES CANOTIERS DE CES PARAGES,
dits : *canotiers musqués*, mâle et femelle.

LES AVENTUREUSES.
Nous étions trois d'moisell's de magasin,
Tout's les trois jeun's, aimant à rire;
Car lorsqu'on est demoiselle il faut bien
Un cavalier pour vous conduire.

LA GALERIE DU BORD DE L'EAU.
Marque les points et ne joue plus.

Plate 170 Jules Pelcoq, *À la Grenouillère* (*At la Grenouillère*), engraving from *Le Journal Amusant*, no. 991, 1873. Bibliothèque Nationale, Paris. Overall view: 'An Eden where animals and people circulate in pleasant fellowship; a cordial exchange of fleas (on the part of individuals of the canine species)', and vignettes of characters and activities.

Plate 171 Example of the use of photography in topographical panorama, *c.*1880. View of Valetta Harbour, The John Hannavy Picture Collection, Wigan.

If so, however, what he may have found at La Grenouillère was that the conditions of *artistic* 'significance' (or, as Greenberg might put it, the criteria of success or failure of painting as painting) were now indeed at odds with the relatively graspable and 'popular' requirements of illustration – and thus at odds with at least one normal measure of topicality, of comprehensibility, and therefore of significance in the broader culture. My suggestion is that when Monet arrived at La Grenouillère, it still appeared possible that the representation of a modern social life could be reconciled with an interest in modern artistic techniques, but it seems to me that the evidence of what he produced while he was there showed that it was not – for him at least. The 'bad sketches' may not have been what he intended to produce, but nonetheless they pointed inexorably to the future direction of his practice. They may also have seemed to recall him, for the time being at least, to those *limits* on public significance which were supposedly proper to the more modest genres of still-life and landscape (a lesson, if so, that he is unlikely to have been pleased to learn, given his evident ambition). If we look with the benefit of hindsight at the development of Monet's practice after the moment of La Grenouillère, it appears increasingly to be confirmed that the materials of a modern painting were not to be derived from the appearance of the modern social world, but rather had to be generated through modernization of the 'impression'.

Seeing the modern

I do not mean to suggest that after 1869 painters in general gave up the attempt to reconcile 'modernity' (what was conceived of as modern in general) with 'modernism' (what was conceived of as modern in artistic practice), or that the social world suddenly disappeared from painting in the 1870s. Of course it did not. The evidence did not all point in the direction that it apparently did for Monet. In a following section, we shall be considering a range of works from the 1880s in which various forms of social life are addressed. Nor can the question of aesthetic interest be entirely divorced from questions about the representativeness of Monet's work with respect to Impressionism as a whole. Even if we exclude Manet and Degas from consideration as Impressionists, it is clear that the once-conventional image of Impressionist painting as an art of landscape, light and atmosphere both misrepresents the variety of work associated with the movement and glosses over the world of problems from which that work emerges (the problem, for instance, of what it was that made some landscapes rather than others suitable as 'modern'

subjects, or the problem of the painter's own place in the landscape, the position from which it was being seen and thought about). This simplified conventional image concerned Meyer Schapiro as early as 1937, when he asserted that 'Early Impressionism ... had a moral aspect'; he continued:

> In its unconventionalized, unregulated vision, in its discovery of a constantly changing phenomenal outdoor world of which the shapes depended on the momentary position of the casual or mobile spectator, there was an implicit criticism of symbolic social and domestic formalities, or at least a norm opposed to these.
>
> ('The nature of abstract art', pp.77–8)

Some important recent studies of Impressionism, T.J. Clark's among them, have followed Schapiro's lead and emphasized the continuing engagement of artists, Monet included, with urban and suburban subjects during the 1870s, while, as we shall see in the following essay, reconsideration of Berthe Morisot's work has emphasized the significance of her class and gender as determinants upon her work, thus questioning the universality of the tendency of Modernist painting. Clearly these considerations cannot be ignored in the name of some supposed victory for 'pure' painterly concerns. The claim made in Modernist theory, however, is that such considerations fail to affect the substantial evidence of the paintings themselves: that as the practice of Impressionism defined itself between 1869 and the first group exhibition of the independent artists five years later, it became increasingly clear that, for better or worse, however socially topical or morally worthy its subject-matter might be, a painting would appear to fail, and to fail conclusively, if it was not both vivid and coherent in its formal effects.

This claim should not be allowed to stand without further examination, however, 'Clear to whom?', we should ask. 'Fail in whose eyes and on what grounds?' 'Effects upon whom?' In the passage quoted above, Clark conjures up an imaginary voice unfriendly to the 'new painting', a voice which might go on to note that anecdote and narrative were the means by which 'other classes' traditionally made their presence felt in art, and to ask whose interests are best served by a form of painting which makes displacement of anecdote and narrative a condition of its impressionism, its modernism and its 'purity'.

We shall return to these questions. Before I proceed, however, I should acknowledge that, though it does not silence the questioning voice, my account of the La Grenouillère paintings and of their implications appears so far to support the priorities of the Modernist critical tradition. Indeed, the account has been organized in such a way as to explore the practical ground of those priorities; that is to say, to consider the circumstances under which artistic Modernism became identified with a kind of critical independence from the visible forms of social life.

Should we, then, see Modernist criticism as the 'natural' accompaniment to a 'Modernist' art? Or should we look sceptically through the priorities and protocols of Modernist criticism in pursuit of a different account of modern art – one in which 'modern art' is allowed to mean something different – one, for example, which accords priority to artists more evidently engaged with the social world than were Monet or Cézanne, less single-minded in pursuit of visual 'effects', 'impressions' and 'sensations'?

The problem uncovered here is that of the role of judgement in the representation of (art) history. Though history may pretend to a kind of neutrality in the matter of value judgements, we would still, I think, be suspicious of an art-historical review of the Italian Renaissance which failed to mention Leonardo or Michelangelo, or a review of the English nineteenth century which made no mention of Constable or Turner. And the basis of that suspicion would be a belief that the work of these artists is too important (too good? too interesting?) to be ignored. To discuss the English painting of the nineteenth century is, among other things, to confront what is distinctive in the art of Constable and Turner and to seek to explain it. If we wish to undermine the Modernist assertion of the importance of

Monet and Cézanne, then we must either find other grounds for our interest in their work or explain why we choose to ignore them. If we agree about the importance of Monet and Cézanne, but not with the theory which would connect them in terms of an inexorable 'orientation towards flatness', then we stand in need of an alternative account of what is distinctive in their art. As we have already seen, the theory and the set of judgements are mutually implicated, since the theory purports to explain what it is that connects paintings of the highest quality. It will be a weak argument against the supposed orientation to flatness which cites exceptions already excluded by the Modernist on the grounds of lack of quality – such as the paintings of Caillebotte. Or rather the argument will be weak *unless* we are able to explain Caillebotte's exclusion from the canon in some way which amounts to a criticism of the canon itself and of the means of its formation. If it turns out, for instance, that the quality of 'modernity' expressed in Caillebotte's work has been disparaged on grounds which are not disinterested – for example, *simply* because his paintings are relatively popular and graspable – then we shall have good grounds for looking again at that connection between Modernist quality and explicitness of facture which is made in the writings of Greenberg.

There is a final possibility. We might, in the end, assent to the canon, to the relative importance and quality of the work of Monet and Cézanne; we might also agree that the best of modern painting can be connected in terms of an observable 'orientation to flatness'; but we might nevertheless want to reject the *explanation* of the connection that Modernist theory advances. That's to say, we might feel that in order to understand the meaning and value of modern painting's flatness, we need to look beyond the 'problems intrinsic to painting' and to search that wider world of social and psychological experiences about which Modernist criticism has had relatively little to say.

Plate 172 Camille Pissarro, *La Grenouillère à Bougival* (*La Grenouillère at Bougival*), *c*.1869, oil on canvas, 35 x 46 cm. Collection of the Earl of Jersey. Photo: Robin Briault.

Plate 173 Camille Pissarro, *Le Lavoir, Bougival* (*The Wash-House at Bougival*), also known as *Le Lavoir, Pontoise*, 1872, oil on canvas, 46 x 56 cm. Musée d'Orsay, Paris. Photo: Giraudon.

With this possibility in mind, and as a kind of footnote to the discussion so far, two further paintings deserve mention before we leave La Grenouillère. Both were executed by Camille Pissarro. The first (Plate 172), though formerly known by the title *L'Oise à Pontoise* and attributed to the early 1870s, has recently been identified as a picture of La Grenouillère and has been conjecturally redated to the period when Monet and Renoir were also painting at Croissy. On one bank of the river what may be the bathing place appears, overhung by trees. On the other, a small factory serves as a reminder that there was a side to the suburban expansion of Paris other than the growth of facilities for leisure. The second painting, dated 1872, shows the same factory from a slightly more distant viewpoint (Plate 173). The bathing place is now out of sight, and anyway, the scene is set too late in the year for bathing. A woman in the left foreground has the signs of a washerwoman, and a communal wash-house occupies the centre of the middle ground.

Pissarro's later adoption of an anarchist philosophy has led interpreters to scrutinize his early work for evidence of radical political intent. One recent commentator has written of the first of the present paintings that Pissarro 'contrasts' La Grenouillère with the factory, 'setting leisure and work on equal terms' (R. Shikes, 'Pissarro's political

philosophy and his art', p.45). Another has written of 'a tacit dichotomy between industry and leisure' (R. Thomson, *Camille Pissarro*, p.24). In fact, these interpretations appear to be claiming more for the painting than the painting itself needs to claim. Its success, it seems to me, does not depend on the factory and the bathing-place being seen as translatable symbols meaning 'work' and 'leisure' respectively. If the factory was there, it was there to be seen and painted. Of course, we can grasp readily enough what is meant by the sentence 'leisure and work are set on equal terms', and it is tempting to adopt the form of words as a key to the painting. But the statement fails to describe what the painting shows and how it shows it. Yet the existence of Pissarro's painting does insinuate a new consideration into our experience of Monet's and Renoir's. In the context that their paintings establish, we realize, the factory is not so much unrepresented and unseen as *unimaginable*. Of course, they were looking in a different direction as they framed their compositions. But in the analysis of pictures the question of where the painter happened to be, and what the painter happened to be looking at, is of more than passing interest. Inquiry along these lines directs us to the figurative materials of art. That much is obvious. But by asking these questions we may additionally learn something about the nature of those conceptual and ethical materials from which art is also made. The second of Pissarro's paintings makes the observable occasions of labour a central part of what it shows. We might even say that the painting establishes some form of relationship between those occasions of labour and the shortening and dulling of daylight in late autumn and early winter. We are reminded that pictorial atmosphere is always potentially metaphorical, however apparently 'direct' and 'original' the impression to which it testifies. This recognition goes some way to opening the Impressionist surface – the displayed evidence of Impressionist painting's relative flatness – to an understanding of its potential sociological and psychological depth.

It does not follow, however, that we are licensed to move directly from this understanding to the making of judgements, ethical or aesthetic or otherwise. We could compare two views from the same position in Louveciennes, one by Renoir and one by Pissarro (Plates 174 and 175). It might be said that the first represents the viewpoint of a tourist looking for a rural idyll, the second the viewpoint of a self-effacing inhabitant, perceiving landscape as the site and product of other peoples' labour. But like all paintings these are artificial things, related in different ways to what they purport to show. Our conclusions will be insecure if they fail to take account not only of differences of season and time of day, but also of the different technical interests and procedures by which the respective paintings have intentionally been shaped. Similarly, that Pissarro 'saw' the factory at La Grenouillère, and that he painted a picture which included it, *may* tell us something about Pissarro. It may also tell us something about what Monet and Renoir chose *not* to look at or to represent. What it does *not* tell us, however, is that looking at factories and painting them is either more virtuous, or more conducive to artistic merit or intensity than ignoring them altogether.

We may say that aesthetic achievement is not necessarily to be found where we assume there is moral or political virtue, but that – Clive Bell notwithstanding – to discover aesthetic merit in a work is not necessarily to disqualify inquiry into the moral and political materials and circumstances of its production.

In the next section, we shall inquire further into the relationship between pictorial and aesthetic order on the one hand and social and political materials on the other. In the process we shall inevitably return to the question of how (or whether) aesthetic judgements can be related to forms of historical explanation.

Plate 174 Auguste Renoir, *A Road in Louveciennes*, c.1870, oil on canvas,
38 x 46 cm. All Rights Reserved. The Metropolitan Museum of Art, New York;
bequest of Emma A. Sheafer 1974. The Lesley and Emma Sheafer Collection
1974. 356.32.

Plate 175 Camille Pissarro, *Printemps: Vue de Louveciennes* (*Spring: View from Louveciennes*),
1868–89, oil on canvas, 52 x 82 cm. The National Gallery, London. Reproduced by permission
of the Trustees.

Pissarro

Effect and sensation

In the first exhibition of what was to become the Impressionist group, Pissarro showed a painting with the title *Hoarfrost (Gelée blanche)*, now known as *Hoarfrost, the Old Road to Ennery* (Plate 176). This will serve both to further discussion of the interests of Modernism and to return us to the claim discussed earlier, that vividness and coherence of effect became inescapable criteria of success in Impressionist painting. Firstly, we need a better understanding of the meaning of 'effect', a concept that played an important part in the theory of painting in later nineteenth-century France, and which was to become central to the Modernist understanding of the experience of art, though it changed its meaning subtly in the process. Two quotations will help to indicate the field of reference. The first is from a review of the 1874 exhibition.

> One effect of *Gelée blanche*, by Pissarro, reminds us of Millet's best themes. We believe that he intentionally eliminates shadows, even though he merely selects those sunless, gently luminous days that leave the tones all their colour values and soften planes. What we must demand is more precisely defined relief in the branches and tree trunks.
>
> (P. Burty, *La République fançaise*, 25 April 1882, quoted in *The New Painting*, p.138)

Plate 176 Camille Pissarro, *Gelée blanche, ancienne route d'Ennery, Pontoise* (*Hoarfrost, the Old Road to Ennery, Pontoise*), 1873, oil on canvas, 65 x 93 cm. Musée d'Orsay, Paris; bequest of Enriqueta Alsop 1972. Photo: Giraudon. (Exhibited in the first Impressionist exhibition, 1874.)

Plate 177 Claude Monet, *Effet de neige, Vétheuil* (*Snow Effect, Vétheuil*), 1878–79, oil on canvas, 52 x 71 cm. Musée d'Orsay, Paris RF 3755. Photo: Réunion des Musées Nationaux Documentation Photographique. (Exhibited in the fourth Impressionist exhibition, 1879.)

Here 'effect' refers to a quality in the picture – a quality of relatively even illumination and gradual transition – which the writer explains partly in terms of the painter's technique ('he intentionally eliminates shadows'), and partly in terms of effects observable in the world (on 'those sunless, gently luminous days'). The 'effect' of the painting is thus in a sense figurative. It is a form of representation of the atmospheric appearance of the world. Pissarro subtitled various of his paintings *'effet de neige'* (snow effect), *'effet de pluie'* (rain effect) and *'effet de brouillard'* (mist effect), though, significantly, none before 1869. Monet used similar subtitles for works painted during the mid-1870s and after (Plate 177). In the work of both painters the subtitle serves to draw attention to the fact that the world is being seen and represented under a certain *aspect,* an aspect which serves to justify an overall quality in the painting itself. (A rough-and-ready distinction between 'impression' and 'effect' is that an impression is a visual experience received or captured, while an effect is a quality conveyed.) The typical Impressionists charged the palpable surfaces of their paintings with representations of a world of fleeting appearances, often, and tellingly, by recourse to effects which subvert the apparent tangibility of the world – not only mist, snow and rain, but fog, shimmer, haze, smoke, reflection, even the turbulence of high wind. In strategic contrast to the measures of competence and accuracy which regulated Academic practice, they established truth to *sensation* of the natural world as a measure of the truth of experience – and thus as a measure of objective reality.

During the late nineteenth century, the relationship of 'sensation' to 'reality' was to remain a matter of strong concern for artists and interested critics alike. This concern was often expressed as an anxiety about the potential for confusion between thoughtful imagination on the one hand, and individualistic fantasy on the other. In his review of the

Plate 178 Paul Cézanne, *Une Moderne Olympia* (*A Modern Olympia*), *c*.1873–74, oil on canvas, 46 x 55 cm. Musée d'Orsay, Paris. Photo: Réunion des Musées Nationaux Documentation Photographique. (Exhibited in the first Impressionist exhibition, 1874.)

first exhibition of the independent painters, Castagnary noted the priority accorded to 'the sensation produced by the landscape'. But, though he applauded the 'quick intelligence of the object' demonstrated in the work of Pissarro, Monet, Sisley, Renoir and Morisot (the 'spontaneity' of their figuration), he also saw the work they exhibited as necessarily provisional. Either the artists would have to improve their technique in order to produce a more complete and more thoughtful account of the world, or, if they pursued the 'impression' to excess, they risked giving themselves up to an 'unbridled romanticism', to those 'personal, subjective fantasies without any echo in general reason' that Castagnary saw as exemplified in the work of Cézanne (see, for example, Plate 178, shown in the 1874 exhibition).

Subsequent criticism of Impressionist painting was to be beset by uncertainty about the status and value of the painterly effect. Was it the sign of an individual and subjective *sensation*, as it came to be viewed during the late 1880s by the advocates of Symbolism? Or was it the outcome of an objective and highly attuned response to nature – as the early Modernists, Bell, Fry and Cheney, believed – and was Impressionism therefore a form of Realism or Naturalism? To put the question another way, was the vivid painterly effect a testimony to the individuality of the artist's psychology, or to the origins of experience in the vividness of the natural world? Did 'truth' lie in the reality of the thing seen, or in the sincerity with which the experience of seeing was represented? In fact, as Richard Shiff has argued, the differences between 'Symbolist' and 'Naturalist' accounts of Impressionism can largely be reconciled if priority is placed, as it was by the Impressionists themselves,

upon the mode rather than the objects of perception – upon the *experience* of the world as the measure of its truth.[5] When Cézanne spoke of his 'sensation before nature' he conflated the experience produced by the natural world on the one hand, and the sense of integrity governing his representation on the other. As late as 1891, Pissarro wrote to his son, 'the Impressionists have the true position, they stand for a robust art based on sensation, and that is an honest stand' (Rewald, *Pissarro, Letters to his son Lucien*, p.171).

Now we can note the contradictoriness of Phillipe Burty's demand for 'more precisely defined relief in the branches and tree trunks' of Pissarro's painting. What the critic is missing is just that kind of modelling which would serve in a more conventional landscape to detach the trees clearly from the surrounding space and atmosphere, and he can't help reproving the painter for what he sees as incompetence. In this he was representative of those many writers – Zola foremost among them – who were committed to new forms of naturalist representation in literature and who supported what they saw as compatible techniques in the new painting, only to be disappointed when Impressionist paintings failed to conform to their sense of how a naturalistic picture ought to look. What Burty demonstrates is the limit of his *own* competence as a viewer of Impressionist painting, for, as he himself has observed, the whole point of the *effect* is that form is softened and dissolved by the overall quality of the light. Though Burty can relate the painting to relevant phenomenal effects in the world, when he matches it against other *paintings* he fails to understand the real grounds of its difference and its independence, which lie in the relatively undifferentiated and 'all-over' quality of its spatial illusion. It is a distinguishing characteristic of the painting, that's to say, that the sensation of space and depth is achieved largely *without* modelling.

In fact, if Pissarro's *Hoarfrost* is to be criticized in formal terms, it could be said that its weakness lies in that one component which is indeed treated in a 'more precisely defined relief', namely the figure of the peasant. T.J. Clark has spoken of *Hoarfrost* as a painting in which 'man and nature still [stand] in intelligible relation to one another', the peasant still serving, as it were, as 'the sign of why these brilliant ephemeral things are here at all as something worth painting and capable of being painted' (Open University, A315, *Pissarro*) And yet, in formal terms, the peasant stands apart from the otherwise coherent and integrated surface of the rest of the painting – or rather appears to project from it. The figure has been solidly modelled in a fashion which the technique used for the rest of the painting would seem to rule out. (In the blue area of the peasant's coat, for instance, the paint appears thick and glutinous and the surface has dried to a dull sheen.) To say this is to say that though the peasant may be very much a part of the scene, he fails to become wholly a part of the *painting*.

Of course, in suggesting that a *judgement* might be made in these terms, I am viewing the painting with a regard informed both by Modernist criticism and by Impressionist painting itself. In thus analyzing the painted surface, I am deliberately applying principles of consistency with which the contemporary writer would have been unfamiliar or which would have been seen as irrelevant or absurd. An unmodelled peasant would have seemed to Burty even more perverse than an unmodelled tree. He no doubt took the

[5] 'Both Impressionist and Symbolist art exemplified ways of investigating the world, of discovering the real or the true, of experiencing life. The *mode* of perception, of vision, was of greater consequence to the Impressionist or Symbolist artist than the view seen or the image presented. In this respect both Impressionists and Symbolists placed themselves in opposition to what they regarded as 'academic' art, for such art found its reality and truth in the object of its own creation – its representation – the character of which was determined by the Academy's rules and standardized technical procedure. The truth which the Impressionist sought could be found in any act of perception that had (or seemed to have) the idiosyncratic character associated with a personal, spontaneous 'impression'. Nevertheless, the impression, as an image or an object of vision, was not the end of Impressionist art, but the means to that end, the means to an *experience* through which the true could be apprehended in an act of seeing' (R. Shiff, *Cézanne and the End of Impressionism*, pp.12–13).

Plate 179 Jean-François Millet,
Le Départ au travail (*Going to Work*),
1850–51, oil on canvas, 56 x 46 cm .
Glasgow Art Gallery and Museum.

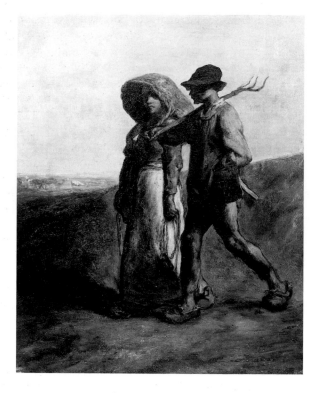

peasant as the key to the painting, the guarantee, as it were, of its having a subject – a suggestion supported by his reference to Millet, who was known first and foremost as a painter of peasant subjects (Plate 179). In that sense, Clark has a point. On the other hand, applying the terminology of Greenberg's 'Modernist Painting', we might say that Burty was viewing the painting in the manner appropriate to an Old Master, that he saw what was *in* the picture before seeing it as a picture. If the painting is viewed as a 'Modernist painting', one is 'made aware of the flatness' – and, in this case, of an *interruption* of that flatness – 'before, instead of after, being made aware of what that flatness contains'.

It is now time to introduce the second quotation, and to see, in the process, how the meaning of 'effect' became 'autonomized' in Modernist criticism. The writer is Clement Greenberg:

> It is quite evident that the illustrated subject – or let's say 'literature' – can play, does, and has played, a crucial part in figural art ... Nonetheless, it remains peculiarly difficult to talk with relevance about the literary factor in painting or sculpture ... It does seem that literary meaning as such seldom decides the qualitative difference between one painting or sculpture and another. Yet I say 'seem' advisedly. For at the same time the illustrated subject can no more be thought away, or 'seen away', from a picture than anything else in it can. The thing imaged does, somehow, impregnate the effect, no matter how indifferent you may be to it. The problem is to show something of how this happens, and that is what I cannot remember having seen any art writer do with real relevance – with relevance to the quality of the effect.
>
> ('Complaints of an art critic', p. 8)

The important difference here seems to me to be that whereas Burty assumes the possibility of tracing the 'effect' of a painting back into the world, Greenberg assumes that effect is first and foremost the property of a painting in its autonomous, non-figurative aspect, though he proceeds to acknowledge that this effect will inescapably be 'impregnated' by the painting's figurative content – by its imagery, or 'literary meaning', as he calls it.

For Burty the connection to the world is the justification and guarantee of such effects as the painting may have. For Greenberg, quality and meaning inhere in the effect of the *painting*, and it is in the face of this quality of effect that any attempt to connect the painting to the world must aim to justify itself. Of course, Burty is struggling to deploy an available vocabulary in the face of new painting, while Greenberg is addressing a general issue with the benefit of hindsight. Between the two quotations lies more than a century of abstract paintings, the vivid effects of which, if they are traceable back into the world in some fashion, are not generally to be matched against atmospheric 'appearances'.

As far as I'm concerned, the effect of *Hoarfrost* as a painting is that the consummately achieved and atmospheric 'impressionist' surface is broken (as it were, 'broken through') by the figure of the peasant, which appears to be modelled in the style of Millet – that is to say in the style of a previous generation of painting. Could Pissarro have intended this effect? Could he, for example, have meant to make a point about the displacement of the peasantry from the land (as a consequence of the encroachments of industry into agriculture), and if so, can we say that the painting is successful? I don't think so. It *is* just conceivable that the liberal Pissarro could have had some such intention, but if so it was in conflict with another intention which the painting surely declares more overtly: the intention to produce a coherent and integrated Impressionist painting. To put it crudely, if Pissarro pursued the aim of portraying the peasant in some relation to the land – an aim which we might associate with the artistic tendency of 'Realism' – to the extent that this aim could be satisfied, the painting's success as a technically modern, 'Impressionist' painting was put at risk. For the purposes of painting at least, the 'thought' behind the image was not one which could honestly be 'based on sensation'.

In fact, I don't think it very helpful to take the artist's assumed intentions as *starting points* for inquiry and interpretation. It may be that the interpretation we should hope to *end up with* is the one which most faithfully reproduces the artist's intention, but if so it will need to be acknowledged, firstly that not all intentions are conscious intentions, and secondly that the intentions with which artists complete their work are not necessarily the same as those with which they began. An artist will often change a work in the process of its execution, and the intention to do so is likely to have been formed out of dissatisfaction with what it looks like. Whatever assumptions we make about the artist's intentions, we still have to face up to the actual appearance of the painting – or, to go back to Clive Bell's criteria, we have to ask whether 'form' has been used aesthetically, as part of the whole composition, or whether it has just been used rhetorically, to make a point.

I would say that to ask whether *Hoarfrost* is a successful 'Realist' painting or an unsuccessful 'Impressionist' painting is merely to play with labels. The argument seems indifferent to the actual practice of art – as criticism and art history often are when the search for intentional meaning strays too far from the brute facts of making. For what the opinion is worth, I think it more likely that Pissarro included the peasant because he intended him to be a part of his *painting* and of its whole form – because he felt that the figure belonged as part of the representation. But the apparent evidence of the painting, I feel, is that he could not make the peasant 'belong' in this sense. It is as if the Impressionist surface has refused to admit him. Artists often fail to do what they mean and as often produce effects which they did not consciously intend. I suggest that whatever Pissarro's aims were, the reconciliation of the figure of the peasant with the all-over atmospheric landscape – the landscape which was 'modern' in *painting* – had become a practical and philosophical impossibility by 1873.

How such a circumstance might have come about is not a question which will admit of simple explanation. We are talking, after all, about the relationship between the broad social and economic tendencies of history and the specialized interests and procedures of art, between technical skills and political sympathies, between the labour of one class and

the culture of another, between what artists can imagine and what they can achieve. The pictures the artist paints will not always carry the meanings that he or she would wish them to. You can paint a picture of a peasant trudging across a field. You can feel sincere sympathy for the plight of the peasantry. It does not follow, however, that sympathy will be what the paint expresses or can express. Art tends to develop in a space between intended meaning and possible meaning. Just where, in the end, this space is to be found will be largely determined by historical factors outside the artist's control. To view Pissarro's *Hoarfrost* in the terms I have suggested is not simply to make an aesthetic judgement about whether or not it is formally successful. It is also to inquire into the conditions which have made it impossible for the artist altogether to reconcile what he thought about with what he could make.

It could, I think, be said that the very impossibility of this reconciliation *is* what the painting vividly represents; that though the image of the peasant was available to thought and imagination, this was no longer any guarantee that that image could be sensibly located within the world of modern painting. If that is so, should we allow priority to the aesthetic criteria of Modernism and view the painting as a relative failure? Or, alternatively, might we say that the quality of paintings such as this, and, from its different perspective, Monet's *Bathing at La Grenouillère*, lies precisely in their offering such vivid testimony to a moment of fracture between a world of social values and a world of aesthetic values – or, at least, to some historically specific tendency for those two worlds to divide; that it is a paradoxical measure of their quality that these paintings stimulate us both to question the very authority and stability of the aesthetic and to look more deeply into historical processes in search of relevant explanations?

I believe that these are open questions. They are asked not because I think that they can or should receive definitive answers, but rather in order to encourage further speculation about the relationship between aesthetic assessment and historical explanation. Without pre-empting the direction which such speculation might take, I propose in the next section to consider a group of paintings in which prominence is clearly accorded to the human figure and to its social setting, rather than to landscape and its 'atmosphere'.

Painting and human content

As we have seen, Modernist theory describes a tendency in which pictorial space is progressively flattened and human content squeezed out in pursuit of independence or 'purity' for painting as an art:

> All recognizable entities … exist in three-dimensional space, and the barest suggestion of a recognizable entity suffices to call up associations of that kind of space. The fragmentary silhouette of a human figure, or of a teacup, will do so, and by doing so alienate pictorial space from the two-dimensionality which is the guarantee of painting's independence as an art.
>
> (Greenberg, 'Modernist Painting', pp.6–7)

> Roughly speaking, the history of painting from Manet through Synthetic Cubism and Matisse may be characterized in terms of the gradual withdrawal of painting from the task of representing reality – or of reality from the power of painting to represent it – in favour of an increasing preoccupation with problems intrinsic to painting itself.
>
> (Fried, 'Three American Painters', pp.115–16)

The authors of these texts had more recent art in mind: those forms of abstract painting which they saw as the best Modernist art at the time they were writing, and which they were concerned to establish as the most *logically* defensible forms of development of the tradition of modern art. The hindsight they apply is one which serves the ends of a current conviction. This is not to say that hindsight is therefore *necessarily* discredited, but in view of the cautions against historicism suggested earlier, we should be alert to any evidence which might count against it. On these grounds we shall now briefly consider a group of works which appear – at least at first sight – to be exceptions to the Modernist rule about painting's 'orientation to flatness' and its 'withdrawal from the task of representing [human and social] reality'.

Carolus Duran's *The Merrymakers* (Plate 180) was painted in 1870. It is a painting of a kind which was likely to have found a ready welcome at the Salon, where the artist was a regular exhibitor. In the aftermath of a meal, a family servant entertains a chubby infant in the presence of two plainly but smartly dressed women. Given the facial resemblance between these two, we may see them as mother and elder daughter, or as mother and her younger sister, or possibly as grandmother and young mother. The specific relationship we attribute to them matters less to the effect of the painting, I think, than the fact that they are clearly ranged together at the other side of a class division from the woman on the left, whose costume and features are accorded a quite different style. I don't think we have to work very hard to imagine the grounds on which such a painting might have appealed to the typical Salon patron. I am not here thinking solely of the matter of convergence of taste. I mean that the painting is so designed as to construct an imaginary spectator or witness who is socially and psychologically at ease with its subject: one placed in the position of the observing male – the returning *flâneur* perhaps – secure in the awareness that nothing is required of him but complacency at the charm of his offspring and satisfaction with the management of his household.

Plate 180 Carolus Duran (Charles-Émile-Auguste Duran), *Les Rieuses* (*The Merrymakers*), 1870, oil on canvas, 90 x 139 cm. Detroit Institute of Arts. Founders Society Purchase, Robert H. Tannahill Foundation Fund.

ate 181 Édouard Manet, *Le Déjeuner dans l'atelier* (*Luncheon in the Studio*), 1868,
on canvas, 118 x 154 cm. Neue Pinakothek, Munich, Staatsgemäldesammlungen, Munich.

If Carolus Duran's is a painting which appears to radiate reassurance in the direction of the potential bourgeois patron, there are other contemporary and later paintings which suggest a very different kind of spectator – or at least a spectator very differently disposed in both a social and a psychological sense. Manet, for instance, was Carolus Duran's contemporary, and though he often took his subjects from the same social world, the imaginary frame of mind within which those subjects are experienced is never as untroubled or as unselfconscious as *The Merrymakers* allows it to be; see, for example, his *Luncheon in the Studio* of 1868 (Plate 181).

We shall have more to say about Manet's painting in passing. For the moment, however, a more extreme contrast is furnished by a work which Vincent Van Gogh painted in Holland in 1885, a year before his arrival in Paris. *The Potato Eaters* (Plate 182), draws us into a very different social world – one which offers no obvious place in the scheme of things to a spectator with the imaginary identity of a bourgeois paterfamilias. Of course, this fact alone does not necessarily rule out the possibility that the painting could have appealed to the bourgeois or aristocratic patron *as a picture*. That's to say, though this is clearly a painting of a peasant meal in a peasant dwelling, it is not its overt subject which would have made it unattractive to the normal viewer. On the contrary, paintings of peasant subjects – genre scenes – had been a regular and thoroughly marketable stock-in-trade for Dutch and Flemish painters since the seventeenth century, and for French painters since the eighteenth. The significant differences between Van Gogh's painting and Carolus Duran's, I suggest, lie not simply in *what* is shown, but also in *how* that showing is done. That 'how' is crucial in deciding the form of imaginative experience which any given painting provokes or enables. It is the manner of organization

of a picture – those various features which we think of as belonging to the art of *composition* – which decides our position *and character* as spectators.

What is distinctive about *The Potato Eaters* is not so much that its subject is unappealing as that it presents this subject in a thoroughly uningratiating fashion. The viewer in search of an amusing subject is confronted with a number of formal and technical obstacles, which, if they were not explicitly intended as such by Van Gogh, were certainly the actual outcome of a series of careful drawings and sketches. For instance, the group of peasants is organized into a closed circle within the claustrophobic space of the painting. Furthermore, the back of the nearest figure is so placed and outlined as to present an emphatic barrier. This silhouetted figure serves to bar imaginative entry into the pictorial space. (Note, in contrast, how the space of Carolus Duran's picture is rendered open and inviting at just the equivalent point, while in Manet's painting, though the foreground figure faces the spectator, it is not he who returns the spectator's regard.) The same figure also dissuades from any attempt to 'read in' to the painting's social and psychological space by identifying with its own position – as figures thus placed often permit us to do in more conventional 'conversation pieces'. One further point to note is that the actual material character of Van Gogh's painting appears to affirm this resistance to imaginative entry. Its surface is dark and opaque and is marked by just those kinds of abrupt and emphatic transition which Carolus Duran has so painstakingly avoided. Van Gogh appears to have made no concession to the standards of finish – and thus of competence – associated with the tradition of genre painting. (Whether or not this effect is

Plate 182 Vincent Van Gogh, *Aardappeleters* (*The Potato Eaters*), 1885, oil on canvas, 72 x 93 cm. Stedelijk Museum, Amsterdam.

Plate 183 Auguste Renoir, *Un déjeuner à Bougival* (*A Luncheon at Bougival*), also known as *The Luncheon of the Boating Party*, 1881, oil on canvas, 129 x 173 cm. Phillips Collection, Washington.

a consequence of some actual incompetence is an open question to which we shall return in relation to the work of Cézanne.)

Now, it would be possible to make out a case for the relative quality and originality of Van Gogh's painting which was consistent both with the account so far offered and with the findings of Greenberg's 'Modernist painting'. We could say, for instance, that Van Gogh uses art to call attention to art; that his painting frankly declares the surface on which it is painted; and that this artificiality and this frankness serve the ends of self-criticism. This is to say, firstly, that the *The Potato Eaters* establishes a standard of quality according to which *The Merrymakers* appears to fall short, and, secondly, that this quality in Van Gogh's painting is inseparable from its relative artificiality and frankness. If we agree, so far so good. But should we let the matter rest there? That's to say are these differences to be considered *simply* as matters bearing upon the critical relationship between one painting and another? Are the problems which *The Potato Eaters* addresses adequately represented as 'problems intrinsic to painting'? The two pictures display evident differences in subject-matter, composition and style. It has been argued, however, that they are distinguished not simply by these differences of appearance, but more profoundly, by the very different ways in which they position and characterize the spectator, both socially and psychologically. Could we not, then, see the supposed 'problems intrinsic to painting' as problems largely given in, and representative of, the realities of human social and psychological life and therefore not really intrinsic at all?

To put the matter bluntly, though it is certainly possible imaginatively to enter the world of *The Potato Eaters*, I am not at all sure that it was or is possible to enter it as a *bourgeois* – and certainly not as the form of untroubled bourgeois who seems to be presupposed by *The Merrymakers*. I don't mean that to be bourgeois was, or is, to be debarred from 'seeing' Van Gogh's painting. Nor do I mean that Van Gogh was either a non-bourgeois or an 'anti-bourgeois' artist. (After all, in so far as there have been interested observers of modern painting they have tended to be members of the middle class, while the profession of artist is, by definition, not a form of labour.) I mean rather to suggest that *The Potato Eaters* could not and still cannot be experienced in all its particulars without some devaluation *in imagination* of those powers and competences with which the authority of the bourgeoisie has historically been associated. I also suggest that a similar kind of devaluation could be said to be implicit in Manet's *Luncheon in the Studio*, where the boatered youth is ironically isolated from the silent communication between spectator and servant. If this is a valid form of hypothesis, it would follow that the critical relationship of one painting to the other is not simply the manifestation of a self-critical development in modern painting, but is rather a testimony – witting or unwitting – to the conflicting 'realities' of experience in class society. To say this would be to imply that the question of the quality of a given work of art cannot be entirely dissociated from the question of its position in the relations between classes.

We have been exploring the idea that works of art cast a critical light upon each other, and we have extended or revised the Modernist notion of self-criticism to include criticism of social norms and positions. That's to say, we have considered the relative qualities of

Plate 184 Gustave Caillebotte, *La Partie de Bésigues* (*The Game of Bezique*), 1880, oil on canvas, 125 x 165 cm. Private Collection. Photograph by courtesy of Brame and Lorenceau, Paris. (Exhibited in the seventh Impressionist exhibition, 1882.)

The Merrymakers, The Luncheon in the Studio and *The Potato Eaters* both with regard to their respective technical qualities *and* with regard to the forms of social experience which are drawn upon in imagination. Lest it appear that I intend a simple correspondence between artistic quality and modernity on the one hand and the critique of the bourgeois social world on the other, I will introduce a fourth painting – another meal. Renoir's *Luncheon of the Boating Party* (Plate 183) was painted between 1880 and 1881, and was included in the seventh Impressionist exhibition in 1882, under the title *A Luncheon at Bougival*. In a show which was largely composed of landscapes, the painting attracted attention and acclaim second only to Caillebotte's *Game of Bezique* (Plate 184). In *La Vie Moderne*, 11 March 1882, the critic Armand Silvestre called it 'one of the most beautiful pieces that this insurrectionist art by Independent artists has produced' (quoted in *The New Painting*, p.413). The probable models include the son of the restaurant owner (standing at the extreme left), Renoir's future wife, Aline Charigot (bottom left), Gustave Caillebotte (extreme right), and other friends and associates of the artist – an actress or two, a former cavalry-officer, a banker and amateur art historian, a journalist.

Of all the Impressionists, Renoir was the most emphatic in his insistence upon the virtues of 'pure art', but he was also the most assiduous in cultivating the kinds of portrait-painting commission that could best be secured through success at the Salon. Among its other qualities, *The Luncheon of the Boating Party* serves to advertize Renoir's considerable skills as a modern painter of modern types – skills which the reviewers were quick to notice. One observed that the painting was 'a charming work, full of gaiety and spirit, its wild youth caught in the act', another that it showed 'the most entertaining type of Parisian woman that one can imagine' (quoted in *The New Painting*, p.413).

How is this painting to be viewed in the terms of the preceding discussion? What effects does it reproduce and produce? What kind of position does it construct for the imaginary spectator? And what can we learn from considering it in these terms that might be relevant to an assessment of its quality? It is not because answers come readily to hand that I raise such questions as these. *The Luncheon of the Boating Party* seems to me hard to pin down, both in its relation to other relevant forms of painting, and in its mode of

Plate 185 Camille Pissarro, *Les Moissonneuses* (*The Gleaners*), 1887–89, oil on canvas, 65 x 81 cm. Öffentliche Kunstsammlung, Basel; Dr H.C. Émile Dreyfuss Stiftung, Kunstmuseum, Basel.

Plate 186 Georges Seurat, *Un Dimanche d'été sur l'île de la Grande Jatte* (*Sunday Afternoon on the Island of La Grande Jatte*), 1884–86, oil on canvas, 206 x 306 cm. Art Institute of Chicago. Courtesy of the Art Institute of Chicago, Helen Birch Bartlett Memorial Collection, 1926.224.

representation of the social world. My aim is to focus a certain kind of attention on Renoir's painting and to encourage readers to draw out from the comparison with *The Merrymakers, The Luncheon in the Studio* and *The Potato Eaters* respectively some further questions about the kind of light which one work of art can shed on another.

According to a memoir by Renoir's son, the setting for this painting was the Restaurant Fournaise at La Grenouillère, where the artist had first painted in 1869 (J. Renoir, *Renoir, My Father*, pp.187–90). We might thus view the work, if not as a direct outcome of the earlier sketches of La Grenouillère, at least as motivated by a continuing ambition to produce relatively complex and large-scale paintings on plausibly modern social themes – the same ambition that Monet apparently abandoned. In fact, it is clear that this ambition continued among many of the most prominent avant-garde French painters of the later nineteenth and early twentieth centuries, whatever difficulties there may have been in reconciling such themes with the technical interests of modern painting, and whatever disagreements there may have been on the question of where – in what strata of society – the typical representatives of the modern were to be found. During the 1880s Pissarro was increasingly preoccupied with scenes of peasant life, and towards the end of the decade he painted several ambitious works in which groups of figures are monumentalized into brightly coloured scenes of rural labour (Plate 185). In fact, though Monet generally devoted himself to landscape subjects, I believe there is evidence that even he retained some interest in the modernization of history painting – as regards its scale and complexity, at least, if not its traditional themes. We shall return to this

suggestion in the concluding section. Of the core group of Impressionists, Sisley alone remained to the end a painter of sketch-like atmospheric landscapes, and it could be said that, for all the consistent competence which his work displays, that very consistency marks a kind of limit on the interest of his art.

Before we end this section, there is one more artist to be mentioned. In the last Impressionist group exhibition, held in 1886, a new recruit, Georges Seurat, included his *Sunday Afternoon on the Island of La Grande Jatte* (Plate 186), a painting which, by virtue of its size, its technique and its multi-figure subject, clearly identified itself as an ambitious attempt to reconcile modern themes with avant-garde technical interests. The picture was painted as a pendant to the same artist's *Bathing at Asnières* (Plate 187). For much of the twentieth century these two paintings were generally viewed in the context of a 'Neo-Impressionist' movement, and thus seen as standing primarily for the radical systematization of Impressionist colour and the Impressionist brush stroke. More recent writing has restored to the two paintings that sense of fascinated but ironic engagement with the appearance of modern life which contemporary commentators were quick to observe, but which the priorities of Modernist criticism have tended to disparage. T.J. Clark writes of *Bathing at Asnières* as a 'serious depiction' not only of that shifting world of scenes and values created by the interaction of industry and nature, but also of the forms of behaviour which these 'new circumstances' determine, while he interprets *La Grande Jatte* as a painting 'which attempts to find form for the appearance of class in capitalist society' (*The Painting of Modern Life*, pp.201 and 261).

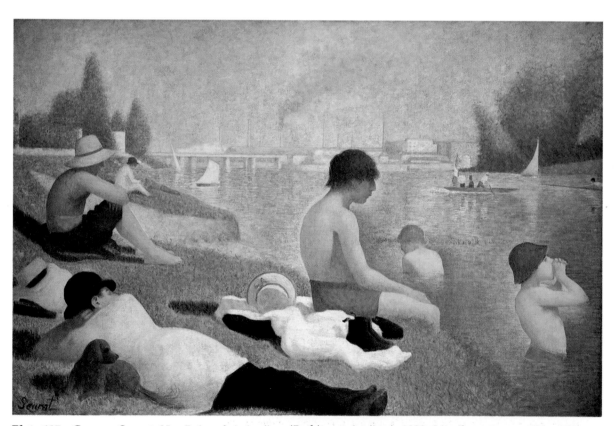

Plate 187 Georges Seurat, *Une Baignade à Asnières* (*Bathing at Asnières*), 1883–84, oil on canvas, 201 x 300 cm. The National Gallery, London. Reproduced by permission of the Trustees. (Exhibited in the eighth Impressionist exhibition, 1886.)

In reviewing this group of works I have meant to question the notion that painting in the later nineteenth century can properly be viewed in terms of a divorce between 'reality' on the one hand and 'problems intrinsic to painting' on the other. It should be acknowledged, however, that an important and interesting footnote supports and qualifies the passage from Michael Fried's 'Three American Painters', which I quoted at the outset and to which I now return. Acknowledging that 'Manet's ambitions are fundamentally realistic', he notes the effect on Manet's work of self-consciousness about his *relationship* to reality – self-consciousness of the same order, I think, as we noted in *Luncheon in the Studio*, where it functions to signify an uneasiness and complexity in social and psychological experience which is quite foreign to such works as *The Merrymakers*. Fried describes Manet as 'the first painter for whom consciousness itself is the great subject of his art'. In making the spectator aware that what he or she is looking at 'is, after all, merely a painting' and in that frank assertion of the flatness of the surface remarked by Greenberg, Manet is responding to the need to make 'the estranging quality of self-awareness an essential part of the content of his work'. The 'founding of Modernism', then, is a direct consequence of the attempt 'to achieve a full equivalent to the great realistic painting of the past'. Fried's Modernism is not quite the argument for 'pure art' which it may have appeared to be from the passage quoted at the outset of this section. According to his account, engagement with 'problems intrinsic to painting', even if it is not a direct engagement with social problems, is nevertheless the price modern painting has to pay for its very engagement with the determining realities of human social and psychological existence.

Cézanne

Paul Cézanne was included among the independent artists in 1874 as a consequence of Pissarro's advocacy, and reputedly despite the misgivings of some other of the founder members. He showed three paintings in the first group exhibition: *A Modern Olympia* (Plate 178), a landscape of Auvers-sur-Oise entitled *The House of the Hanged Man* (Plate 188) and a further landscape study of Auvers. Two contemporary notices are deserving of mention. The first, by a writer signing himself 'Jean Prouvaire', is representative of those for whom Cézanne served as an image of avant-garde absurdity and extremism:

> Shall we mention Cézanne, who, by the way, has his own legend? No known jury has ever, even in its dreams, imagined the possibility of accepting a single work by this painter, who came to the Salon carrying his paintings on his back, like Jesus Christ carrying his cross.
>
> (*Le Rappel*, 20 April 1874, quoted in *The New Painting*, p.126)

He had first submitted work to the official Salon in 1863; it was to be a further nineteen years before he had a painting accepted. The second notice was written by the writer Émile Zola, a friend from the artist's boyhood and a supporter of Manet:

> Among the works that caught my eye, I was particularly struck by a remarkable landscape by Paul Cézanne, one of your compatriots from the South, a native of Aix, who shows great originality. Paul Cézanne, who has been struggling for a long time, unquestionably has the temperament of a great painter.
>
> (*Le Sémaphore de Marseilles*, 18 April 1874, quoted in *The New Painting*, p.126)

This favourable mention of Cézanne's work was demonstration of the persistence of friendship, though it is noteworthy that Zola was writing in a provincial paper for the

Plate 188 Paul Cézanne, *La Maison du pendu* (*The House of the Hanged Man*) *c.*1874,
oil on canvas, 55 x 66 cm. Musée d'Orsay, Paris. Photo: Réunion des Musées Nationaux
Documentation Photographique. (Exhibited in the first Impressionist exhibition, 1874.)

consumption of fellow Provençals and thus not risking his judgement before a Parisian
audience, and that the emphasis placed on originality, struggle and temperament was
such as to leave an impression of promise unfulfilled. As late as 1880 Zola was to describe
Cézanne as one who 'has the temperament of a great painter but who still struggles with
problems of technique'.

Three years after the date of the first review quoted, in one of the few favourable
notices that Cézanne received on the occasion of the third group exhibition, Renoir's
friend Georges Rivière observed that 'Cézanne has come in for more abusive treatment …
at the hands of both press and public, over the last fifteen years … than any other artist
you care to name'. In Rivière's eyes, however,

> What he most closely resembles is a Greek of the golden age. That imperturbable calm in
> all of his canvases is also found alike in Greek painting or vases. Those who ridicule his
> *Bathers*, for example, are just like the Barbarians who find fault with the Parthenon.
> Cézanne is a great painter …
>
> (quoted in S. Orienti, *The Complete Paintings of Cézanne*, p.8)

Clearly these are widely differing views, and they are not to be explained in terms of
progress or development in Cézanne's work between the first exhibition and the third (in
which he showed sixteen works). The painting which Rivière singled out for particular
praise, now known as *Fantasy Scene* or *The Fishermen* (Plate 189) was almost certainly

executed in the early 1870s. For Rivière, this painting was 'strikingly majestic and extraordinarily calm … vast and sublime, like a beautiful memory' (quoted in *The New Painting*, p.213). It is not hard to understand, however, how the same work might also have been seen, even by the well-disposed Zola, as demonstrating more promise than achievement. At first glance the modelling of the figures appears rough and abrupt, and the composition awkward, with the dark silhouette projecting emphatically into the bottom left-hand corner and the grey sail slicing into the picture space at the right.

This divergence of opinion concerning Cézanne's work is symptomatic of the role he had already come to play in the development of a distinct set of proto-Modernist values. In the late 1870s he seems to have been singled out as the artist of his generation around whose work critical opinion polarized. This polarization was to some extent a reflection of the wider changes taking place within the French art world and within French culture as a whole. Just as the more conservative critics like 'Jean Prouvaire' needed figures of ridicule to use in their justifications of traditional values and traditional notions of artistic competence, so those who identified with the emergent avant-garde needed models of modernity and sincerity to point to. In 1866 Manet had furnished such a model for the young and ambitious Zola. After the first exhibition of the independent artists in 1874, the work of Monet and the other 'Impressionists' provided a new standard around which progressive opinion could rally. By 1877 it was the painting of Cézanne which appeared to offer in strongest measure what Greenberg was to call the 'challenge to taste'. The terms in which Cézanne was singled out by his early admirers reveal a rapid evolution in the conceptual apparatus of Impressionist theory and criticism. 'In all his paintings', Rivière

Plate 189 Paul Cézanne, *Scène fantastique* or *Les Pêcheurs* (*Fantasy Scene* or *The Fishermen*) 1873–75, oil on canvas, 54 x 81 cm. Private Collection. (Exhibited in the third Impressionist exhibition, 1877.)

wrote, 'the artist produces emotion, because he himself experiences before nature a violent emotion which his craftsmanship transmits to the canvas'. The notion of painting as the recording of sensation had clearly been accepted into the vocabulary of sympathetic criticism. What was now at stake was the *strength* of this sensation. Where the conservative critic found – or claimed to find – evidence of incompetence, naïvety and even insanity, the sympathetic critic found originality, individuality of temperament and a capacity for strong emotion.

We should not be too ready to ridicule those – Manet reputedly among them – who were unable to take Cézanne's painting seriously in the 1870s. Academic painters such as Alexandre Cabanel, Jean-Léon Gérôme and Bouguereau were unquestionably competent in the procedures they used to plan their paintings and in the techniques they used to realize them – or at least they were while any authority attached to their notion of art. So long as the works of painters such as these were taken as models of accomplishment, how could the work of Cézanne possibly be seen as other than incompetent? For example, if we compare one of Cézanne's studies of bathers from the early 1880s (Plate 190) with a contemporary contribution to the genre from Bouguereau (Plate 191), we may initially be hard pressed to identify the nature of those relative virtues by which the Cézanne is supposedly distinguished.

It may be more instructive to start where the less sympathetic critics themselves started, to note the kinds of technical competence displayed in the Bouguereau – the

Plate 190 Paul Cézanne, *Bathers*, 1883–85, oil on canvas, 63 x 81 cm. Staatsgalerie, Stuttgart.

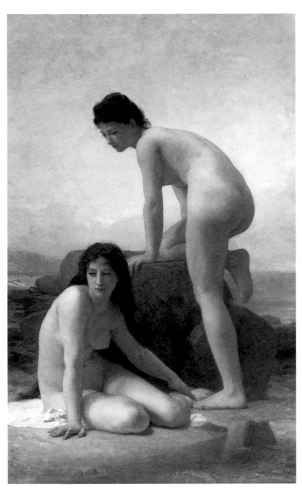

Plate 191 William-Adolphe
Bouguereau, *Les Baigneuses*
(*The Bathers*), 1884, oil on canvas,
201 x 129 cm. A.A. Munger
Collection, 1901.458
© The Art Institute of Chicago.

careful delineation and smooth modelling of the human form, the practised framing of a deep illusionistic space, the easy blending of colour and tone, the discreet subordination of brushwork to the requirements of illusion – and to observe how few of them are to be found in Cézanne's painting. The majority of contemporary critics noted the apparent lack of such competences in Cézanne's art and not unnaturally viewed that lack as a form of failure. Looking at his paintings of bathers, they assumed that he had attempted works of the order of Bouguereau's and had simply fallen well short. They saw figures which were badly drawn, misshapen and flat; pictorial spaces silted up with variegated texture; abrupt changes of tone and colour; brushwork which was sketchy and unfinished. This is to say that, rather than perceiving the effects of Cézanne's work as intentional, they saw them as the involuntary consequences of incompetence – and thus as insignificant. After all, no serious painter could *intend* to appear incompetent. Hence the tendency to ridicule Cézanne's pretension – his constant attempts to claim a place for his work in the official Salon. To be an 'original' in this sense is to be a figure of ridicule. I suggest, then, that instead of asking why the majority of observers were unable to appreciate the virtues of Cézanne's work, we may learn more by asking how it was that his art came to be seen by a small minority of critics – and more significantly of other artists – as intentional, competent and even exemplary.

One reason, I think, is that certain precedents had been established in France by artists who had achieved recognition in the face of previous ridicule, Courbet and Manet foremost among them. With the benefit of hindsight we can say that this implied that there

had been some form of breakdown in the established consensus of taste, or some substantial challenge to that authority by which taste itself was defined. Although the organization of the Salon des Réfusés in 1863 was by no means an avant-garde enterprise, it was one manifestation of this breakdown, and on that occasion Zola, and Cézanne himself, had been among the visitors who admired Manet's rejected works. The recognition of an avant-garde in art requires an audience wanting to distinguish itself by the difference – in effect the avant-gardism – of its taste (an audience which will be, at least in part, an audience of other artists).

Under these circumstances the 'challenge to taste' was a form of avant-garde call to arms, and by the mid-1870s it could be recognized instantly in the vocabulary of avant-garde criticism as we have already encountered it: 'sensation', 'effect', 'originality' and 'temperament'. According to the avant-garde theory of the time, originality was the quality to watch for and it made itself known through distinctive effects. These effects were read as the signs of those powerful sensations which impressed themselves upon the temperament of the original artist, who became increasingly idealized as the model of the authentic and authentically *uncommercial* being (whatever may have been the nature of his or her actual operations in the market-place). Cézanne was in many ways well cast as the type of the avant-garde artist in the later nineteenth century. After the early 1880s he remained largely isolated from Paris and from the social occasions of the art world, while a myth of his integrity and obsessiveness developed among those few younger artists (Émile Bernard and Maurice Denis foremost among them) who maintained some acquaintance with his work.

One important question is begged by this account. How was the spectator (and how are we even now) to tell the pictorial effects of the original and temperamentally gifted artist from those of the hapless incompetent? Modernist theory offers no easy answer to this question. On the one hand it is assumed, in Bell's words, that 'Art' – authentically original art, presumably, 'speaks for itself to those that can hear' (*Art*, p.98). Greenberg talks of artists 'proving themselves' and of a disinterested and involuntary 'consensus of taste' among those who pay most thoughtful attention to art (T. Evans, 'A conversation with Clement Greenberg', p.8). On the other hand, the insecurity of discriminations based on fixed standards of competence is increasingly acknowledged, indeed even celebrated, in Modernist theory, by extending the canon of approved art to include the work of 'primitives' of various orders: children, craftsmen from tribal societies, the naïve and the untaught (see Plate 192).

It is perhaps easier to address the problem if we think of competence, skill and so forth not as fixed and absolute values (which is how they were largely regarded in the discourse of the Academy), but rather as the modes by which the intentional practice of the artist is at any given time organized and directed in relation to a specific *world* of values – for example a given set of ideas about what art ought to look like. We can sometimes learn as much by noticing which forms of accomplishment artists avoid or discard as we can by attending to those they display.

With this idea in mind we might conceive of the very absence of Academic competences in Cézanne's work as a kind of competence in itself – the result of a determined intention *not* to paint a Bouguereau, *not* to accept naturalistic or photographic likeness as a sufficient form of relationship to the world, instead to make the effects of the painting interesting in themselves. In a letter of 1874 he wrote to his mother:

> I have to work all the time, not to reach that final perfection which earns the admiration of imbeciles. – And this thing which is commonly appreciated so much is merely craftsmanship and renders all work resulting from it inartistic and common. I must strive after perfection only for the satisfaction of becoming truer and wiser.
> (Rewald, *Cézanne's Letters*, p.142)

Plate 192 Henri Rousseau, *La Fabrique de chaises* (*The Chair Factory*), known as *View of the Chair Factory and the Seine Quay at Alfortville*, (large version), *c*.1897, oil on canvas, 73 x 93 cm. Collection J. Walter P. Guillaume, Orangerie, Paris. Photo: Réunion des Musées Nationaux Documentation Photographique.

Conceived in these terms, the attractions of Cézanne's work are perhaps easier to understand. In comparing Cézanne to a 'Greek of the golden age', Rivière was, by implication, levelling a charge of decadence both at the likes of Bouguereau and at those who were his (bourgeois) admirers. For the avant-garde audience which responded to them, Cézanne's paintings stood as powerful forms of refusal or negation, *and thus* as demonstrations of a singular and interesting integrity. According to this point of view, the force of his individual temperament impelled him to work against the grain of established culture – specifically against the grain of such cultural forms as had become representative of a standard bourgeois taste. This very resistance was what 'originality' had come to mean by the 1870s, and it is what it largely continued to mean in the criticism of modern art for the next hundred years.

With the possible interests of contemporary viewers furnishing a form of context, we can perhaps now consider the merits of Cézanne's *Bathers* with more confidence. We can notice how a complex rhythm is established by the silhouettes of the various figures, how the placing of these figures relative to each other creates an effect of space and volume, how, in fact, the entire worked surface of the painting contributes to this almost sculptural effect. We can also observe that the Bouguereau appears by contrast to be weakly theatrical, inert and largely vacant. And if we note the prospect of psychological engagement which the Bouguereau holds out – by virtue of the relative particularization of the features, and the absorbed gaze of the nearer figure – the complete exclusion of any

such prospect from Cézanne's painting seems like a form of critical admonition. In effect, once we are equipped with the means to view Cézanne's painting as competent, it is the Bouguereau which comes to seem suspect. Like Fildes' *The Doctor* as Clive Bell viewed it, it has the aspect of an over-rehearsed performance. However well practised its illusionistic techniques may be, from the stand-point of Modernist interests, it is *aesthetically* incompetent, impersonal and unoriginal.

Cézanne's *Dejeuner sur l'herbe*

I want to consider two further works by Cézanne, one earlier than the *Bathers* and one later. The first, known as *Le Déjeuner sur l'herbe* (*Luncheon on the Grass*, Plate 193) dates from about the same time as Monet's and Renoir's paintings of La Grenouillère. The second, *The Grounds of the Château Noir* (Plate 194) was painted in about 1900, towards the end of the artist's life. The first is one of a group of works of romantic themes which are now generally ascribed to the period 1867 to 1871. It is clearly a 'subject painting', and one which appears to invite psychological interpretation of its symbolism, if only because the bald figure in the foreground is manifestly a self-portrait. Cézanne must surely have had in mind Manet's *Déjeuner sur l'herbe* which he had seen in the Salon des Réfusés, and if he did not actually see Monet's work of the same title in the mid-1860s, he must certainly have known of the project. Though there is no reason to suppose that its present title is Cézanne's own, his painting asks to be considered in relation to these, and to the various other multi-figure paintings on outdoor themes which addressed the same persistent problem: how on the one hand to express an interest in the representation of the modern, while on the other addressing traditional measures of elevated painterly ambition and competence. The earlier artists Cézanne admired were all painters in whose work rich

Plate 193 Paul Cézanne, *Déjeuner sur l'herbe*, (*Luncheon on the Grass*), 1869–70, oil on canvas, 60 x 81 cm. Private Collection.

Plate 194 Paul Cézanne, *Dans le parc du Château Noir* (*The Grounds of the Château Noir*), *c.*1900, oil on canvas, 91 x 71 cm. The National Gallery, London. Reproduced by permission of the Trustees.

effects of colour were combined with sensuously modelled and animated figures: the Venetians of the sixteenth century, Rubens, Delacroix. In his more romantic works of the later 1860s and early 1870s he seems to have been attempting to find modern pictorial themes with which he could emulate their achievements. Like Monet at La Grenouillère, he may have aimed to succeed as a very different kind of painter from the one he subsequently became.

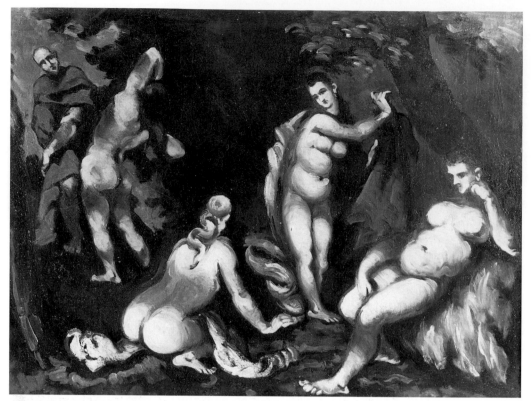

Plate 195 Paul Cézanne, *Le Tentation de Saint Antoine* (*The Temptation of St Anthony*), 1867–70, oil on canvas, 54 x 73 cm. Fondation E.G. Bührle Collection, Zürich.

During this period Cézanne was continuing to submit work to the official Salon and it's probable that he was considering the possibility of some more substantial subject painting than the *Déjeuner* in its surviving version. In a letter to a mutual Provençal friend, written in the summer of 1866, Zola described Cézanne as 'engaged in painting works, great works, on canvases four to five metres wide.' In fact none of Cézanne's surviving paintings of his early years is larger than 150 centimetres wide and the great majority are considerably smaller. But if he did indeed attempt works on such a scale during the 1860s, as Monet did, then it may be that paintings such as the *Déjeuner* and the contemporary *Temptation of St. Anthony* (Plate 195) offer some indications of what they were to have been like. Certainly the density of the surface, which in his contemporary still-lifes produces a sense of expressive gravity (see Plate 196), leads in *Déjeuner sur l'herbe* and *The Temptation of St. Anthony* to a claustrophobic denseness in the pictorial space. That's to say, it does indeed seem at first sight as if these latter paintings might have benefited by being realized on a larger scale. And yet such an enlargement would surely have led to conflicts as acute as those which I believe would have attended upon the hypothetical panorama suggested by Monet's studies of bathing at La Grenouillère: a conflict, for instance, between the private and elusive character of Cézanne's theme and the public rhetorical aspect conventionally associated with large-scale figure compositions; and a conflict between the painterly style of the work as it stands, with its marks of individualism, strength of sensation and originality, and those technical requirements of balance, breadth and coherence which were virtually unavoidable in subject paintings of larger dimensions. As with Monet's 'bad sketches', though by no means for all the same reasons, those qualities which make *Déjeuner sur l'herbe* 'modern' seem inseparable from its size

Plate 196 Paul Cézanne, *Nature morte à la bouilloire* (*Still-Life with Coffee Pot*), *c.*1869,
oil on canvas, 64 x 81 cm. Musée d'Orsay, Paris.
Photo: Réunion des Musées Nationaux Documentation Photographique.

and scale. Its execution appears as if marked by a quality of awkward and confessional
urgency. According to the critical conventions of the avant-garde, this apparent urgency is
a sign of temperament and the guarantee of originality. The measure of the painting's
authenticity as a *modern* painting, in other words, is that the artist himself is not simply
pictured in the painting, but also somehow expressed *by* it. This sense of the artist's
psychological presence is not quite of the same order as the self-consciousness which Fried
attributes to Manet (for whom, Fried said, 'consciousness itself is the great subject'), but it
may function in a similar way to render the painting's relationship to 'reality' open to
question.

The evidence suggests that Cézanne's *Déjeuner* is autobiographical at some level, and
that the interrelation of the figures can be read as symbolic of some pattern in Cézanne's
own relationships, at least as he conceived them. We need not pin the painting down to a
more specific reading of its symbolic content than this, but we should note some of the
questions which any such reading would have to address. How, for instance, should we
interpret the gesture which Cézanne has shown himself making? Is the standing woman
offering or refusing the apple or orange? Is she to be seen as tempting, giving or withhold-
ing? Do the two figures receding at the left represent a later stage in the same ambiguous
transaction – the outcome of a decision perhaps – or are they simply two additional
characters? What parts in the symbolic scheme are played by the dark-haired woman, the
fair-haired young man and the pipe-smoker with folded arms? How are we to interpret

the dog, the bottle and chain nearby, and the folded parasol in the bottom right-hand corner? In pursuit of an interpretation, what information is it relevant to bring to bear from 'outside' the painting? For example, it was in 1869 that Cézanne first began to live with Hortense Fiquet, the model who was to become his wife seventeen years later. Should we assume that the painting belongs to that year and read it in the light of this information?

For the sake of our present discussion what matters is not that these questions should receive definitive answers, but rather that the painting itself should be characterized as one which seems to raise issues of psychological interpretation by virtue of its figurative content. It is a painting which seems to have a kind of story to tell, if only we could decipher it. Such paintings do tend to attract the attention of iconographers ambitious to establish correct interpretations.[6] And yet it may be that the identity of Cézanne's painting, as a painting, lies rather in the 'if only' – in that very resistance to verbal language which enabled the artist to externalize in painting those psychological materials which he could not treat successfully in any other fashion.

The idea that painting is *useful* where the limits of language are reached may serve to shed further light on an otherwise obscure point made by Clive Bell and quoted and discussed earlier. In his criticism of Fildes' *The Doctor*, Bell distinguished between form used as an object of emotion, as he believed it was by Cézanne, and form used to suggest emotion, as he believed it was by Fildes. The case is that Fildes' painting suggests emotion through a narrative which the spectator elaborates around the painting, and, by implication, that the painting is therefore unoriginal in the sense that it is not itself the origin of the spectator's emotion. Cézanne's painting, on the other hand, tends to resist translation into narrative. We are conscious of the effect of the painting rather as a kind of state which the painting itself exemplifies or establishes. This was what the making of the painting was *used* for: to give form to this state. Its function was fulfilled when this was done. To enlarge the composition to the scale of a history painting would simply have been to make inflated pictorial rhetoric out of an original expressive state.

The Grounds of the Château Noir

In considering Cézanne's *Grounds of the Château Noir*, painted some 25 to 30 years after *Déjeuner sur l'herbe* we can finally bring together the idea that originality is a measure of truth to the vivid sensation of the world, with the idea that 'orientation to flatness' is a defining tendency of Modernist painting. Unlike the *Déjeuner,* the later painting offers no apparent psychological content to interpret. It represents a view across an outcrop of rock into a tunnel of trees. Though the painting conveys an almost palpable sense of space and recession, there is virtually no gradual modelling. The whole scene is built up out of a series of juxtaposed planes and lines. This method for creation of the illusion of depth is one factor serving to distinguish Cézanne's work as modern, in the terms of our preceding discussion. In a letter to the younger painter Émile Bernard, written in 1905, Cézanne referred to 'the obstinacy with which I pursue the realization of that part of nature, which, coming into our line of vision, gives us the picture. Now the theme to develop,' he continued, 'is that … whatever our temperament or form of strength face to face with nature may be – we must render the image of what we see, forgetting everything that existed before us. Which, I believe, must permit the artist to give his entire personality, whether great or small' (Rewald, *Cézanne's Letters*, p.316). Cézanne's expressed aim was to measure up to the achievement of past painting, but to be original, in the sense of absolutely empirical, absolutely free of all but that which was apparent in nature. Only by

6 See, for example, the reading of the *Déjeuner* offered in Krumrine, *Paul Cézanne: The Bathers*, pp.67–75.

such concentration upon what was given in experience he believed, would artists realize themselves.

But this concentration involved simultaneous attention to the means by which the representation – the painting – was to be achieved.

> Now, being old, nearly 70 years, the sensations of colour, which give the light, are for me the reason for the abstractions which do not allow me to cover my canvas entirely nor to pursue the delimitation of the objects where their points of contact are fine and delicate; from which it results that my image or picture is incomplete.
>
> (Rewald, *Cézanne's Letters*, pp.316–17)

Cézanne here uses the concept of abstraction to refer to the process of transformation of a sensation into an effect. 'Abstraction' refers to the critical business of transcribing some aspect or detail of the perceived world – be it a single plane or illuminated surface conveying a sensation of a certain vividness – into an accent of equivalent weight and vividness within the very different world of the two-dimensional painted surface. In Cézanne's mature practice, each accent in the painting – each 'point of contact' or edge between one object and plane or another – had not only to be measured in relation to that actual sensation of depth or contrast in the natural scene which it aimed to reproduce, it had also to be tuned so that it functioned proportionately *within* the autonomous painted composition. In theory, there was no limit to the process of discrimination involved. It is not surprising that many of Cézanne's later paintings remained 'incomplete'.

Let us assume for the sake of argument that Cézanne begins his *Grounds of the Château Noir* with the strongest visual 'sensation' presented by his chosen motif: the 'point of contact' at which the brightest light meets the darkest dark, where the top of the illuminated rock in the central foreground stands out against the shadowed depth of the wood beyond. On the canvas an equivalent contrast is established by setting a light orange-yellow against a deep purplish-blue. The next most emphatic contrast – say, where the edge of the tree trunk at the left foreground projects against the space beyond – will then have to be established with a weight relative to the first, and the next in turn in relation to these two and so on. And in order to achieve the maximum intensity and variety on the painted surface, these relationships will be established not as simple meetings of a lighter with a darker tone, but rather by the operation of one shade of *colour* upon another. As Cézanne works his way around the canvas, gradually defining relationships, laying in one plane after another, each accent or contrast he transcribes will tend subtly to modify the balance of the whole. Composition will proceed as a process of increasingly complex adjustment and 'tuning', a process constrained *both* by the need for unremitting fidelity to the sensation of the natural world *and* by the need for coherence and vividness of effect on the flat and decorated surface of the painting.

The paradox which animates Cézanne's painting lies in the gap between two worlds, on the one hand the three-dimensional world which is the scene of our activities and the limitless object of our vision, on the other the bounded two-dimensional canvas, within the literal edges of which any transcription of that world must be adjusted. The almost unrealizable aim will be that the painting – as a thing in itself – should be both original in the sense of faithfully responsive to the individual experience of the world, and self-sufficient as an achieved and unavoidably flat decorative whole.

One important point remains to be made both about that concentration upon the truth of sensation which distinguishes the art of Monet, Pissarro and Cézanne, and about the form of self-awareness which Fried finds in Manet. In each case the actual effect is peculiarly resistant to being translated into a form of words. Though we may argue at length about meaning and intention, the distinctive quality or content of the work is inextricable from the medium of its expression, which is pictorial. It is a condition of painting as an art that we respond at an emotional level to its formal effects.

Monet's Nymphéas

Monet spent the last years of his life at Giverny, where he constructed a large garden, with ponds full of water-lilies or *Nymphéas* (Plate 197). Between the turn of the century and his death in 1926 he painted several large canvases based on views across these ponds, representing their surfaces as complicated by the various effects of light and weather and by consequent modulations of transparency and reflection. The culmination of this series was a suite of panoramic paintings which now occupy the Orangerie in Paris (Plates 198 and 199). The National Gallery's *Waterlilies* (Plate 200) shows a work painted as a single image. It is large enough entirely to fill the visual field of a spectator standing about a metre back from the canvas – that's to say, at the distance measured by an extended arm holding a long brush. There is no visible horizon. The viewpoint is based on the position of someone standing at the right-hand end of the represented scene, looking obliquely down and across the receding plane of water. This plane itself is not so much defined as established circumstantially, on the one hand by the receding clusters of lily leaves and petals, on the other by the evidence of reflections in its surface and of glimpses through the same surface into a world of weed and shadow.

The deepest point of the pictorial space is registered by a dab of bright purplish-pink at the top left-hand corner. Though this is readable as a figurative mark serving to represent a flower, it is also a compositional mark serving to strengthen that part of the painting's surface. The dual function of this detail illustrates the form of 'vibration' by which the whole work is animated. The painting relies for its effect upon the skill with which Monet has tuned the tension between two substantial planes: on the one hand the receding surface of water, its figurative extent established through a series of illusionistic devices, its liquid and figurative quality conveyed through the interweaving of layers of colour; on the other the flat surface of the painting which remains upright, frontal and

Plate 197 Water-lily pond at Giverny, showing trellises Monet had installed on the Japanese bridge for trailing wisteria, *c.*1904, Photo: Bulloz.

Plate 198 Claude Monet, *Les Nymphéas. Soleil couchant. (Waterlilies. Sunset)*, left section, 1916–23, oil on canvas, Musée de l'Orangerie, Paris. Photo: Giraudon.

opaque. The inescapably material character of the painting prevents us from losing ourselves in its atmosphere, and keeps our experience the right side of the critical line which divides the discriminating activity of imagination from the self-serving passivity of fantasy. There is difficult cognitive work to do in looking at such a thing.

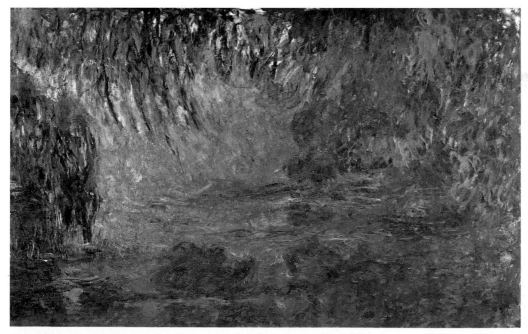

Plate 199 Claude Monet, *Les Nymphéas. Soleil couchant. (Waterlilies. Sunset)*, right section, 1916–23, oil on canvas, Musée de l'Orangerie, Paris. Photo: Giraudon.

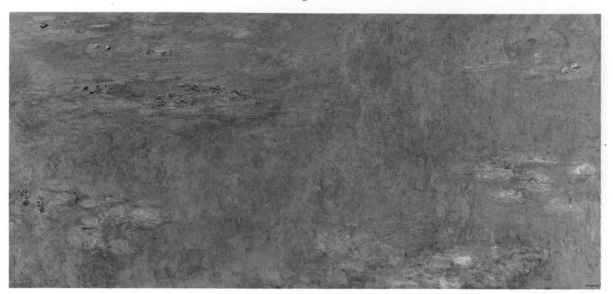

Plate 200 Claude Monet, *Nymphéas* (*Waterlilies*), after 1916, oil on canvas, 200 x 427 cm. The National Gallery, London. Reproduced by permission of the Trustees.

There is nothing in this or in other similar paintings of Monet's old age which reveals either the moralizing themes of traditional history painting or the social contexts of modern life as they had appeared to beckon in the late 1860s. By virtue of its scale and the breadth and complexity of its effects, however, this is a work which invites comparison with the most ambitious endeavours of the past. It may be connected to the La Grenouillère paintings in two other respects: through the panoramic scope of its pictorial space and through its concentration upon the apparently momentary effects of light on broken water. If we are to say that such painting is still significantly modern, it must somehow be this scope and these effects which make it so. Certainly, if such works do not demonstrate the kind of 'significant form' which Bell found in Cézanne's work (Bell called Monet's *Nymphéas* 'polychromatic charts of desolating dullness' (*Art*, p.187)), they nevertheless amply fulfil the implied condition of 'Modernist Painting'. In 1956 Greenberg drew attention to the importance of Monet's last works for those Americans of his own generation whom he then regarded as 'the most advanced of advanced painters': Barnett Newman, Mark Rothko and Clyfford Still ('The Late Monet', pp.44–5)

It comes as something of a surprise to learn of the conditions under which some of these works were painted. Monet's house at Giverny was separated from his studio (Plate 201) by a railway line; during the 1914–18 War this line was regularly used to carry troops and munitions to the front; that front was close enough, at times, for the firing of the guns to be audible to someone standing at the spot where Monet's painting notionally places us. What are we to make of such information? Is it relevant to our experience of the painting and if so how? Does it bear upon the matter of aesthetic judgement and value? Should we take it as testifying to the rapid widening of that chasm between the interests of the aesthetic and the interests of the social and historical which had appeared to open with the beginnings of modern art? Should we take it as proof of the irredeemably idealistic character of (at least some) modern art? Are those who claim to value the achieved autonomy of paintings such as these merely finding consolation and reassurance in their own flight from history? Or should we see the achievement of that autonomy as a hard-won and realistic form of confirmation: proof that the practice of art enables the

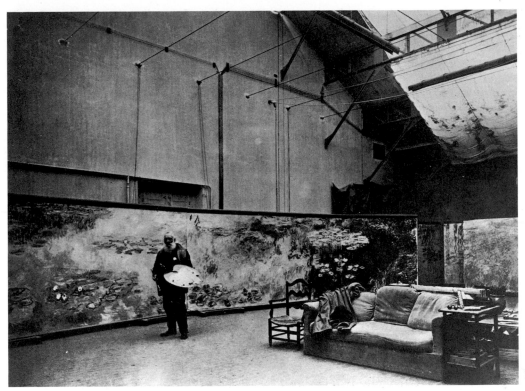

Plate 201 Claude Monet in the studio specially constructed for the *Nymphéas* series, *c.*1923.
Photo: Archives Durand-Ruel, Paris.

expression of human values and safeguards the quality of human experience even under
the most unpromising of conditions?

How we answer such questions will depend to some extent upon our beliefs and
theories about the function of art and about the relations of culture and history. But it will
also depend upon the kind of value and importance we find in Monet's work – which is to
say upon the nature of our *experience* of the painting in question. Criticism in the
Modernist tradition encourages us to accord priority to that experience. It instructs us that
the real content or quality of a work of art is not to be identified with what it simply
depicts, but rather with the effect of its total form. And to quote a recent writer on the
relationship between language and pictures, 'We can never understand a picture unless
we grasp the ways in which it shows what cannot be seen' (W.J.T. Mitchell, *Iconology:
Image, Text, Ideology*, p.39) – nor, we might add, unless we grasp the ways in which it
shows what cannot be *said*.

References

BELL, C., 'The aesthetic hypothesis', in *Art*, London, Chatto and Windus, 1931 (first published 1914).

BELL, C., *Art*, London, 1931 (first published 1914).

Camille Pissarro: *Impressionism, Landscape and Rural Labour*, exhibition catalogue, R. Thomson (ed.), South Bank Centre, London, 1990.

CHENEY, S., *A Primer of Modern Art*, New York, Tudor Publishing Company, 1939 (first published 1924).

CLARK, T.J., *The Painting of Modern Life: Paris in the Art of Manet and his Followers*, London, Thames and Hudson, 1985.

DENIS, M., 'Cézanne', translated by Roger Fry, *Burlington Magazine*, XVI, January 1910, pp.207–219 (part 1), and February 1910, pp.275–80 (part 2) (originally published in *L'Occident*, September 1907; an edited version is reprinted in Harrison and Wood, *Art in Theory 1900–1990*, section 1.a.7).

EVANS, T. (ed.) 'A Conversation with Clement Greenberg', *Art Monthly*, January, 1984.

FRIED, M., 'Three American Painters: Kenneth Noland, Jules Olitski, Frank Stella', Fogg Art Museum, Harvard University, 1965, pp.4–10 (the opening section is reprinted in Harrison and Wood, *Art in Theory 1900–1990*, section VI.b.8).

GREENBERG, C., 'The late Monet', in *Art and Culture: Critical Essays*, Boston, Beacon Press, 1965.

GREENBERG, C., 'Modernist Painting' in *Modern Art and Modernism*, F. Frascina and C. Harrison (eds), London, Harper and Row in association with The Open University, 1982 (originally published in *Arts Yearbook*, no.4, 1961; revised version published in *Art and Literature*, no.4, spring 1965, pp.193–201; reprinted in Harrison and Wood, *Art in Theory 1900–1990*, section VI.b.4).

GREENBERG, C., 'Complaints of an Art Critic', *Artforum*, New York, October 1967 (reprinted in C. Harrison and F. Orton (eds), *Modernism, Criticism, Realism*, London and New York, Harper and Rowe, 1984).

HARRISON, C. and WOOD, P. (eds), *Art in Theory 1900–1990*, Oxford, Blackwell, 1992.

HERBERT, R.L., *Impressionism*: *Art, Leisure and Parisian Society*, New Haven and London, Yale University Press, 1988.

Impressionism: Art in the Making, exhibition catalogue, London, National Gallery, 1991.

KRUMRINE, M.L., *Paul Cézanne: The Bathers*, London, Thames and Hudson, 1990.

MITCHELL, W.J.T., *Iconology: Image, Text, Ideology*, Chicago, Chicago University Press, 1986.

NOCHLIN, L., *Impressionism and Post-Impressionism, 1874–1904*, New Jersey, Prentice Hall, 1966.

THE OPEN UNIVERSITY, *A315, Modern Art and Modernism*: *Manet to Pollock*, Television Programme 8, *Pissarro*, 1983.

ORIENTI, S., *The Complete Paintings of Cézanne*, introduced by I. Dunlop, Harmondsworth, Penguin, 1985.

RENOIR, J., *Renoir, My Father*, London, Collins, 1962 (first published in French in 1958).

REWALD, J. (ed.), *Cézanne's Letters*, Oxford, Bruno Cassirer, 1976 (extracts reprinted in Harrison and Wood, *Art in Theory 1900–1990*, section 1.a.6).

REWALD, J. (ed.), *Pissarro, Letters to his Son Lucien*, London, Routledge and Kegan Paul, 1980

REWALD, J., *The History of Impressionism*, New York, Museum of Modern Art, 1961.

SCHAPIRO, M., 'The nature of abstract art', *Marxist Quarterly*, vol.1, no.1, 1937.

SHIFF, R., *Cézanne and the End of Impressionism*, Chicago, University of Chicago Press, 1984.

SHIKES, R.E., 'Pissarro's political philosophy and his art', in C. Lloyd (ed.) *Studies on Camille Pissarro*, London and New York, Routledge, 1986.

TUCKER, P., 'The First Exhibition in Context', in *The New Painting*.

The New Painting: *Impressionism 1874–1886*, exhibition catalogue, C. Moffet (ed.), Oxford, Phaidon, 1986.

CHAPTER 3
GENDER AND REPRESENTATION
by Tamar Garb

Introduction

In a lecture given in connection with the Renoir retrospective in London in 1985 the speaker declared that to bring a feminist analysis to bear upon a Renoir painting was akin to 'playing a violin with a spanner [wrench]'. For this speaker the Renoir painting and feminism occupied two, irreconcilable worlds: the one the sphere of Art, autonomous and disinterested, the other the realm of politics, of vested interests, partiality and 'real-life' struggles. The substance of his metaphor is that a feminist analysis is inappropriate to Art. In his view, the result of such a conjunction could only be jarring. But what are these apparently incompatible worlds which our speaker invoked? The Renoir painting is the product of the hand of an individually named famous artist who has an acknowledged place in academic histories of art. Feminism is a political position, it is a 'world-view', a philosophical mode of enquiry, something both open and contested. The image associated with the painting here is the violin: finely tuned, demanding sensitive handling, refined, with its connotations of harmony, pleasure and a cultured sensibility. Feminism's tool on the other hand is the 'spanner': utilitarian, mechanical, clumsy. The implication is that feminism invades the elevated world of Culture with the extraneous concerns of life, and that Art is thereby diminished or spoiled.

Our Renoir scholar has an illustrious pedigree of intellectual forebears and much of the institutional fabric of the art-world (curators, publishers, connoisseurs) behind him. He speaks the language of 'commonsense' and of good taste. When faced, for example, with Renoir's *La Loge* (Plate 202) there are few art-lovers who would want to destroy what they have been taught is their innocent 'pleasure in looking', and the suspicion is that feminism does just that.

For feminists, neither the experience of 'pleasure' nor the processes of 'looking' are neutral and value-free. Both are intricately connected to the different ways we have learned to live as men or women in the world. There is no single solution which feminist theory offers to explain the differences between men and women, but most reject the idea that these are located entirely in our biologies or our fixed 'natures'. Biological essentialists do trace such differences back to biology alone, positing an unchanging biological essence or singling out an identifiable physiological cause which they see as the origin of human behaviour. Other kinds of essentialists see men and women as having fixed and unchanging differences which stem from psychological or mental predispositions (for example, men are rational, women emotional). These are sometimes, but not always, traced back to biology.

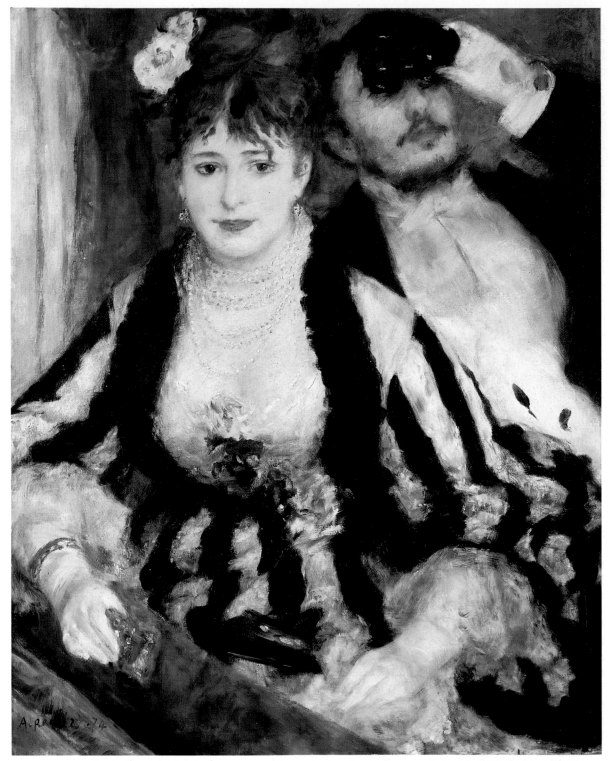

Plate 202 Auguste Renoir, *La Loge*, 1874, oil on canvas, 80 x 64 cm. Courtauld Institute Galleries, London.

There are certainly some feminists who link their theories to biological roots, but feminist theorists from different schools argue more often over the psychic and social meaning of masculinity and femininity. Everyone acknowledges that men and women have different sexual characteristics and capacities, for example women can give birth, men cannot, but it is the value and meaning that different societies and cultures attribute to this fact, these differences, not the differences themselves, that is important for much feminist scholarship. Some feminists place their emphasis on social conditioning and the learning of behavioural roles which become internalized as our natural 'femininity' or 'masculinity', usually called 'gender' differences. Others object to such explanations for they allege that they are premised on the assumption that society is normatively hetero-sexual and that the acquisition of gender identities is a stable and unproblematic process which is achieved and maintained without difficulty. These theorists focus, therefore, on the instability of difference and, drawing on psychoanalytic theory, locate its acquisition in the complex psychic journey which each 'subject' undergoes unconsciously, in the difficult passage through childhood and adolescence towards an adult 'masculinity' or 'femininity' which are always unstable. Such 'subject positions' are said to stem from what is usually called 'sexual difference' rather than 'gender difference', the latter most often implying the *social* acquisition of identity. While many theorists work with both these models in an attempt to integrate the psychic with the social, others opt for one or the other. In this discussion you are sure to find references to both sexual and gender differ-ence and the difficulty of maintaining a rigid distinction between them will, at times, be-come apparent. Feminists often use psychoanalytic theories as a tool for understanding the formation of subject positions or a culture's maintenance of distinct categories of 'masculinity' and 'femininity' within a specific historical context. How identities (fragile as they may be) are learned within such a situation might involve psychic adaptation to social norms.

In this chapter I shall be using terms like 'subject' as opposed to 'individual' or 'person' to suggest that the identities of which we speak are not fixed, predetermined or secure, but are produced by the forces to which they are subjected and in relation to which they assert their subjectivity. Men and women, it is here assumed, are not at the 'origin' of their world but are the products of it. They take up a position in relation to those forces. 'Subjectivity' is understood as the available way in which people live out what appears to them as their individuality. To use this terminology signals an understanding that men and women do not possess a given identity which pre-exists language but learn who they are through acquiring language. For much feminist theory, this is a crucial starting point.

In the last two decades, the issues of viewing and spectatorship and their relationship to questions of gender and sexuality have received much attention from feminists. Few have remained unaffected by the theories of looking which film theorists, many working with psychoanalytic concepts, have developed. Although the language of psychoanalysis is highly specialized and esoteric, and the relationship between psychoanalysis and feminism remains contentious, it has provided a set of symbolic terms which have become indispensable to much contemporary cultural analysis. Looking is central to psycho-analytic analyses of the acquisition of subjectivity for, in psychoanalytic theory, it is through sight that a recognition of sexual difference first occurs in the infant boy or girl. The focus for Freud is less on the scene which is looked at than on what the developing subject does, unconsciously, with that which is seen. As Jaqueline Rose has put it, for psychoanalysis 'the relationship between viewer and scene is always one of fracture, partial identification, pleasure and distrust' ('Sexuality in the field of vision', p.227). A theory of art which is influenced by psychoanalytic theory could see the viewing of art as haunted by such psychic processes. The very phrase, 'pleasure in looking' has its own name, 'scopophilia', in psychoanalytic theory, and is listed in classical Freudian theory as one of the 'component instincts' from which adult sexual instinct develops. Looking, for Freud, can be associated with forms of exclusively masculine response where gratification

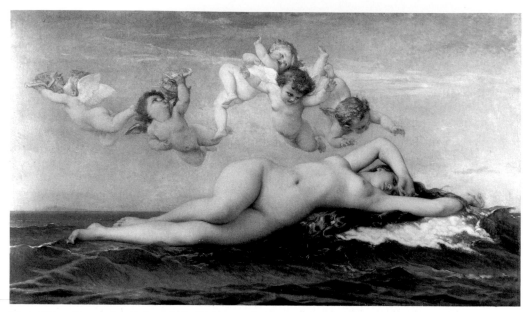

Plate 203 Alexandre Cabanel, *La Naissance de Vénus* (*The Birth of Venus*), 1863, oil on canvas, 130 x 225 cm. Musée d'Orsay, Paris. Photo: Réunion des Musées Nationaux Documentation Photographique.

is derived from a disavowal of fear through fetishism (where objects are endowed with sexual significance and through which sexual gratification is sought so that fear of loss of power (castration) is compensated for) or voyeurism (where sexual gratification is achieved through surreptitious looking at the sexual activities or parts of others). Visual images can substitute for such scenes, and responses can be seen as collective (even dominant) ways of looking for some psychoanalytic cultural theorists. For example, the repeated representation of parts of women's bodies in advertising can be analysed as a form of fetishism which is culturally acceptable in Western societies in the late twentieth century. Within this theoretical framework, looking and the pleasures derived from it are profoundly linked to questions of sexuality and may be connected to our earliest psychic experiences. There is no such thing as a simple 'pleasure in looking'. Nor is it ever politically innocent; power is always at stake.

For feminism the very phrase 'pleasure in looking' raises the questions: whose pleasure and whose looking is at stake? What is the relationship between power and the act of looking or being looked at? Who has the right to look and how is looking legitimated and culturally coded? And crucially for us, how do the processes of representation and the act of looking *at* art or the elaborate conventions by which looking is staged *in* art, relate to the conditions of looking in life for men and women? One of the earliest discussions of this problem was made by the critic John Berger in the early 1970s who, in what appears now as an overgeneralized and oversimplified polarization, claimed that '*men act* and *women appear*. Men look at women. Women watch themselves being looked at' (Berger, *Ways of Seeing*, p.47). This proposition constructs men as the active bearers of the look, women as its object, trapped in narcissistic self-obsession. Men and women operate in such an account as monolithic categories, taking no account of the social and sexual differences which may actually exist among them. The dominant images of Woman in art (as beautiful spectacle, penitent Magdalen or pious Madonna) stand for the position in which actual women find themselves in Western culture. For Berger, one of the systems of representation which brings image and 'life' into an active engagement with each other is advertising, but 'High Art' is equally implicated in establishing and maintaining existing

power relations. The special status accorded to 'Art' is, for Berger, a form of mystification which perpetuates oppressive social relations.

The objectification (reducing to the level of an object) of women in representation is one of the main themes of Roszika Parker and Griselda Pollock's influential study *Old Mistresses*, published in 1981. In describing the tradition of the female nude in modern Western painting, they echo Berger's formulation in attributing an active, powerful gaze to men while seeing the representation of women as enshrining their passivity. Referring to images like Cabanel's *The Birth of Venus*, 1863 (Plate 203), they write:

> The images reproduce on the ideological level of art the relations of power between men and women. Woman is present as an image but with the specific connotations of body and nature, that is passive, available, possessable, powerless. Man is absent from the image but it is his speech, his view, his position of dominance which the images signify.
> (Parker and Pollock, *Old Mistresses*, p.116)

What Parker and Pollock stress is that the customary objectification of Woman in representation is a function of male fantasy. It tells us more about the dominant construction of masculinity, its projections, fears and anxieties, than it ever could about the femininity which it purports to represent. Femininity in such a representational system is conditional on an absent, masculine creativity, which defines and controls the world it creates. For writers like Berger, Parker and Pollock, Art is particularly implicated in the formation and cementing of the unequal power relations between men and women. Art does not only reflect these but constitutes one of the sites of their formation. The way that traditional patterns of 'looking' and 'being looked at' are related to gender identity and accepted notions of sexual pleasure are crucial in this respect.

For the typical viewer of Renoir's *La Loge*, who takes pleasure in the spectacle of a richly textured surface on which a beautiful woman, elaborately costumed, is depicted, pleasure may seem like the most natural response in the world, but it is nevertheless one that is socially legitimated and historically specific. By this, I mean that it is one which a particular society at a given historical moment, sanctions and endorses. No one would argue, surely, that a person from a different culture (let us say, Islamic,) or a different time (the Middle Ages, perhaps) would not 'see' Renoir's image differently. If culture, time and place are implicated in 'seeing', then so might race, class, gender, or age be. The socially and psychically produced look, the non-innocent look of culture, has come to be known in contemporary theory as the 'gaze'. The 'gaze' is never arbitrary, personal or idiosyncratic. To talk about the 'gaze' is to talk about shared, habitual modes of vision through which the human subject in particular social contexts looks, and is looked at. For feminists, men and women have, necessarily, a different relationship to processes of looking and being looked at (ie. 'the gaze'). It is these differences which are addressed in much of the work of the contemporary feminist artist Barbara Kruger, who juxtaposes images (culled from advertising and art) with pithy sayings and words to point to some of the ways in which men and women are positioned in relation to the gaze in Western systems of representation (Plate 204).

Renoir's *La Loge*

Let us now explore some of these issues in relation to *La Loge*. The painting was exhibited at what has subsequently come to be called the 'first Impressionist exhibition' of 1874. That it demonstrates consummate skill and facility in terms of the aesthetic principles according to which it was produced, is, by now, undisputed. *La Loge* is traditionally discussed in the literature as an example of virtuoso paint handling, of summary treatment, dazzling light effects, evocations of transparency and opacity and fluid drawing. Few people would now argue with this description, although what now stands for fluidity of handling might in the Paris of the 1870s have denoted sloppiness; luminosity now,

Plate 204 Barbara Kruger, *Untitled*
(*Your Gaze Hits the Side of My Face*),
1981, photograph, 55 x 41 cm. Collec-
tion of Vijak Mahdavi and Bernardo
Nadal-Ginaud, courtesy of Mary
Boone Gallery, New York. Photo:
Zindman/Fremont.

could have been garishness then; lightness of touch could easily have seemed like a lack of
finish. Interpretation is by no means static and there is nothing neutral about description.
When now made to stand as a 'European masterpiece' *La Loge* does its job well. There
seems to be nothing 'in the picture itself' which goes against the grain of such a designa-
tion. We have long forgotten the anxiety which its technique and the site of its initial
exhibition caused some of its original viewers (except as an indication of their ignorance).
Nor does the world presented to us by Renoir conflict with the notion of appropriate
social roles endorsed by our own dominant culture (as enshrined in mainstream cinema,
much popular fiction, advertising and some contemporary art). A richly jewelled woman
dressed in sumptuous décolletage is placed at the front of an opera box, eyes demurely
unfocused, fan and handkerchief (appropriately 'feminine' attributes) in one hand, gold
opera-glasses in the other. Behind her, in the shadows, dressed in austere masculine
costume, face half-obscured by his opera-glasses, is her companion who looks up intently,
perhaps, as was the custom, towards the occupants of another opera box. It was usual for
men to be positioned behind their female companions on occasions like this. Both the
demands of gallantry and discretion made this appropriate. Women were thereby assured
the best view and men, from their half-secluded positions, could discreetly survey the
audience while their standing and social status was confirmed by the *toilette* and overall
appearance of their women-folk. It was this arrangement that became a standard conven-
tion in representations of this subject, offering the artist a suitable modern-life subject both
in setting and in the sexual roles deemed characteristic of modern urban culture (see
Plates 205 and 206). In *La Loge*, the male figure acts as a foil to the dominant presence of
the woman. His action, the twist of his body and the gesture of his hand (forming a fram-
ing edge to the overall triangular composition and echoing the inner triangle which her
body itself forms) set off her implacable stillness. It is the woman who takes up the bulk of
the picture and it is she who is the focus for the viewer.

La Loge could be said, metaphorically, to stage socially legitimated forms of 'looking' and thereby to reinforce traditional relations of spectatorship, not only between the man and woman as represented in the painting but between the projected viewer outside of the image and the painting itself. No one in the image seems to step out of line and lay claim to 'unnatural' forms of behaviour. There is neither a transgressive usurping of power here within the image, nor a radical unsettling of conventional ways of looking at paintings for the viewer. The composition is constructed to focus the viewer's attention on the face and bodice of the woman. The diagonal formed by the barrier of the *loge* is reinforced by the ermine wrap which frames the woman's left arm and falls across the shirt of the male figure to construct an enclosed space in which the highly orchestrated patterns of the woman's costume are contained. The heightening of colour in the flowers, lips, jewellery and opera-glasses invite the viewer to traverse the body of the woman (and the sumptuous surface of the painting) with an appreciative, lingering look. The face, while more carefully delineated than the costume, is not confrontational or challenging. It is as though the carefully contrived lack of focus in the woman's eyes assures the viewer of the comfort of being able to stare without being observed. What is more, the instrument by which the woman could potentially be empowered with active sight, her opera-glasses, has a primarily decorative function, both in terms of her costume and in terms of the orchestration of colour rhythms in the painting. It is the male figure within the picture who seems empowered with the right to stare and he does so by purposefully raising his opera-glasses, symbol of his possession of sight and power and a pointer to his access to 'pleasure in looking'. It is the male figure who is shown to 'act' rather than merely to 'appear'. The role of spectacle is projected onto the woman alone.

This raises the question of the relationship between the viewer outside the picture and the represented figure within it who is shown actively to look. In *La Loge* a spectator, in the form of the male figure, is pictured within the frame. But it is by no means clear whom he is meant to represent or what he is looking at. While this figure cannot be simply conflated with the viewer of the painting itself, it is tempting to suggest that he stands, metaphorically, for him. The way that looking is staged within an image can echo (or subvert, in some instances) dominant patterns of looking within the culture in which it is produced. In *La Loge*, for example, it is important to stress that it is only the male figure who is shown to be actively looking within the picture. And that very act is responsible for obscuring part of his face and denying his value as spectacle. In contrast, his companion's value lies in her availability to be looked at; this availability is in part consequent upon the unfocused, undirected looking of her eyes. While the purposive activity of looking, akin to that of the viewer's, could be argued to be represented by the figure of the man, it could not possibly be symbolized by the figure of the woman. It is possible, therefore, that the man within the picture can act as the representative of the viewer/artist who looks at the woman/painting. In such an argument, looking as a form of active engagement is represented within the painting by the male figure, who stands for looking as a masculine prerogative within late nineteenth-century French culture.

But such an analysis is surely too neat, and is fraught with problems. For one thing, it takes at face value the ostensible power relations which are staged within the image, on the one hand accepting the power encapsulated in the position of the male figure as free from anxiety, and on the other making it very difficult for us to imagine any space for a female spectator of the image. Let us start with this second objection. In the analysis of the painting which strictly demarcates the active and passive as 'masculine' and 'feminine', a very particular viewing position is constructed for the female viewer who, caught in this scenario, has few options: either she must (as Laura Mulvey has suggested in the context of the viewing conditions specific to film) identify herself with the male viewer (both viewer of the picture and, by association, the viewer in the picture), or identify with the female in the picture (Mulvey, 'Visual pleasure and narrative cinema'). The first option enables her to occupy, temporarily, the position of the masculine subject, the possessor of

Plate 205 Abel Damourette, *À l'Opéra* (*At the Opera*), 1852, engraving. Reproduced from Edmond Texier, *Tableau de Paris*, 1852, vol. 1, p.8. Bibliothèque Nationale, Paris.

A l'Opéra.

sight and the power that comes from sight (expressing thereby her repressed active aspects), but in so doing she has to transgress the boundaries of her normal 'femininity'. The second constructs her as an object of the male gaze herself, thus denying sight and power to her. She is thus rendered 'blind', incapacitatingly passive, an impossible position for a female viewer. Where, we might ask ourselves, does such an analysis place the figure of the woman artist in 1874, let alone the woman viewer, then or now?

But perhaps it is an unreflective acceptance of the scenario as staged in the painting which leads us to this impasse. To sum up: Man is enshrined as powerful possessor of the gaze, Woman as its object. In reading the painting as representing and reinforcing dominant gender roles, we are in danger of forgetting one of the crucial lessons of psychoanalysis: that the relationship of the viewer to the scene is made up of the complicated and contradictory impulses of, to use Rose's words again, 'fracture', 'partial identification', 'pleasure' and 'distrust'. If we take this lesson seriously, we cannot possibly read the painting as an unproblematic reflection of the power of the male gaze. If we accept the premises of this theoretical position, we could see the very rigid separation which the structure of the picture enforces, as disclosing an anxiety which is at the heart of the maintenance of sexual difference in modern bourgeois culture. It is as if the painting 'protests too much'. We might be lead to ask, why is the idea of man functioning explicitly as an object of display so threatening that it must be so absolutely ruled out of court in paintings like this one? Why, in the modern sexual economy, is the 'hyperspecularization' (extreme concentration on display-value) of the female subject dependent on the 'despecularization' (complete absence of display value) of the normative heterosexual male subject?[1] The attention brought to such an absolute polarization by our example, *La Loge*, suggests the possibility that it functions as a defence. In psychoanalytic terms, the argument might go that man has to defend himself against the fact that ultimately his power lies in his ability to exhibit that he is in possession of that which woman has not got, that is the penis, the token of his access to the phallus, symbol of power itself. But to

[1] K. Silverman uses these terms in another context; see *The Acoustic Mirror*, p. 24.

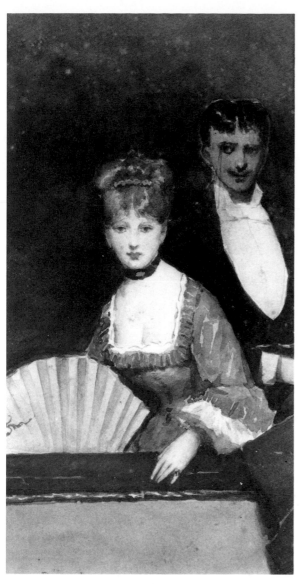

Plate 206 Jean Béraud, *La Loge*, watercolour, 23 x 12 cm. Private collection. Photograph by courtesy of Christie's.

draw attention to himself in this way is (in psychoanalytic language) to re-invoke castration anxiety, to point to his own vulnerability and to the tenuous relationship which this small token has to power as such. He clothes himself in the attributes of the phallus, the costume of public power, sheaths his necessary exhibitionism in scopophilia and projects the whole package of tendencies associated with display (narcissism and exhibitionism) onto Woman.

To read *La Loge* as a metaphoric acting out of this mechanism is to acknowledge the anxieties, for men and women, which it holds in fragile balance. No man can fully read himself into that powerful gazing figure (except in a moment of delusion), nor can the range of female subjectivities be contained by the image of Woman as represented here. The man's gaze, although powerful, has no reassuring object in view and the remoteness of his companion's unfocused look may serve to enshrine their isolation rather than endorse his power. To look at this painting 'as a woman' therefore, might be to recognize how it encodes dominant modes of looking, but instead of seeing the image as a bald assertion of masculine power, to acknowledge it as the cultural product of a highly fragile and tenuous masculine subjectivity. To look as a woman, then, might involve moving

between the available subjectivities on offer here, which our culture so rigidly polices as 'masculine' and 'feminine'. Indeed, to look as a man might even involve a transgressive identification with the forbidden luxury of exhibitionism so apparently enjoyed by the woman in the painting.

But do such explanations as have been offered here over-emphasize a narrative reading of pictures? Do they impose upon paintings forms of interpretation which are more appropriate to realist fiction or narrative cinema than to static images? Are there special modes of looking which modern paintings demand which resist the patterns of story-telling which are among the ways in which we seek to establish meaning in the world? Do such readings fail to acknowledge that *La Loge*, as a painting which exists spatially rather than temporally, as image rather than narrative, accords as much painterly significance to the cufflink on the man's sleeve and the cord which holds back the curtain of the opera box (even if they seem less heavily loaded with 'meaning'), as the flowers or the fan? To read a painting is to acknowledge it as both a surface and an object as well as an image. A painting does not unfold in time. It is present to us in its entirety at any given moment. This implies the need for a resistance to an over-cinematic and narrativizing reading of what is crucially a static image which demands to be read synchronically rather than diachronically. Part of the interest of paintings lies in the tension between the temporal narratives that they suggest and their non-temporal nature as static images. Perhaps part of the interest of recent art-historical scholarship (feminist included) lies in the complex means by which it tries to take account, on the one hand, of the material presence of the object, with its physical identity and institutional history, while addressing on the other hand the way that the stories, myths and narratives through which our culture structures meaning, inform its identity as an image. To address one without the other may be both to misunderstand the complexity of representation and to underestimate the power it wields.

There is indeed an elaborate literature on the surfaces of Renoir's paintings which draws upon conventional gender hierarchies to make sense of the pleasures of looking at them. What is claimed in this context is that the painting of the surface, for Renoir, is as much a caressing of the woman's body as an act of depiction. Paint and colour seem to pay tribute to the voluptuous beauty of the female figure: her swollen bosom, her glistening lips, her sparkling pearls. As Lawrence Gowing rather mischievously put it:

> An artist's brush had hardly ever been so completely an organ of physical pleasure and so little of anything else as it was in Renoir's hand. Its sensate tip, an inseparable part of him, seemed positively to please itself. In the forms it caressed it awakened the life of feeling …
>
> (Gowing, 'Renoir's sentiment and sense', p.31)

Robert Herbert's 'description' of *La Loge*, although a little more restrained, has similar implications. He does not quite imagine the brush as a penis but the painted surface comes close to being seen as the woman's body and the appreciative gaze of the connoisseur has decidedly phallic associations. Comparing this painting with the achievements of Titian, Velasquez and Rubens, Herbert writes:

> It has their opulence of painted surface and of rich garments, the two so closely associated that we cannot separate the one from the other. The woman's extraordinary striped garment forms a lyre shape around her bosom, which is touched with flowers and surmounted by a cascade of pearls.
>
> (Herbert, *Impressionism*, p.96)

For Gowing, the act of painting itself becomes analogous to a sexualized touch, for Herbert, the act of looking a kind of sensual reverie. The language of art history conflates body and surface. To describe the painting is to describe the woman. To respond to the image is to be seduced by 'her' charms. Painting and woman, in this case, become one because the fit is so easy. Surface comes to stand for flesh. The act of viewing and the act of painting function as forms of possession and mastery. In a world in which artists and

viewers are constructed as male, beautiful models as female, and paint is offered as a celebration of the senses, this painting can function simultaneously and unconsciously as the ultimate paean to surface and subject, and the ultimate reassurance to male artist and viewer. What seems to be an innocent appreciation of art and beauty participates in a subtle endorsement of a social and symbolic order which fixes the 'masculine' and the 'feminine' in traditional ways.

Renoir scholars are by no means the first to construct the act of painting as phallic and the surface of the painting as analogous to female flesh. Indeed, the tradition into which Herbert inserts Renoir is one which is redolent with such associations. He and Gowing follow in the footsteps of such venerated connoisseurs and *littérateurs* as the poet Paul Valéry who, in an essay on 'The nude', made explicit the connection between the mastery of painting and the possession of Woman:

> When Titian arranges a purely Carnal Venus, softly stretched out on purple, in all the fulness of her perfection as goddess and as subject for paint, it is obvious that for him to paint meant to caress, a conjunction of two voluptuous sensations in one supreme act in which self-mastery and mastery of his medium were identified with a masterful possession of the beauty herself, in every sense.
>
> (Valéry, 'The nude', p.48)

In such a view the woman represented is a crucial presence, but only in so far as she invokes the power and potency of the maker, or, potentially, his substitute, the viewer. We are now one step removed from the uninitiated viewer whose focus, may be more strongly on the body of the woman as represented than on the identity of the painting as painting. We are in the realm of the sophisticated modern connoisseur caught in the double bind of painting, in the tension set up between surface and subject. As we saw in Chapter 2, for the Modernist viewer, whether looking at contemporary or older paintings, the most elevated form of looking at art is one which resists a narrative reading. To be seduced by the subject-matter of a painting alone (as if it were a fragment of life) is to fall prey to vulgar sentimentalism. But the appreciation of the surface here is closely tied up with the appreciation of the woman's body: to look (like to paint) *is* to caress, to possess. The sensuous qualities of looking in which Valéry, Gowing and Herbert revel, cannot be divorced from their sexual foundations. Rather than eclipsing the 'subject' of the painting (the woman), Valéry displaces it onto the process of painting, which is the magical means by which the woman is both represented and caressed, she is both surface and subject. The act of painting (and viewing) is endowed with sexual attributes, associated not only with sight and mastery but with touch and self-assurance. In such accounts the painting as object becomes the residue of the act itself. For feminism therefore, the focus of inquiry becomes not only what the painting represents, but the way in which the very act of representation and its concomitant modes of viewing are culturally constructed as gendered.

The gendering of surface and matter as feminine, of creativity and the mastery over material as masculine is implicit in much modern writing about art. In a language in which Nature is addressed as 'she' and the artist conventionally referred to as 'he', such assumptions are never far from the surface. We do not need sculptures or paintings which depict women as passive, supine or sexually available for such gendered assumptions to be called to mind. Material alone, in its 'raw' and 'natural' state is enough to invoke the feminine and in this invocation 'woman' can be projected as both the generator of life and the harbinger of death. Even a maker of pristine, minimalist sculptures like Carl Andre draws on the dominant metaphoric underpinnings of our culture in some of his pronouncements on art. In his words:

> Wood is the mother of matter. Like all women hacked and ravaged by man, she renews herself by giving, gives herself by renewing. Wood is the bride of life in death, of death in life. She is the cool and shade and peace of the forest. She is the spark and heat, ember and

dream of the hearth. In death her ashes sweeten our bodies and purify our earth. In her plenty is never wasteful, passion is never wanton. She never betrays us even when we are unworthy. She greets us in the morning of our birth and embraces us in the evening of our death whether dark in the chambered earth or bright in the consuming fire. O mother of matter, may we share your peace.

(Carl Andre, *Wood*, np)

This fantasy of feminine plenitude and renewal in which the weary masculine imagination can find sustenance underpins an artistic practice in which no bodies as such are represented. All that we have is the material, processed, manipulated and managed by the artist and his assistants, and inserted into the space of the gallery. But even in such apparently neutral territory, it is still a gendered construction of the universe that gives particular significance to the act of creating. As the masculine God created the universe from the feminized earth, so the artist creates art from the materials at his disposal. The mythic biblical narrative still subtly underpins many of the structures of thought which characterize the modern period. And in this context, the mystery of creation is still conceived of in terms of traditional gender relationships. When we look at an art-work therefore, it is not only what the work overtly represents which is relevant to an analysis of the gender relations which conditioned its production. Sometimes these are present in the myths and underlying narratives through which our culture gives meaning to things. Gender figures in more than the obvious ways.

To read Renoir's *La Loge* from a feminist perspective, therefore, we might need to take account of it from a number of aspects: (1) as an image which pictures certain gender relations by staging them; (2) as an object which is produced within a culture which is institutionally gendered; (3) as the residue of an act (painting) which itself has been understood in gendered terms; and (4) as an object which is viewed by gendered subjects whose relationship to their own sexuality is fractured and unstable. There is, of course, no orthodox or unitary feminist interpretation, although there is, for feminists, a shared interest in exposing those naturalized ways of looking which may blind us (and previous viewers) to the gender implications encoded in the very fabric of a painting.

I hope that I have raised more questions than answers in these introductory speculations. At the least, I may have unsettled ready-made assumptions about the neutrality of making, consuming and writing about visual images, and established the centrality of questions of gender to an understanding of the problems of 'pleasure' and 'looking'. For some this may indeed have spoiled their 'pleasure in looking'. How often have we not heard people say plaintively, 'but I used to like that painting', after listening to a radical critique of a favourite image. For others, the pleasures of a certain kind of understanding far outweigh the supposed delights of less reflective modes of looking. An unpacking of the power relations which pictures might embody can lead to new forms of pleasure, the pleasures of ambiguity in representation, the pleasures of being unable to hold on to a unified response to pictures, the pleasures of empowerment. Whatever these pleasures are, they are themselves never innocent and always carry with them vested interests of some sort. We need now to trace a more systematic path through some of these issues and to consider their implications for the study of artists, viewers and representations.

Artists

The term 'artist' is an apparently genderless one, applying equally to men and women. But the very existence of the phrase 'woman artist' as the feminine equivalent of the word 'artist' belies its sexual neutrality. Nor does the category 'artist' mean the same thing at different historical moments or in different cultural contexts. In late nineteenth-century France there were a number of ways in which individuals could practise art, design or

craft. Each of these practices carried the associations of the institutions in which they were taught and of the gender and class positions of their producers. Hierarchies of practice existed accordingly. From the education received by boys and girls, their position within the context of the family, the social expectations placed upon them, and the roles they were taught to think were naturally theirs, there was little chance that they would grow into men and women with equal access to occupying the identity of 'artist'. Even if they were in the unusual position of having been raised in unconventional ways (even to transgress traditional gender stereotypes), they would have faced an art world and a society which was institutionally structured in gender specific ways. It was for men to discuss art and politics in the cafés of Paris, it was for women to embroider at home; it was for men to enter into the rigorous training procedures of the state-funded art schools, it was for women to enter the fashionable and expensive private academies where they could learn to become accomplished amateurs; it was for men to rise to the rigours of a competitive market, it was for women to temper their ambition in the name of feminine modesty.

The status of women artists

An acknowledgment that the identity of the artist is gendered is not new. In the nineteenth century some feminists were keen to establish that what was seen as the disparity between male and female achievements in the arts was more indicative of the relative social position of men and women than the consequence of their intrinsic qualities. As the Republican feminist Maria Deraismes put it in 1876: 'It is easily understood that the narrow and sedentary life which custom imposes on women has prevented them until now from finding any means of excelling among the best in the field of art' ('Les femmes au Salon', p.115). She accompanied this observation with a statement about the poor quality of art education offered to women, pointing to their lack of training as what had hampered them in the past. French nineteenth-century feminists were pitting themselves against the widespread belief that women were neither physically nor psychologically equipped to produce masterpieces and that this explained why no female Michelangelo had ever existed. They also had to counter the belief that this was necessarily so for the benefit of the nation and the race. Any undermining of traditional social roles, it was felt, could threaten the social order so fundamentally that the future of France would be at risk. Feminists and women artists had to contend with such typical statements as: 'Women have never produced any masterpieces in any genre … but they have produced something greater than this: it is on their knees that honest men and honest women (and there is no greater thing in the world) are formed' (Harvard, 'Exposition de l'Union des femmes peintres et sculpteurs', np).

Feminists and women artists protested vociferously at such claims, some challenging the view that women had never produced any significant artistic or literary works, others accepting this claim as true and seeking to account for it socially. Despite the intensity of such protests, little impact was made on the rapidly developing discipline of art history, which has largely constructed a canon of its accredited male geniuses. Although certain women were acknowledged to have some talent, it was impossible for women to qualify as truly great. This required genius, a quality which, in the nineteenth century, was thought to be beyond a woman's realm. According to Edmond de Goncourt, 'there are no women of genius, and … if they manifest it, it is by some trick of nature, in the sense that they *are men*' (quoted in Uzanne, *The Modern Parisienne*, p.128). What is seen to disqualify women from possessing 'genius' is their innate lack of originality, their conservatism, their imitativeness, their emotional intensity accompanied by intellectual deficiency and the necessarily all-absorbing concerns of maternity. It has been one of the aims of feminist scholarship to uncover the gendered implications of the term 'genius' which is so central to modern conceptions of the artist.

Questions of quality

Views of appropriate social roles for men and women have changed very slowly and the assumption that women have not produced 'great art' because they are incapable of it has persisted throughout most of the twentieth century. It was this claim which became one of the central issues of a radical feminist critique in the 1970s. Linda Nochlin, like Maria Deraismes a hundred years before her, drew attention to the social and institutional conditions which hampered women's creative development ('Why have there been no great women artists?'). For Germaine Greer, writing a few years later, the absence of women from the canon is ultimate proof of the historic suppression of women's talents and potential. In her view, through having been oppressed psychically and socially, women have been unable to achieve great creative expression and have therefore not been qualified for entry into the canon (*The Obstacle Race*). For other feminists, the whole notion of a canon of great artists is a form of oppression itself as it serves to reinforce and give value to the dominant, white, male, Western 'tradition', without questioning the values by which it has been constituted and the interests it continues to serve (see Duncan, 'When greatness was a box of Wheaties', and Parker and Pollock, *Old Mistresses*). What has been opened to question in this debate is 'greatness' itself. Feminists have revealed how this notion has been both exclusive of women and has mystified the processes by which art is produced, tied up as it is with the concepts of inspiration, genius, inexplicable talent, virility, seminality, potency, precociousness, and so on. Such concepts hide the real work which goes into producing art and misrepresent the contexts of its production (the school, the studio, the workshop), presenting creation and creativity as an inexplicable form of directed masculine energy which separates true artists from ordinary men and from all women. Indeed, this energy comes to be seen as a necessary condition for the production of significant work. A history of art centred on a history of 'great artists', in which that category remains unquestioned serves both to reflect and to reinforce traditional gender relations and to maintain a myth of artistic creativity which is couched in metaphysical terminology.

To study the woman artist is to make a stand against conventional accounts of the artist. But there are many ways in which this has been done. There are some feminists who are content to search for women artists, hidden from history, showing them to be as 'great' as men, and thereby exposing many of the prejudices against women which are reflected in the canon. Accounts of this type often lack any critical understanding of the way that the term 'greatness' has served certain gender interests and underestimate the problems involved in transposing such a term onto women's art. Other feminists, therefore, have felt as uncomfortable with such judgements of 'quality' as they have with the issue of greatness itself. They have concentrated on historical analysis of the conditions of artistic production and the explicit and implicit gendering of the identity of the artist within particular social contexts. Both the notion of the 'artist' and judgements of 'quality' are, in such analyses, seen as historically produced, continually changing and specifically gendered. For example, properties such as forcefulness, delicacy, boldness, strength, intelligence and originality, to which value is attached, may all be used to back up judgements of quality, but they are all applied in cultures where they have specifically gendered connotations. Men and women have been thought to have different access to them. To use them in relation to paintings or painters might involve drawing on their meanings in other spheres. Judgements of quality and the terms through which works are ascribed value are not neutral. They are invariably connected to gender expectations and need to be understood in these terms.

Another way of dealing with the question of 'quality' has been to replace traditional judgements of aesthetic merit with new criteria according to which certain works or certain artists may be interesting, challenging or provocative. A notion of the 'aesthetic' as the most elevated (and appropriate) mode of experiencing art is not necessarily operative in such an approach, and works can be valued for many other reasons. In analysing the

Plate 207 Rosa Bonheur, *Le Marché aux chevaux* (*The Horse Fair*), 1853, oil on canvas, 245 x 407 cm. All Rights Reserved, the Metropolitan Museum of Art, New York; Gift of Cornelius Vanderbilt, 1887.

works of women artists of the past, for example, judgements of quality may be connected to an understanding of how women artists have negotiated (consciously or unconsciously) contemporary constructions of 'femininity' in specific historical periods, or to an examination of how a particular conflation of 'masculinity' and creativity may have made certain genres, the artist's self-portrait, for example, particularly difficult for women artists. An interesting or valuable painting in this context might be one that raises problems of sexuality and representation in particularly challenging ways. One can think, for example, of Rosa Bonheur's ambitious *The Horse Fair* (Plate 207), which in terms of Modernist criteria of value would be of little interest (it would not even be taken seriously in this context), but in terms of questions of gender, sexuality and representation is a fascinating case study. By virtue of its scale, subject-matter, commercial success and critical reception, it is a very important picture in the context of Second Empire Paris and provides a precedent of a woman artist who transgressed gender stereotypes (in her person and her work) and became therefore a mentor for many subsequent women artists. Valorizing this painting in this way does not necessarily mean that absolute claims of quality are being made for it. Indeed, there is much debate among art historians as to whether such claims can ever be made. Nor are timeless or universal female qualities necessarily sought in the image, although there certainly have been (and continue to be) feminists who have looked for an unchanging feminine aesthetic in art-works produced by women. In whatever way feminist art historians approach questions of value and history, all are united against the continuing defence of art history, whether implicitly or explicitly, as a celebration of the achievements of the canonical male artist.

Modern representations of the artist

Until very recently, if the standard histories of art and the displays in major art museums were to be believed, we could easily have come away with the view that no women artists worth noting have ever existed. And late nineteenth-century France would have been no exception. The paintings which have been discussed by subsequent art historians and the 'documents' or 'records' of the most 'advanced' artistic circles of this period seem to corroborate this view. Most famous among these are Fantin Latour's *Studio in the*

Plate 208 Henri Fantin Latour, *L'Atelier aux Batignolles* (*Studio in the Batignolles Quarter*), 1870, oil on canvas, 173 x 208 cm. Musée d'Orsay, Paris. Photo: Réunion des Musées Nationaux Documentation Photographique.

Batignolles Quarter (Plate 208) and Bazille's *The Artist's Studio, 9 rue de la Condamine* (Plate 209), a studio which was also situated in the Batignolles Quarter. The title of Fantin Latour's painting evokes the famous Café Guerbois located at 11 Grande Rue des Batignolles, where Manet and his friends gathered in the evenings to drink and exchange views. The people represented in the group portrait are among those who frequented the café and identified with the new theories being propounded by naturalist and realist writers and painters. For the historian of Impressionism, John Rewald, 'the friends who met at the Café Guerbois ... constituted a group, united by a common contempt for official art'. They did not constitute a school but instead were called 'Le groupe des Batignolles', and Rewald claims that it was they who formed the nucleus of progressive painting in the last years of the Second Empire and the early years of the Third Republic (*History of Impressionism*, p.205). While Rewald goes to some length to explain the absence of Degas, Cézanne and Pissarro from the portrait, the fact that it shows an all-male gathering is not mentioned. He does not deem it necessary to explain Berthe Morisot's absence, for example. Nor is there any acknowledgment that the informal gatherings in cafés were only frequented by male artists and any women present would have been waitresses, demi-mondaines, or working-class women, not women artists, drawn most often from the bourgeoisie. To find the sphere within which the woman artist circulated you would have had to look elsewhere: to the sitting room, the private studio, the formal *soirée*.

While Fantin Latour's painting is composed within the formal conventions of group portraiture, with the young acolytes, Monet, Renoir, Bazille, Zola and Astruc, among others, gathered around their mentor Manet in his studio, Bazille's contrives to create an atmosphere of an informal chance gathering of almost the same group of friends: Maitre

Plate 209 Jean-Frédéric Bazille, *L'Atelier d'artiste, 9 rue de la Condamine* (*The Artist's Studio*), 1870, oil on canvas, 98 x 129 cm. Musée d'Orsay, Paris. Photo: Réunion des Musées Nationaux Documentation Photographique.

plays the piano, Zola is positioned on the stairs speaking to Renoir, who is seated on the table, Manet looks at the canvas on the easel with Monet looking over his shoulder and Bazille himself is pictured with the palette in his hand. While the former painting seems positively to embrace the values of bourgeois respectability, the latter harks back to the romantic conception of the artist as a member of a marginalized sub-culture as captured in Henri Murger's 'Scènes de la vie de Bohème', first serialized between 1845–49. It would be difficult to imagine the presence of a woman artist in either of these contexts. There is no place for women artists here, either in the tradition of the self-important gathering of respectable experts in which the first painting can be situated, or in the culture of bohemia which informs the second – the meagre stove, stacked paintings, minimal furnishings and work in progress providing stock props. The presence of such objects alone are sufficient to invoke the world of the marginal male artist, as in Bazille's smaller *The Artist's Studio, rue Visconti* (Plate 210).

The absence of women from group portraits of artists calls to mind the institutional position of women artists in late nineteenth-century France. Despite the fact that many women artists exhibited their work during this period, they functioned within an art-institutional power structure that was exclusively male. Excluded from all official bodies, either by legislation or custom, they were never to be seen in formal group portraits of experts. There was no female representation on the Salon jury until 1898, no women students in the École des Beaux-Arts until 1897, no women in the prestigious Académie des Beaux-Arts throughout the nineteenth century and no women on the organizing committees of the Expositions Universelles or any important decision-making body concerned with fine art throughout this period. The position for women artists was no better

Plate 210 Jean-Frédéric Bazille,
L'Atelier d'artiste, rue Visconti, Paris
(*The Artist's Studio*), 1867, oil on
canvas, 64 x 49 cm. Virginia Museum
of Fine Arts, Richmond, Collection Mr
and Mrs Paul Mellon.

in the cultural milieu of the *flâneur* (the sophisticated dandy) or in the myths and spaces of changing notions of bohemia. Such identities were premised on the mythology of masculine mobility and virility, a freedom to parade in, inhabit and peruse the city in ways which were unavailable to women of the middle and upper-middle-classes, groups from which the majority of women artists were drawn. Although the arcades and shopping passages of modern Paris were used by many wealthy women who frequented them in groups or carefully chaperoned, such access to the city was not considered by many women artists to compensate for the freedom and mobility which they felt men possessed. In the words of the painter Marie Bashkirtseff writing in 1882:

> Ah! how women are to be pitied; men are at least free. Absolute independence in every-day life, liberty to come and go, to go out, to dine at an inn or at home, to walk to the Bois or the café; this liberty is half the battle in acquiring talent, and three parts of everyday happiness.
> (Bashkirtseff, *Journal*, p.536)

Freedom of movement was particularly circumscribed for the single woman. Unaccompanied she risked being mistaken for a prostitute and humiliated at the hands of the morals police who regulated the numbers of women on the streets. As Jules Michelet, writing in 1859, put it:

> How many irritations for the single woman! She can hardly ever go out in the evening; she would be taken for a prostitute. There are thousands of places where only men are to be seen, and if she needs to go there on business, the men are amazed and laugh like fools. For example, if she should find herself delayed at the other end of Paris and hungry, she will not dare to enter a restaurant. She would constitute an event. She would be a spectacle. All eyes would be constantly fixed on her and she would overhear uncomplimentary and bold conjectures.
> (Michelet, *La Femme*, p.66)

The limited sphere in which it was appropriate for bourgeois women to circulate, there-fore (the arcade, the suburban park, the private garden) was not sufficient to counter the widespread view that their movement was curtailed. Their exclusion from the public sphere was paralleled by their exclusion from the prevailing constructions of the 'Artist', represented in the paintings by Fantin-Latour and Bazille. But if there is no actual woman represented here, this is not to say that there is no representation of 'Woman' within these paintings. In the Fantin Latour she stands as a mythic classical referent, a small figure on the table but resonant with associations of 'Woman as Muse', 'Woman as abstract ideal', 'Woman' as carrier of any number of symbolic displacements (Plate 208). In the Bazille 'Woman' represents, in the pictures on the walls, both the seriousness of the artist's in-volvement in his work (few ambitious artists could afford to neglect the Nude), and his identification with the new naturalist aesthetic, that is the tendency to see painting as an accurate representation of the world as observed by the artist (Plate 209). The most promi-nent of the paintings shown in the studio are ostensibly of observed female forms, most often naked, or occasionally clothed, enshrining this serious young artist as one of a new school of painters. The uses to which the image of Woman as symbol can be put cut across conventional classical/naturalist divisions. The naturalist, no less than the classical painter may use the symbolic power of the body of Woman to define his own position in the world of artistic practice. Henri Gervex's, *Une Séance de jury de peinture* (Plate 211), for example, shows the bustle and confusion that surrounded the top-hatted members of the all-male jury as they made their decisions while workmen removed, unpacked, and brought in the entries. Against the wall behind their raised sticks and umbrellas, is the object over which they are shown to be voting, a painting of an idealized female Nude. Gervex's painting fits into the newly popular genre of 'modern-life' paintings and the very modernity of its subject-matter is underlined by its difference from the painting over

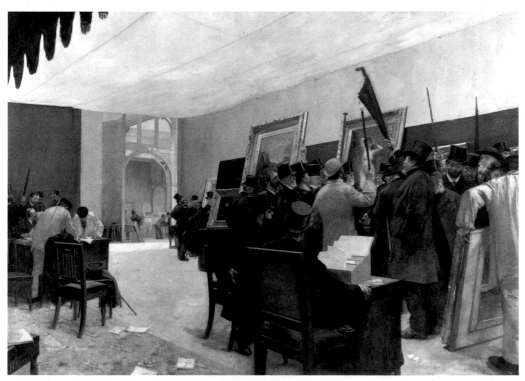

Plate 211 Henri Gervex, *Une Séance de jury de peinture* (*A Meeting of the Painting Jury*), oil on canvas, Musée d'Orsay, Paris. Photo: Réunion des Musées Nationaux Documentation Photographique.

which the jury is shown to be voting. The depicted painting, with its classical conventions for the representation of the body in a remote, idealized setting, stands as a sign for the type of painting which the Gervex is not. The body of Woman, as encoded in the representation, functions as a sign which confers a particular identity on the artist himself and on the exclusively male experts. Woman's position in representation is clear: she occupies the familiar role of the muse, the art-historical referent, the allegorical figure, even the embodiment of the natural against which the cultural is defined and maintained. If women were represented as actual artists in representational groupings such as the Fantin-Latour and the Bazille, they might have disrupted the potential of the body of Woman to function as an abstract symbol.

But women were a vociferous, if marginalized, presence in the art world at this time. They may not have frequented such retrospectively heroicized sites as the Café Guerbois or attended the adjudication sessions at the Salon, nor could they easily fit into the representational conventions which were used to 'document' such events, but they certainly existed. At the time when Bazille's and Fantin Latour's 'studio portraits' were being executed, two women, Eva Gonzalès, who was a few years younger than the rest, and Berthe Morisot, the same age as Bazille, Monet and Renoir, formed part of the group of painters and critics which had gathered around Manet. Berthe Morisot had in fact been introduced to Manet by Fantin-Latour himself in 1867 or 1868 and Eva Gonzalés was working in Manet's studio, as his pupil, during this period. Gervex's painting was exhibited in the year after women artist activists had made their first bid for entry onto the Salon jury on the grounds that their interests could not possibly be represented by an all-male jury.

There were unprecedented numbers of women artists who worked professionally in late nineteenth-century France and negotiated the institutional fabric of the art world.

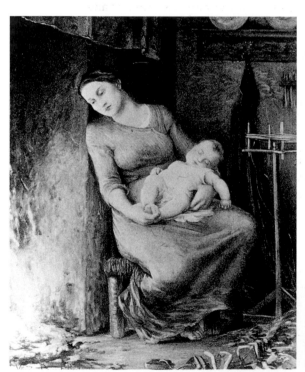

Plate 212 Virginie Demont-Breton, *L'Homme est en mer* (*The Man is at Sea*), 1889, oil on canvas, dimensions unknown. Present whereabouts unknown, formerly in the Walker Art Gallery, Minneapolis.

Plate 213 Hélène Bertaux, *Psyché sous l'empire du mystère* (*Psyche in the Realm of Mystery*), sculpted stone boss, Palais du Luxembourg, Paris. Photo: Giraudon.

Plate 214 Madeleine
Lemaire, *Five o'clock (thé
élégant dans l'atelier de
l'artiste)* (*An Elegant Tea
Party in the Artist's
Studio*), exhibited in the
Salon 1891, oil on canvas,
115 x 140 cm. Where-
abouts of oil painting
unknown, print in
Bibliothèque des Arts
Décoratifs, Paris. Photo:
Lauros-Giraudon.

There were those like Virginie Demont-Breton who aspired towards academic careers and participated in the lengthy campaign for the entry of women into the École des Beaux-Arts (Plate 212); those like Madeleine Lemaire who took advantage of the multifarious world of art dealing and the growing private exhibition structure in addition to exhibiting regularly at the Salon (Plate 214); those like Rosa Bonheur who via her dealer sold her work independently in France and abroad (Plate 207); those like Mme. Léon Bertaux who joined together with other women to form women's forums to counteract prejudice and exclusion (Plate 213); those who showed work at the Salon and women's *cercles* and salons like Eva Gonzalès or Marie Bashkirtseff (Plates 237 and 215); and those like Mary Cassatt and Berthe Morisot who came to favour the juryless structure of the independent Impressionist exhibitions and showed their works there (Plates 240 and 251). The woman artist, representative of the growing number of professional women, became a stock character for the caricaturist and an easy target as an image of the 'unwomanly woman' or 'naive ingenue'. The prospect of women artists confronting the naked male model especially offered ample opportunity for smutty humour in a world which seemed effectively turned upside down (Plates 216 and 217).

The diversity of the art world, with its elaborate infrastructure of private exhibition initiatives, a complex art market, as well as independent exhibition venues, allowed women to chart a professional path without state support or the freedom of movement enjoyed by men. But women still had to counteract the prevailing view (encoded in institutional exclusions, and across the discourses of criticism, science, medicine, law and morality) that a serious and professional engagement with art was beyond a true woman's capacities. If there were women who demonstrated outstanding ability in art then it was felt that they had, of necessity, to renege on their intrinsically 'feminine' attributes and thereby threatened to undermine the whole social structure on which modern France was based. If women were blessed with a refined sensibility and developed aesthetic awareness, then these were to be expressed in the suitable domestic pursuits of home-making, needlework, album-making and water-colour, nothing too exacting or ambitious, nothing

Plate 215 Marie
Bashkirtseff, *L'Académie
Julien, c.*1880, oil on
canvas, dimensions
unknown. Present
whereabouts unknown.
Photograph by courtesy of
the Witt Library,
Courtauld Institute of Art.

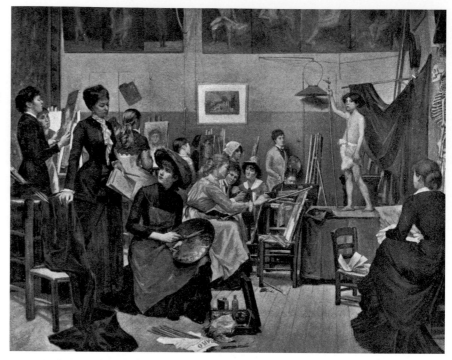

Plate 215 Marie Bashkirtseff, *L'Académie Julien, c.*1880, oil on canvas, dimensions unknown. Present whereabouts unknown. Photograph by courtesy of the Witt Library, Courtauld Institute of Art.

that would remove them from their primary duties as mothers and wives. To be a professional woman artist was, in many quarters, to transgress social expectations. While the mechanisms of coping, both conscious and unconscious, might have varied, there was not a woman artist in late nineteenth-century France who could escape from the conflict, internal and external, which the tension between her aspirations as a professional artist, and the 'feminine' ideal entailed.

It is interesting to consider whether these tensions were also articulated in portraits of women artists by their male contemporaries. Until very recently Manet's portraits of Berthe Morisot and Eva Gonzalès have been more widely reproduced and better known than any of their own works. In most standard accounts of the period, Gonzalès and Morisot are represented as Manet's beautiful models or his pupils. (Morisot had, in fact, never been Manet's pupil, although like the artists who had figured in the group portraits, she was highly influenced by his work.) Manet's *Portrait of Mlle E.G.,* as it was titled when it was shown at the Salon of 1870, is the best known image of a woman artist, Eva Gonzalès, represented as such, from this period (Plate 218). Manet's other submission to the Salon in this year was *The Music Lesson,* showing his friend, the painter and writer Zacharie Astruc, in the guise of a guitar player while an unidentifiable young woman holds open and points at some sheet music (Plate 219). Submitted together to the Salon of 1870, these paintings can be read, as a pair, to represent the currently acceptable manner in which upper-middle-class women could engage with artistic practice. But there is a significant difference between them. Both are elaborately staged studio set pieces in which figures are made to act out designated roles, but whereas the identity of the figures in *The Music Lesson* is immaterial (Manet, like many of his peers often used his friends as models) that of the former is crucial as it was exhibited as a portrait of a named individual, if only by her initials, rather than as a genre/modern life painting.

Plate 216 'Allons Darancourt, gros indécent' ('Come on, Darancourt, you gross slob, remember that you are no longer at the baths; you represent Achilles and you are posing in front of your wife and your daughter, Clara.'), lithograph from *Pièces sur les arts*, tome 6, BN Kc.164. Bibliothèque Nationale, Paris.

Plate 217 'Songez que vous peignez l'histoire' ('Remember that you are painting History'), lithograph by Ratier, from *Pièces sur les arts*, tome 6, BN Kc.164. Bibliothèque Nationale, Paris.

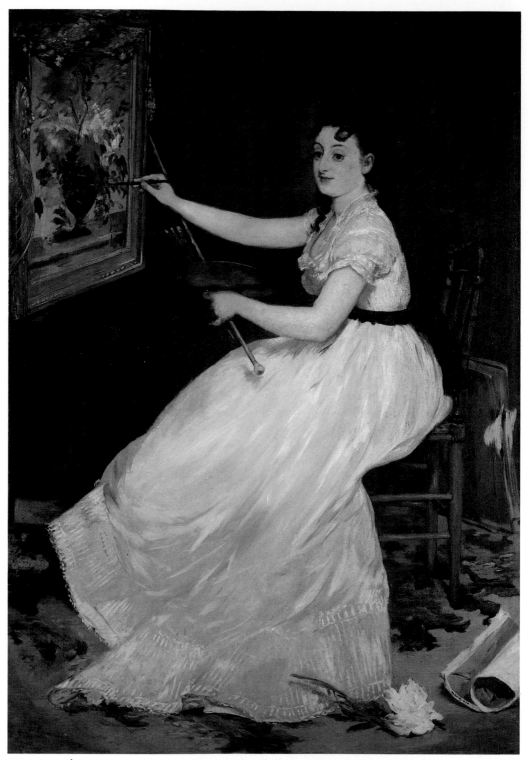

Plate 218 Édouard Manet, *Portrait of Mlle E. G.*, 1870, oil on canvas, 191 x 133 cm. National Gallery, London, Lane Bequest, reproduced by permission of the Trustees.

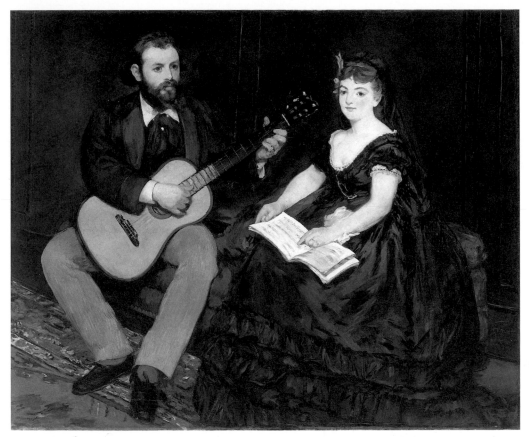

Plate 219 Édouard Manet, *La Leçon de musique* (*The Music Lesson*), 1870, oil on canvas, 140 x 173 cm. Anonymous Centennial Gift in memory of Charles Deering. Courtesy, Museum of Fine Arts, Boston.

Eva Gonzalès

In most of the art-historical literature, Eva Gonzalès is represented as an inconsequential painter but a beautiful model. As George Heard Hamilton unself-critically put it: 'The poignantly lovely portrait of Eva Gonzalès is proof of Manet's sensitivity to the charm of the young woman as she sat working in his studio' (*Manet and his Critics*, p.141). To what extent, we might ask, does the manner of her representation here, and the conventions of female portraiture on which it draws, contribute to the received image of Eva Gonzalès as wealthy amateur and beautiful dabbler, the quintessential representation of the acceptable woman artist? In the painting Gonzalès is placed at an easel, the primary indicator of her identity as artist. But, simultaneously, all other signs in the image collaborate to discount the seriousness of her involvement with her work. As in Renoir's *La Loge*, the eyes of the woman are averted, this time both away from a potential confrontation with the viewer and from the work on the easel at which she unconvincingly daubs. She is positioned, beautifully gowned in evening dress, for our delectation, her lids are half-closed, her eyes characteristically unseeing. The palette and brush operate as so many fashion accessories, rather than as the tools of her trade. And the painting at which she is ostensibly working, is of course a still-life, in fact an unidentifiable flower-painting, deemed at the time to be the genre most suited to women's innate delicate sensibilities and inferior powers of reason. As such, the painting on the easel functions more as a fictitious sign of gender than as a particular painting executed by the artist who is represented. What is more, it is already framed and finished, its frame draped by a transparent cloth as if its cover has

Plate 220 *Deux Femmes devant un chevalet (Two Women in front of an Easel)*, 1880s, fashion plate from the *Gazette des femmes*. Bibliothèque Nationale, Paris BN fol 2, 132.

Plate 221 *Deux Femmes et un chevalet (Two Women and an Easel)*, 1880s, fashion plate from the *Gazette des femmes*. Bibliothèque Nationale, Paris BN fol 2, 132.

been lifted for the duration of the sitting. The act of painting, here imaged, provides no more than a fitting setting for the beautiful, accomplished and appropriately 'feminine' young woman. This is finally underlined by the subtle assertion that the studio depicted is not that of the artist represented, as might be expected, but of the artist representing. If we look at the scrolled image on the floor we can detect Manet's signature on the border, a signature both of the painting within the painting, and of the portrait itself. It stands as the sign of the artist outside of the image, invoking his presence and authority. It is here juxtaposed with the image of the flower, evocative of the still-life, evocative of the woman herself, evocative of narrative traditions in which women are identified with flowers: plucked, blooming, or withered. In illustrations for the contemporary *Gazette des femmes* the props for the display of the new fashions are, similarly, the easel, the palette and the brush (Plates 220 and 221). They are not in themselves signs of a subversion of traditional female roles but invoke the world of feminine accomplishment. When combined with standard conventions of female portraiture – the full-length elaborately costumed and adorned female body – their potential, in other contexts, to signify as professional attributes is discounted. Manet's painting functions simultaneously therefore as the elaborate staging of Gonzalès' professionalism and the denial of it.

In the *Portrait of Mlle E.G.*, Gonzalès' femininity is guaranteed by her value as spectacle. To be positioned in this way is to be placed reassuringly as the 'object of the gaze'. The professional identity of the painter, which involves the use of sight as mastery (an

identity which, in women, is potentially subversive in the context of nineteenth-century constructions of sexual difference) is here contained by the display value of the female body. It was widely thought in nineteenth-century Paris that when women became painters, writers or intellectuals, they forgot their primary function, self-adornment. As Octave Uzanne lamented: 'The first result which followed their jealousy of men's genius was that they lost their own; that genius for dress in virtue of which they are – or should be – both poets and poems' (*The Modern Parisienne*, p.134). It was through their *toilette* that women could legitimately exercise their creativity and yet remain objects of delectation. For Baudelaire, women's self-adornment amounted to a duty:

> Woman is quite within her rights, indeed she is even accomplishing a kind of duty, when she devotes herself to appearing magical and supernatural; she has to astonish and charm us; as an idol, she is obliged to adorn herself in order to be adored. Thus she has to lay all the arts under contribution for the means of lifting herself above Nature, the better to conquer hearts and rivet attention. It matters but little that the artifice and trickery are known to all, so long as their success is assured and their effect always irresistible.
> (Baudelaire, *The Painter of Modern Life*, p.33)

Plate 222 Édouard Manet, *Eva Gonzalès peignant dans l'atelier de Manet* (*Eva Gonzalès Painting in Manet's Studio*), 1870, oil on canvas, 56 x 46 cm. Private Collection.

Femininity, for Baudelaire, is unashamed and necessary artifice. It is a woman's duty to devote herself to its perfection, to turn her gaze upon herself and render herself an object of delectation. For women to lay claim to an artistic identity which involves a command of the gaze, a looking out, an apparent mastery of the world, is to renege on that very narcissism which modern masculinity projects onto women as reassurance. As with *La Loge*, we get a sense of the fragile balance within which such relations of power are maintained and of the threat which their potential inversion invariably provokes.

The success of Manet's painting may indeed lie in his unconscious articulation of one of the central anxieties of modern culture, that between spectacle and specularity, the régime of looking and being looked at which is so carefully socially and sexually regulated and which the existence of the woman artist threatened to undermine. Her usurping of the gaze could render masculinity on display. Her gaze has therefore always to be contained and turned upon herself. It was for men to be the scrutinizers, to look beyond themselves, to shield themselves from being looked at. In this light it is interesting to consider a little known contemporary painting by Manet which seeks to invert dominant power relations and is never resolved or completed in the same way as the *Portrait of Mlle E.G.*; this is the contemporary *Eva Gonzalès Painting in Manet's Studio* (Plate 222). In this painting, the artist's back is firmly turned away from the viewer as she works intently on the large canvas in front of her. She provides no value as spectacle. This function resides rather uncomfortably with the figure of a young androgynous model (Léon Leenhoff) dressed as a matador, who perches awkwardly on a table behind the artist. While the costume that the model wears is effectively a masculine one in its own cultural context, Spain, in the context of France, such a display effectively feminizes the figure in the representation. The flamboyant costume, so different from the uniform of modern, urban masculinity which Fantin-Latour's painting so neatly represented, marks the figure as culturally different from Manet and his audience. Perhaps the power of the woman artist to refuse specularity in an image like this one is bought at the expense of the 'masculinity' of the model. Once he is 'exoticized', made culturally alien, her power is diffused and 'he' can comfortably assume the position of spectacle without threatening traditional gender roles. Empowered French masculinity (located outside the image) remains intact, even in the face of a woman who turns her back, intent on her work.

Berthe Morisot

It is interesting that on the many occasions when Manet painted the other woman painter of his circle, Berthe Morisot, he avoided all references to her professional status. Manet had used Morisot as a model (much in the way that he used Astruc in *The Music Lesson*) in *The Balcony* (Plate 223) but he also painted a number of portraits of her alone, the most ambitious of which was *Le Repos* (Plate 224). In all of these Morisot is represented as a mysterious, rather melancholy, dark-eyed beauty, and it is this construction of her person that art history has inherited and perpetuated. It is the languid inertia of the pose, drawing on standard conventions for the representation of a passive but sensuous femininity, which is interesting. The image of supine, almost seductive waiting is characteristic of earlier prints by Achille Devéria (see Plate 225). The figurative elements of the painting and the print are uncannily similar: in both, the semi-reclining woman, luxurious sofa, interior with art-work, attributes of handkerchief and fan, and single outstretched foot, contrive to create the atmosphere of the boudoir or private sitting room. In *Le Repos* the only art-work represented is a Japanese woodblock print by Kuniyoshi, probably in Manet's possession at the time, which helps to situate the figure in what would have been seen as a comfortable but avant-garde setting, evoking some of the ambiguities of Manet's own situation in the art world at the time. The presence of the Japanese print has nothing to do with Morisot's output as a painter, which by this time was substantial. The overwriting of the identity of the sitter by the presence of the artist, which we saw in the

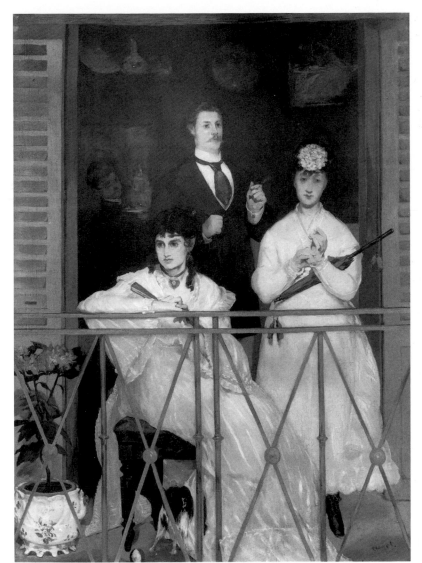

Plate 223 Édouard Manet, *Le Balcon* (*The Balcony*), 1868–69, oil on canvas, 169 x 125 cm. Musée d'Orsay, Paris. Photo: Réunion des Musées Nationaux Documentation Photographique.

Portrait of Mlle E.G., is common to many of Manet's portraits. But it seems all the more obliterating of the independent identity of the sitter when it is a portrait of a professional woman (rather than a man). There are no established conventions for the representation of the professional woman equivalent to the representation of the 'man of letters', into which such paintings as the *Portrait of Émile Zola* can be inserted (Plate 226). When Manet places his signature prominently on a pamphlet on the table in this image, the reference is to a shared professional world which artist and critic occupy. The painter pays homage to the writer who was one of his staunchest defenders. Whereas portraits of men were generally judged in terms of their capacity to represent character and identity, those of women were expected to capture beauty and elegance, conveyed by costume and surroundings as much as in the rendering of the face and pose. The idea of the male artist capturing the essence of 'femininity' in portraiture was perfectly acceptable. But the reverse was not the case. While it was deemed absolutely appropriate that men, who were seen as connoisseurs of art and female beauty, should paint portraits of women at this time, for a woman artist to execute a portrait of a man was a delicate and contentious project, and was usually only permissible if the sitter was a close relative (see for example Morisot's portrait of her husband Eugène Manet and their daughter Julie, Plate 227).

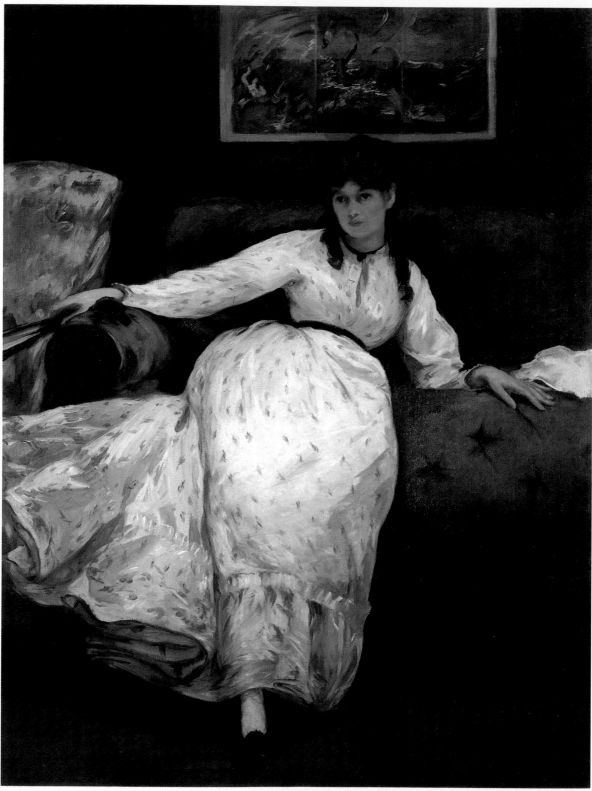

Plate 224 Édouard Manet, *Le Repos* (*Rest*; *Portrait of Berthe Morisot*), 1870, oil on canvas, 148 x 113 cm.
Museum of Art, Rhode Island School of Design, Bequest of the Estate of Edith Stuyvesant Vanderbilt Gerry.

Plate 225 Achille Devéria, *Jeune Femme sur un canapé* (*Young Woman on a Couch*), lithograph. Bibliothèque Nationale, Paris, Dc 178 bt, 4, no.788 80 892.

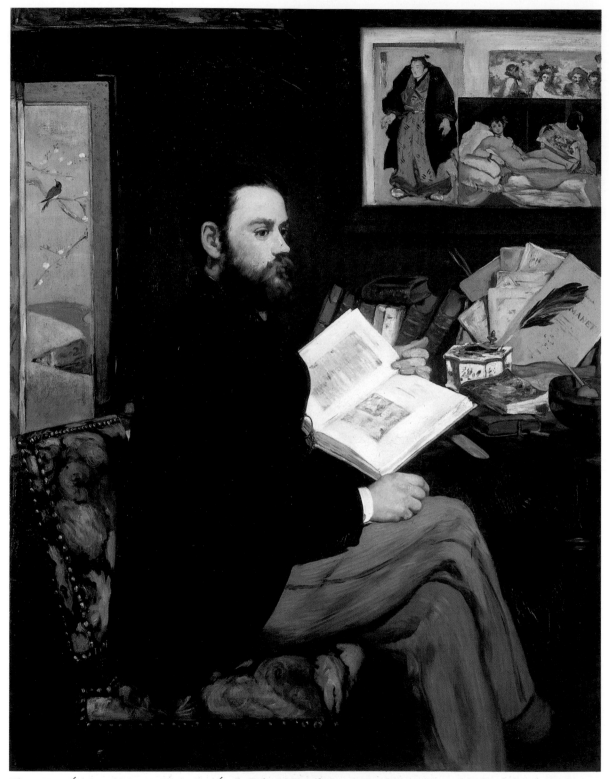

Plate 226 Édouard Manet, *Portrait of Émile Zola*, 1868, oil on canvas, 146 x 114 cm. Musée d'Orsay, Paris. Photo: Réunion des Musées Nationaux Documentation Photographique.

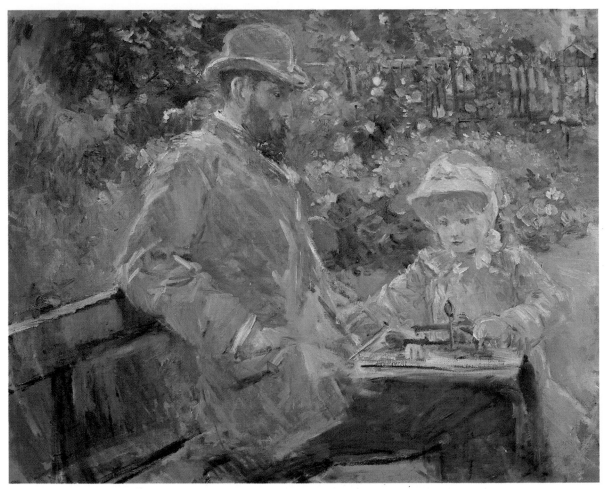

Plate 227 Berthe Morisot, *Eugène et sa fille à Bougival (Eugène Manet and his Daughter at Bougival)*, 1881, oil on canvas, 73 x 92 cm. Private Collection, Paris. Photo: Giraudon.

On those very rare occasions when women painted portraits of male public figures, critical eyebrows were raised and questions were asked about the capacity of women to be objective enough to capture the character of their sitter or brazen enough to confront them with their gaze. For a male artist, the potential confrontation with the representation of a deviant femininity could be evaded by the obliteration of all references to it, as in *Le Repos*, or the diffusion of it as in the *Portrait of Mlle E.G.*, so that what is left is a painting which evokes normative constructions of femininity. But there were other options. When Degas painted Mary Cassatt in a seated, alert and forward thrusting position, legs slightly apart, he was adapting conventions of male portraiture for this representation of an unconventional woman, perhaps thereby asserting the independence and autonomy of an American woman in Paris (Plate 228). And when, in the last decade of the century, some women artists self-consciously rejected the trappings of an oppressive femininity and proclaimed the professional identity of their mentor Rosa Bonheur, they had to invent a means of representing the professional woman artist, one in which professional attributes took the place of conventional props of femininity in order to confer an identity on the sitter. (See, for example, Anna Klumpke's *Portrait of Rosa Bonheur* (Plate 229) and Mme Achille Fould's *Rosa Bonheur* (Plate 230).) Unknown to them, Edma Morisot, had, as early as 1865–68, executed a portrait of her sister painting at the easel, eyes securely fixed on the canvas in front of her and paintbrush poised at the palette (Plate 231).

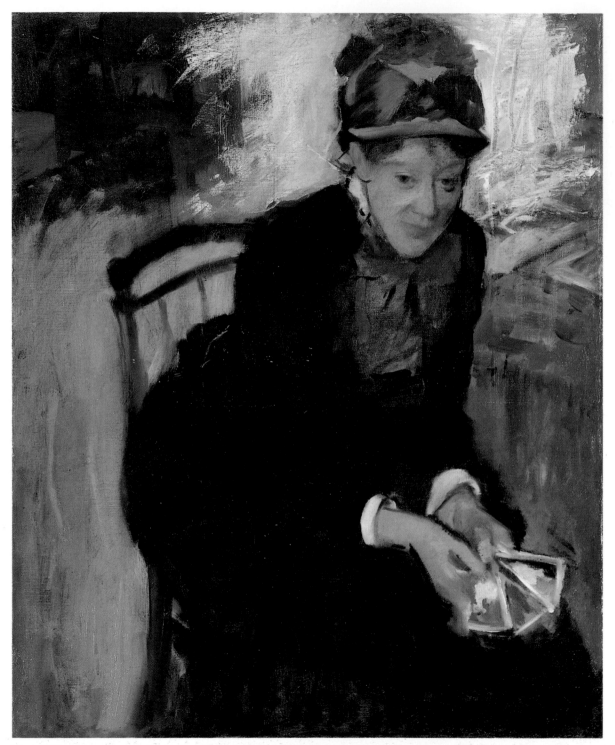

Plate 228 Edgar Degas, *Portrait of Mary Cassatt*, *c*.1884, oil on canvas, 72 x 59 cm. The National Portrait Gallery, Smithsonian Institution, Washington DC; gift of the Morris and Gwendolyn Cafritz Foundation and Regent's Major Acquisitions Fund, Smithsonian Institution, no. NPG. 84.34.

Plate 229 Anna Klumpke, *Portrait of Rosa Bonheur*, 1898, oil on canvas, 117 x 98 cm. All Rights Reserved, the Metropolitan Museum of Art, New York; gift of the Artist in Memory of Rosa Bonheur 1922.

Plate 230 Mme Achille Fould, *Rosa Bonheur*, exhibited Salon 1893, oil on canvas, dimensions unknown. Present whereabouts unknown.

Generally the attributes of gendered subjectivity, as inscribed on the body and its accoutrements, together with more covert conventions of setting and pose, construct normative images of masculinity and femininity in portraiture. Only occasionally do they subvert them. Portraiture most often draws upon the visual codes present in other forms of representation (fashion, for example), but does its own work in naturalizing these by either personalizing them or transforming them into elevated types. Pose and props function simultaneously to indicate personal traits and preferences and gendered or classed attributes. Manet's portraits of Eva Gonzalès and Berthe Morisot manipulate the available symbols of middle-class femininity to great effect, but they leave us completely uninformed about the lives and achievements of the women that they represent. The attempts of art historians to use them as 'documents' which are expected to yield information about their sitters as people, are singularly misguided. They yield little such 'information'. But as paintings which can tell us something about dominant constructions of a historically contingent femininity, they are deeply resonant.

So far we have concentrated on the iconography and signifying properties of these paintings without paying particular attention to their surfaces as paintings. It is worth returning, at this stage, to some of those questions, flagged in the introduction to this chapter, which ask whether problems of gender in representation can be addressed to imagery alone or whether a more complex consideration needs also to be inflected by addressing questions of technique. I have already alluded to the way in which an attention to surface can involve an eroticized looking which effectively displaces attention from the figure represented ('the prettiness, say of a girl, her colouring, her expression, her attitude', to use Clement Greenberg's words), to a caressing of the surface itself as feminine. But Greenberg more than anyone is aware that it is the tension that is set up between surface and subject which provides the interest in figurative painting. In his words, '...the illustrated subject can no more be thought away, or "seen away" from a

Plate 231 Edma Morisot, *Portrait of Berthe Morisot*, 1863, oil on canvas, 100 x 71 cm. Private Collection, Paris. Photograph by courtesy of Galerie Hopkins-Thomas.

picture than anything else in it can'. Indeed it was this tension, if understood rather differently, that made Manet's *Le Repos* untenable for at least one of its first viewers. It offended him, not so much for the type of femininity that it represented (indeed there was little offensive here) but for the manner in which it represented it. In terms of contemporary conventions of picture-making, Manet's works were highly transgressive. Their fluidity of handling, their lack of surface finish and their rich contrasts of dark and light devoid of acceptably subtle tonal modulation, were not easily absorbed by the majority of their contemporary viewers. When *Le Repos* was shown at the Salon of 1873 the manner of its execution was seen by one critic as an affront to the delicacy of the subject it portrayed. While Manet's robust technique seemed quite suited to his earthy, masculine and lower-class figure in *Le Bon Boc*, shown together with *Le Repos*, it did not seem so for the delicacy and refinement which a portrait of a young lady should capture (Plates 224 and 232).[2] For this critic, Manet's technique functioned in the one case as an appropriate analogue to the brutality of its coarse, male subject and in the other as an insult to accepted notions of bourgeois femininity. In the latter case, it assaulted its subject with its directness. Considerations of gender are here inflected by those of class. A hostile response to the way the painting is executed, claims as its alibi a reverence for bourgeois femininity. In so doing it reaffirms traditional social relations while simultaneously denouncing formal innovation.

[2] George Lafenestre wrote: 'And Manet himself shows, in his *Repos*, that what is adequate for the interpretation of the good-humoured appearance of a ruddy smoker stuffed with dinner, becomes remarkably inadequate when it is a question of rendering the grace, delicacy and spontaneity in the figure of a young woman' (quoted in Hamilton, *Manet and His Critics*, p. 168).

Manet's *Le Repos* offered difficulties therefore for some of its first viewers, who were
hostile to innovative painting techniques. Its acceptability as a work which represented
dominant social attitudes was impaired by its unconventional means of representation.
Technique functions as a barrier, a form of resistance to the easy exchange of dominant
social attitudes via the work. The work, on some level, went against the grain of the very
attitudes to which it owed its existence. It exists in a complex and contradictory relation to
them. It is perhaps part of the feminist project to hold on both to the oppressive narratives
which have historically informed and continued to produce meaning and the tensions that
are set up in their material realization.

Painting as a woman

So far we have used paintings of artists, mostly by men, as a focus for a discussion of the
context within which the woman artist worked in late nineteenth-century France. Now we
need to address the issue of women's artistic production itself within this social context.
By examining a number of paintings by women which draw on the same subject as
Renoir's *La Loge* we can ask some comparative questions about the position of the woman
artist as the active maker of art during this period. We need also to consider what happens
to our reading of a painting when we know that a woman has painted it. Is this a relevant
question at all? In some recent theoretical inquiries, particularly literary studies, the text
has come to be seen to have a life which is relatively independent of its author. In such

accounts it is at the moment of consumption or reception that meaning is produced, and such meaning is consequently neither fixed nor intrinsic but changes over time and place. Renoir's *La Loge*, for example, meant something very different for its first viewers at the 'Impressionist' exhibition of 1874 than it does for its admirers in the Courtauld Institute today, irrespective of the fact that it is the same work. What then is the role of authorship and the identity of the artist in conferring meaning on the work? Does it matter who makes the work and under what conditions? Is there a way of talking about the moment of production and the agency which brought the work into being without falling back onto simple solutions which see artworks as the product of the identity, biography or stated intentions of the unique artist?

The opera as a site of modernity

Certainly the positions from which women and men in late nineteenth-century Paris painted pictures representing the opera, with its standard visual accoutrements of woman, binoculars and evening dress, differed enormously. For men who identified with Charles Baudelaire's call for an art which represented the 'heroism of modern life', the opera offered only one of a number of scenes of urban leisure which could be seen to embody the spirit of modernity. But for women it was one of the very few such subjects to which they had access. The motifs which have come to be seen as the most significant within Impressionist iconography were unavailable to them. La Grenouillère, for example, offered Monet and Renoir the perfect setting for the development of an iconography of the

Plate 233 Edgar Degas, *Danseuse dan sa loge* (*Dancer in her Dressing-room*), *c.* 1878, pastel, 58 x 44 cm. Private Collection. Reproduced from P.A. Lemoisne, *Degas et son oeuvre*, 1946, Arts et Métiers Graphiques, volume 2.

Plate 234 Jean-Louis Forain, *Loge d'actrice* (*The Actress's Dressing-room*), 1880, watercolour heightened with gouache, 28 x 23 cm. Private Collection, Paris.

Plate 235 Edgar Degas,
L'Étoile (*The Star*), *c.* 1878,
pastel, 60 x 44 cm. Musée
d'Orsay, Paris. Photo:
Réunion des Musées
Nationaux Documentation
Photographique.

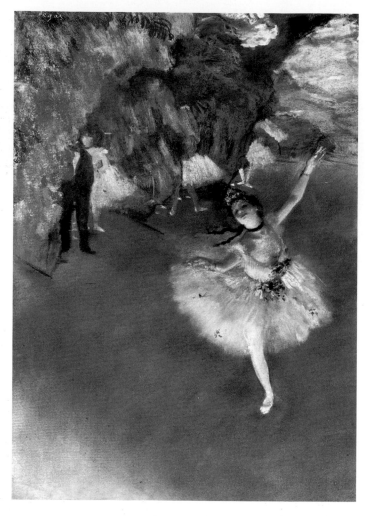

modern: the bustling crowds, the leisure culture, the evocation of speed and movement through broad brush strokes and textured surfaces which have come to be identified as the signs of modernity (Plates 155–60). Similarly the world of popular entertainment, the dance halls, the ballet, the open-air concerts, all of which have come to be associated with 'Impressionism' were the haunts of men and lower-class women and were not accessible to the cultivated *haute-bourgeoise* whose life was more likely to be organized around entirely different activities in the newly developing suburbs of Paris. The opera, therefore, occupies a special place in women artists' iconography of the modern, for here was an environment which they could inhabit without embarrassment, but which also offered a glimpse of the world of urban spectacle to which they had, at best, an uneasy relationship. Certainly, they were not free to wander in its recesses and explore, unobserved, its hidden fascinations. That was the prerogative of men. The eroticized spaces of the *coulisses* (the wings), open to wealthy men who paid their subscriptions to the opera house, or the sexually charged atmosphere of the actresses' dressing rooms were not the arena of the bourgeois woman (Plates 233, 234 and 235). It was the public face of the opera house which provided the spectacle for the woman artist, caught inevitably between her identity as woman, who provides the spectacle, and her identity as artist, who surveys it.

Perhaps something of the complexity of the woman artist's relationship to the opera is captured in a contemporary cover of the fashionable *Gazette des femmes*, aimed at the bourgeois woman (Plate 236). In a number of small vignettes a range of legitimate social

Plate 236 Cover of *Gazette des femmes*, 24–25 December, 1886. Bibliothèque Nationale, Paris.

activities for women is represented. Her musical accomplishment is endorsed, her position at the front of the opera box, replete with the stock props of fan, flowers, binoculars and chaperoning menfolk situated behind, is reinforced, and her realm as an artist is circumscribed within the comfortable domestic interior, the easel existing in the same sphere as the child with her letters. For a woman to attend the opera was perfectly acceptable, but for a woman to paint the opera was to cross boundaries, those between public and private and those between the act of looking and being looked at.

Renoir's *La Loge*, as I argued at the beginning of this chapter, could be read as an elaborate staging of gendered access to looking, a drama which encoded in its compositional structure and in the manner in which it positioned its projected viewer, the privileging of the masculine as the representation of active subjectivity. In the context of our discussion of the relationship of authorship to gender, what do we make of Eva Gonzalès' exactly contemporary *A Loge at the Théâtre des Italiens* in which an analogous scenario is staged (Plate 237)? One contemporary critic, rather overstating the power relations staged here, compared its characters to actors in a puppet theatre in which the husband holds the traditional stick and is ready to thrash his crumbling companion (P. Burty quoted in Bayle, 'Eva Gonzalès', p.115). The point is that the almost caricatural (a word used at the time) playing out of conventional roles represented here, did not go unnoticed by contemporary viewers. In this painting of a luxurious private opera box, the fashionable young woman is placed at the centre of the canvas in sumptuous décolletage, accompanied by flowers, jewels and binoculars in hand, with a soberly attired companion, this time looking towards her. On her right is the bouquet of flowers which was to form one of the stock images in subsequent paintings on this theme but which in 1874 (the year this painting was first submitted and then rejected from the Salon) was associated by critics with her teacher Manet's scandalous bouquet in *Olympia* (Plate 14). It stood in that earlier painting as a symbol of offering, on one level a homage to the prostitute from an absent male admirer, on another a legitimate, if coded, way of symbolizing a woman's genitals, that which was truly on sale in prostitution and yet was so assertively hidden by the insistent, covering hand of the Nude. If the woman's genitals needed to be displaced in order to be represented and if flowers offered the perfect solution (with their vaginal shape, connotations of deflowering (*déflorer*) and easily recognized reference to femininity), then their presence in Manet's *Olympia* is understandable. But this also means that flowers, so refined and ubiquitous a reference to the feminine, could potentially signal woman's sex and so go over the edge of respectability. Small wonder therefore that a work by Gonzalès which included an analogous bouquet would trigger off associations with the most infamous of Manet's works. The respectability of Gonzalès' model could not be guaranteed. Contemporary critics complained that 'honest women' were frightened to be seen in opera boxes for fear of being mistaken for demi-mondaines (Jules Claretie, *L'Opinion nationale*, 1867). The association with *Olympia* is, therefore, not far-fetched. Gonzalès after all submitted the painting in 1874 as the pupil of Manet and Chaplin (her earliest teacher) and her association with the former was constantly remarked upon, and often lamented by her contemporaries. The relationship with Manet is here invoked not only by the fact that she included his name under her own in her Salon submission but in that she remained faithful to those formal characteristics which had become identified with his work of the 1860s: front lighting, absence of tonal gradation, use of black, and sweeping brushstrokes. They functioned as the sign of her mentor, who had exhibited a memorable portrait of her at the easel only four years before and who was reputed to have been involved with the early stages of planning this work. Small wonder, therefore, that the bouquet could not fail to invoke *Olympia* for the informed viewer in the 1870s.

Does the fact that *A Loge at the Théâtre des Italiens* was painted by a woman make the bouquet any more scandalous than it would have been had the work been painted by a man? This is difficult to answer. Suffice it to say that the painting is about display on two levels, one legitimate if threatening, the other transgressive. The legitimate staging of the feminine as display in this painting is, as we have seen, equally if not more strongly articulated than in *La Loge*. There are surely few paintings that more neatly encapsulate the notion of man as the bearer of the look, woman as its object, than this one. Even though the gaze of the woman is directed at the potential viewer, there is nothing challenging or disquieting about it. An image of luxurious seductive femininity is proffered both to the man within the frame and to the viewer outside the picture. But the more problematic display which is evident here is the display of the woman artist's talents in the public

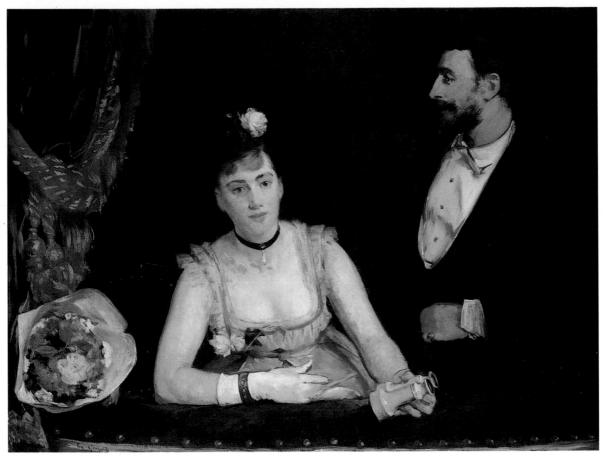

Plate 237 Eva Gonzalès, *A Loge at the Théâtre des Italiens*, c.1874, oil on canvas, 98 x 130 cm. Musée d'Orsay, Paris. Photo: Réunion des Musées Nationaux Documentation Photographique.

arena of the Salon: the woman who puts herself forward for public judgement as artist rather than as delectable object. *A Loge at the Théâtre des Italiens* was, by any standards, an ambitious painting, its 98 x 130 cm far outstripping the customary measurements of genre painting which women had traditionally practised. As such, it was a large statement which not only (like Manet's paintings of the 1860s) subverted contemporary notions about scale and subject-matter (big paintings were suited to heroic subjects and lofty idealism, not to paintings of contemporary life), but also conventional attitudes to women's pictorial aspirations. Small-scale genre painting was more easily tolerated in a woman than large-scale modern life painting. As Philippe Burty remarked when the painting was eventually exhibited in 1879 under the married name of the artist, Mme. Henri Guérard, the skill and power demonstrated here, were surprising for a woman (quoted in Bayle, 'Eva Gonzalès', p.115). *A Loge at the Théâtre des Italiens* was doubly transgressive therefore. The bouquet in the painting could have triggered off anxiety about the display of femininity which goes beyond legitimate boundaries, whether bringing to mind the fictive empowerment of a prostitute who reigns, goddess-like, in her boudoir, or of the usurping of public space and public spectacle by an ambitious woman artist who manipulates standard gender relations to effect, almost threatening to unseat them by staging them so conclusively from her position as the woman who looks rather than the woman who is looked at. Both the prostitute and the woman artist are endowed with knowledge, a knowledge which sees and tells social relations as they are. Both are therefore, in their different ways, dangerous.

For an ambitious young woman artist like Gonzalès, it was existing pictorial conventions which needed to be 'mastered' and struggled over. There was no elaborated or valorized 'feminine' tradition operative within the public sphere into which she could insert herself, if she had felt the need. For women artists there were no precedents for representing urban leisure. By undertaking a 'modern life' painting of this type, Gonzalès had to work with available conventions and enter into a representational system in which pleasure, luxury and sensual indulgence were expressed through the display of women's bodies. For a woman to lay claim to the public sphere and make sense (even enjoy some success) within it, meant to employ a masculine language, an already elaborated system of symbols through which the identity of men and women was constructed. There was little space within this dispensation for the development of an alternative feminine language. There was only 'femininity' as the other side of masculinity, as the representation of its fantasies and fears, the projection of its desires. To paint within urban avant-garde culture meant the immersion of the self in pictorial conventions which were already established and which conditioned the very act of making. The woman artist in such circumstances occupies a complicated position in relation to her work. On the one hand she absorbs existing conventions of representation/language and they speak through her like a ventriloquist's dummy. She enacts the language available to her. She is produced by it. On the other hand, she is not entirely subject to it but must negotiate its tenets from her position as a woman. Sometimes this might entail mimicking its dominant structures, echoing its existing power relations, but always at some distance; there is always a gap between the woman who acts and the action which is wrought from her. Even when a woman seems most to rehearse conventional modes of behaviour, as Gonzalès does in *A Loge at the Théâtre des Italiens*, she cannot be entirely identified with the construction of the feminine which she is representing because she is the artist, she is outside the image; it is she who has made it. Implicated by it she may well be, but identical with it she cannot possibly be. To talk about authorship and agency in this context is to imagine a position outside of the painting from which it is capable of being produced. That position can be imagined as an effect of representation, a product of the image that we confront, rather than as a point of origin for the image. The authorship of the image is in some way part of what is represented in it and what we see as represented in it may depend to some extent on the construction of an imaginary author for it. While this is equally true for works produced by men and women, it matters to our interpretation of the work whether we imagine its author to be a man or a woman. Our reading of the work may depend on this.

Mary Cassatt

Gonzalès' practice was not the only way of negotiating the representation of modernity from the position of the woman artist in this circle. Indeed, Cassatt and Morisot found different ways of working as women artists within avant-garde culture. Like Gonzalès, Cassatt tackled the subject of the opera, producing at least eight variations on this theme. She made a copy of Renoir's second attempt at this subject, *The First Outing* (Plate 238), painted two years after *La Loge*. For an artist to copy the work of a peer demonstrates her attempt to come to terms with the genre as it was currently articulated. It was very common for artists to make copies of works by 'Old Masters' which they admired, less so for works of contemporaries. To do so involved mimicry at its most bald, in this case the mimicry of a world as seen by a man representing women. Cassatt, puts herself, temporarily, into the shoes of the male artist. It was not until 1879 that she began her own series of women in *loges*, in which she departed radically from her precursors. Most daring of these was *Woman in Black at the Opera* (Plate 239), a painting which seems to subvert the gendering of looking encoded in both *La Loge* and *A Loge at the Théâtre des Italiens* while drawing, to some extent, on the compositional arrangement of *The First Outing*. From the

Plate 238 Auguste Renoir, *La Première Sortie* (*The First Outing*), 1876, oil on canvas, 65 x 50 cm. The National Gallery, London. Reproduced by permission of the Trustees.

latter Cassatt seems to have taken the idea of the demure clothing and profile position of her model but instead of capturing the poised expectation of youth and accompanying the day costume with frills, pretty bonnet and flowers, she eschews all such decorative paraphernalia and represents a single mature woman in the *loge*, austerely clad in black with white trimmings, usually the costume associated with men during this period. Like the young women in *The First Outing*, the body of Cassatt's figure is averted from the viewer, but instead of offering the viewer a soft fleshy profile and half-opened lips, her eyes (traditionally associated with seduction) are masked by the binoculars which empower her with active vision. Her body is tense and alert, her fan clasped tightly shut, her expression intent. None of these are the signs associated with luxurious seduction which 'women on display' were meant to embody and for which painting had invented an elaborate sign language. The unrelieved black costume hides the contours of the body. The textured surface and subtle tonal modelling of *The First Outing*, revealing the curvaceous body of the young girl, is refused in favour of a flat, scrubbed surface which seems to deny the body that it represents rather than invite the eye to dwell on it. The space of the canvas is commanded by the dominating silhouette of the woman whose projected gaze traverses the cavernous space before her. In the background, in what is tempting to read as a parody of conventional gendered 'looking', a man is seen to lean forward in his box and look intently through his own binoculars into the *loge* in the foreground.

The fascination of *A Woman in Black at the Opera* is the consummate and knowing way in which it seems to subvert dominant gender roles. The distance between the woman artist and the woman represented does not seem nearly as great as in the case of Gonzalès' painting. The representation of an active, gazing woman in the painting seems easily to stand for the position of the defiant woman artist who refuses to occupy the conventional position as spectacle and looks intently for herself (even though she still functions as specular object for the man in the picture). It is not surprising therefore that some feminists have looked to this image as one of empowerment and dignity with which they can identify. It is important to acknowledge, however, that Cassatt was capable, at other moments, of painting pictures which seem, on first acquaintance, to have much more in common with conventional representations of women as spectacle. *Lydia Seated in a Loge, Wearing a Pearl Necklace* (Plate 240) is worth looking at from this point of view. In this painting the body of the woman (Cassatt's sister) is pushed forward in the shallow space, the sense of context being provided by the elaborate reflection which fills up half of the picture surface. The surroundings which explain her situation are provided only as a flattened image, an illusory space which envelops her, not as a space which she surveys and commands as in *A Woman in Black at the Opera*. Whereas in the latter the viewer is invited to look with the woman across the empty space, in the former, it is the figure of Lydia who attracts our attention and on whom our gaze dwells. The rhythms created by the horizontal bands of the *loges* behind her, the echoing presence of her reflection, the highly individualized features of the face and the enveloping redness of the seat draw the eye back to the figure. There is little anonymous or generic about this figure. It was, after all, exhibited at the fourth Impressionist exhibition in 1879 as the portrait of a particular individual who is named in the title. Granted she may have all the attributes of refined upper-middle-class femininity, indicated in dress, demeanour and setting, but she also shows the particularity of a person in possession of a mind with her animated expression, intent look and erect head. This particularity locks the painting into an anecdotalism and specificity which runs counter both to the overall painterliness of its surface and its ambition as a generic modern-life painting. This tension is a telling indicator of the complex situation of its production. As a portrait of a loved relative, it is more than the representation of a type, as the painting of spectacular femininity it fits into the genre which spawned it. Its awkwardness lies in the irreconcilability of these modes.

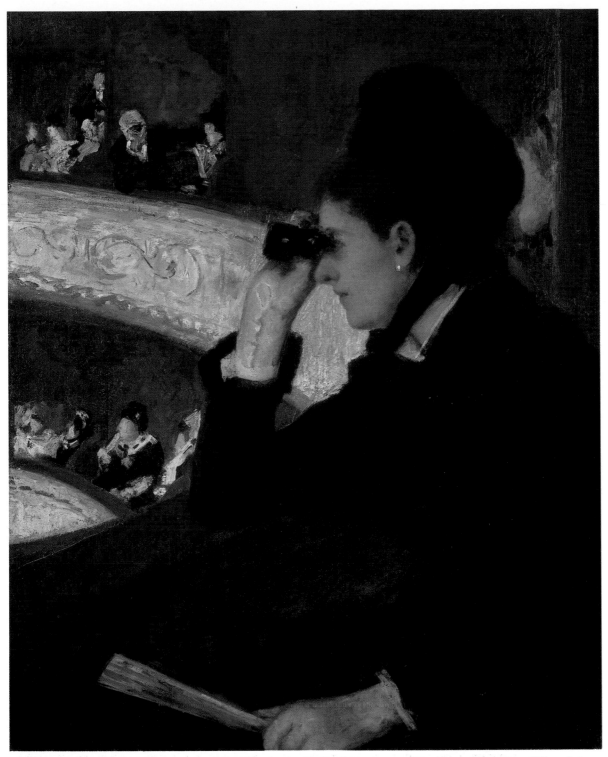

Plate 239 Mary Cassatt, *Woman in Black at the Opera*, 1879, oil on canvas, 80 x 65 cm. Museum of Fine Arts, Boston, the Charles Henry Hayden Fund.

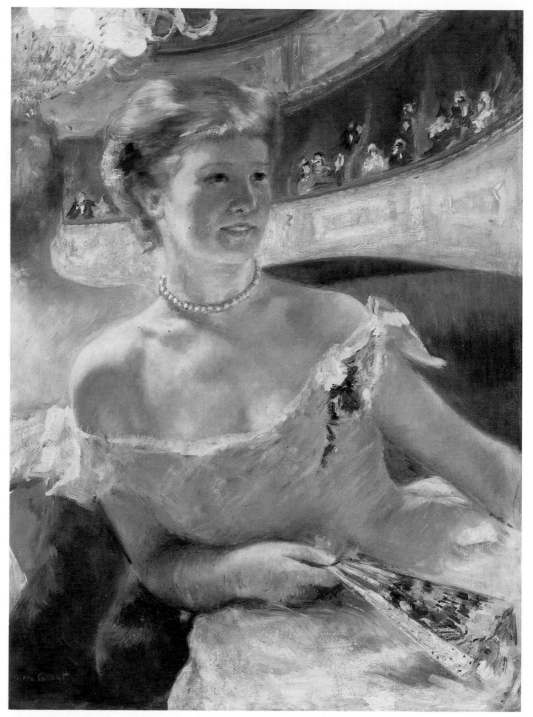

Plate 240 Mary Cassatt, *Lydia Seated in a Loge, Wearing a Pearl Necklace,* 1879, oil on canvas, 80 x 58 cm. Philadelphia Museum of Art, Bequest of Charlotte Dorrance Wright 1978.1.5.

In both these paintings Cassatt departs from conventional representations of women in public spaces as the repository of masculine desire. Her complete refusal of woman as spectacle in *A Woman in Black at the Opera* makes this a more confident statement than the ambivalent *Lydia Seated in a Loge*, but both seek to seize for their female protagonists an active engaged look, a knowing, desiring gaze. There is evident difficulty in attempting this within a representational system which positions men and women in relation to the gaze in particularly circumscribed ways. In a culture in which the truly womanly woman is one who is gazed upon and who must adorn herself for this purpose, how can a woman artist seize the act of looking not only for herself as artist but for the female figures which she represents? For a woman to look defiantly in this sexual economy usually brought to mind the horrific and destructive image of the *femme fatale*. Even the enigmatic gaze of Manet's *Olympia* or the emphatic dark-eyed stare of Berthe Morisot in *Le Balcon* (Plate 223) invoked such fears in their first viewers. It was difficult therefore to imagine a woman who looked assertively without being seen to threaten the social and sexual order, held always in fragile balance. But within realist and naturalist circles, looking, observing, recording, were the crucial catchwords. The woman artist who identified with this aesthetic had to look in order to create, and in representing women she had to represent their relation to dominant relations of looking, that is to the gaze.

Images of motherhood

Moving from *A Woman in Black at the Opera* as a painting which invokes the empowerment of the female gaze, Griselda Pollock has interpreted Cassatt's paintings of mothers and children as inscribing the desiring gaze of the mother, a representation of an active feminized eroticism outside of masculine objectification (Pollock, 'The gaze and the look'). A comparison between Cassatt's *Mother about to Wash her Sleepy Child* (Plate 241) and Renoir's, *Maternité* (Plate 242) indicates their very different approaches to the theme. In the Cassatt the interlocking gazes of mother and child and the circular enclosing form which their bodies make constructs an image of engaged intimacy. In the Renoir, the focal points are the exposed breast of the woman and the sex of the male child, and these construct the act of breast-feeding as a form of erotic display. The woman's pouting expression and her turning away from the child to an imagined encounter with a viewer situate the painting within acceptable conventions of erotic representation which position women as the object of male sexual fantasy. It is a very different construction of sexuality which is represented in the Cassatt. The erotic charge of the picture is in the physical engagement of the mother and child. It is in the conventional role of mother that a legitimately powerful and desiring gaze is ascribed to women. It is unsurprising, therefore, that Cassatt's paintings of mothers and children were among her most admired works. They inspired the critic Huysmans to enthuse:

> ... Woman alone is capable of painting childhood. There is a particular feeling which a man does not know how to render; unless he is singularly sensitive and delicate, his fingers are too big not to leave clumsy and brutal marks; only the woman can pose the child, dress it, pin it without pricking it.
>
> (quoted in Mathews, *Mary Cassatt and the Modern Madonna*, p.65)

How ironic that it is the childless, independent and successful artist, Mary Cassatt, who is ascribed with an essential maternal empathy for her models. The issue of the woman artist's identification with the model which Huysmans saw as the clue to her success is much more complex than he could possibly have imagined. To paint as a woman and to caress as a mother were not the same thing, although the woman artist may indeed have been in a better social position to observe motherhood than her middle-class male contemporaries. There were necessarily fewer barriers between her and her models because of her familiarity with the nursery.

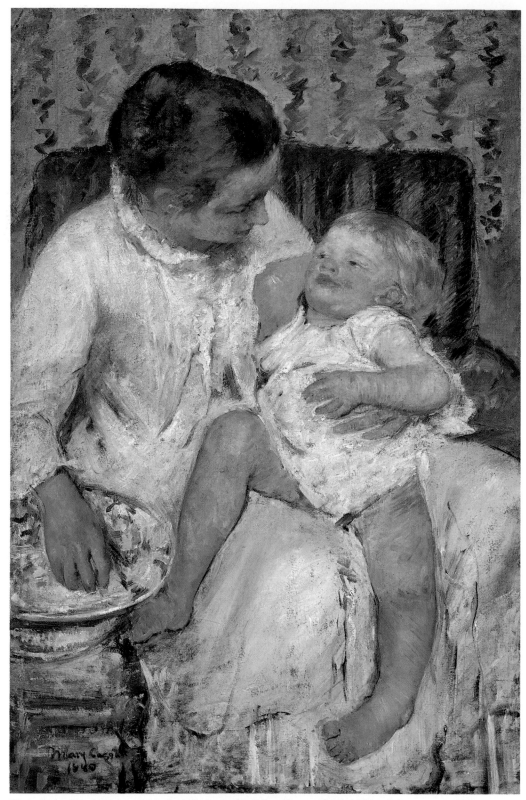

Plate 241 Mary Cassatt, *Mother about to Wash her Sleepy Child*, 1880, oil on canvas, 100 x 66 cm. Los Angeles County Museum of Art, Bequest of Mrs Fred Hathaway Bixby M.62.8.14.

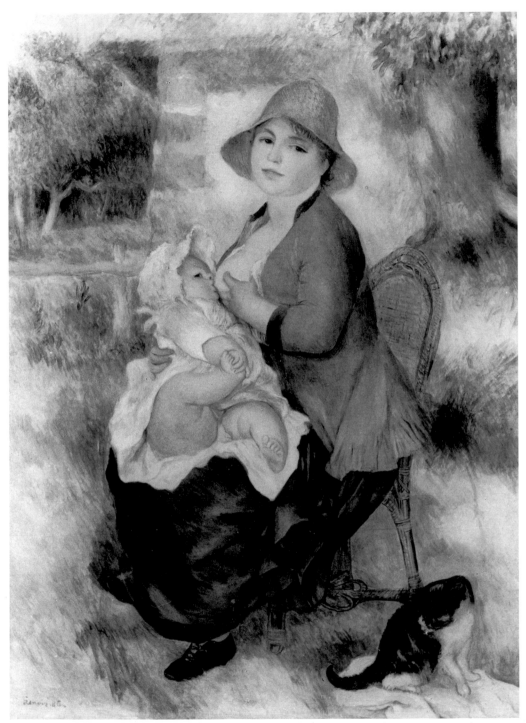

Plate 242 Auguste Renoir, *Maternité, ou femme allaitant son enfant* (*Maternity, or Woman Nursing her Child*), 1885, oil on canvas, 74 x 53 cm. Private Collection. (Sitters are Aline Charigot, whom Renoir married in 1890 and Pierre, their son.)

Here she was indeed empowered to look herself, and to represent the female look in its socially legitimated domain. But how do we respond to an independent woman's pictorial practice whose articulation of women's power is located right in the heart of the family – the site, it has been argued, of women's deepest exploitation in the modern period? Is there a way of claiming the power of motherhood for women, of acknowledging its force and proclaiming its significance, without reinforcing patriarchal ideology which projects motherhood as the only legitimate form of fulfilment for women? Even Cassatt, who was a feminist activist and successful artist, was reputed to have said towards the end of her life, 'After all a woman's vocation in life is to bear children' (quoted in Bullard, *Mary Cassatt, Oils and Pastels*). How literally should we read this statement and of what is it symptomatic? If the 'woman in black at the opera' has seized the gaze only to claim it for maternal desire, then the latter must surely stand as a *metaphor* for female empowerment rather than as a literal validation of motherhood as women's only empowering option. After all, the woman who paints, in this instance, is not a mother, and the gap between the woman artist and the image of maternal power which she constructs sets up an interesting tension between culturally endorsed representations of female power and a relatively transgressive social act, the childless woman who paints for public exhibition.

Morisot's *The Wet Nurse* (Plate 5) sets up different but equally interesting tensions, inflected here by class. In this image, what appears to be a *maternité* scene, conforming to the traditional compositional structure of the 'madonna and child' theme, is in fact an image of work.[3] Morisot's daughter is nursed by the hired 'wet nurse' while her mother paints the scene. The two women at work commune, in a sense, over the body of the child and the presence of the breast. But each takes her position in the world according to the expectations of her class and the demands of her situation. In a very strong sense they share the child. It has been brought into the world and is sustained by their bodies. But while the one woman is a paid servant who doubles up as a model, the other is the natural mother whose position as an artist in this instance is, ironically, conditional on her physical detachment from her child. To paint motherhood for Morisot and Cassatt, therefore, meant to be protected from its demands, either through being childless or being of a class which relegated childcare to hired help. These situations provided both the time and detachment which professional aspirations required.

Modernity and the domestic sphere

Morisot's response to the spectacle of urban modernity was to turn her back on it. Drawing much more from the traditional iconography of women's culture in the private sphere (mothers, children, domestic scenes), an imagery which had been amply elaborated in the albums, watercolours and sketches with which many *haute-bourgeois* women had traditionally been engaged, she never represented the bustling crowds of Paris or the fashionable opera. Instead in Morisot's work we see the occasional staging of the culture of Parisian entertainment and spectacle as a ritual of 'dressing-up'. In *Figure of A Woman (Before the Theatre)* begun in the year after the appearance of *La Loge* at the first Impressionist exhibition, which Morisot had been involved in organizing, we see all the paraphernalia of the visit to the theatre/opera but without the setting (Plate 243). Instead, the figure floats in an undifferentiated space in which floor and ground merge in a haze of thinly applied grey paint. The body of the woman with its elaborate evening gown, gloves, glasses and appended flowers is suggestion enough of the context for Morisot. In such paintings as this one and *At the Ball* (Plate 244), set in the Morisot home in the Rue Franklin, Passy, one of the wealthy suburbs to the west of the city centre, the allusion to urban pleasures in the city of spectacle is encoded in costume, accessories and title alone.

[3] For an interesting discussion of this work see L. Nochlin, 'Morisot's wet nurse: the construction of work and leisure in Impressionist painting', in Edelstein, *Perspectives on Morisot*, pp. 91–102.

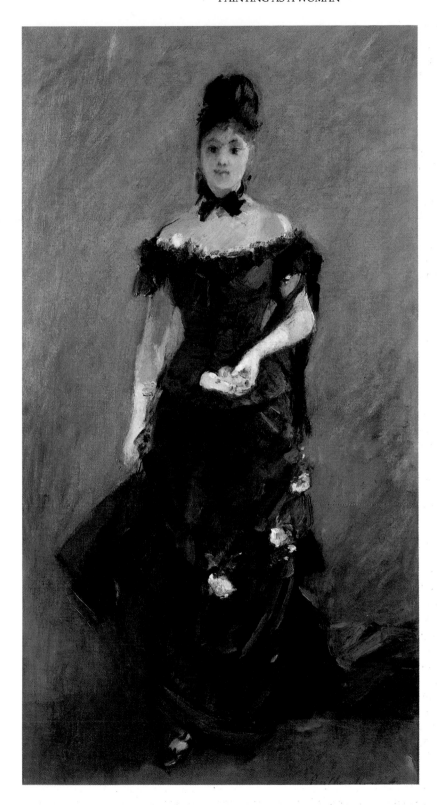

Plate 243 Berthe Morisot, *Figure of a Woman* (*Before the Theatre*), 1875–76, oil on canvas, 57 x 31 cm. Galerie Schroder and Leisewitz, Bremen. Photograph by courtesy of Galerie Beaveau.

Plate 244　Berthe Morisot, *Au Bal* (*At the Ball*), 1875, oil on canvas, 62 x 52 cm. Musée Marmottan, Paris. Photo: Routhier/Studio Lourmel.

Plate 245 Marie Bracquemond, *Les Trois Grâces* (*The Three Graces*), 1880, oil on canvas, 137 x 88 cm. Mairie de Chemille, Maine-et-Loire.

The same is true for Marie Bracquemond's ambitious *The Three Graces* (Plate 245), a modern-life interpretation of the traditional theme, where 'modernity' resides in costume, pose and manner of execution rather than in setting. The focus of Morisot's life and art was the quiet surroundings of her suburban home, its adjacent parks and views, and the family, friends and employees who inhabited this secluded life with her. Artists and writers would be invited into this world at the formal soirées held in the family residence. It was the salon and the studio which was the context for discussion about art, not the café or club frequented by her male colleagues. Morisot differed, in both background and social position, from Gonzalès, the daughter of a writer-father and musician-mother who was raised in an artistic milieu, and Cassatt, an unmarried woman, the outsider with her prosperous Philadelphia upbringing. The vantage point from which Morisot experienced the modern city was much closer to that of other upper-middle-class women than with her peers in avant-garde artistic circles. As such, the focus for her art was the rituals of bourgeois femininity, drawn from the visual culture of modernity's Other side, the home and its inhabitants. It was to the home that our *flâneur* returned after 'botanizing on the asphalt', to use Walter Benjamin's expression. It was the home of the salon, the wife, the children, so scorned by sophisticated metropolitans, which nevertheless formed the stable background for their perambulating. It was from there that they set out in the morning and to which they eventually returned. But for a woman of Morisot's class, it was *the* world, *the* centre, not the downgraded, compromised periphery of modern life. The modernity of the 'masculine' metropolis, when it features in her works, therefore, is a remote, filtered one, its very indistinctness of space and lack of specificity of setting, the result of her view from the outside (Plates 246 and 247).

Plate 246 Berthe Morisot, *On The Balcony*, 1872, watercolour with touches of gouache over graphite on offwhite weave paper, 21 x 17 cm. Gift of Mrs Charles Netcher in memory of Charles Netcher II, 1933. Photograph © 1990, The Art Institute, Chicago. All Rights Reserved.

Let us return now to some of the questions raised earlier in this section. There is surely, to our eyes, no immediate way of telling whether a work like *Figure of a Woman* (Plate 243) was painted by a woman or a man simply by looking at it, but such information does influence our interpretation of it. Does that mean that we are bringing extraneous and irrelevant knowledge to our experience of the work? Certainly, if one subscribes to the view held by some art theorists in this century, for example Clive Bell, that in order to appreciate a work of art one needs to know nothing about its history, then such knowledge would be immaterial, irrelevant to the effect of the work, even

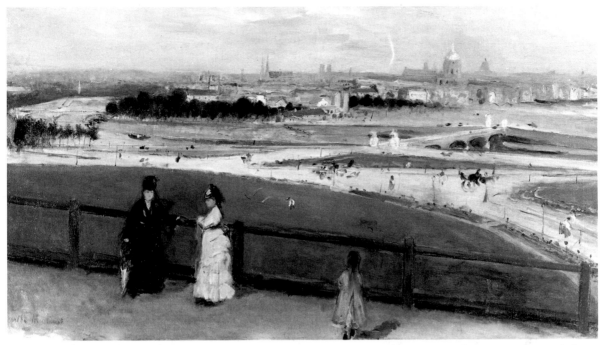

Plate 247 Berthe Morisot, *View of Paris from the Trocadero*, 1872, oil on canvas, 46 x 82 cm. Collection of the Santa Barbara Museum of Art, gift of Mrs Hugh N. Kirkland.

obstructive. Such a view of art gives primacy to the object itself and its capacity to move the sensitive viewer by its sheer physical properties, the way it is made, the way its forms are arranged on the surface, its manipulation of materials and its technical accomplishments. What is occluded in this view is history: the history of the object's place and function in culture, the genesis of its making and the context for which it was made; the condition which made its production possible, the initial and subsequent contexts within which it has been viewed; and its changing signification for successive viewers and in differing viewing contexts. If these questions are taken into account, then the question of whether a work was made by a man or a woman could be crucial: it could explain something about its institutional or canonical position, it could influence our reading of its imagery in the light of historical knowledge, it could affect our relative assessment of size, scale, technique and genre, it could explain something about the context in which it was initially viewed and its critical reception.

To argue for the relevance of the gender of the artist, however, is by no means a plea to see works as unproblematic expressions of their authors' selves whose fixed identity, sexual and otherwise, flows in an unmediated way into the work. To dislodge the fiction of the author as a genderless, placeless, classless being, who is conceived of as an inspired creator, the sole origin and source of the work's meaning, does not mean the removal of the historical producer of works. In this section authorship has been conceived of, on the one hand as an effect of representation, on the other as the historical, social and psychic position from which it is possible to imagine that the work is produced. Both of these conceptions posit an artist who acts to produce the work, but neither takes for granted the identity of that artist or assumes that this identity is unproblematic. Literary theorists have long claimed the 'death of the author', meaning the removal of a final, fixed referent for the meaning of the artwork. For such theorists meaning is contingent and shifting, not unitary and secure. It cannot be attributed simply to the beliefs of the author who expresses them by means of the artwork. Such theories have helped to dislodge common-sensical notions of authorship, of artists expressing themselves in their works or

communicating with their audiences in a simple one-way flow. We know now to be wary of such over-simplified theories. But this does not mean that we need to give up on the whole idea of authorship and make an irrelevance of the producer. Rather we can try to find more useful ways of describing how meaning in works relates to their authorship and how the action of producing art is socially, psychologically and historically contingent. This is particularly crucial for feminists whose claiming and affirming of female authorship has lifted the woman artist from an anonymity and invisibility to which she was relegated for years. How the identity of 'woman' and the profession of 'artist' interact is, as we have seen, complicated and nuanced. It takes into account not only who produces the work and in what context, but how that producer is positioned in relation to that which she represents. For the analysis of this relationship the gendering of authorship is crucial.

The historical viewer

So far much of our discussion has centered around artists and the conditions surrounding the production of artworks. We have made many references, though, to the viewer, the viewing position and the notion that viewing may be a process affected by historical circumstances rather than a natural, genderless or universal one. The viewer or reader, rather than being seen as an empathetic absorber of the artist's message, can more usefully be seen as an historically formed subject whose responses are shaped through language and social context. A distinction needs to be made between a work's initial viewers and subsequent viewing communities. The context within which a work was intended to be shown may presuppose a certain viewing position, both physically and in terms of a set of intellectual and aesthetic predispositions. Courbet's *Origin of the World* (Plate 248), for example, commissioned by the Turkish diplomat Khalil Bey, was made for an entirely different audience from his *La Source* (Plate 249) shown at the Paris Salon. They conform to different notions of decorum in their representation of the female body, the one

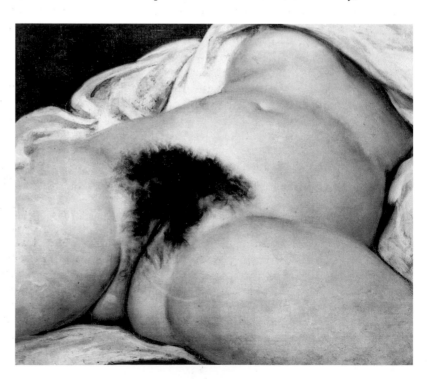

Plate 248 Gustave Courbet, *L'Origine du monde (The Origin of the World)*, 1866, oil on canvas, 46 x 55 cm. Musée Courbet, Ornans, Dépôt Provisoire.

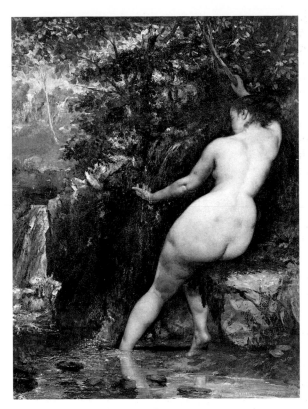

Plate 249 Gustave Courbet, *La Source* (*The Source*), 1868, oil on canvas, 128 x 97 cm. Musée d'Orsay, Paris. Photo: Réunion des Musées Nationaux Documentation Photographique.

provocative but acceptable as public display in the mixed context of the Paris Salon of the 1850s, the other an arguably pornographic work directed to a private, exclusively male world of exchange. Artists may, therefore, arrange their compositions, decide on scale, subject-matter and materials in relation to the intended viewing context of their works, and an imagined spectator for them. Some idea about the potential viewing context of a work is usually operative therefore at the moment of making, and the evidence for this may be traceable in the work. But this does not necessarily determine or circumscribe the subsequent meanings of the work. Once it enters into the public domain its potential signification shifts and alters constantly depending on the uses to which it is put, the context in which it is viewed, and the community by which it is viewed. Certain ways of looking may predominate at given historical moments, conforming to their own common-sense, their own logic and truth. Once these shift, so, necessarily, do the possible meanings attributed to cultural artefacts.

Viewing now may involve a complicated negotiation between an explicit viewing position (one informed, for example, by late twentieth-century feminist theory, or Modernist aesthetics, or psychoanalytic theory) and an attempt at being historically imaginative in order to recover something of the range of meanings that works have had for viewers over time. This might involve a recognition that the implicit gendering of the spectator informs the very structure of the picture. Such a recognition disrupts the traditional art-historical notion of a generic spectator, an ideal imaginary viewer (sophisticated, discerning and sensitive) who while apparently neuter (the masculine pronoun is regarded as generic, after all), has been conceived of in most writing as exclusively male. There is no place in such accounts for an alternative viewing position, one which asserts its difference from dominant modes of looking. *The Origin of the World*, for example, could be described in the dominant context as an 'erotic' work, without it being necessary to pose the questions, 'erotic for whom?', 'erotic from what standpoint?', 'erotic at whose expense?'.

It is through the positing of a different viewing position, a symbolically feminine one, which stands outside of dominant modes of thought, that we can question the notion of the universal, genderless viewer. This may involve imagining a viewer situated in history who is 'differenced', that is capable of occupying a different viewing position from the imagined dominant one operative within a culture (and such a position could be occupied by a 'differenced' male gaze, a non-heterosexual one, for example, or a non-Western one). Or dominant views can be subjected to a differenced gaze, that is the gaze of the historian who looks from a different position and seeks to uncover the power relations at stake in representation.

Critical reception of women's art

It is to the second of these approaches that I want to turn. I want to investigate the way that works produced by women artists in late nineteenth-century Paris were received by some of their contemporary viewers in order to uncover the assumptions about gender that were implicit in these responses. It is through the traces left by former viewers that we can reconstruct some sense of the changing signifying conditions of a work of art. These are left in a number of forms. Sometimes there are records of how works were exhibited, whether they were sold and for how much. Often the artist will leave an account of the work and its reception in journals, memoirs, letters or notes. These will constitute a form of self-narration. Responses by other viewers, family members, friends, supporters, rivals, opponents, professional critics may also be available in similar forms. All these 'responses', as constituted in language and inflected by the formal demands of their genre of writing and their construction of a projected reader, can give us a particular insight into how it was possible for a work to signify at a particular historical moment. In so doing they tell us as much about the viewer as about the work. None of them offers the complete or unquestionable truth, or *the* meaning embedded in the work (although we may find certain explanations more sympathetic or plausible than others), but all are useful to help us draw up a complex map of signification. Often it is through parallel texts, not specifically focused on artworks that a sense of a historically available range of meaning is best gauged.

The contemporary viewers who are given particular authority in art-historical accounts are art critics. Works for public exhibition were likely to generate explanatory texts of a particular sort in late nineteenth-century France. These could exist in the form of exhibition reviews, discursive articles, biographies, or casual commentaries which might appear in the hugely developed newspaper press. In addition, critics and writers published monographs, extended essays, and prefaces to exhibition catalogues. These performed an essential promotional function in an artistic community constructed more than ever before on the notion of the artist as independent professional. Art exhibitions took their place as a form of public entertainment, part of the urban spectacle which constituted metropolitan culture. The critic often functioned as the formulator of public opinion, as the figure who could 'translate' the artwork for the viewing public and was therefore crucial in the making of reputations and the generating of necessary publicity for the sale of works.

But the meanings that were placed on individual works were usually divergent and contradictory, dependent not only on the conventions of criticism, but on the ideological position of the critic. One of the standard strategies of explanation in a culture so bound up with notions of individualism was the construction of the work as symptomatic of the 'style', propensities, proclivities and preferences of its named author, who stood at the core of its meaning. Critical texts, therefore, constructed mythic accounts of individual authors as having consistent and unique characteristics, who were compared and contrasted with others. Salon reviews in fact often followed the alphabetical structure of the layout of the Salon itself so that a review proceeded like a catalogue of the works of

named individuals from A to Z. The 'author' in this context, is formulated at the moment of reception rather than inception of the artwork. This author should be distinguished from the historical agent, the actual person whose material and psychological agency produced the work. Here it is the viewer who creates the artist. This mythic textual construction can become, in subsequent writing, conflated with the actual person, whose actions become explained in relation to a mythic persona which stands in for the person and is subject to subsequent revision. The artist in this context is a fiction, a fabrication of successive viewing communities.

If meaning in late nineteenth-century critical texts is constantly related back to authorship, then the identity of the author becomes crucial and may even condition response. Contemporary viewers of the works of Morisot and Cassatt were acutely aware of their authors' sexual identity and interpretations of their works were directly influenced by this. At the same time Monet's work was never assessed by his contemporaries in relation to how it expressed his 'masculinity'. To do so overtly would have seemed ludicrous. His 'masculinity' was assumed. It was taken for granted. But when women's work was in question critics sought for *the* clue to the works' meaning in their author's femininity, which was understood as a fixed and constant identity, the product of irrefutable biological and concomitant social differences. For their initial critics and subsequent biographers, a construct 'Berthe Morisot' and another 'Mary Cassatt' were evolved and made into coherent explanatory units through which the viewing of these artists' work was mediated or filtered. Neither Morisot nor Cassatt were simply 'artists' for their earliest viewers. They were decidedly 'women artists' and it was in terms of their relationships to this category that they were judged.

It was in both subject-matter and technique that Morisot's and Cassatt's work could prompt speculation on its roots in their female identities. The most frequent adjectives used to describe work by women which was admired during this period were 'delicate', 'tender' and 'charming', each of these the qualities which were admired in women themselves. The terms in which women could be shown to succeed was in the complex balancing of an 'appropriate' femininity and an overcoming of its inherent weakness. Critics looked for the marks of femininity in the very way that women's works were constructed. For them, femininity was something that would inevitably be inscribed in the actual means of representation, not only in its objects. By examining the critical construction of Berthe Morisot, particularly in the 1890s, we will be able to focus on the gendered implication of viewing and the way that it is historically bound up with a conception of the gendered author.

'Scientific' attitudes to women

Art criticism was not, of course, alone in representing the world to itself in gendered terms. Indeed, it provided only one site among many for the articulation of sexual difference and would not have made sense had it not drawn upon beliefs which were deeply embedded in the culture. Where the nineteenth century differed from previous centuries was in its attempts to understand these differences through science, to prove them empirically and use such proofs as the basis for social theory. What had been a concern of religion, philosophy and common sense, became increasingly a matter for medicine, the new disciplines of psychology and social policy. Where the theologians and artists had used faith and metaphor to support their contentions, the scientists offered 'facts' and 'evidence'.

In the face of growing feminist agitation, science was used by the conservative medical and anthropological establishments to corroborate a belief in the natural hierarchy of the sexes. The overriding conclusion to which nineteenth-century scientists came was that women were not fully equipped to deal with the superior mental functions, especially abstract thought. It was in organizing thought, synthesizing material and making judge-

ments based on evidence that women and people from so called 'inferior races' were taken to be particularly stunted. Such inferiority was, it was widely believed, physiologically determined and depended on the structure, size and weight of the human brain. There were social theorists who thought that the scientists had got it all wrong, but they were ready to produce other forms of evidence based on a belief in evolutionary theory, social conditioning or simple observation to support theories of an essential difference between the sexes. While not all of these spoke of the inferiority of women to men, all were convinced of their 'difference'. It was the manner of describing this and the values placed on it that varied.

The findings of 'science' by no means remained the preserve of the experts. Medical theories pervaded everyday life in late nineteenth-century France and doctors became credible mediators between the experiments of the laboratories and the problems of society. Research findings were widely disseminated in popular scientific and general journals, often with the finer points of dispute and doubt eradicated. A general reference book like the *Grande Encyclopédie*, for example, drew heavily on current 'scientific knowledge' in its entry for *femme*, claiming that differences between men and women could be explained through anatomical and physiological factors. The origin of woman's supposed mental weakness was to be found in the structure of her brain which was described as 'less wrinkled, its convolutions … less beautiful, less ample' than the masculine brain. The idea that women's mental capacities were necessarily stunted so that they could fulfil their maternal role was widespread. Pregnancy and menstruation were widely thought to lead to mental regression and women's generative capacities were regarded as responsible for their innate nervousness and irritability. The development of their intellectual capacities, it was feared, would lead to a deterioration in their capacity to breed and to mother effectively. Women were thought, therefore, to stop developing intellectually at the onset of puberty when their constitutions became taken over by their reproductive functions.

Women's intellectual deficiencies were supposedly compensated for by other capacities which were more highly developed in them than in men, notably the emotional and sensitive areas. Although women were intellectually weak they possessed greater *sensibilité* ('sensitiveness') than men. Together with their heightened capacities for feeling, they were believed to possess a 'more irritable nervous system than men', hence the claims, across a number of discourses, for women's 'nervousness' and 'excitability'. Some commentators thought that they had a relatively larger visceral nerve expansion than men and hence were endowed with greater visceral feeling. This allowed them to experience the world more directly through their senses, leading to a tendency to act upon impulse. Whereas in European men responses to sensory impulses were delayed, complex and deliberate, the result of cerebral reflection, in women, children and 'uncivilized races' responses were direct and immediate. Peripheral stimuli led, in these groups, to relatively immediate reactions. They shared a similar psychological make up: they had short concentration spans, were attracted indiscriminately by passing impressions, were essentially imitative, their mental actions were dependent upon external stimuli and they were highly 'emotional' and 'impulsive'. Their strengths lay in their highly developed powers of observation and perception.

Impressionism as a 'feminine' art

Such 'truths', such commonsense beliefs, were widely held and permeated all thought, even reaching such an apparently separate sphere of discussion as art criticism. They affected its judgements of quality, its means of discrimination, its very aesthetic preferences. In an article published in *La Nouvelle Revue* in the summer of 1896, the year of the posthumous retrospective of Morisot's work, Camille Mauclair, a prominent critic, announced that Impressionism was dead. He argued that it had become history; it was an art

Plate 250 Alfred Sisley, *Le Pont d'Argenteuil en 1872* (*The Bridge at Argenteuil*), 1872, oil on canvas, 39 x 51 cm. Memphis Brooks Museum of Art, Memphis, Tennessee, Gift of Mr and Mrs Hugo N. Dixon, 54. 64.

form that had lived off its own sensuality and it had died of it; it was possible now, in the 1890s, to detect on what an unsatisfactory and illusory principle it had been founded ('Le Salon de 1896', quoted in Garb, 'Berthe Morisot and the feminising of Impressionism', p.57). For Mauclair and many of his Symbolist colleagues, Impressionism was a style based on the misguided aim of restricting itself to the seizing of optical sensation alone.[4] A painting like Sisley's *Le Pont d'Argenteuil en 1872* (Plate 250), for example, would have been thought by Mauclair to have rejected all general underlying truths in favour of the appearance of the moment. Constructed to look like an observed scene rather than one which utilized a more lofty and imagined pictorial conception, it could be seen to rely on the meagre resources of the hand and the eye. Mauclair approved of the Impressionists' assertion of 'subjectivity' and their rejection of what he saw as old-fashioned beliefs in academic beauty, but he objected to their reliance on what he called 'realism', by which he meant their restriction of their work to the rendering of immediate experience. He claimed that while understandably avoiding the excesses of idealism, Impressionism had lapsed into crass materialism.

Although it was this view of Impressionism which became prevalent in the 1890s, Impressionism had earlier been regarded as an art form of spontaneous expression, as a means of finding the self in the execution of a painting whose very technique came to represent a vision that was direct and naive. For its supporters it could be defended in terms of its 'sincere' and 'truthful' revelation of the temperament of the artist who filtered the world of visual sensation through the physical acts of making marks on the surface. For many of its detractors, though, Impressionist painting could be construed as a thoughtless, mechanical activity, which required no exercise of the intellect or imagina-

4 For an elaboration of these ideas, see T. Garb, 'Berthe Morisot and the feminising of Impressionism'.

tion, no regard to time-worn laws of pictorial construction, and involved simply the un-
mediated reflex recordings of sensory impulses, a practice which smacked both of deca-
dence and superficiality. But it was Impressionism's alleged attachment to surface, its very
celebration of sensory experience born of the rapid perception and notation of fleeting
impressions, that was to bring it to be regarded, in the 1890s, as a practice most suited to
women's temperament and character. Indeed, Mauclair himself, while denigrating Im-
pressionism at large, called it a 'feminine art' and proclaimed its relevance for the one
artist whom he saw as having been its legitimate protagonist, Berthe Morisot. In turn
Impressionism's demise is traced to its allegedly 'feminine' characteristics, its dependence
on sensation and superficial appearances, its physicality and its capriciousness.

While the discourse which produced this apparently seamless fit between Impression-
ist superficiality and women's nature attained the level of a commonplace in avant-garde
circles in the 1890s, those critics who read the art press had long heard Morisot's work
discussed in terms which described it as quintessentially 'feminine'. In 1877 Georges
Rivière had commented on her 'charming pictures, so refined and above all so feminine'.
When *Un Percher de blanchisseuses* (Plate 251) was exhibited in 1876 and *Jeune Femme en
toilette de bal* (Plate 252) in 1880, the works were praised for their delicate use of brush-
work, their subtlety and clarity of colour, their refinement, grace and elegance, their

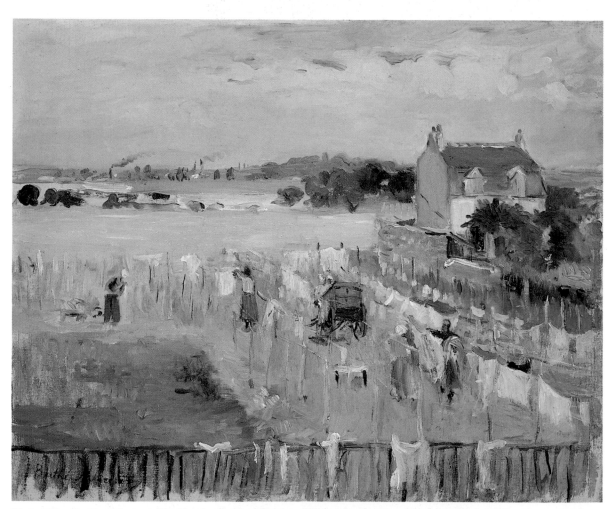

Plate 251 Berthe Morisot, *Un Percher de blanchisseuses* (*Hanging the Laundry out to Dry*), 1875, oil on canvas,
33 x 41 cm. National Gallery of Art, Washington; Collection of Mr and Mrs Paul Mellon.

Plate 252 Berthe Morisot, *Jeune Femme en toilette de bal* (*Young Woman Dressed for the Ball*), 1879, oil on canvas, 71 x 58 cm. Musée d'Orsay, Paris. Photo: Réunion des Musées Nationaux Documentation Photographique.

delightfully light touch. Her paintings were repeatedly praised for that familiar quality, their 'feminine charm'. It is true that the qualities of 'grace' and 'delicacy' were on some occasions used to describe the techniques of the male Impressionists. Alfred Sisley was even credited with a 'charming talent' and his *Le Pont d'Argenteuil en 1872* was said to show his 'taste, delicacy and tranquillity' (Plate 250). But the analysis of work by men in these terms alone was few and far between. What is more interesting than the occasional application of traditionally feminine attributes to individual male arts was the 'feminizing of Impressionism' as a whole.

The first critic to develop a sustained argument which sought to prove that Impressionism was an inately 'feminine' style was the Symbolist sympathizer, Théodor de Wyzewa, who, in an article written in March 1891, claimed that the marks made by Impressionist painters were expressive of the qualities intrinsic to women. For example, the use of bright and clear tones paralleled what he called the lightness, the fresh clarity and superficial elegance which make up a woman's vision. It was, he claimed, appropriate that women should not be concerned with the deep and intimate relationships of things, that they should see the 'universe like a gracious mobile surface, infinitely nuanced. ... Only a woman has the right rigorously to practise the Impressionist system, she alone can limit her effort to the translation of impressions'. In his introduction to the catalogue for her

first solo exhibition in 1892, Gustave Geffroy had called Morisot's a 'painting of a lived and observed reality, a delicate painting … which is a feminine painting'. Writing in the *Revue Encyclopédique* in 1896, Roger Marx felt able to assert that 'the term Impressionism itself, announced a manner of observation and notation which is well suited to the hyper-sensitivity and nervousness of women' (de Wyzewa, 'Berthe Morisot'; Geffroy, *Berthe Morisot*; and Marx, 'Berthe Morisot', quoted in Garb, 'Berthe Morisot and the feminising of Impressionism', p.58).

Women artists, according to these critics, could give expression to their intrinsic natures by being Impressionists. What was particular to women was the sensitivity of their sensory perceptions, and the lack of development of their powers of abstraction. What was peculiar to Impressionism was its insistence on the recording of surface appearance alone. As such they were made for each other. Of course, particular definitions of 'Woman' and 'Impressionism' are at stake here. In the 1890s, while the Symbolists valorized the 'imagination', promoting an art of suggestion and mystery requiring sensitivity and depth on the part of its creator, there was a very different but contemporaneous resurgence of various forms of 'idealism' based on Academic reverence for an art of cognitive and rational clarity. In this context, Impressionism came to connote a relatively inadequate aesthetic model based on the filtering and recording of impressions, hastily perceived, of the outside world. While Impressionism was attacked as a serious art form from both sides, women were excluded both from Academic art institutions and from the first Symbolist exhibition group, the Salon de la Rose et Croix, formed in 1891. Interestingly, the Impressionist group shows had been one of the few independent mixed exhibition organizations to welcome women. By the 1890s, it was left to 'Woman', the graceful, delicate, charming creature, nervous in temperament, deficient in intellect, superficial in her understanding of the world, dexterous with her hands, sensitive to sensory stimuli and subjective in her responses, most legitimately to embody the current notion of what Impressionism was. In particular, the name 'Berthe Morisot' came to stand for the happy fusion of the constructions 'Woman' and 'Impressionism'.

In order for the myth of Morisot's well adjusted femininity, which expressed itself in her 'intuitive Impressionism', to be taken literally, her artistic practice had to be seen as the result of an unmediated outpouring rather than as a self-consciously adopted aesthetic credo. Implicit in much of the Morisot criticism during this period is the assumption that her painting was achieved without effort. Gustave Geffroy compared her hands to those of a magician. Her paintings were the results of 'delicious hallucinations' which allowed her quite naturally to transport her 'love of things' into an intrinsic gift for painting. Moreover her strength was said to reside in the fact that her powers of observation allowed for the intuitive filtering of the outside world through feminine eyes, which were, in the words of Georges Lecomte, uncorrupted by any learned system of rules (Lecomte, *Les Peintres impressionnistes*, quoted in Garb, 'Berthe Morisot', p.59).

Morisot's art is described as 'all womanhood – sweet and gracious, tender and wistful womanhood'. But such gifts set her apart from other women artists. She had, since the 1880s, been compared with her female contemporaries whom she was said to outstrip in 'femininity'. Rosa Bonheur's masculine attire and 'manly' subjects had long disqualified her as a woman in some quarters and even Mary Cassatt, whom Huysmans had so admired for her alleged maternal tenderness, did not quite match up to Morisot in the femininity stakes. In 1907 the critic Roger Marx was to describe Cassatt as 'that masculine American' and this judgement had more to do with technique than subject-matter, for there were certain technical practices which were regarded as manly (Marx, *Les Impressionnistes*, quoted in Garb, 'Berthe Morisot', p.59). To show excellence in them was to 'paint as a man'. Neither Cassatt nor Bonheur eschewed linearity, precision of execution or contrived compositional arrangements. Neither of them was prepared to concentrate on 'colour' at the expense of 'line'. They were both accomplished at drawing. As such they were seen to be reneging on their natural feminine attributes. If women were constitu-

tionally different from men, it followed that they should see differently and by extension make a different kind of art.

That certain kinds of mark-making and picture construction came to be seen as masculine while others were regarded as feminine in the late nineteenth century, was by no means accidental. The debates on the relative merits of drawing and colour had been couched in gendered terms since at least the seventeenth century. In the seventeenth and eighteenth centuries, however, sexual difference provided just one of many ways of conceptualizing the relative merits of drawing and colour, and seems to have operated more as a metaphor than as a literal framework for the assessment of the pictorial practices suited to men and women. By the mid-nineteenth century, drawing (*dessin*) with its connotations of linearity and reason, and the closely associated design (*dessein*), with its connotations of rational planning and the cerebral organization of the elements on the surface, were firmly gendered in the masculine, not only as metaphorical terms but as indicators of artistic practices exclusively suited to the male of the species and his supposed manner of perceiving. Colour, on the other hand, with its associations with contingency, flux, change and surface appearance was firmly grounded in the sphere of the feminine.

The gendering of formal language was most clearly expressed for late nineteenth-century students in Charles Blanc's widely used textbook, *Grammaire historique des arts du dessin* ('Historical grammar of the arts of drawing') published in 1867, with which most *fin de siècle* art critics would have been educated. Blanc proclaimed the dominance of line over colour, taking issue with the relative importance that thinkers like Diderot had attributed to colour. 'Drawing', he proclaimed, 'is the masculine sex in art, color is its feminine sex'. The importance attributed to drawing lay in the fact that it was, in his view, the basis of all three *grands arts*, architecture, sculpture and painting, whereas colour was only essential to the third. But the relationship between colour and drawing within painting itself was likened to the relationship between women and men:

> The union of drawing and colour is necessary for the engendering of painting, just as is the union between man and woman for engendering humanity, but it is necessary that drawing retains a dominance over colour. If it were otherwise, painting would court its own ruin; it would be lost by colour as humanity was lost by Eve.
>
> (Blanc, *Grammaire historique*, quoted in Garb, 'Berthe Morisot', p.61)

Colour is seen to play the feminine role in art: 'the role of sentiment; submissive to drawing as sentiment should be submissive to reason, it adds charm, expression and grace.' What is more, it must be submitted to the discipline of line if it is not to go out of control. A formal hierarchy is framed within an accepted hierarchy of gender which functions as its defence.

Where Morisot's talent was said to triumph over her misguided female contemporaries was in her intuitive translation of perception through a natural ability to draw and harmonize colour. Her work seemed, to her critics, to be untainted by a system of drawing or composition which involved the intellect. Nor did she have unseemly ambitions of exploring the imaginative and mysterious elements of colour which the Symbolists embraced. She was praised therefore for not betraying the characteristics intrinsic to her sex. By being an Impressionist, Morisot was being, truly, herself. An exemplary *haute bourgeoise*, she came to represent, for her admirers, the acceptable female artist. In her refined person and secluded domestic lifestyle, she could be seen to embody the dignity, grace and charm which was regarded as the mark of a peculiarly French femininity. In comparison with the 'deviant' women who threatened to disturb traditional social and moral values – the 'new women', who were a focus of anxiety for numerous French commentators in the 1890s – Berthe Morisot, wife, mother and elegant hostess, could be acclaimed as a suitably womanly woman. What was more, her wholehearted identification with the Impressionist project and crucial position as one of its technical innovators,

could be seen as an expression of an intrinsically feminine vision at the very moment that women were being accused of denying their unique qualities and adopting the perverse posture of the *hommesse* (or manly female).

Against the background of feminist agitation and the proliferation of women artists who were thought mindlessly to mimic their male mentors, Morisot's apparent ability to harness the art of her time into a practice which was expressive of her 'femininity' deserved the highest praise. While many critics commented on her indebtedness to Manet, most praised her for successfully transforming his art into one of grace and charm befitting a lady of her class and background. What had on occasion been described as the robustness of Manet's technique was suitably feminized through the lightening of palette, delicacy of brushstroke, and fluidity of handling, which was the hallmark of her style. Morisot's true 'femininity', therefore, was not only seen to reside in the 'woman's world' which she pictured but, significantly, in her manner of perceiving and recording that world: 'Close the catalogue and look at the work full of freshness and delicacy, executed with the lightness of brush, a finesse which flows from a grace which is entirely feminine ... It is the poem of the modern woman, imagined and dreamed by a woman', wrote one enthusiast. Where Manet had been the painter of the modern from the dominant masculine, metropolitan viewpoint, Morisot represented its feminized opposite, contained, separate and suburban, but vibrating with the energy of a feminine sensibility which expressed itself in the very marks on the surfaces of her canvasses.

Gender figures in representation in complicated ways therefore. We are not engaged simply in collecting stories of forgotten women artists or of looking at how women or men have been represented in art in the past, although such forms of enquiry may be very productive. Gender is embedded in representation in much more fundamental and far-reaching ways than these. The division of the world into man/woman and masculine/feminine, has been one of the basic conceptual structures underlying all thought in our culture and history. It has been identified by feminists as the bedrock of patriarchal thinking. Society has been organized in relation to such divisions and nature has been invoked to defend its structures. Abstract thought has been conceptualized symbolically in terms of the masculine and its opposite the feminine. Such binary oppositions (opposites which are bound together and dependent on one another for their meaning) always serve to accord value to the first term and situate the second as its inversion, its opposite, the Other.

The viewers of Morisot's works in the 1890s were equipped with a set of current beliefs which informed their critical responses. One cannot but hear the echo of the scientific vulgarizers in the language of the art critics (and vice versa). In the popular scientific theory of the late nineteenth century, Woman was projected as a being who was not quite in control. Hysteria could be seen as the extreme expression of characteristics intrinsic to all women. Prey to her sensory impulses, Woman could become excessive, dangerous. Like 'colour', she threatened to overspill her boundaries, to corrupt the rational order of *dessin/dessein*. She needed to be disciplined, controlled by rational forces. But she could not usurp that world of reason and make it her own. To do that would have been to step outside the natural boundaries on which order and civilization was based. For the woman artist to absorb academic art theory, to aspire to *la grande peinture* (painting in the elevated genres), or to complete ambitious imaginative work based on a reverence for the spiritual, would have been laughable, even unnatural. Such work called upon capacities which women did not possess. And if they did, they would be reneging on their identities as women. They would become men.

Berthe Morisot's position within this nexus of anxieties is fascinating. A delicate balance is struck. In her, women's innate qualities are turned to the good. They are harnessed to a project which is seen as the fulfilment of her 'sex' and as unthreatening to the social order. As an Impressionist, she can fulfil both her role as artist and as woman. Only occasionally do we sense in the excessive language of her critics a fear that she will go over the

edge, that she will live out her 'femininity' too fully and become ill. One such instance was in 1883 when Huysmans described her work as possessing 'a turbulence of agitated and tense nerves', suggesting that her sketches could perhaps be described as *hysterisées* (quoted in Garb, 'Berthe Morisot', p.63). In a review of the 1876 Impressionist exhibition where Morisot exhibited *Un Percher de blanchisseuse* (Plate 251), Albert Wolff had commented that 'Her feminine grace lives amid the excesses of a frenzied mind'.

But for the most part critics in the formative 1890s saw in Morisot's work the realization of a well adjusted femininity. Hers was the kind of painting legitimate in a woman. Her painting gave stature and dignity to a way of perceiving which was different from men's. For men to practise Impressionism in this decade would have been to relinquish their powers of reason, of abstraction, of deliberate thought and planning. It would have led to an art which was weak, an 'effeminate' art. But for a woman to be an Impressionist made sense. It was tantamount to a realization of self.

That we would be hard pressed to tell the difference between some works by Morisot and Monet simply by looking at them, does not mean that they are not deeply implicated by the gender relations in which they were produced and consumed. How would we understand that a Monet such as *The Meadow* (Plate 253) could potentially be regarded within Symbolist circles as effeminate in the 1890s if we did not understand the formation of the category and its implications in relation to the greater value accorded to the masculine term. Indeed, it might have been the very discrediting of Impressionism by the 'feminine' characteristics attributed to it, together with a reaction against the emasculating

Plate 253 Claude Monet, *Le Moisson* (*The Meadow*), 1874, oil on canvas, 57 x 80 cm. Nationalgalerie, Staatliche Museen Preussischer Kulturbesitz, Berlin. Photo: Jorg P. Anders.

Plate 254 Claude Monet, *Grainstack* (*Snow Effect*), 1890–91, oil on canvas, 65 x 92 cm. Gift of Misses Aimée and Rosamond Lamb in memory of Mr and Mrs Horatio A. Lamb. Courtesy, Museum of Fine Arts, Boston.

domesticity (the domestic, remember, is always associated with the feminine) of the environments in which they were intended to be shown, that led an artist like Monet to develop a practice in the 1890s which allowed for a 'heroic' presentation of his artistic self without embracing the scale of the big Salon painting (Plate 254). (This he was to do later in his monumental water-lily paintings.) Seurat had, of course, managed to do this in the 1880s with his heroic paintings of modern life represented with the detachment of pseudo-scientific precision and the harnessing of traditional rules of composition and design which has always been coded in the masculine (Plates 186–87). Seurat's highly intellectual and analytical way of working did not run any risk of being dubbed 'feminine'. And in the late 1880s and early 1890s it was Seurat's challenge which had to be met by any self-respecting painter of the 'modern'. In the years between his small Impressionist landscapes, and the grandiose personal statements focused on his water-lily garden, Monet invented a means of asserting the self through repetition and variation of set motifs. In his 'series' paintings, Monet evolved a pictorial practice which constantly invoked the moment of creation, calling to mind the Romantic tradition of the artist whose energies are pitted against the trials of Nature. Monet was thereby able to assert his protean masculine creativity, compromised by Impressionism, both in the struggle with nature which his persistent return to certain motifs invoked, and his triumph over the small, the delicate and the domestic, which his collective display in the Paris galleries of many versions of the same scene suggests. Size was compensated for by quantity, the representation of modernity by the celebration of a very modern, and exclusively masculine construction of the artist.

In this context it is useful to stress how both viewers and artists depend upon each other for their definitions of self. As art in modern Western culture is a social and public activity it addresses itself to a climate of reception which in turn feeds off current and past

artistic and critical practices for the languages it needs to make sense of practice. But this is not, as I have attempted to show, a hermetically sealed world, a world of rarified aesthetics and elevated sensation. It takes place in the world, deriving its meanings, its institutional existence and material sustenance from the world and does its own work maintaining or undermining its dominant structures. Gender takes its place as one of the central means through which the social is ordered, and sexual difference is crucial to the construction of the psyche. The relationship of the psychic and the social is negotiated through representation and it is as representation that art is inextricably caught up in the processes of differentiation through which masculinity and femininity are continually defined and redefined.

References

BASHKIRTSEFF, M., *Journal* (1891), introduction by R. Parker and G. Pollock, London, Virago, 1985.

BAUDELAIRE, C., 'The painter of modern life' (1863) in *The Painter of Modern Life and Other Essays*, Oxford, Phaidon, 1964.

BAYLE, P., 'Eva Gonzalés', *La Renaissance*, June 1932, pp.110–15.

BERGER, J., *Ways of Seeing*, London, Penguin, 1972.

BULLARD, E. J., *Mary Cassatt, Oils and Pastels*, New York, Watson Guptill, Oxford, Phaidon, 1972.

Carl Andre, Wood, exhibition catalogue, Van Abbemuseum Eindhoven, 1978.

DERAISMES, M., 'Les femmes au Salon', *L'Avenir des femmes*, 6 August 1876, pp.115–17.

DUNCAN, C., 'When greatness was a box of Wheaties', *Artforum*, October 1975, 63, pp.60–64.

EDELSTEIN, T.J. (ed.), *Perspectives on Morisot*, New York, Hudson Hills Press, 1990.

GARB, T., 'Berthe Morisot and the feminising of Impressionism', in Edelstein, *Perspectives on Morisot*, pp.57–66.

GOWING, L., 'Renoir's sentiment and sense', in *Renoir*, exhibition catalogue, Hayward Gallery, 1985.

GREER, G., *The Obstacle Race: The Fortunes of Women Painters and their Work*, New York and London, Secker and Warburg, 1979.

HAMILTON, G. H., *Manet and his Critics*, New York, Norton, second edition, 1969.

HARVARD, H., 'Exposition de l'Union des femmes peintres et sculpteurs', *Le Siècle*, 25 January 1882, np.

HERBERT, R., *Impressionism*, New Haven and London, Yale University Press, 1988.

MATHEWS, N. M., *Mary Cassatt and the Modern Madonna of the Nineteenth Century*, Ph.D New York University, 1980.

MICHELET, J., *La Femme* (1859), reprinted Paris, Flammarion, 1981.

MULVEY, L., 'Visual pleasure and narrative cinema', *Screen*, 16, No. 3, 1975, pp.8–18.

NOCHLIN, L., 'Why have there been no great women artists?' (1973), reprinted in E. Baker and T. Hess (eds.), *Art and Sexual Politics*, London, Collier Macmillan, 1982.

PARKER, R., and POLLOCK, G., *Old Mistresses; Women, Art and Ideology*, London, RKP, 1981.

POLLOCK, G., 'The gaze and the look: women with binoculars – a question of difference', in R. Kendall and G. Pollock (eds.), *Dealing with Degas: Representations of Women and the Politics of Vision*, London, Pandora Press, 1992, pp.106–30.

REWALD, J., *History of Impressionism*, London, Secker and Warburg, fourth edition, 1973 (first published 1946).

ROSE, J., 'Sexuality in the Field of Vision' (1984), *Sexuality in the Field of Vision*, London, Verso, 1986.

SILVERMAN, K., *The Acoustic Mirror: The Female Voice in Psychoanalysis and Cinema*, Bloomington and Indianapolis, Indiana University Press, 1988.

UZANNE, O., *The Modern Parisienne* (1894), English translation, London, Heinemann, 1912.

VALÉRY, P., 'The nude' in *The Collected Works*, 1936, p.48.

Index

Illustrations are indicated by italicized page numbers.